MASTERS OF THE 20TH CENTURY
THE ICOGRADA DESIGN HALL OF FAME

Published by
Graphis Inc.
307 Fifth Avenue
New York
NY 10016

ISBN: 1-888001-85-2

This book was printed on
Sappi Magno Satin 170gsm
which was kindly donated
by Sappi Fine Paper Europe

Set in Futura and Bauer Bodoni

Setting and reproduction
by Creative Input Ltd.

Printed in Hong Kong by Dai Nippon

GRAPHIS NEW YORK

160202

MASTERS OF THE 20TH CENTURY

THE ICOGRADA DESIGN HALL OF FAME

CONCEIVED DESIGNED AND EDITED BY MERVYN KURLANSKY

FOREWORD
By Mervyn Kurlansky

The idea for this book grew out of the celebration of the 25th anniversary of the Icograda London Design Seminars. It is not intended as a record of the unique seminars themselves but is more of a salute to the 110 leading figures in the field of graphic design who spoke at them between 1974 and 1999 - a galaxy of stellar names who collectively make up the Icograda Design Hall of Fame.

When I was asked by Mary Mullin to be the chairman of the 25th anniversary seminar, scheduled for February 1999, I was reminded not just of the distinguished history of the series but of the tight budget. So my initial idea to invite all 104 past speakers to make a guest appearance in London quickly bit the dust. But not so a celebration of the heritage of the event. My alternative plan, developed with design writer Jeremy Myerson over a pint of beer with scampi and chips, divided the seminar into three parts: past, present and future.

The past would be covered by a multi-media presentation of the work of the past speakers, the present by a sample of young, hot practioners, and the future? Well, we'd all enjoy looking in the crystal ball to see where trends might lead us. "Great idea," said my organising committee, "but how are you going to get the work of the past speakers? Some have died, others are no longer in contact with Icograda. And, by the way, how will you finance a multi-media presentation?"

I needed answers quickly and enlisted my daughter Karen (nobody more tenacious or effective at this type of task) to contact past speakers. Around half of the them were or had been members of AGI (Alliance Graphique Internationale) so I also asked fellow member, David Hillman of Pentagram, for help. As luck would have it, Pentagram was holding the work of AGI members who had featured in FHK Henrion's 1987 book on AGI prior to the work going into the archives of the Design Museum in Essen, Germany. David let me have access to it.

That was my first stroke of good fortune. The second was finding the right team to produce an exciting, quality, multi-media presentation on a shoestring. Through D&AD, we were put in touch with Philip Giggle at Buckinghamshire Chiltern University College whose students had won D&AD's student gold award. It was all falling into place. Now all I had to do was to find a sponsor. I approached Sappi, an international paper manufacturer, who is committed to supporting the design community. Sappi agreed to sponsor the Icograda Foundation, the seminar, the multi-media presentation and now this book. Bless you, Sappi!

As the clock ticked down, all that was left was to race outstanding work to the Buckinghamshire team to complete the scanning and production of the multi-media presentation in time for the event. Karen, Phil and his students hit the deadline, the 25th and final Icograda London Design Seminar went according to plan and the multi-media presentation opened the show.

When it was all over and I decided to create this book, it seemed an easy task. We had all the work. What could stand in our way? The problem was that although the technical quality of the work was acceptable for digital reproduction on CD-Rom, in most cases it was unacceptable quality for print. To jump this final hurdle, I enlisted my daughter Dana (equally tenacious and effective) to help. We had to connect with all 110 past speakers (and families, libraries and museums in cases where the speakers were no longer alive) to request additional work of better quality together with career information. There were two people who could not be traced and there was one, just one, who did not respond to our request.

The work shown here is my personal choice from the examples sent in (you can find all the work on the interactive CD-Rom provided with this book). I feel very privileged to have been given the trust of these Masters of the 20th Century and I hope you enjoy viewing their work as much as I have enjoyed compiling this volume.

Mervyn Kurlansky, Hornbaek, Denmark, January 2001

SAPPI

By Craig Halgreen

Sappi is one of the leading paper producers in the world. Our speciality is making coated papers that are specifically designed for the production of annual reports, calendars, promotional brochures, catalogues, labels, posters and high quality books like the one you are reading. They are manufactured in a range of finishes, with glossy, silk and matt surfaces to choose from, and a wide variety of weights depending on the specific requirements of graphic designers, printers and customers at the end of the chain.

In 1997, Sappi became the first global coated fine paper company, with paper mills on three continents and a sales network covering almost every country in the world. This is a considerable achievement considering that up until the last decade, Sappi was purely a South African based company that came into being in 1936, making paper from straw.

Our two paper mills in Germany were once Hannover Papier. In the Benelux, the three mills were known as the Koninklijke Nederlandse Papierfabriek. In Austria, the paper mill that now houses the world's largest coated paper machine with a capacity of 500,000 tons of paper produced per annum, was previously known as Leykam-Mürztaler. The four paper mills in the United States were called the S.D. Warren Paper Company. All these mills, together with the three Sappi mills in the United Kingdom and the three fine paper mills in South Africa, are now concentrated into one focussed organisation called Sappi Fine Paper. Centuries of tradition combined with the latest technology and research and development facilities that are ensuring perfect coated paper surfaces that meet the requirements of the new millennium.

Sappi is probably better known today by the names of the most well-known coated paper brands on the market, namely Magno, HannoArt, Uni, Royal, Somerset, Lustro, Strobe and Empress, to name a few. We are committed to providing the finest possible papers for our paper users. For almost a quarter of a century, we have been rewarding printers for excellence in printing by means of the Sappi Printer of the Year Awards. Printers in every corner of the globe now participate in this contest, proving that they are committed to providing superior print to the market.

Graphic designers are also playing an increasingly active role in the specification of papers on which their creative designs are realised. Consequently we are dedicated to adding value to the design community by creating the Idea Exchange, a programme where we facilitate idea generation and sharing, and communication

across the design and print community. When graphic designers visit www.ideaexchange.sappi.com on the Internet, they find a comprehensive database of global contacts and a knowledge bank of invaluable technical information. There is also a library of ideas from which designers can access actual printed designs and ideas from around the world. And there's the possibility to get information about us and our paper brands, and order samples directly on-line. It's an evolving website and as time goes by, there's no limit as to how it will grow to becoming an essential portal for designers.

Furthermore, we believe that graphic designers are intrinsically designing for a better world. We know that many of them have great ideas that could raise the awareness of, and even funds for, worthy humanitarian causes that they feel strongly about. Too many of these ideas are not being realised due to the lack of funds made available to the organisations that care for these causes. With the introduction of the annual Ideas that Matter initiative we are inviting graphic designers from around the world to apply for substantial grants from Sappi to realise these ideas and help society in a way they feel is important. Together with the graphic design community we know we can make a generous contribution to society.

In addition to supporting causes dear to the hearts of the design community, we play our part in ensuring a sustainable future for generations to come. Where we manufacture our paper and grow our trees, we manage our impact on the local environment by implementing internationally recognised environmental systems and certification. We care for air-emissions, wastewater treatment and water usage as well as noise levels where our operations are located. Our innovation in terms of oxygen bleaching and reduced chlorine usage is world renown. Sappi contributes substantial funding to the World Wide Fund for Nature each year and has been awarded the Gold Panda Award in this regard. Manufacturing paper with care for its impact is entrenched within our operational policies.

Sappi will continue to grow as a company and as such will expand its operations and the availability of its papers more widely than ever before. We are ensuring that as we develop we continue to be focussed on the technical performance requirements of printers and the preferences of graphic designers. We firmly believe that through a close relationship of understanding, we can supply coated papers that contribute significantly to the visual appeal of printed ideas.

Craig Halgreen, Brussels, January 2001

ICOGRADA

By David Grossman

Icograda, the International Council of Graphic Design Associations, represents the international community of professional graphic designers. Established in 1963, Icograda is composed of national professional associations and design centres. It works closely with numerous international bodies impacting on the design environment and closely collaborates with its sister organisations ICSID (representing industrial designers) and IFI (representing interior designers and architects).

The original establishment of Icograda reflected the maturation of the graphic design profession in Western Europe in the sixties. As graphic designers came to realize both the potential and the responsibilities of their profession, they realized that through collaboration they could do much to raise standards, establish professional practices and promote graphic design. Stronger through united action, Icograda attracted the leading graphic designers of the day and quickly made a substantial impact on the scene.

The importance of education in achieving the goals of Icograda has always been clear. Introducing high standards of achievement and professional conduct to students during the formative period of their studies is the best way of assuring a responsible and able professional community. The Icograda London Student Seminar is a reflection of this conviction and for twenty-five years the event was an annual, internationally respected, celebration of graphic design. The pages of this book record the parade of true masters of twentieth century graphic design who gave of themselves to make lifelong impressions on the minds of thousands of young students.

At a certain point, The Icograda Foundation, established to support graphic design education, became responsible for organizing the ongoing series of seminars. It is impossible to name all the people who have selflessly given of their time and energy to make the seminars possible. This was truly a labor of love and devotion which well illustrates the 'spirit of Icograda' established by the founders of Icograda as personified by Willy de Mayo. Nonetheless, I must salute some of the individuals whose contributions ensured the continuity of the project: FHK Henrion, the first chairman; Alan Fletcher, who continued as chairman and finally Mervyn Kurlansky, the last chairman and the person responsible for the creation of this important book. And always, behind the scenes, were Marion Wesel Henrion and Mary Mullin.

The last twenty-five years have seen enormous geo-political changes, accompanied by (and perhaps a result of) relentless technological development. As the profession of graphic design is a critical

component of the modern economy, it is not surprising to see our profession in a continuing state of change. Icograda, as the world representative of the profession, naturally must reflect these changes.

As Icograda renews itself to ensure its ability to serve the needs of the international graphic design community, a new energy and vitality is evident. While the design process remains fundamentally unchanged, the professional challenges facing current graphic design in the fast paced global economy, accelerated by the demands of the evolving visual communications media of enormous potency, reaffirm the need for collaboration within the professional community.

At a time when the marketplace is becoming truly international, new graphic design communities are being established, often in difficult circumstances, in almost every country on the planet. Over the past few years, the focus of Icograda has changed to meet these urgent needs. While Icograda activities were once confined to a relatively small number of highly industrialized nations, the Icograda network of contacts and activities now circles the globe.

When graphic designers meet, they share more than a profession and a visual vocabulary. There quickly develops a wonderful friendship between colleagues. A bond is quickly formed, be they from countries as distant as Mongolia and Zimbabwe, Cuba and Vietnam or even as close as Israel and Lebanon.

Icograda is operating today on a truly global scale, taking advantage of new technologies to serve members and promote graphic design. No designer can afford to be isolated today and by active participation in Icograda any designer is instantly linked with the professional community.

The spirit and quality exemplified by the Icograda London Student Seminars is alive and well and will continue to serve the community through dozens of meetings, seminars and workshops affiliated with Icograda all over the world.

David Grossman, President (1999-2001), Icograda

HISTORY OF THE SEMINARS

By Marion Wesel-Henrion

1973:

Tony Madders of the Grand Metropolitan Hotel Group contacted the Design Council and the Chartered
Society of Designers (then known as the SIAD) with an idea to create a design student seminar during the
winter months when Grand Met's London hotels were not fully booked. Madders was given FHK Henrion's
name and they discussed the idea in detail. Madders' special events department offered to find a venue,
provide hotel rooms in London at reduced rates, negotiate cheap train tickets with British Rail for students
outside London, inform colleges and deal with the bookings. But a designer was needed to plan the
programme, invite speakers, design invitations and posters, and produce a comprehensive list of all the
colleges to be approached. FHK Henrion agreed to give it a go.

1974:

The first London Design Student Seminar took place in February. The chairman was Dick Negus and
the subject was 'Game'. John Halas, Ken Garland, Colin Forbes and FHK Henrion were the speakers.
It proved a great success and it was decided to continue the following year. After talking to the Design
Council, FHK Henrion thought it should now take place under the umbrella of Icograda.

1975:

The first Icograda London Student Seminar took place, chaired by FHK Henrion. The subject: Graphics.
From that year until 1990, FHK Henrion continued to be chairman. After two years he declined to
give the seminar a subject because he found that most speakers simply preferred to show and talk about
their work. The seminar series became a fixed and eagerly awaited event on the UK college calendar.
Many students continued to come in later years as teachers or as practising designers. The news spread
internationally and the seminar attracted people from all over Europe, Asia, Africa, Canada, USA,
Mexico and South America.

1982:

By now the running of the seminars had been taken over by David Campbell of Banks Sadler and
Henrion had initiated the idea of designing posters to go out to the colleges with programme information.

1989:

FHK Henrion asked Alan Fletcher if he would be prepared to take over from him after the 1990 event.
Fletcher did so.

1991:

As a tribute to FHK Henrion, Alan Fletcher suggested a social evening named 'Henrion Evening'. This was the first evening of each seminar hosted by Marion Wesel-Henrion. It took place in turn at the RSA, Pentagram, Fitch, Wolff Olins and the American College. It gave a number of students and their teachers the chance to meet the speakers in a relaxed atmosphere with drinks and snacks.

1992:

Fletcher introduced afternoon workshops following on from the morning seminars. 'Type Matters', moderated by Colin Banks, and 'Real World', moderated by Chris Ludlow and later by Quentin Newark.

1995:

An afternoon discussion forum, moderated by Lynda Relph-Knight, was added to the programme.

1997:

Mervyn Kurlansky took over from Alan Fletcher as chairman. He reintroduced subjects to create an awareness amongst students of social, environmental, political and technological issues to prepare them for important challenges which they would have to face in the years to come.

1998:

Mary Mullin, the Secretary General of Icograda, who for many years had been closely involved in the successful running of the seminars, and Brian Davies, Director of the Icograda Foundation, took over full responsibility of the seminars from Banks Sadler and commissioned Sharon Irving as seminar organiser.

1999:

This was the 25th and last Icograda London Student Seminar, sponsored by Sappi Fine Paper Europe and in association with D&AD. It started with a multi-media show conceived by Mervyn Kurlansky and produced by Philip Giggle with students from Buckinghamshire Chilterns University College, showing the work of the speakers of the past 25 years. A seminar on editorial design was organised by D&AD, led by Vince Frost and Simon Esterson. Colin Banks continued The 'Type Matters' workshop, which was produced by the Society of Typographic Designers, staged and funded by the London College of Printing.

Marion Wesel-Henrion, London 2001

1974

Colin Forbes
Ken Garland
John Halas
FHK Henrion

1975

Nancy Fouts
Malcolm Fowler
Lou Klein
Bernard Lodge
David Pelham
Arnold Schwartzman

1976

Colin Cheeseman
Wim Crouwel
Germano Facetti
Alan Fletcher
FHK Henrion

1977

David Bernstein
John McConnell
Ootje Oxenaar
Richard Williams

1978

Louis Dorfsman
David Gentleman
Sam Haskins
Jurriaan Schrofer

1979

David Hillman
Hans Hillmann
Herb Lubalin
Otto Treumann

1980

Saul Bass
Pierre Bernard/Grapus
Michael Peters
JVD Toorn Vrijthoff

1981

Matthew Carter
Gert Dumbar
Willy Fleckhaus
Rudolph de Harak

1982

Burns/Cooper
Alan Fletcher
Aaron Marcus
Kurt Weidemann

1983

Ivan Chermayeff
Rolf Müller
Arnold Schwartzman
Henryk Tomaszewski

1984

Ben Bos
Richard Hess
Mervyn Kurlansky
Marcello Minale

1985

Keith Godard
Fritz Gottschalk
Takenobu Igarashi
Malcolm Lewis

1986

Ken Cato
Tom Geismar
JVD Toorn Vrijthoff
Hermann Zapf

1991

Peter Brookes
B. Martin Pedersen
Henry Steiner
Wolfgang Weingart

1987

Jaap Drupsteen
Martin Lambie-Nairn
Bernard Lodge
Uwe Loesch
Niko Spelbrink

1996

Philippe Apeloig
George Hardie
Pierre Mendell
Michael Nash
Roland Scotoni
Tomato

1992

Malcolm Garrett
Benoît Jacques
Javier Mariscal
Paula Scher
Erik Spiekermann
Michael Wolff

1988

Adrian Frutiger
David Gentleman
Bruno Monguzzi
Bruno Oldani

1997

Karen Blincoe
David Carson
Mervyn Kurlansky
Tad Mann
Mike Portelly

1993

Aziz Cami
Huntley Muir
H-G Pospischil
Peter Saville
Waldemar Swierzy
Daniel Weil

1989

Saul Bass
Alan Fletcher
Richard Hess
Hans Rudolf Lutz

1994

Neville Brody
Abram Games
Alan Kitching
Italo Lupi
Per Mollerup
Woody Pirtle

1998

St Lukes
Antirom
Tory Dunn
Larry Keeley
Rankin Waddell

1990

Shigeo Fukuda
Ootje Oxenaar
Robert Probst
Dan Reisinger

1999

P. Scott Makela
Paul Porral
Alain le Quernec
David Redhead
Richard Seymour

1995

Michael Beirut
David Ellis – Why Not Associates
Brian Grimwood
Mary Lewis
Gunter Rambow
Tony Vines

MASTERS OF THE 20TH CENTURY

by Steven Heller

When I hear the word 'master' I reflexively kneel to one knee and bow at the waist. Really, I do. I am a true believer in the master/apprentice principal, whereby a generation of leaders passes its collective knowledge and wisdom to others. Of course, what goes into determining who is anointed 'master' is the question that only a board of mastery can answer. But presumably, consensus plays a role in the process. In our graphic design profession physical evidence of one's mastery is clear for all to see, yet the master is not merely someone of proven general accomplishment. In addition to individual prolificacy he or she has also contributed value through invention, whatever that may be.

As I read the list of names of designers represented in 'Masters of the 20th Century' there are very few that are unknown to me. Indeed the overwhelming majority includes designers whom I have admired from near and far, who have proven their mastery. In fact, I can honestly say that I regret having never attended an Icograda design seminar as a listener (or a speaker, although I would not call my self 'master' and

I'm lucky if I get called 'Mr.' Rather than 'hey you'). The opportunity to hear Ken Garland, Henryk Tomaszewski, David Pelham, Wim Crouwel, Richard Williams, Hans Hillmann, Marcello Minale, Burns/Cooper, Grapus (at the height of its powers), among others, would doubtless have enhanced my understanding, appreciation, and insight into a field upon which I have built a life.

A book, no matter how precise the transcription, rarely recreates the charged atmosphere of a live presentation. For the respective attendees who heard the talks and interacted with the personae, the memory of these events will have untold resonance. For the rest of us, this document of who participated in the seminars is but a vicarious record. But don't misunderstand me, it is by no means irrelevant. This celebration of those who contributed to Icograda's student seminars is an important archive – a 'keeper,' as we say in the book collectors world.

Although we do not hear their words, we see their work. Although we are not told exactly why they are masters, we can draw conclusions of our own from the evidence before us. The various chairpersons of Icograda's student symposium chose to invite these designers because they believed each and every one of them added a voice to the diversity of design practice, theory, and history. This determination was based on the unique quality in each of their work that transcended a momentary fashion or trend, or involved a characteristic that so utterly defined their respective eras that without them the fashion or trend would not have occurred.

Since some of the 'masters' in the early years of the seminar have passed away, and their memories are fading,

reintroducing their work to a new generation adds dimension to the entire practice. Young students have the unfortunate tendency, certainly at the outset of their careers, to regard past accomplishment as passé. What a loss it would be for the profession to forget Herb Lubalin, Saul Bass, Abram Games, Willy Fleckhaus, and Dick Hess. Surely, every student should be aware of Henryk Tomaszewski, Takenobou Igarashi, Lou Dorfsman, and Rudolph de Harak. Their individual contributions are the foundation on which conceptual graphic design – the big idea – is built. They raised the levels of typography, illustration, photography, and general aesthetic excellence. I can only imagine, what their seminar sessions were like, but I'm certain they were electrifying, even the subdued ones.

A year before Herb Lubalin died in 1981, I heard him lecture on the challenge of print communications in an increasingly motion-based media world. He spoke softly (one might say he even plodded along at a snail's pace). But the words were gems. He not only discussed the influence of film and television, but of transport vehicles, like buses and trucks, that carried type, and the necessity for type designers and typographers to be aware of how audiences would receive words and pictures in the future. Much of what he said seemed like science fiction (pre-Blade Runner), and I recall being mildly restless. But in retrospect he was correct. I have subsequently quoted and paraphrased Lubalin's talk many times. Doubtless, Lubalin and the speakers at Icograda's seminars have left similar intellectual time bombs set to explode as students mature in their professional lives.

The range of practice represented during the twenty-five years covered in this volume is indicative of Icograda's range of

concern. The list of speakers, while dominated by a male presence in an increasingly gender-balanced profession – addresses every corner of design practice – from magazine design to corporate identity. Students were privy to orthodox Modernism and Post-Modernism, traditional typography and experimental typography, rationalism and expressionism, eclecticism and, well more eclecticism, in all kinds of media. Therefore, the work exhibited in this book is equally remarkable for its inclusiveness, from the pristine elegance of Philippe Apeloig to the brutish stylism of David Carson. What is even more interesting is the interconnectedness of this work. Although the styles may be radically different, there is a common cause – communication. Although aesthetic tensions are evidenced, each body of work addresses the issues that all designers must confront – balance. As much as this is a portfolio of 'decontextualized' work, it is also a document of how designers balance art and commerce, individualism and collectivism. Before each designer could be designated a 'master' he or she had to prove that the line between service and indulgence, or rather client versus self, could be toed. Stepping too far on either side means jeopardy. Stay the course and the most difficult challenge is met. This is the trait that is being celebrated here. And I for one, find myself kneeling on one knee, bending at the waist.

Steven Heller is art director of the New York Times Book Review, co-chair of the School of Visual Arts MFA/Design program, and author of over seventy books on design, illustration, and political art.

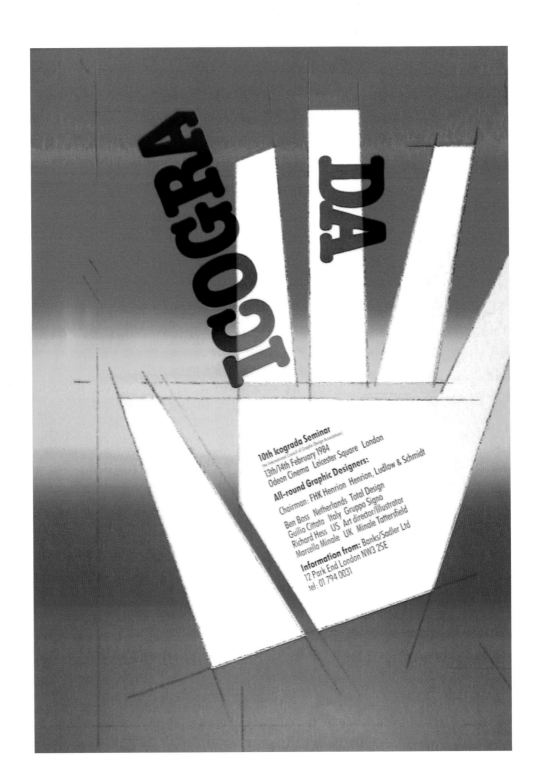

10th Icograda Seminar
(the International Council of Graphic Design Associations)
13th/14th February 1984
Odeon Cinema Leicester Square London

All-round Graphic Designers:

Chairman: FHK Henrion Henrion, Ludlow & Schmidt
Ben Boss Netherlands Total Design
Guilio Cittato Italy Gruppo Signo
Richard Hess US Art director/Illustrator
Marcello Minale UK Minale Tattersfield

Information from: Banks/Sadler Ltd
12 Park End London NW3 2SE
tel: 01 794 0031

10th Icograda London Design Seminar 1984 FHK Henrion

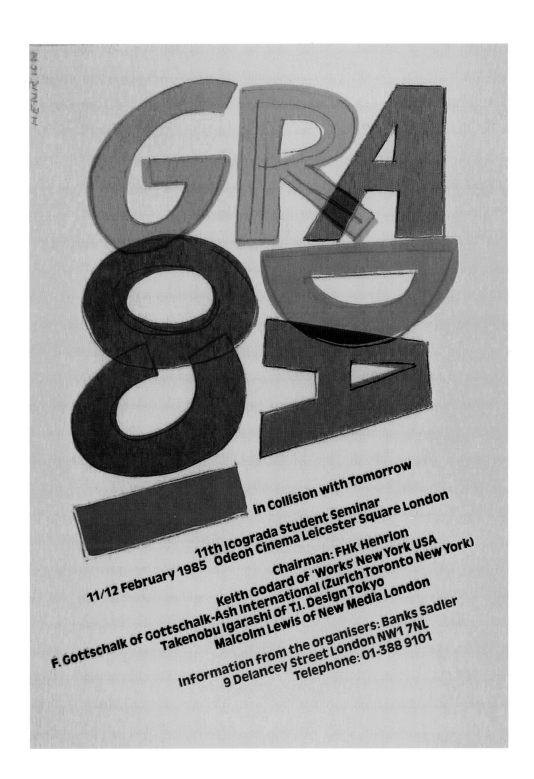

in Collision with Tomorrow

11th Icograda Student Seminar
Odeon Cinema Leicester Square London
11/12 February 1985

Chairman: FHK Henrion
Keith Godard of 'Works' New York USA
F. Gottschalk of Gottschalk-Ash International (Zurich Toronto New York)
Takenobu Igarashi of T.I. Design Tokyo
Malcolm Lewis of New Media London

Information from the organisers: Banks Sadler
9 Delancey Street London NW1 7NL
Telephone: 01-388 9101

11th Icograda London Design Seminar 1985 FHK Henrion

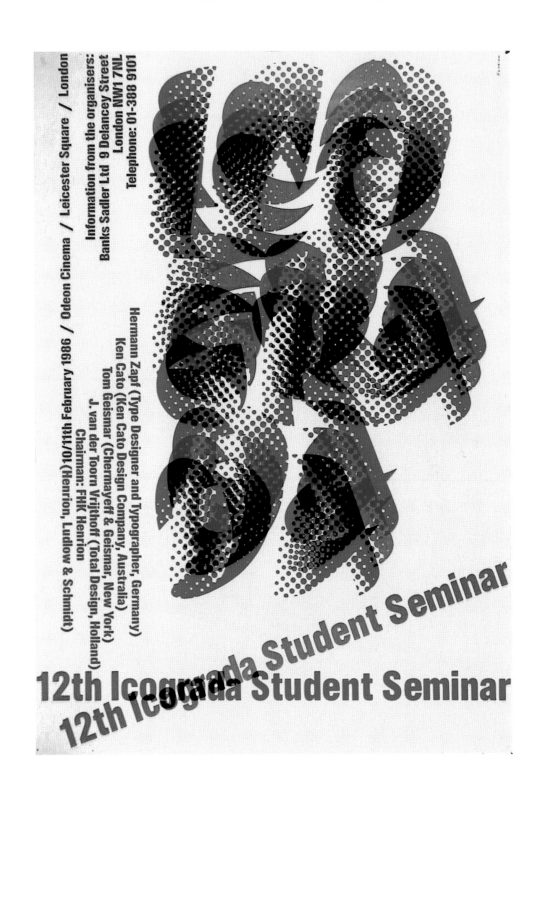

12th Icograda London Design Seminar 1986 FHK Henrion

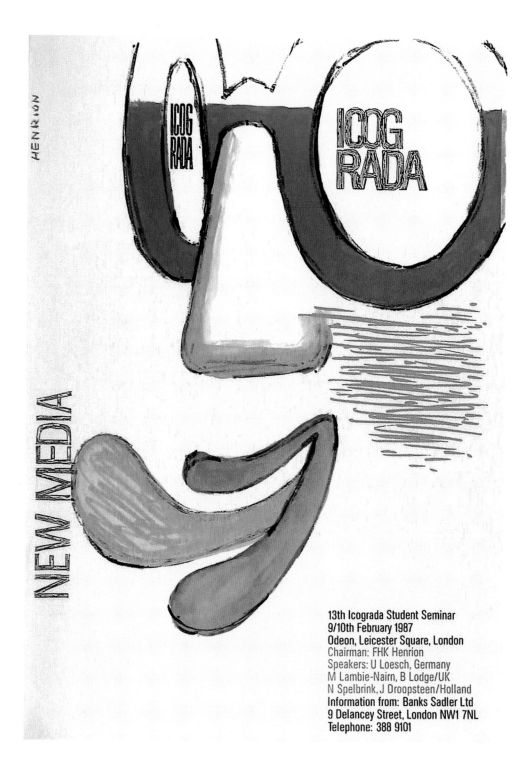

HENRION

NEW MEDIA

ICOG RADA

13th Icograda Student Seminar
9/10th February 1987
Odeon, Leicester Square, London
Chairman: FHK Henrion
Speakers: U Loesch, Germany
M Lambie-Nairn, B Lodge/UK
N Spelbrink, J Droopsteen/Holland
Information from: Banks Sadler Ltd
9 Delancey Street, London NW1 7NL
Telephone: 388 9101

13th Icograda London Design Seminar 1987 FHK Henrion

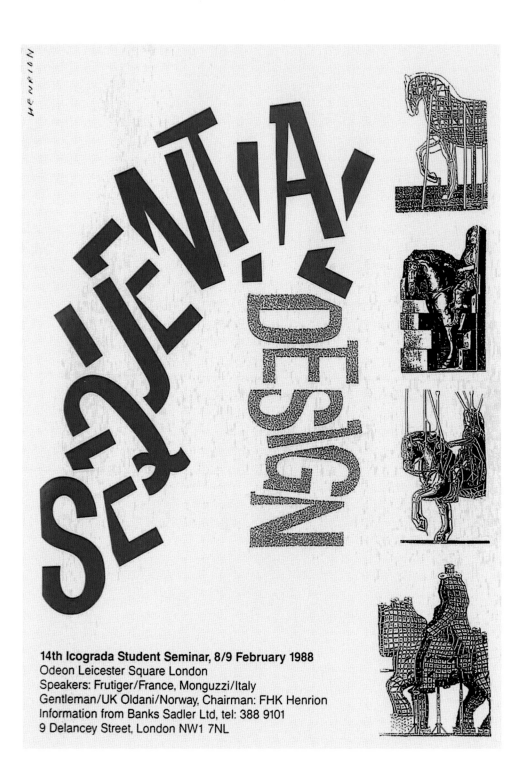

14th Icograda Student Seminar, 8/9 February 1988
Odeon Leicester Square London
Speakers: Frutiger/France, Monguzzi/Italy
Gentleman/UK Oldani/Norway, Chairman: FHK Henrion
Information from Banks Sadler Ltd, tel: 388 9101
9 Delancey Street, London NW1 7NL

14th Icograda London Design Seminar 1988 FHK Henrion

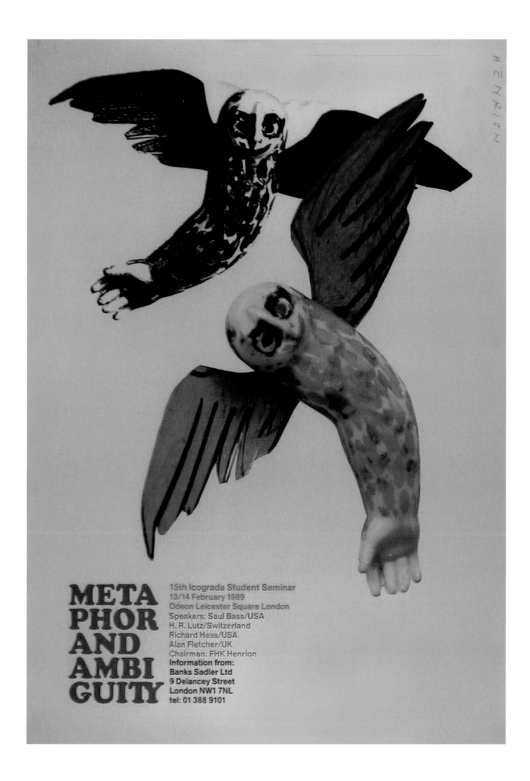

METAPHOR AND AMBIGUITY

15th Icograda Student Seminar
13/14 February 1989
Odeon Leicester Square London
Speakers: Saul Bass/USA
H. R. Lutz/Switzerland
Richard Hess/USA
Alan Fletcher/UK
Chairman: FHK Henrion
Information from:
Banks Sadler Ltd
9 Delancey Street
London NW1 7NL
tel: 01 388 9101

15th Icograda London Design Seminar 1989 FHK Henrion

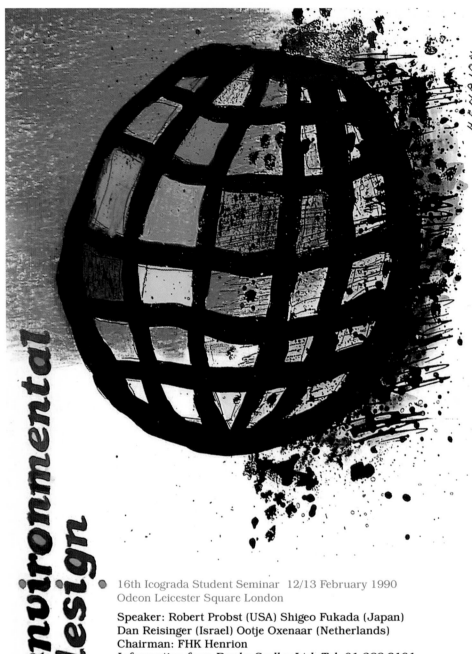

HENRION

environmental design

16th Icograda Student Seminar 12/13 February 1990
Odeon Leicester Square London

Speaker: Robert Probst (USA) Shigeo Fukada (Japan)
Dan Reisinger (Israel) Ootje Oxenaar (Netherlands)
Chairman: FHK Henrion
Information from Banks Sadler Ltd. Tel: 01-388 9101
15 Pratt Mews NW1 0AD

16th Icograda London Design Seminar 1990 FHK Henrion

images

For information please contact:
Banks Sadler Ltd, 15 Pratt Mews
London NW1 OAD, Tel (071) 388 9101
Telex 261200, Fax (071) 383 4794

Wolfgang Weingart (Swi) on typography
Peter Brookes (UK) on illustration
Henry Steiner (Hong Kong) on symbols
Martin Pedersen (USA) on magazines

Theme of the seminar:
The design process
from the idea to
the final solution

Seventeenth Icograda Student Seminar
9:30am to 12:00 on 11/12 February 1991
Odeon Cinema, Marble Arch, London
International Council of Graphic Design Associations

Eighteenth Icograda Student Seminar 10/11 February '92

The speakers are Malcolm Garrett, Benoît Jacques, Javier Mariscal, Paula Scher, Erik Spiekermann and Michael Wolff.

The Icograda Student Seminars have annually attracted some 1200 design students from all over Europe. They are the most important international gathering of students and their lecturers. This year the programme has additional speakers and events. It is also open to practising designers for the first time.

icograda International Council of Graphic Design Associations

The Lecture Programme

9.15 am to 12.00, 10 & 11 February
The theme of the speakers will be on the design process, commencing with initial ideas through to the final solution.

Chairman: Alan Fletcher (Pentagram)

The Odeon Cinema
Marble Arch, London W1

Monday 10 February:

Malcolm Garrett UK
Benoît Jacques Belgium
Paula Scher USA

Tuesday 11 February:

Javier Mariscal Spain
Michael Wolff UK
Erik Spiekermann Germany

The Real World Symposium

2.30 pm to 5.00, Monday 10 February
Discussion workshops on the realities of earning a living. Held by practising designers for the seminar delegates.

Chairman: Chris Ludlow (CSD)

Chartered Society of Designers
29 Bedford Square, London WC1

The Henrion Evening

6.30 pm to 8.30, Monday 10 February
Additional ticket required. An informal gathering to meet the speakers and other delegates.

Chairman: Mary Mullin (Icograda)

Pentagram
11 Needham Road
London W11

Type Matters Symposium

2.30 pm to 5.00, Tuesday 11 February
Discussion workshops on the state of the art. Held by practising designers and typographers for the seminar delegates.

Chairman: Colin Banks (STD)

Society of Typographic Designers
29 Bedford Square, London WC1

For information contact:

David Campbell (Organiser)

Icograda Student Seminars
Banks Sadler Ltd
15 Pratt Mews London NW1
Telephone: (071) 388 9101
Fax: (071) 383 4794

18th Icograda London Design Seminar 1992 Alan Fletcher

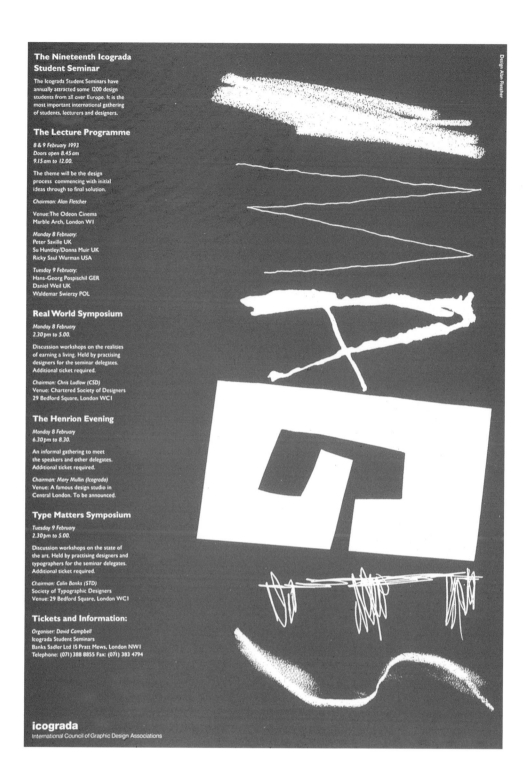

Design Alan Fletcher

The Nineteenth Icograda Student Seminar

The Icograda Student Seminars have annually attracted some 1200 design students from all over Europe. It is the most important international gathering of students, lecturers and designers.

The Lecture Programme

8 & 9 February 1993
Doors open 8.45 am
9.15 am to 12.00.

The theme will be the design process commencing with initial ideas through to final solution.

Chairman: Alan Fletcher

Venue: The Odeon Cinema
Marble Arch, London W1

Monday 8 February:
Peter Saville UK
Su Huntley/Donna Muir UK
Ricky Saul Wurman USA

Tuesday 9 February:
Hans-Georg Pospischil GER
Daniel Weil UK
Waldemar Swierzy POL

Real World Symposium

Monday 8 February
2.30 pm to 5.00.

Discussion workshops on the realities of earning a living. Held by practising designers for the seminar delegates. Additional ticket required.

Chairman: Chris Ludlow (CSD)
Venue: Chartered Society of Designers
29 Bedford Square, London WC1

The Henrion Evening

Monday 8 February
6.30 pm to 8.30.

An informal gathering to meet the speakers and other delegates. Additional ticket required.

Chairman: Mary Mullin (Icograda)
Venue: A famous design studio in Central London. To be announced.

Type Matters Symposium

Tuesday 9 February
2.30 pm to 5.00.

Discussion workshops on the state of the art. Held by practising designers and typographers for the seminar delegates. Additional ticket required.

Chairman: Colin Banks (STD)
Society of Typographic Designers
Venue: 29 Bedford Square, London WC1

Tickets and Information:

Organiser: David Campbell
Icograda Student Seminars
Banks Sadler Ltd 15 Pratt Mews, London NW1
Telephone: (071) 388 8855 Fax: (071) 383 4794

icograda
International Council of Graphic Design Associations

19th Icograda London Design Seminar 1993 Alan Fletcher

The six speakers:

Neville Brody UK
Abram Games UK
Alan Kitching UK
Italo Lupi Italy
Per Mollerup Denmark
Woody Pirtle USA

20th Icograda Design Seminar

The Icograda International Design Seminars annually attract over 1,000 students, college lecturers and young designers from all over Europe.

The two day programme provides a unique opportunity to hear and meet distinguished designers, attend two workshops, make contact with other delegates, visit design studios and go to galleries and museums.

The Lecture Programme

21 & 22 February 1994
Doors open 8.45 am
9.15 am to 12.00

The theme is images of the creative design process from the initial ideas through to the final solution.

Alan Fletcher/Chairman
[Annual Icograda Design Seminars]
Venue: The Odeon Cinema
Marble Arch, London W1

Monday 21 February

Italo Lupi Italy
Abram Games UK
Woody Pirtle USA

Tuesday 22 February

Alan Kitching UK
Per Mollerup Denmark
Neville Brody UK

Real World Symposium

Monday 21 February 1994
2.30pm to 5.00
[Additional ticket required]

Discussion workshops on the realities of making a living. Held by practising designers for the seminar delegates.

Chris Ludlow/Chairman
[Chartered Society of Designers]
29 Bedford Square, London WC1

The Henrion Evening

Monday 21 February 1994
5.30pm to 8.30
[Additional ticket required]

An informal gathering at a famous design studio to meet all the speakers, seminar delegates and sponsors .

Mary Mullin/Chairman
[Secretary General, Icograda]
Venue: Fitch, Porters South,
Crinan Street, London N1

Type Matters Symposium

Tuesday 22 February 1994
2.30pm to 5.00.
[Additional ticket required]

Discussion workshops on the state of the art. Held by practising typographers for the seminar delegates.

Colin Banks/Chairman
[Society of Typographic Designers]
29 Bedford Square, London WC1

Tickets & Information

David Campbell/Organiser
Banks Sadler Ltd, 15 Pratt Mews,
London NW1 0AD
Telephone: [071] 388 8855
Fax: [071] 383 4794

Icograda

International Council of Graphic Design Associations

Poster printed by CWS Arts. Design: Alan Fletcher

20th Icograda London Design Seminar 1994 Alan Fletcher

21st Icograda London Design Seminar 1995 Alan Fletcher

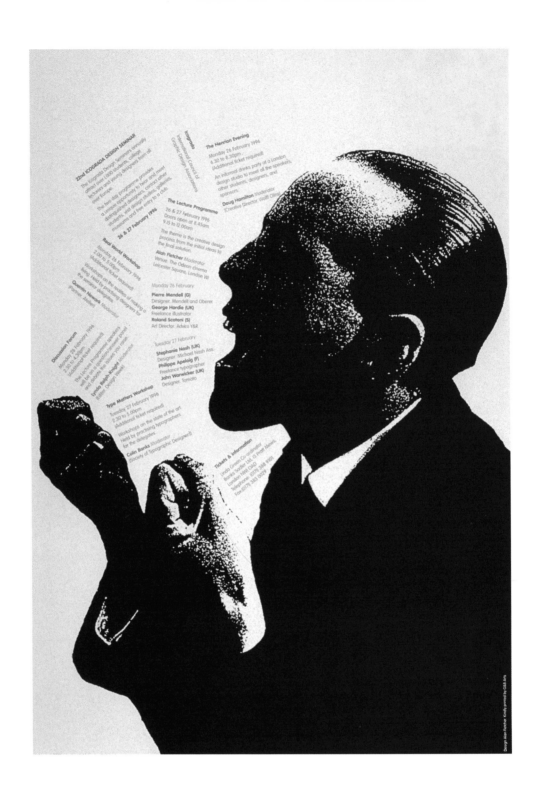

22nd Icograda London Design Seminar 1996 Alan Fletcher

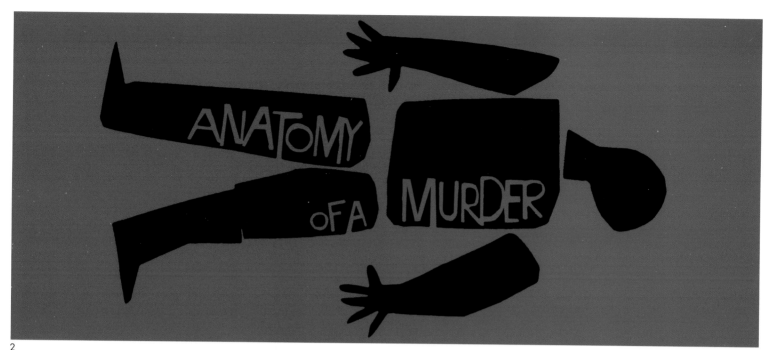

2

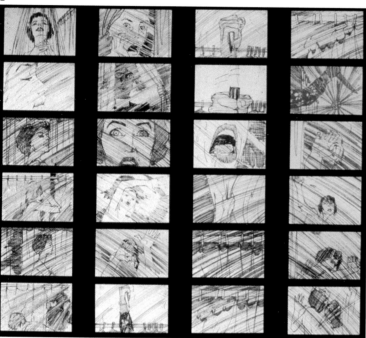

3

4

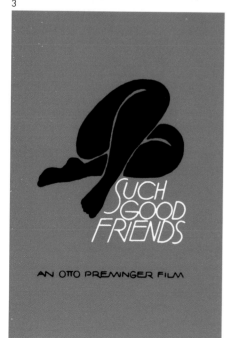

5

1
Film poster for
'The Man With The Golden Arm'
(Otto Preminger 1956)

2
From film title sequence for
'Anatomy of a Murder'
Director Otto Preminger
(Columbia 1959)

3
Storyboard for shower sequence
from 'Psycho'
(Paramount 1960)

4
From film title sequence for 'Vertigo'
(Universal 1958)

5
Film poster for 'Such Good Friends'
(Otto Preminger)

6
Film poster for 'Bonjour Tristesse'
(Otto Preminger 1955)

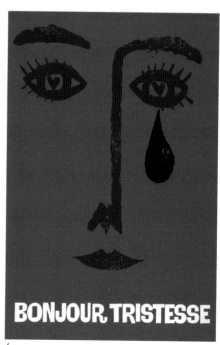

6

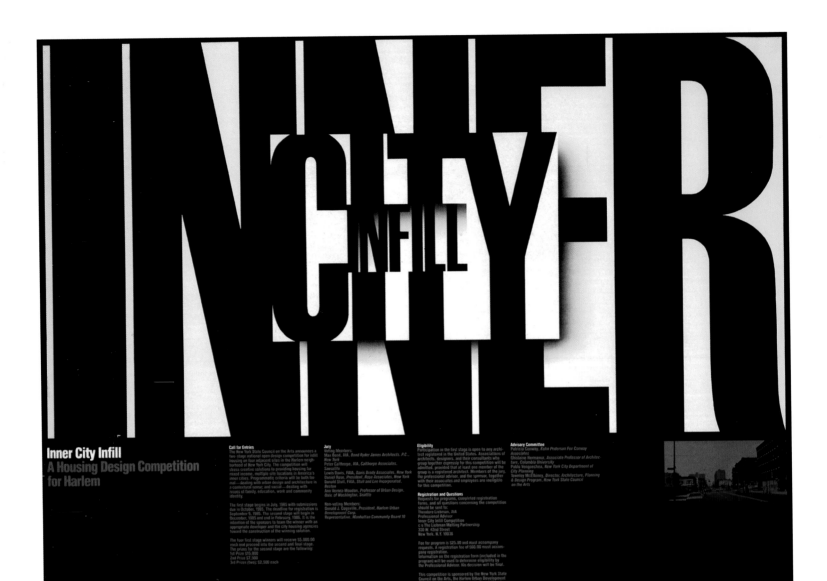

Inner City Infill
A Housing Design Competition for Harlem

Call for Entries
The New York State Council on the Arts announces a two-stage national open design competition for infill housing on four adjacent sites in the Harlem neighborhood of New York City. The competition will stress creative solutions to providing housing for mixed income, multiple site locations in America's inner cities. Programmatic criteria will be both formal—dealing with urban design and architecture in a contextural sense; and social—dealing with issues of family, education, work and community identity.

The first stage begins in July, 1985 with submissions due in October, 1985. The deadline for registration is September 9, 1985. The second stage will begin in December, 1985 and end in February, 1986. It is the intention of the sponsors to team the winner with an appropriate developer and the city housing agencies toward the construction of the winning solution.

The four first stage winners will receive $5,000.00 each and proceed into the second and final stage. The prizes for the second stage are the following:
1st Prize $15,000
2nd Prize $7,500
3rd Prizes (two): $2,500 each

Jury
Voting Members:
Max Bond, AIA, Bond Ryder James Architects, P.C., New York
Peter Calthorpe, AIA, Calthorpe Associates, Sausalito
Lewis Davis, FAIA, Davis Brody Associates, New York
Daniel Rose, President, Rose Associates, New York
Donald Stull, FAIA, Stull and Lee Incorporated, Boston
Ann Vernez-Moudon, Professor of Urban Design, Univ. of Washington, Seattle

Non-voting Members:
Donald J. Cogsville, President, Harlem Urban Development Corp.
Representative, Manhattan Community Board 10

Eligibility
Participation in the first stage is open to any architect registered in the United States. Associations of architects, designers, and their consultants who group together expressly for this competition will be admitted, provided that at least one member of the group is a registered architect. Members of the jury, the professional advisor, and the sponsor, together with their associates and employees are ineligible for this competition.

Registration and Questions
Requests for programs, completed registration forms, and all questions concerning the competition should be sent to:
Theodore Liebman, AIA
Professional Advisor
Inner City Infill Competition
c/o The Liebman Melting Partnership
330 W. 42nd Street
New York, N.Y. 10036

Fee for program is $25.00 and must accompany requests. A registration fee of $60.00 must accompany registration.
Information on the registration form (included in the program) will be used to determine eligibility by the Professional Advisor. His decision will be final.

This competition is sponsored by the New York State Council on the Arts, the Harlem Urban Development Corporation, Manhattan Community Board 10 and the New York Landmarks Conservancy.

Advisory Committee
Patricia Conway, Kohn Pedersen Fox Conway Associates
Ghislaine Hermanuz, Associate Professor of Architecture, Columbia University
Pablo Vengoechea, New York City Department of City Planning
Townley McElhiney, Director, Architecture, Planning & Design Program, New York State Council on the Arts

Design: Michael Bond
Printing: Ascona Printing

1

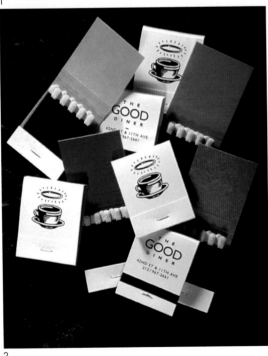

2

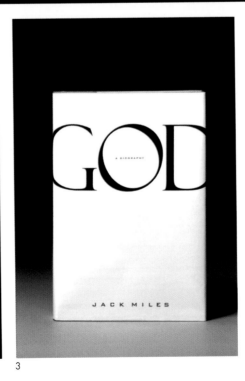

3

4

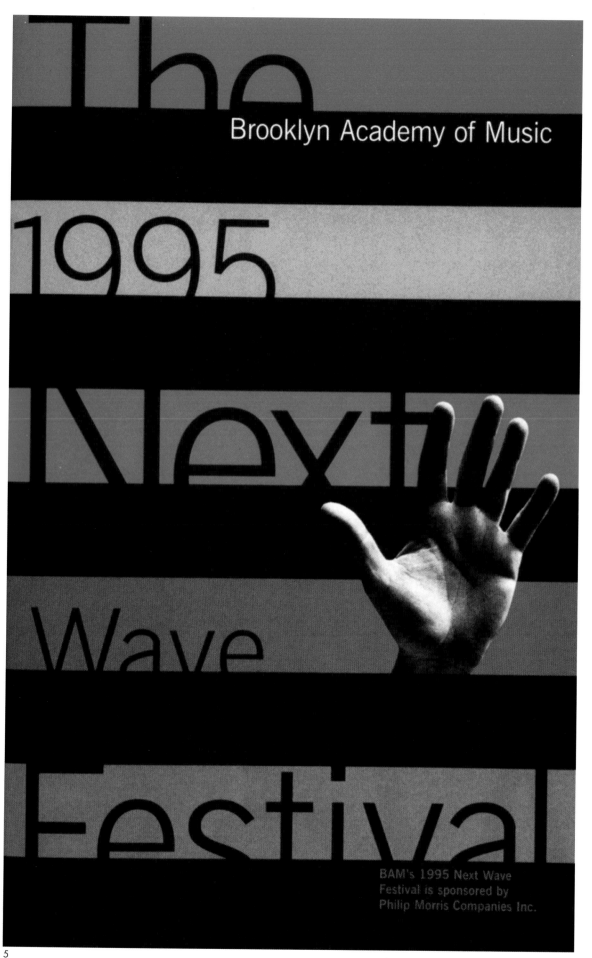

The
1995
Next
Wave
Festival

Brooklyn Academy of Music

BAM's 1995 Next Wave
Festival is sponsored by
Philip Morris Companies Inc.

5

1
A poster for a 1984 architectural
competion sponsored by the New York
State Council for the Arts, to solve the
problem of a vacant lot in Harlem.
Partner/Designer: Michael Bierut

2
The Good Diner
Client: Gotham Equities
Identity, August 1992
Partner/Graphic Designer:
Michael Bierut
Partner/Illustrator: Woody Pirtle
Designer: Lisa Cerveny

3
Alfred A. Knopf
God: A Biography
Book cover 1995
Partner/Designer: Michael Bierut

4
Children's Museum of Manhattan
Identity - 1989
Partner/Designer - Michael Bierut
Designer - Alan Hopfensperger

5
Brooklyn Academy of Music (BAM)
Consultancy, 1995 ongoing
Partner/Designer: Michael Bierut
Designer: Emily Hayes
Photographer (Next Wave hand):
Timothy Greenfield

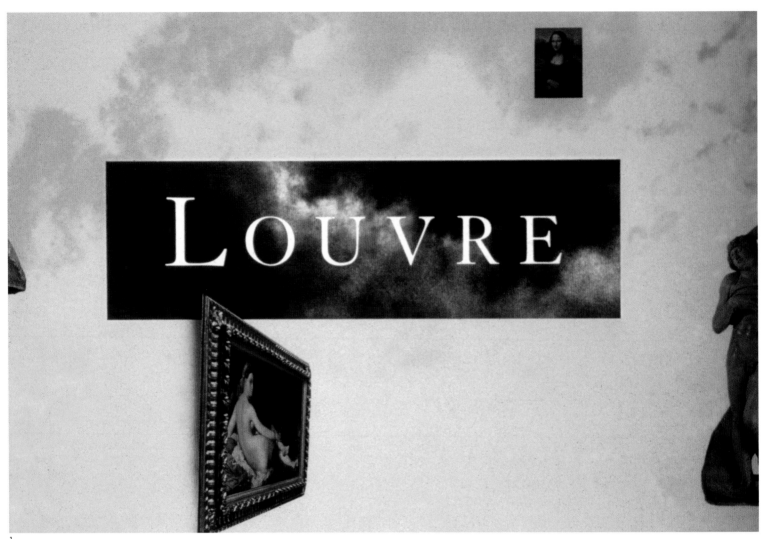

1

2

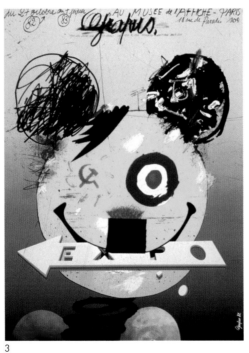

3

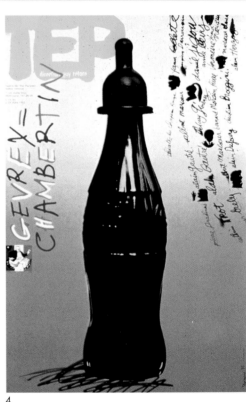

4

1
Logotype and graphic identity for the Louvre
Museum, 1990

2
Poster for a theatre play, 1976. (Grapus)

3
Poster for the Grapus exhibition at Musée de
l'Affiche in Paris, 1983. (Grapus)

4
'Gevrey Chambertin', poster for a theatre play,
1982. (Grapus)

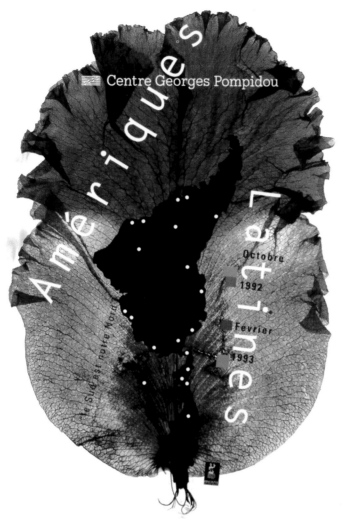

5

6

7

8

9

5
Poster announcing a South American event in
Centre Georges Pompidou

6
S.O.S. Kinderdorf poster, 1997

7
Poster for a Grapus exhibition, 1979. (Grapus)

8
Poster announcing a symposium: the child in the
industrial society, 1977. (Grapus)

9
Design Renaissance poster announcing an
Icograda event in Glasgow, 1993. (Grapus)

"matter is frozen energy"

[einstein]

"the big idea is a paradigm shift...

from the ptolemaic to the copernican world view...

or the post-it-note which changed our view of... glue"

**creativity is the ability to see something in a new way,
as if for the first time, and to articulate and communicate
that insight**

"an idea is a triumph of imagination set free by limitation..."

freedom without constraint is anarchy

freedom within constraint breeds creativity

"the brief is a frozen idea"

[bernstein]

the designer is an interface. he's an explainer.

he is the link between the thing and the user, between

the company and the customer.

"communication begins at the end..."

end has two meanings:

(i) purpose, aim, intention

(ii) end of a line [ie the end of the process, the respondent]

you should not begin to communicate unless you know:

(i) what you intend to achieve

(ii) whom you are communicating with

an idea involves a change of perspective

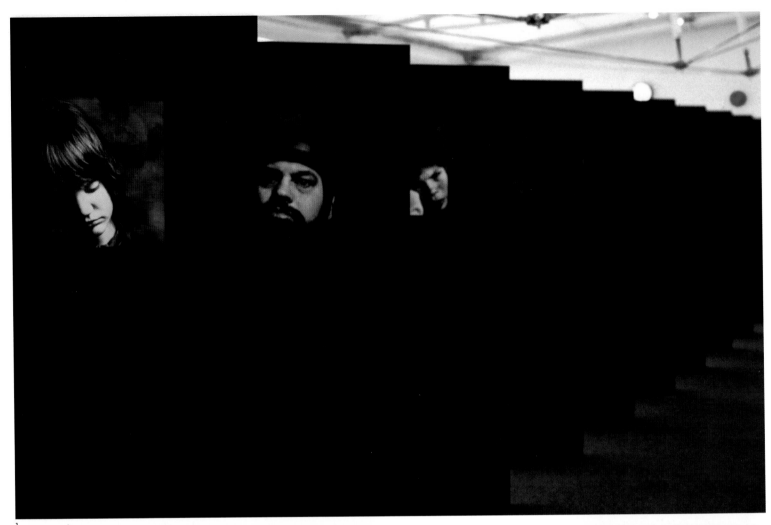

1

2

3

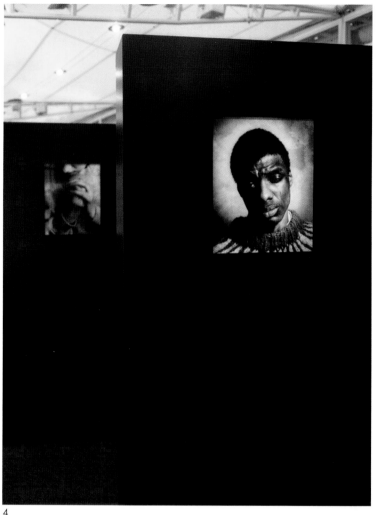

4

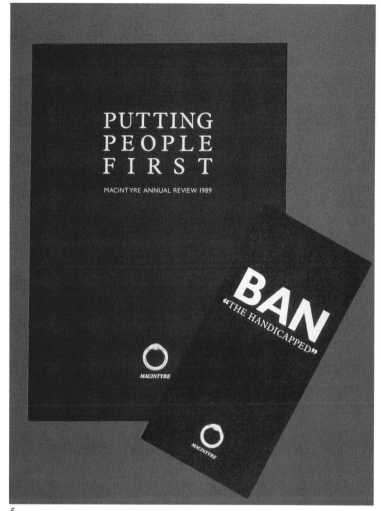

PUTTING
PEOPLE
FIRST

MACINTYRE ANNUAL REVIEW 1989

BAN
"THE HANDICAPPED"

MACINTYRE

MACINTYRE

5

ENVIRONMENT BY
DESIGN

6

G
M

7

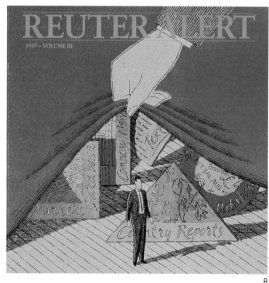

REUTER ALERT
1987—VOLUME III

8

1,4
Exhibition of portraits created for
the MacIntyre Schools Annual Report,
Photographer John Claridge

2
Identity for Pegasus Printers Limited

3,5,6
MacIntyre Schools Annual Report

7
Identity for Graeme Montgomery,
photographer

8
Quarterly corporate publication for
Reuters Limited

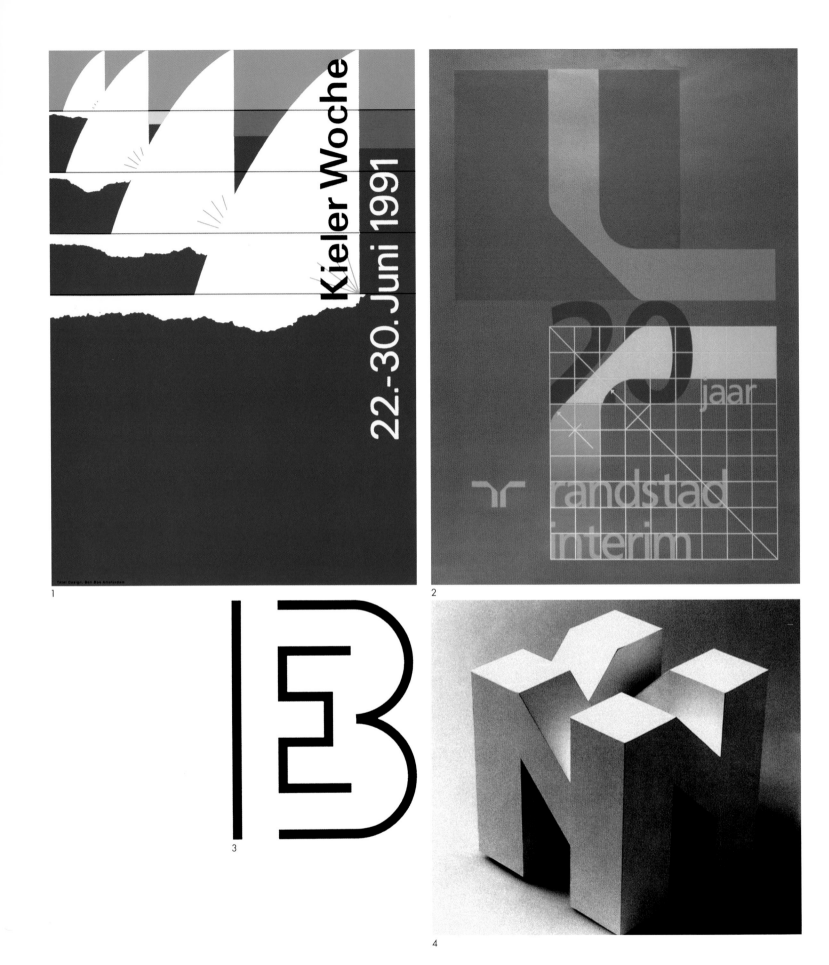

Kieler Woche

22.-30. Juni 1991

Total Design: Ben Bos Amsterdam

1

2

jaar

randstad
interim

3

4

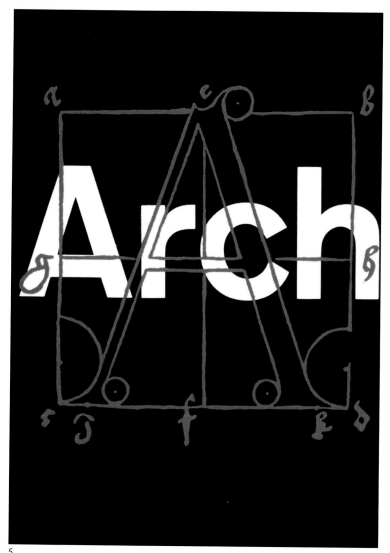

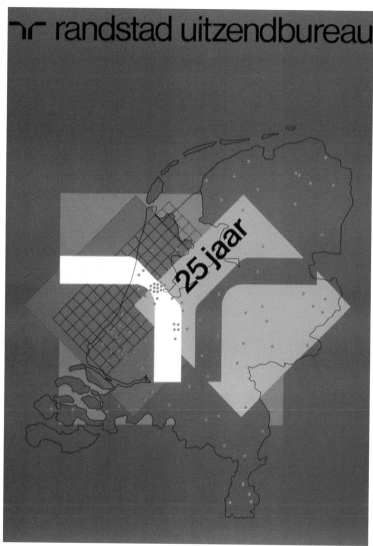

5

7

6

1
Kieler Woche; event design, 1991

2
Randstad, poster '20 years', 1991

3
EB, logotype for European Banking Association
(Amsterdam/Brussels), 1990

4
Netwerk 3, security (Amsterdam)
logotype, 1985

5
Arch, architects at Waddinxveen,
logotype, 1975

6
Randstad uitzendbureau (staffing services)
'25 years', poster, 1985

7
B&G Hekwerk
Best Fencing Manufacturers,
(Netherlands)
Logo, corporate design, 1978

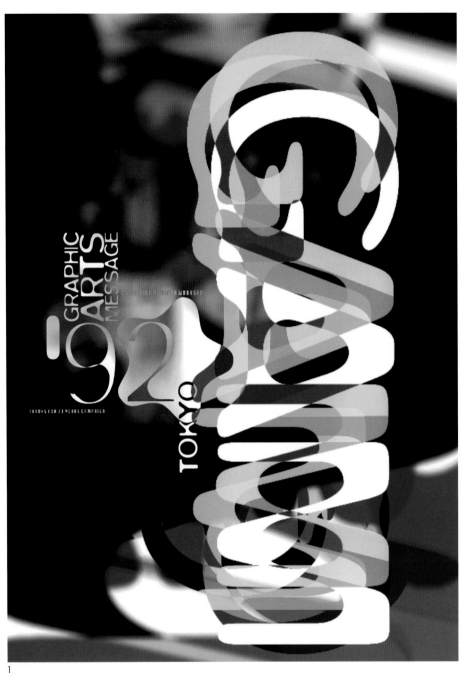

1

2

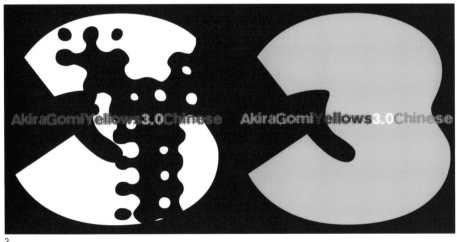

3

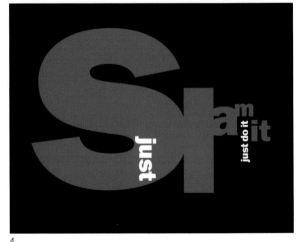

4

1
Poster for Graphic Arts Message, Too Corporation,
Tokyo, 1992

2
Image for Fuse98, a conference produced
by Meta Design, Neville Brody and FSI in
San Francisco, 1998

3,5
Yellows, CD-Rom published by Digitalogue
Japan, 1996

5

6

7

8

9

4
TV Commercial for Nike
for Wieden and Kennedy,
Los Angeles, 1988

6
Zumtrobel AG, Annual Report, 1994/95

7,8,9
Audiorom

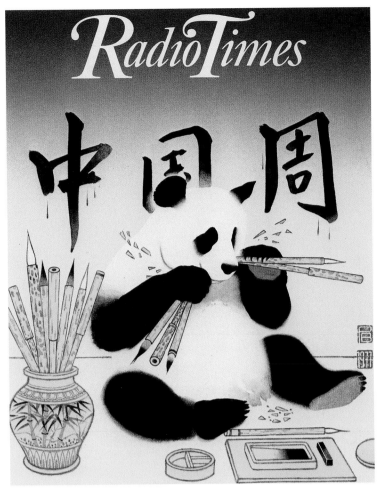

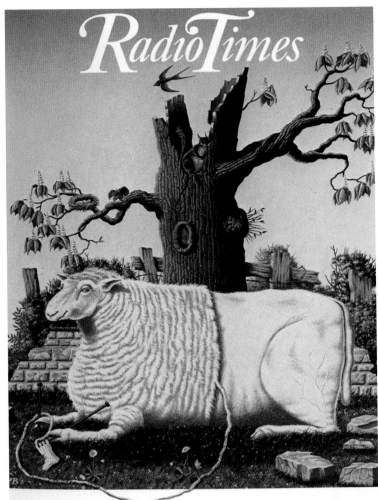

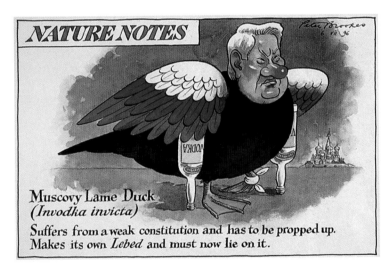

THE SPECTATOR

24 February 1990 — Est.1828 — £1

Timothy Garton Ash in Bonn and Berlin

One Fatherland

Murray Sayle
Small earthquake in Japan

Polly Toynbee
We can't stop divorce

THE SPECTATOR

16 January 1988 — Est.1828 — £1

Geoffrey Robinson on government exploitation of secrecy laws

Ring of confidence

Auberon Waugh
The madness of Peter Bottomley

Geoffrey Wheatcroft on
1968

Simon Courtland on
hunting parsons

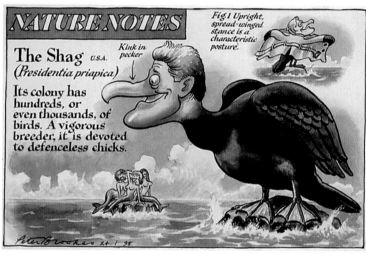

NATURE NOTES

The Shag U.S.A.
(*Presidentia priapica*)

Its colony has hundreds, or even thousands, of birds. A vigorous breeder, it is devoted to defenceless chicks.

Kink in pecker

Fig 1 Upright, spread-winged stance is a characteristic posture.

1

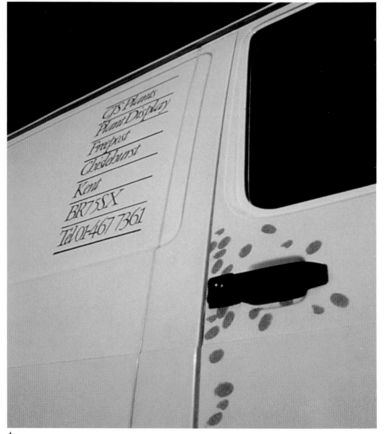

2

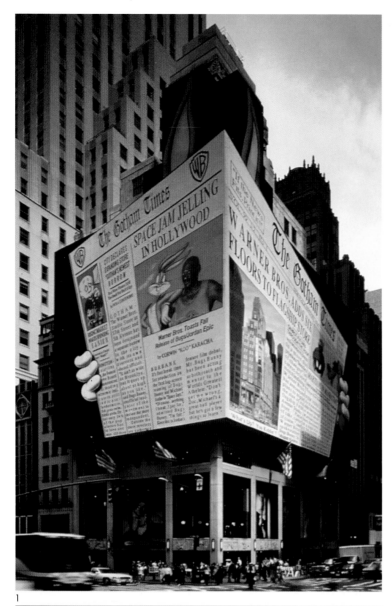

3

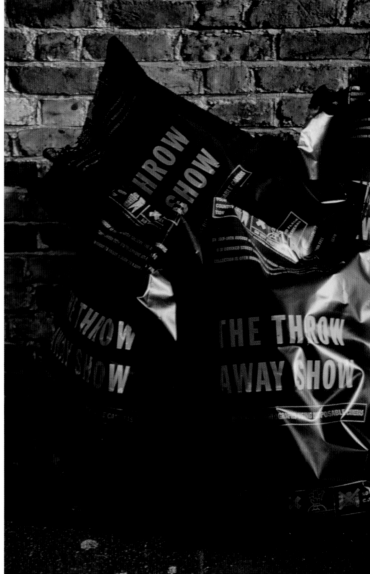

4

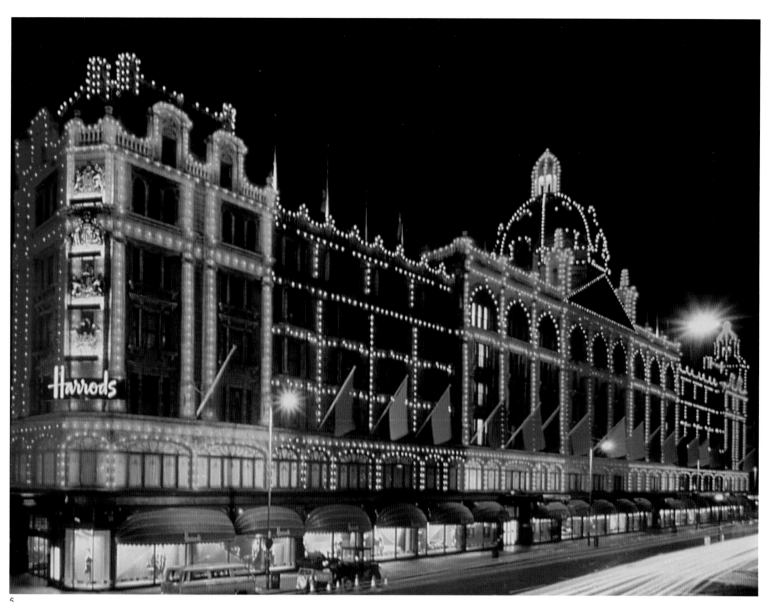

5

6

1
Client: Warner Bros.,
Project: Bugs Bunny hoarding (1996)

2
Client: Association of Photographers,
Project: Throw Away poster (1993)

3
Client: Wedgwood, Project: Identity (1977)

4
Client: CJS Plants, Project: Identity (1985)

5
Client: Harrods,
Project: Colourful Lights store promotion (1989)

6
Client: ISTD Fine Papers,
Project: Parilux paper mailer (1995)

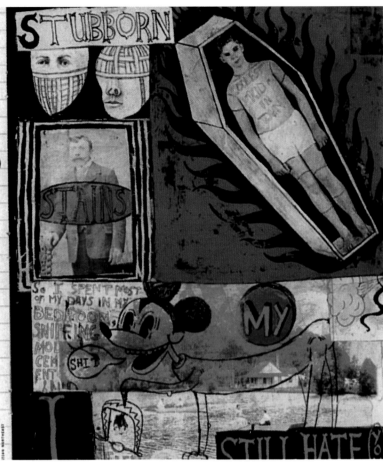

1
Raygun 19 1994 Spread (illustrator: Christian Northeast)

2,4,6,8
Posters for ACA Workshops

3
Raygun 5 1993 Cover (illustrator: Jim Sherraden)

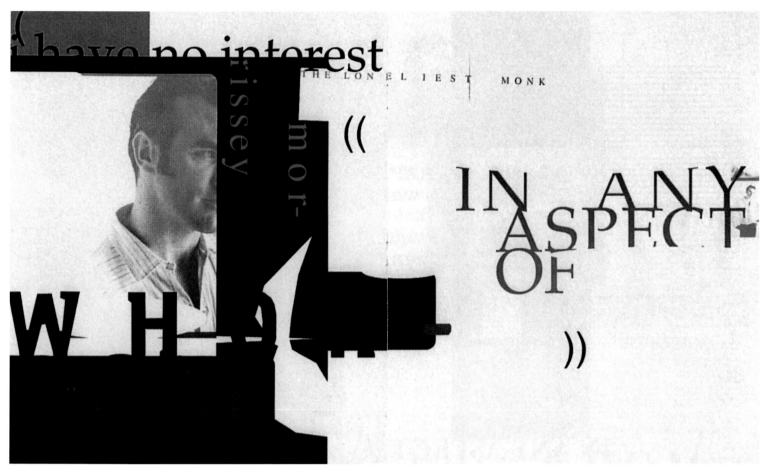

5

6

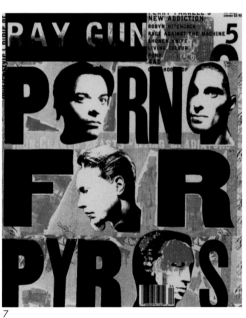

7

8

MATTHEW·CARER'S
MANTINIA
A·NEW·DESIGN
WiTH·CAPITALS
TALL·CAPITALS
ALERNATIVES
SUPERIORS·&
LIGATURES

2

&AABCDEE FF
GHIIJKK
LMMNOPQRR
STTUVWXX
YZ & ÆŒ
123467890 54·
$£¥ƒ.,:∴;-!?○□◇{}°‴"
+−×=±÷∾¬<>
ªº©←→‹›«»*†‡
ÅÅÇÉÏÏÑÔÔØÙ
¶§ΔΠΣΩ❧

30 How can the quality of a t
33 How can the quality of
36 How can the quality o
42 How can the quali
48 How can the qu
54 How can the q
60 How can the
72 How can t

FAR
EASTERN
EARLY
MEDIÆVAL
THE ART OF
ISLAM
ENGLISH
SCULPTURE
MUSICAL
INSTRU-

1
Sample of Mantinia tiling typeface design,
1993

2
Character set for Sophia typeface,
showing alternative forms in red, 1993

3
Snell Roundhand Bold

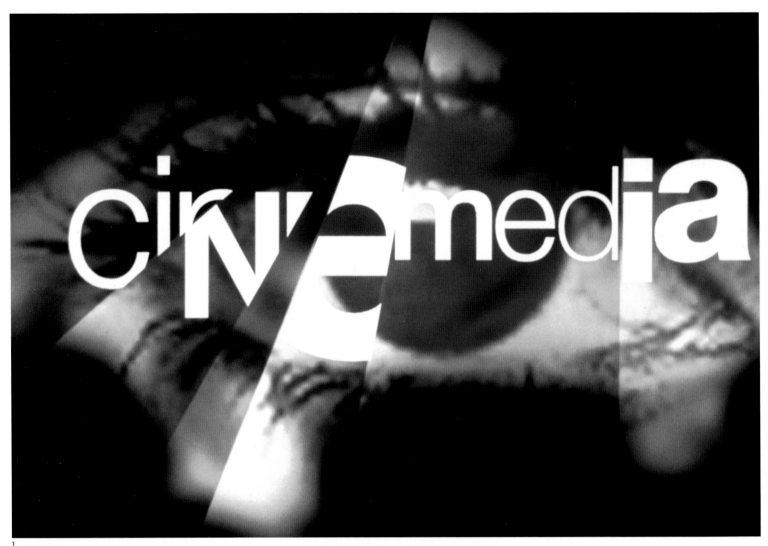

1

2

3

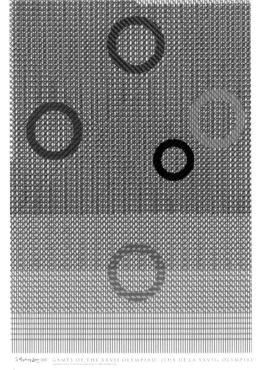

4

1
Visual Identity, Cinemedia, a production, distribution, exhibition and archive centre

2
Exhibition Posters, DDD Gallery, Japan

3
Cover for the annual publication of the Australian Commercial and Magazine Photographers

4
Invitational Poster, Sydney Organising Committee for the Olympic Games, 2000

5

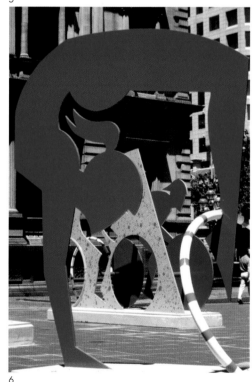

6

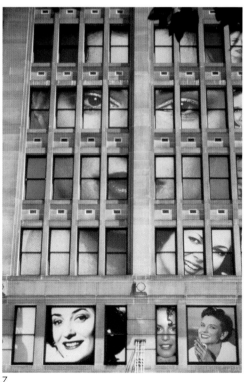

7

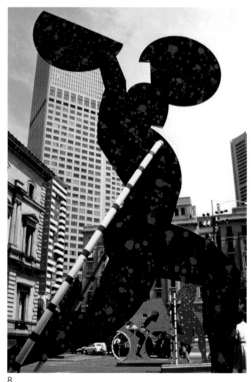

8

5
Multimedia corporate identity, ARC Music TV

6,8
3D Steel Sculptures, Streetscape sculptures to raise public awareness of Melbourne's bid to host the Olympic games, Melbourne Olympic Candidature 1996

7
Digital Prints for David Jones Department Stores 70th Anniversary Birthday Celebrations. A retail store predominantly for women

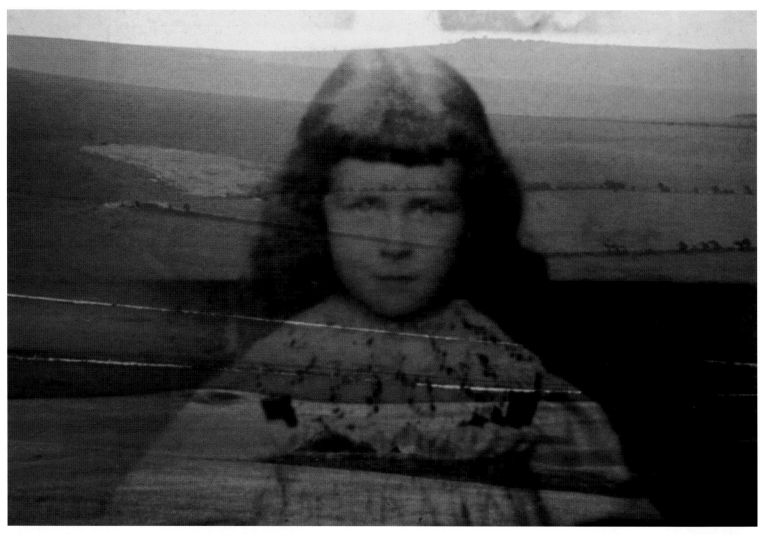

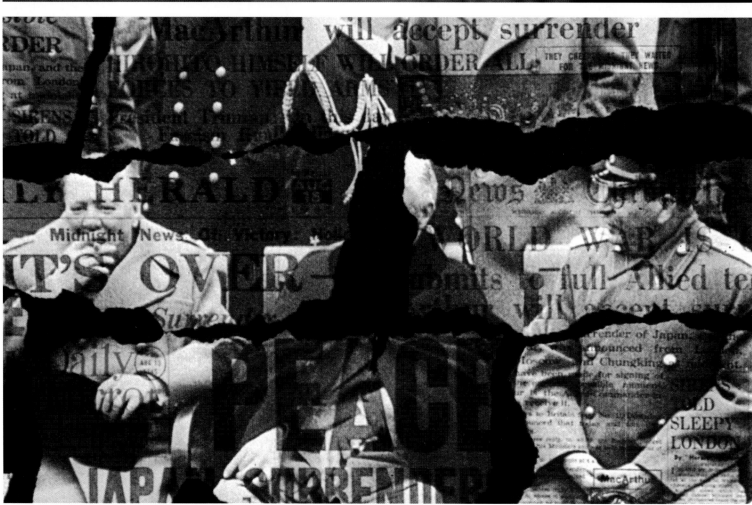

1

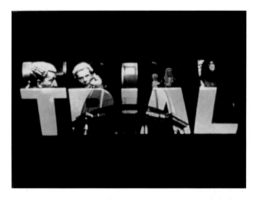

2

3

1
How Wars End
Title sequence for a series of TV lectures by
A J P Taylor for Channel 4

2
Trial Mr. X
Title sequence for a TV series

3
Doctor Who, 1973 version
Title sequence for a science fiction serial
for BBC TV

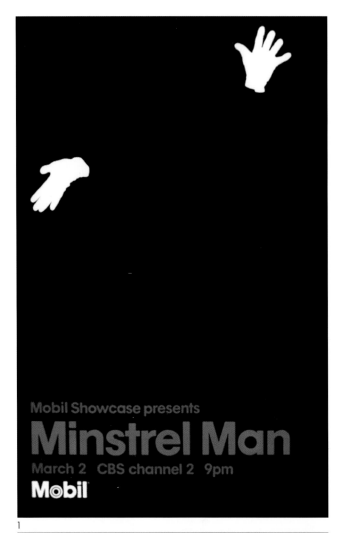

Mobil Showcase presents
Minstrel Man
March 2 CBS channel 2 9pm
Mobil

1

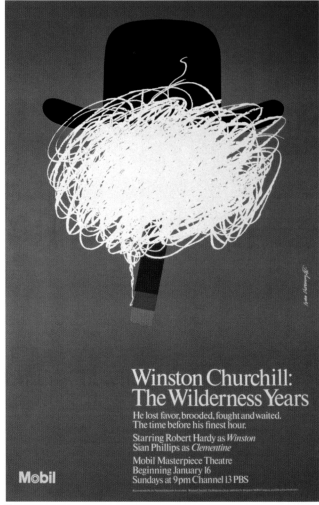

Winston Churchill:
The Wilderness Years
He lost favor, brooded, fought and waited.
The time before his finest hour.
Starring Robert Hardy as *Winston*
Sian Phillips as *Clementine*

Mobil Masterpiece Theatre
Beginning January 16
Sundays at 9pm Channel 13 PBS

Mobil

2

Ivan Chermayeff 1997-98 Art Council Distinguished Visiting Lecturer
UCLA Department of Design

Lecture: 7:30 pm, March 18, Dickson Auditorium, UCLA
Reception: 6:00 pm, New Wight Art Gallery, UCLA
Exhibition: March 16–19
All events are free and open to the public
Contact (310) 825-9287 for more information
The lecture is being presented in association with the AIGA/Los Angeles

3

National Museum of American Art Smithsonian Institution March 27-August 9, 1998

4

1
Mobil poster for
The Minstrel Man

2
Mobil poster for
Winston Churchill

3
Poster for UCLA

4
Poster for the National
Museum of American
Art: Posters American
Style

5
'Helix' sculpture
at Mt. Sinai Hospital

5

1

2

3

4

5

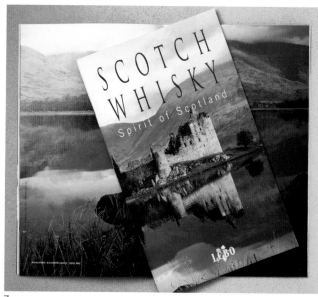

7

8

6

1,2,3
LCBO
Food & Drink Magazine
Concept, Design and Art Direction:
Heather Cooper & Eric Graham

4
Paradise
Oil on canvas, created as a symbol for all
living things, Northern and Southern Hemisphere.
Reproduced as a limited edition.

5
The Muses
Oil on canvas, commissioned by Petro Canada
in celebration of their ongoing support of the
performing arts. Reproduced as a poster and
promotional print.

6
Lion and the Lamb
Oil on board, in honour of March,
Heather Cooper's birth month, in like a lion - out
like a lamb, or the dilemma of personality, how
are you perceived. Printed in various forms.

7, 8
LCBO
The Spirit of Scotland, Brochure
Concept, Design and Art Direction:
Heather Cooper & Eric Graham

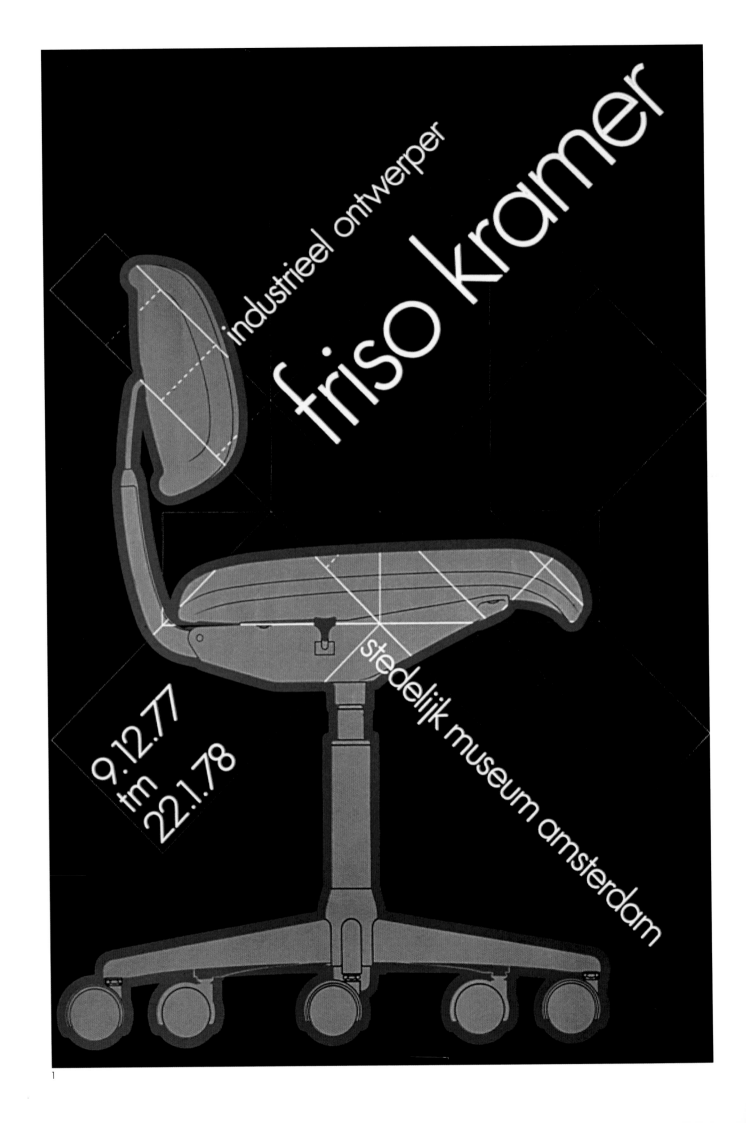

industrieel ontwerper
friso kramer
9.12.77 tm 22.1.78
stedelijk museum amsterdam

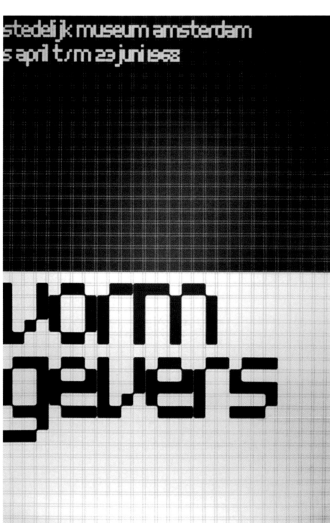

1

Poster for an exhibition of Friso Kramer RDI,
The Netherlands, 1977

2

Poster for an exhibition on design,
The Netherlands, 1968

3

Type design for the computer age, 1967

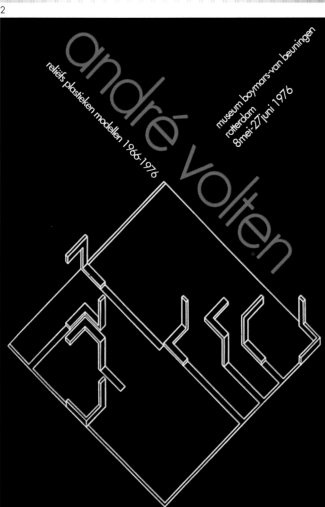

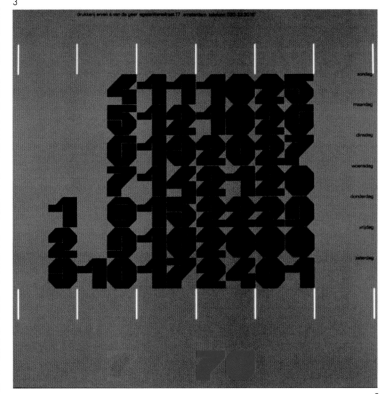

4

Poster for an exhibition of the sculptor
Andre Volten, Museum Boymans-Van Beuningen
Rotterdam, The Netherlands, 1976

5

Calendar for the printers Erven E. Van de Geer,
Amsterdam, The Netherlands, 1976

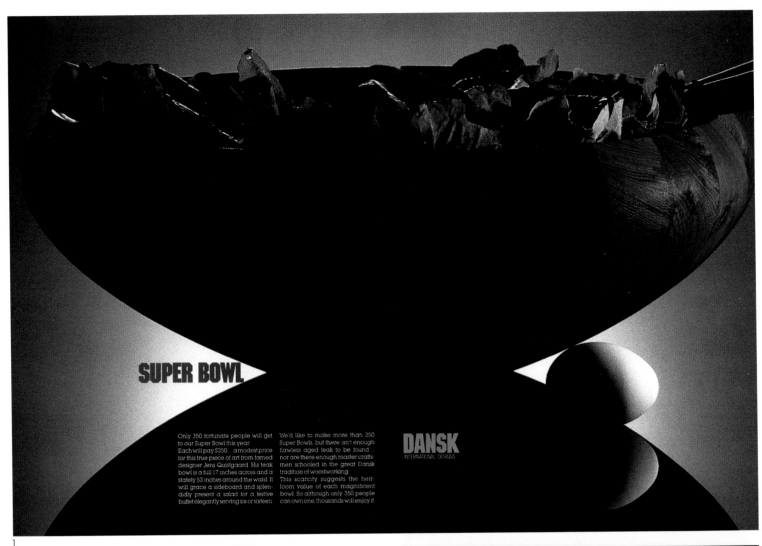

SUPER BOWL

Only 350 fortunate people will get to our Super Bowl this year.
Each will pay $250... a modest price for this true piece of art from famed designer Jens Quistgaard. His teak bowl is a full 17 inches across and a stately 53 inches around the waist. It will grace a sideboard and splendidly present a salad for a festive buffet elegantly serving six or sixteen.

We'd like to make more than 350 Super Bowls, but there isn't enough flawless aged teak to be found... nor are there enough master craftsmen schooled in the great Dansk tradition of woodworking.
This scarcity suggests the heirloom value of each magnificent bowl. So although only 350 people can own one, thousands will enjoy it.

DANSK
INTERNATIONAL DESIGNS

1

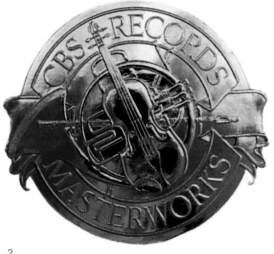

2

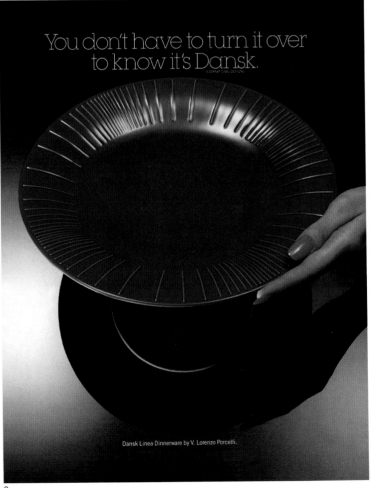

You don't have to turn it over to know it's Dansk.
INTERNATIONAL DESIGNS

Dansk Linea Dinnerware by V. Lorenzo Porcelli.

3

72

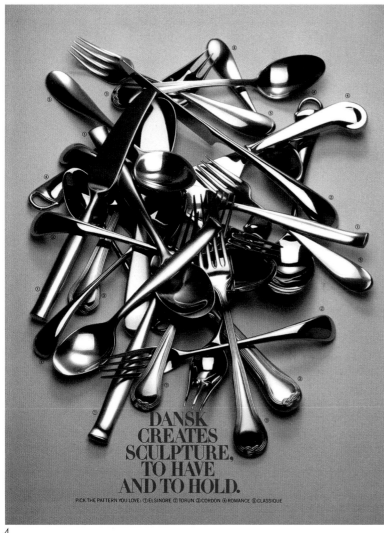

DANSK
CREATES
SCULPTURE,
TO HAVE
AND TO HOLD.

PICK THE PATTERN YOU LOVE: ① ELSINORE ② TORUN ③ CORDON ④ ROMANCE ⑤ CLASSIQUE

4

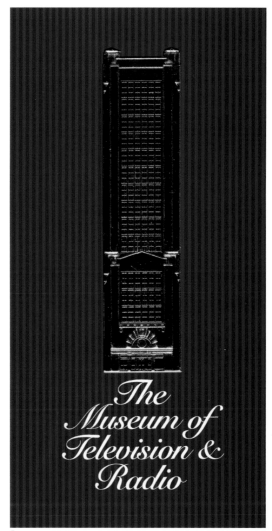

The
Museum of
Television &
Radio

5

Neighborhoods
Reborn.

Promises Kept.

6

7

1
Super Bowl,
Dansk Designs,
Double page
advertisement

2
CBS
Masterworks
Classics,
Logo Marque

3
Linea
Dinnerware,
Dansk Designs,
Single page
advertisement

4
Dinnerware
Cutlery,
Dansk Designs,
Single page
advertisement

5
The Museum
of Television
& Radio
'Gala Awards
Evening'
Brochure

6
LISC Poster

7
Classic
American Foods
Logo Marque

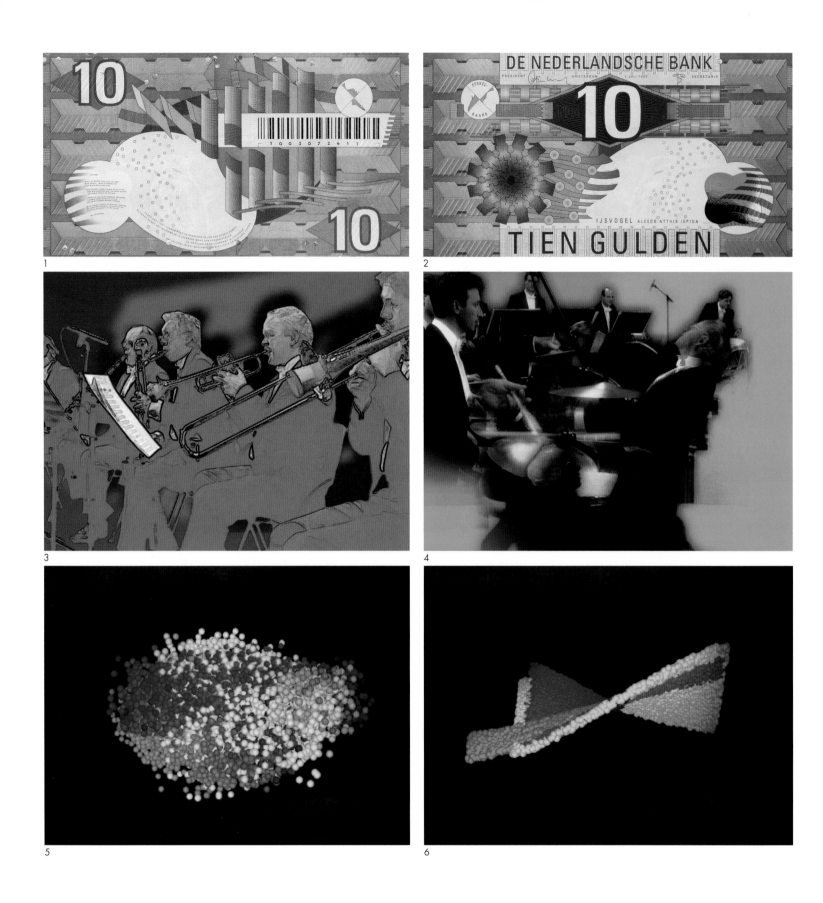

1,2
Recto and verso of 10 guilder banknote

3,4,9,10
Image sequence 'Sinfonia' for Dutch television

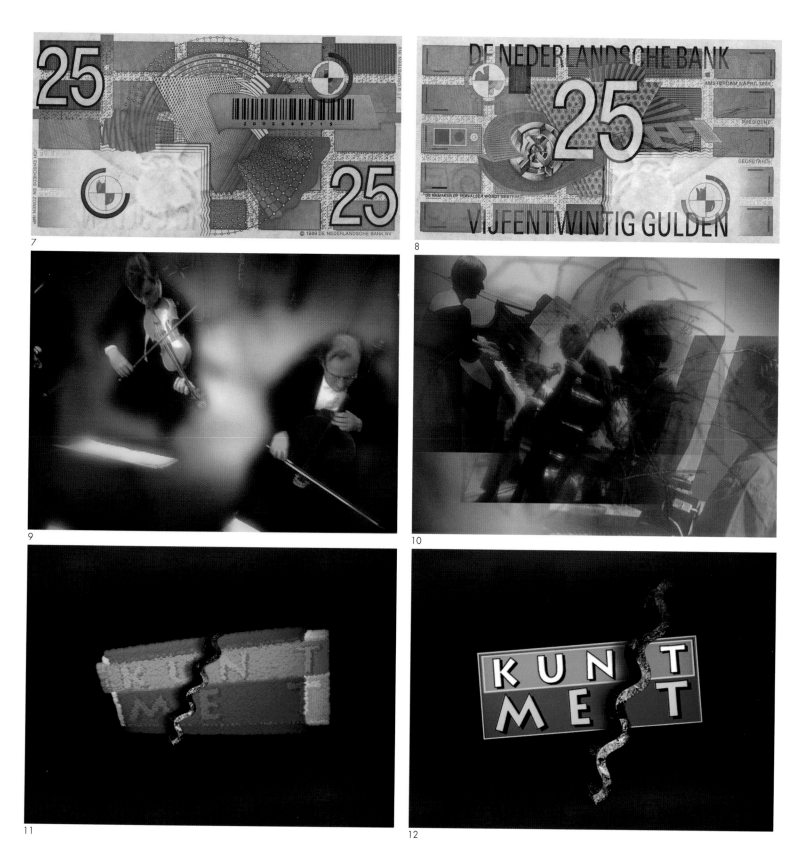

7

8

9

10

11

12

5,6,11,12
TV title sequence for Kunstmest

7,8
Recto and verso of 25 guilder banknote

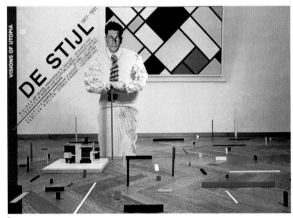

1

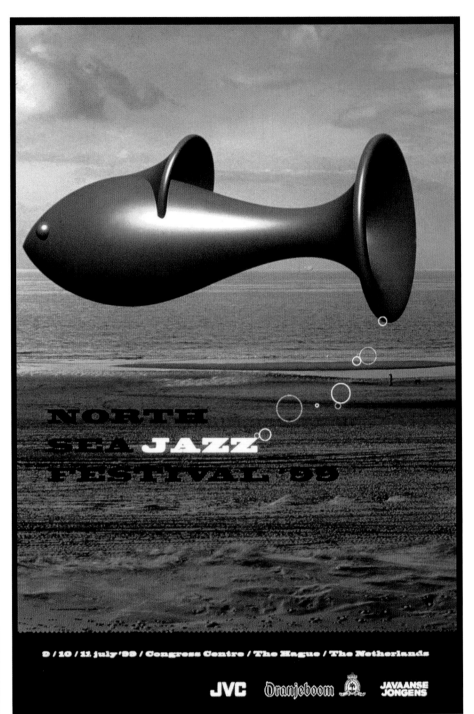

2

3

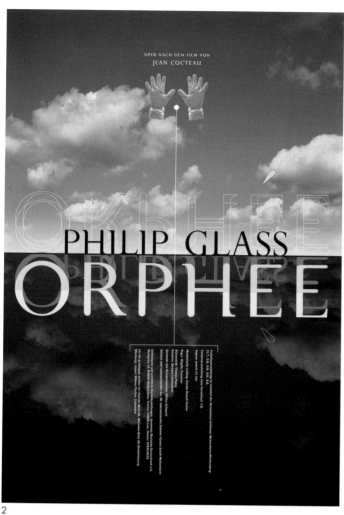

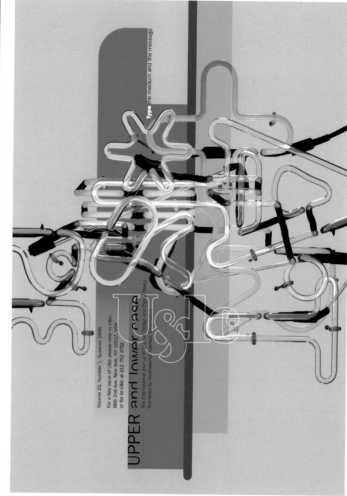

2

3

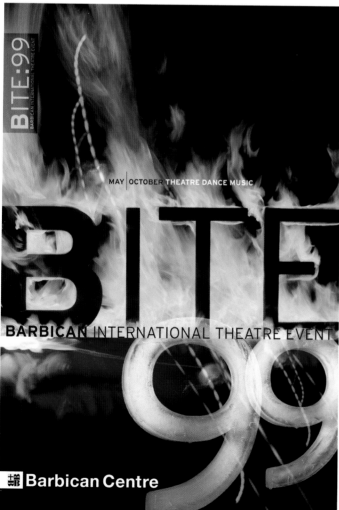

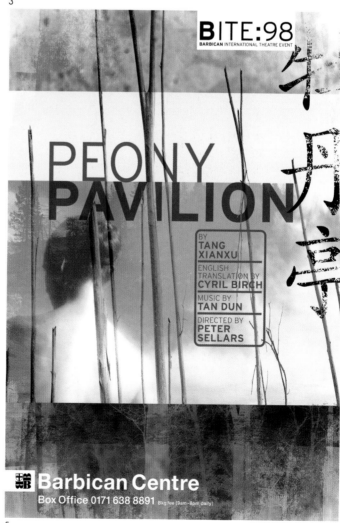

4

5

Within the images, the following visible text appears:

OPER NACH DEM FILM VON
JEAN COCTEAU

PHILIP GLASS
ORPHEE

BITE:98
BARBICAN INTERNATIONAL THEATRE EVENT

PEONY
PAVILION

BY
TANG
XIANXU

ENGLISH
TRANSLATION BY
CYRIL BIRCH

MUSIC BY
TAN DUN

DIRECTED BY
PETER
SELLARS

Barbican Centre
Box Office 0171 638 8891 Bkg fee (9am-8pm daily)

BITE:99
BARBICAN INTERNATIONAL THEATRE EVENT

MAY | OCTOBER THEATRE DANCE MUSIC

BITE
99

BARBICAN INTERNATIONAL THEATRE EVENT

Barbican Centre

Volume 23, Number 1, Summer 1996

UPPER and lower case

The caption text in the right margin reads:

1,4,5
Promotional
material
for
Barbican
Centre
BITE:
98/99
Photo
credit:
Rocco
Redondo,
E Valette,
Mark
Molloy,
Photodisc

2
Poster for
Philip Glass
opera
Orphée
Photo
credit:
Why Not
Associates
Düsseldorf
1993

3
Design of
Summer
1996
Issue for
typographic
Magazine
U&lc
Neon Photo
credit:
Rocco
Redondo

Bertolt Brecht

Threepenny Novel

2

3

4

5

6

7

1,2,4,6
Design: Germano Facetti

3,7
Art Direction: Germano Facetti
Design: Ole Vedel

5
Art Direction: Germano Facetti
Design: Colin Forbes

twen

PARAGRAPH 175

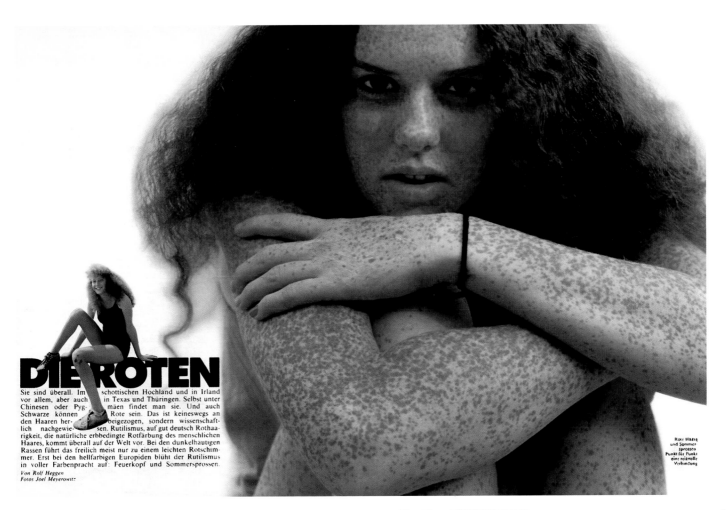

DIE ROTEN

Sie sind überall. Im schottischen Hochland und in Irland vor allem, aber auch in Texas und Thüringen. Selbst unter Chinesen oder Pyg- mäen findet man sie. Und auch Schwarze können Rote sein. Das ist keineswegs an den Haaren her- beigezogen, sondern wissenschaft- lich nachgewie- sen. Rutilismus, auf gut deutsch Rothaa- rigkeit, die natürliche erbbedingte Rotfärbung des menschlichen Haares, kommt überall auf der Welt vor. Bei den dunkelhautigen Rassen führt das freilich meist nur zu einem leichten Rotschim- mer. Erst bei den hellfarbigen Europiden blüht der Rutilismus in voller Farbenpracht auf: Feuerkopf und Sommersprossen.

Von Rolf Heggen
Fotos Joel Meyerowitz

Rote Haare und Sommer sprossen Punkt für Punkt eine reizvolle Verbindung

Cover and spreads from Twen Magazine

Rotes Haar hatte auch Ju- das, der Verräter unter den Jüngern Je- su. Jedenfalls nach Meinung vieler Maler des Mittelalters. In der germani- schen Sagenwelt taucht der verschlage- ne und betrügerische Loki auf, eben- falls ein rothaariger Kerl. In der Didriks- saga treibt Sifki sein Unwesen, rot an Haupthaar und Bart. Donar, der Gewit- tergott, wütet mit rotem Antlitz, rotem Haar und rotem Bart. Auch dem Leibhaf- tigen selbst hängt man gerne rotes Haar an. Roter Bart nach Teufelsart, hieß es im Mittelalter. Daran konnte auch Kaiser Otto II., „der Rote", ein wenig beliebter Monarch seiner Zeit, nichts ändern. Kon- rad von Würzburg dichtete ihm an: „Er hete roetelehtez hâr / und was mit alle ein übel man, / sin herze in argem muote bran." Was trugen Hexen aller Art, lange bevor Rot zur Modefarbe in den Haarsty- ling-Studios wurde? Hänsel und Gretel bekamen es gar mit einer rot- äugigen Hexe zu tun.

Die Sonne bringt's an den Tag: Sommer- sprossen sprießen vor allem dort, wo die Strahlen unge- hindert ankommen

anyonewhospaces
lowercaseletters
wouldstealsheep.
fredericgoudy

1
Poster for
British paper
merchant
VIPC

2
Cats drawn
with the
wrong end of
a dip pen

3
Emblem for
use on
postcards,
posters and
T-shirts, etc

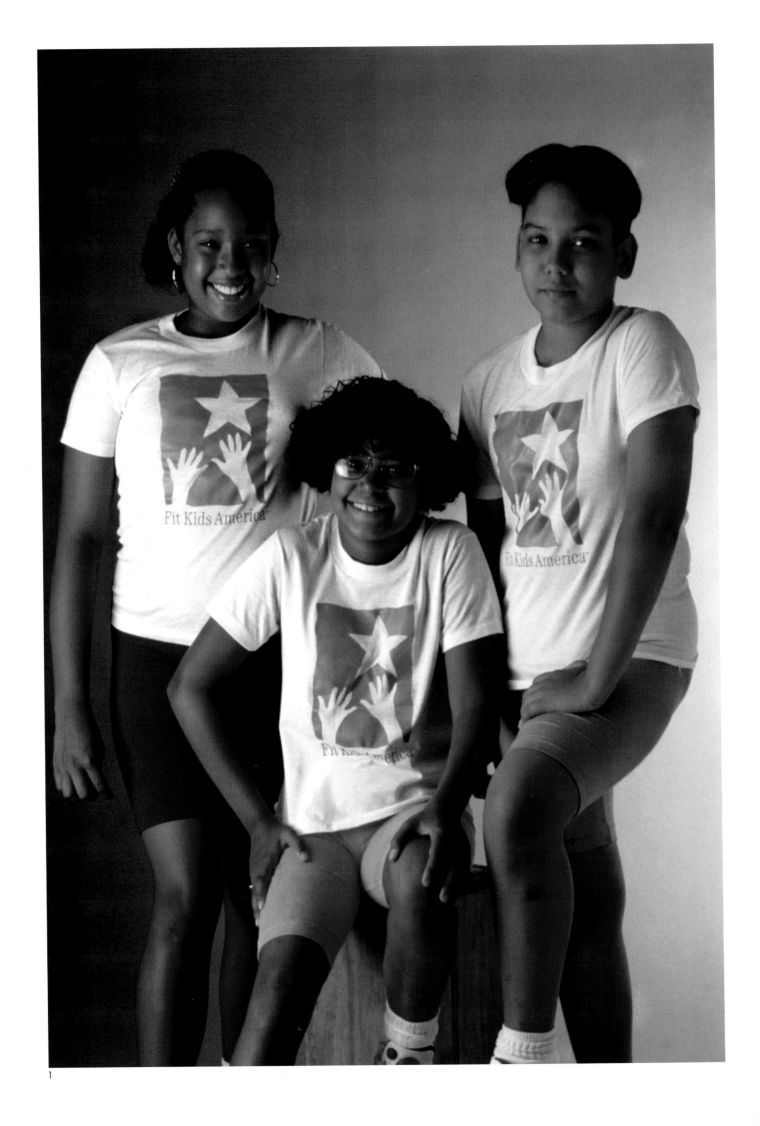

2

3

4

5

6

1
Fit Kids America Aerobic Team, Inc.
Logo, stationery and T-shirts, August 1991
Partner: Colin Forbes
Designer: Donna Ching

2
Kubota Corporation
Logotype, 1989
Partner: Colin Forbes
Partner/Designer: Woody Pirtle
Associate: Michael Gericke

3
New Britain Symphony Society
Symbol, October 1983
Partner: Colin Forbes
Designer: MaryAnn Levesque

4,6
Hotel Hankya International
Produced with OUN Design Corporation
and Densu Inc.
Identity, packaging, 1990
Partner: Colin Forbes
Associate/Designer/Typographer:
Michael Gericke
Designer: Donna Ching
Illustrator: McRay Magleby

5
The Atheneum Suite Hotel & Conference Center
Client The International Center Co.
Logotype, June 1990
Partner: Colin Forbes
Associate/Designer: Michael Gericke
Illustrator: Mirko flic

Delhi. From July 5th.

virgin atlantic *Virgin*

SMOKING CAUSES FATAL DISEASES

Chief Medical Officers' Warning
5 mg Tar 0.5 mg Nicotine

1
Agency: Rainey Kelly Campbell
Client: Virgin Atlantic
Art Director: Martha Riley
Copywriter: Richard Bessening
Photographer: Mike Parson

2
Agency: Saatchi & Saatchi
Client: Gallaher
Art Director: Martin Casson
Photographer: Donna Trope

PERFORMING ON THE VILLAGE GREEN? (7,7)

13mg TAR 1·1mg NICOTINE
SMOKING WHEN PREGNANT HARMS YOUR BABY
Health Departments' Chief Medical Officers

3

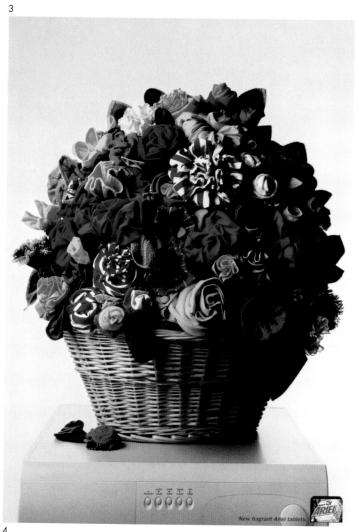

4

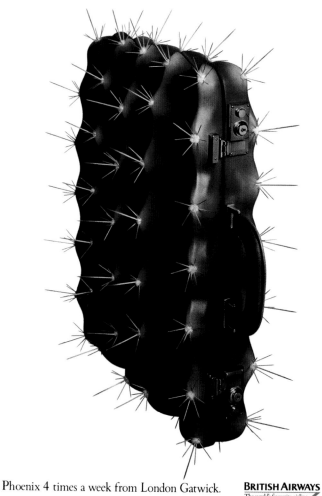

Phoenix 4 times a week from London Gatwick.

BRITISH AIRWAYS
The world's favourite airline

5

3
Agency: Lowe Howard Spink
Client: Gallaher
Art Director: Kitt Mar
Photographer: Nancy Fouts

4
Agency: Saatchi & Saatchi
Client: Procter & Gamble
Art Director: Bill Gallaher
Copywriter: Chris Bleackley
Photographer: Kavin Summers

5
Agency: M & C Saatchi
Client: British Airways
Art Director: David Dao
Photographer: Andy Barter

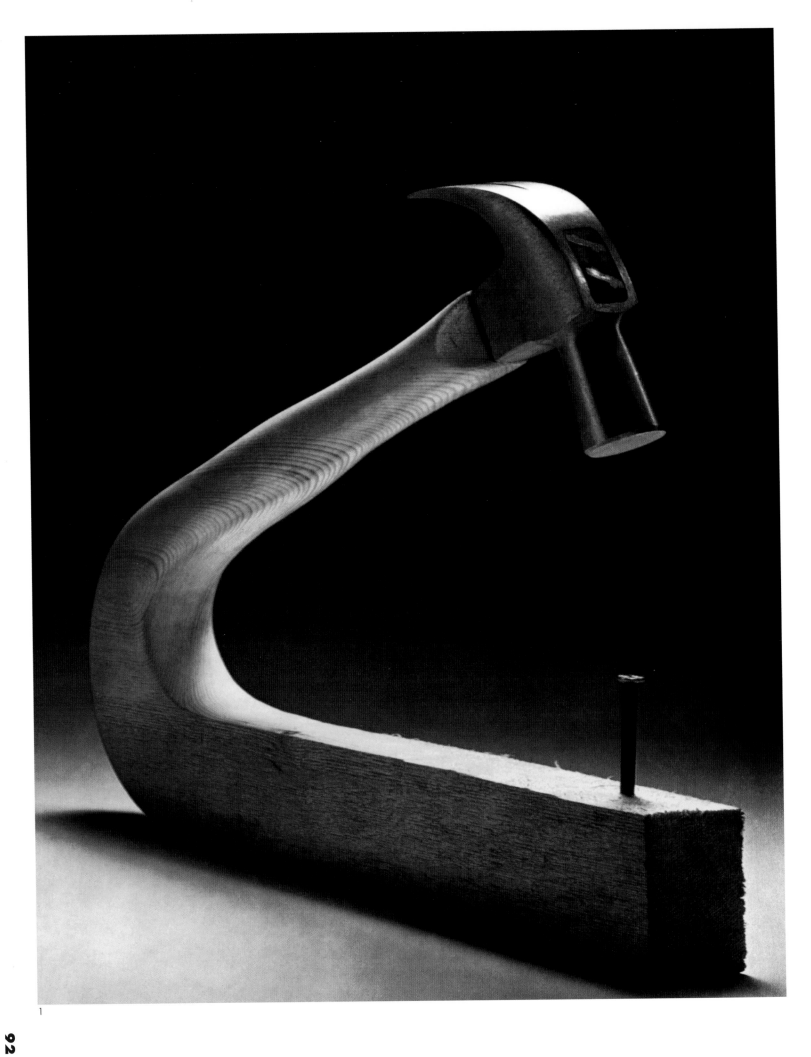

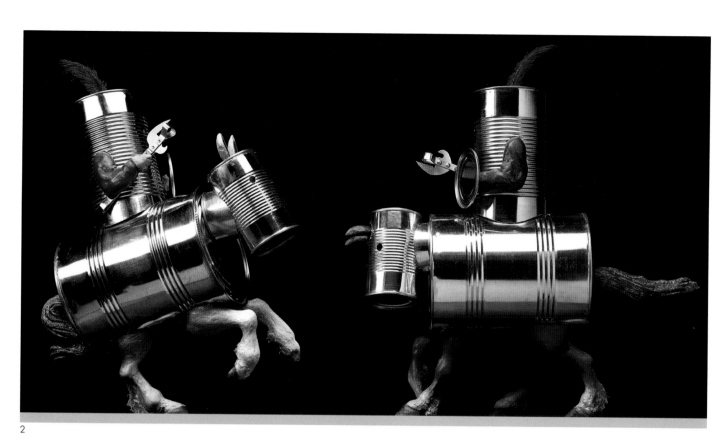

2

1
'Hammer'
1970
Cover for
D&AD
Annual

2
'Tin Can
Knights'
1993
Self
Promotion
piece

3
'King Size
Saw'
1987
Sculpture
for
Childrens
Art Expo

4
'Knight in
Armour'
Poster for
Silk Cut
Cigarettes
(Greece)

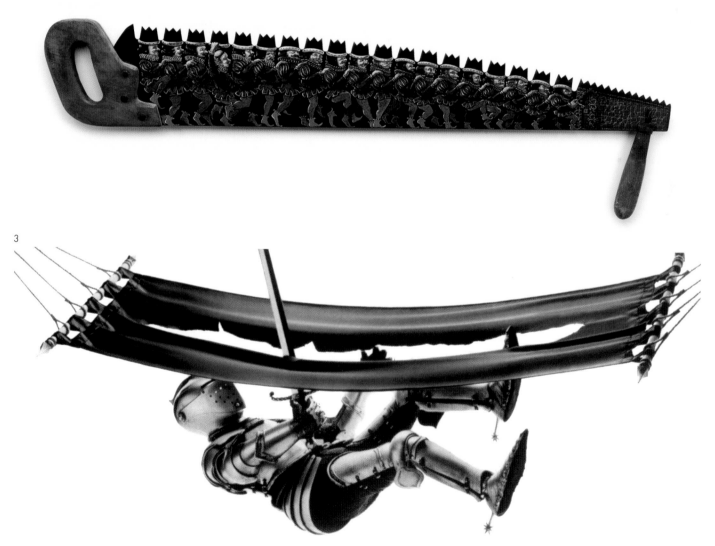

3

4

Religious Symbols

Univers

abcdefghijklmnopqrstuvwxyz
ABCDEFGHIJKLMNOPQRSTUVWXYZ

Frutiger

abcdefghijklmnopqrstuvwxyz
ABCDEFGHIJKLMNOPQRSTUVWXYZ

Vectora

ABCDEFGHIJKLMNOPQRSTUVWXYZ
ABCDEFGHIJKLMNOPQRSTUVWXYZ

Herculanum

abcdefghijklmnopqrstuvwxyz
ABCDEFGHIJKLMNOPQRSTUVWXYZ

Glypha

abcdefghijklmnopqrstuvwxyz
ABCDEFGHIJKLMNOPQRSTUVWXYZ

Avenir

abcdefghijklmnopqrstuvwxyz
ABCDEFGHIJKLMNOPQRSTUVWXYZ

Meredien

abcdefghijklmnopqrstuvwxyz
ABCDEFGHIJKLMNOPQRSTUVWXYZ

Serifa

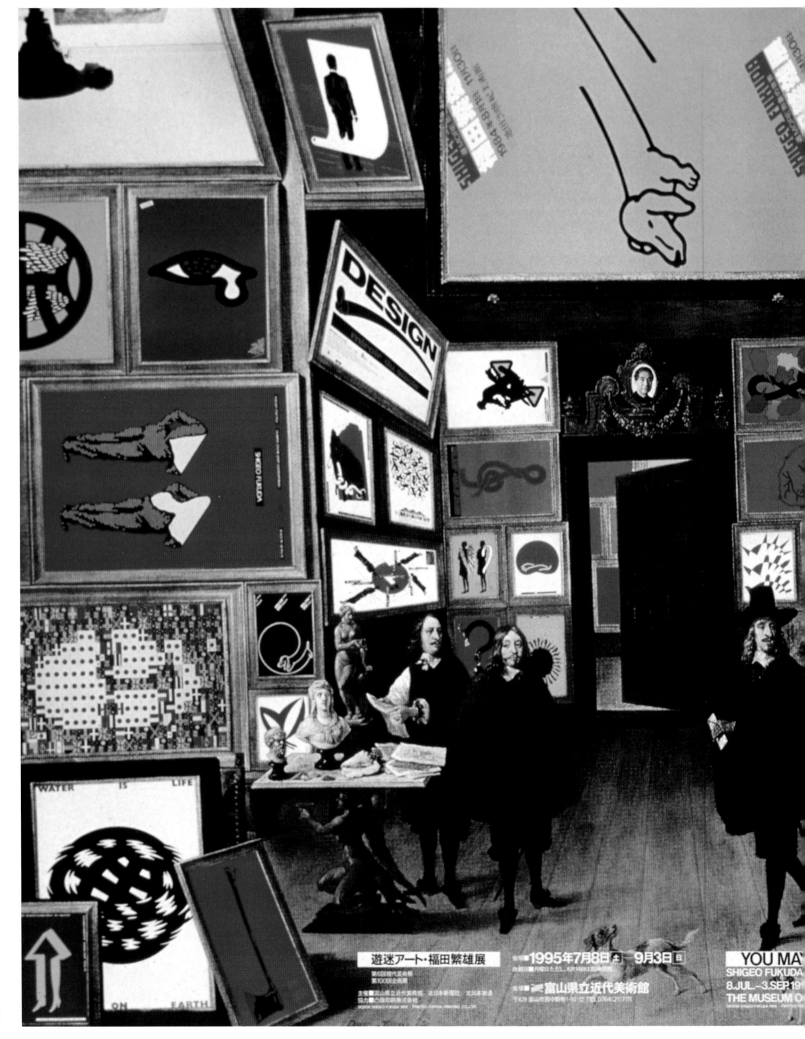

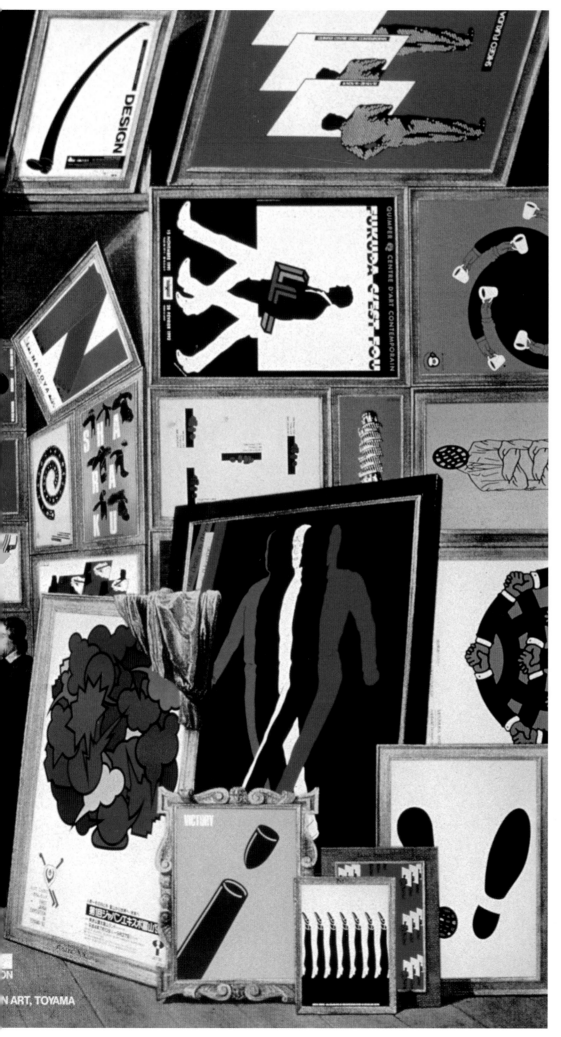

Poster for an exhibition
of the artist's work, at the
Museum of Modern Art,
Toyama, 1995

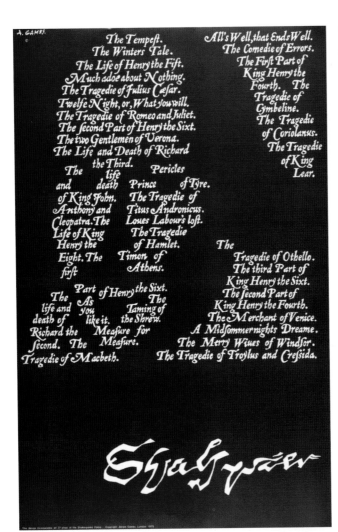

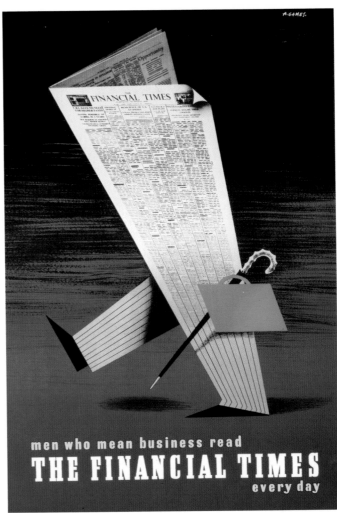

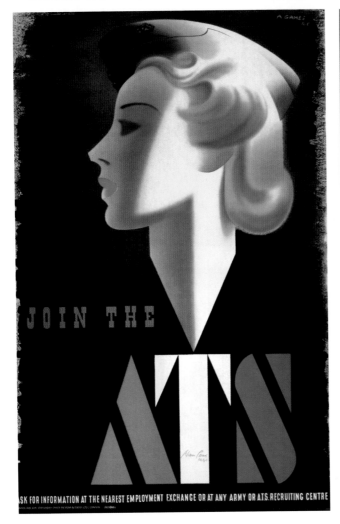

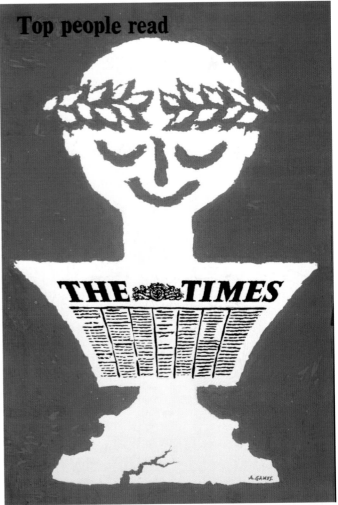

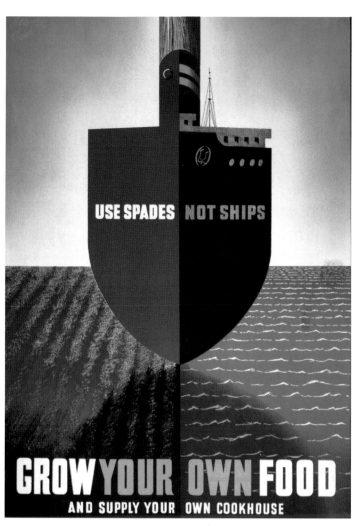

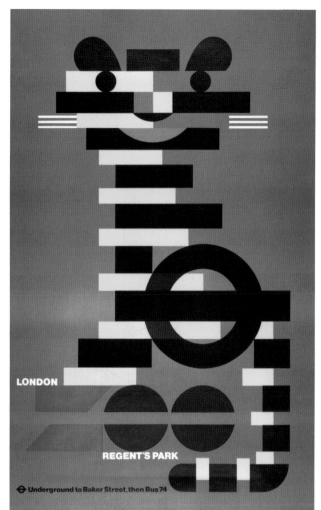

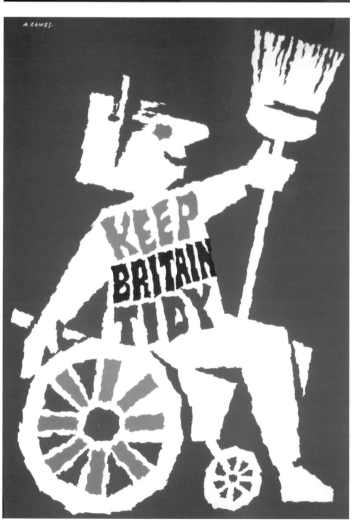

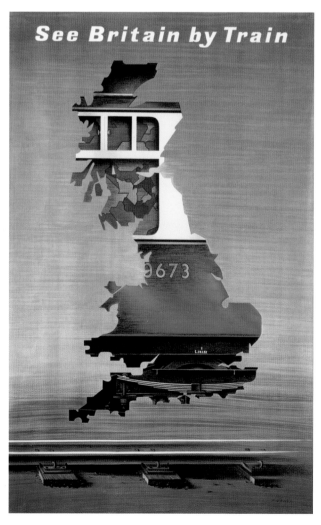

GALT'S
EARLY
STAGES
1963

1

GALT
TOTS

never
mind: we
guess
you'll
know
it's
Galt
Toys

2

FAY GODWIN OUR
FORBIDDEN
LAND

3

5

6

8

7

5
'Tool or Tyrant' Poster for Simpson

6
Shopping Bag 50th year Anniversary
of Museum of Modern Art

7
Announcement for Exhibition

8
Mobil Logo

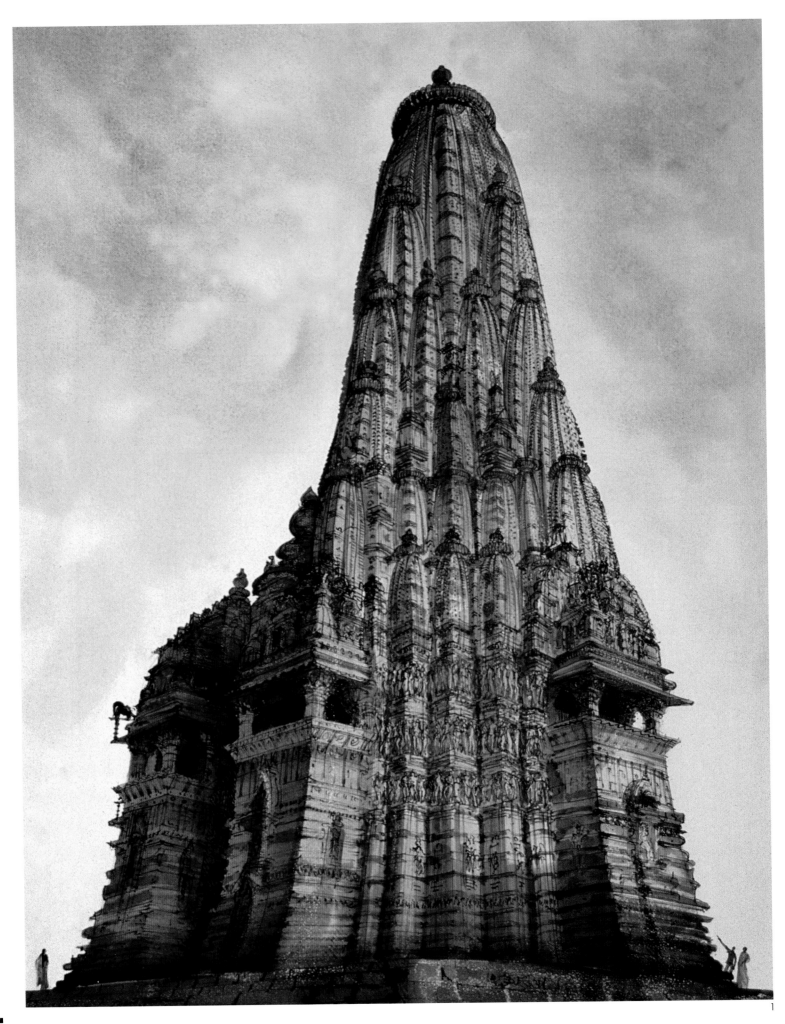

1
Watercolour of Khajuraho from David Gentleman's India, published by Hodder and Stoughton

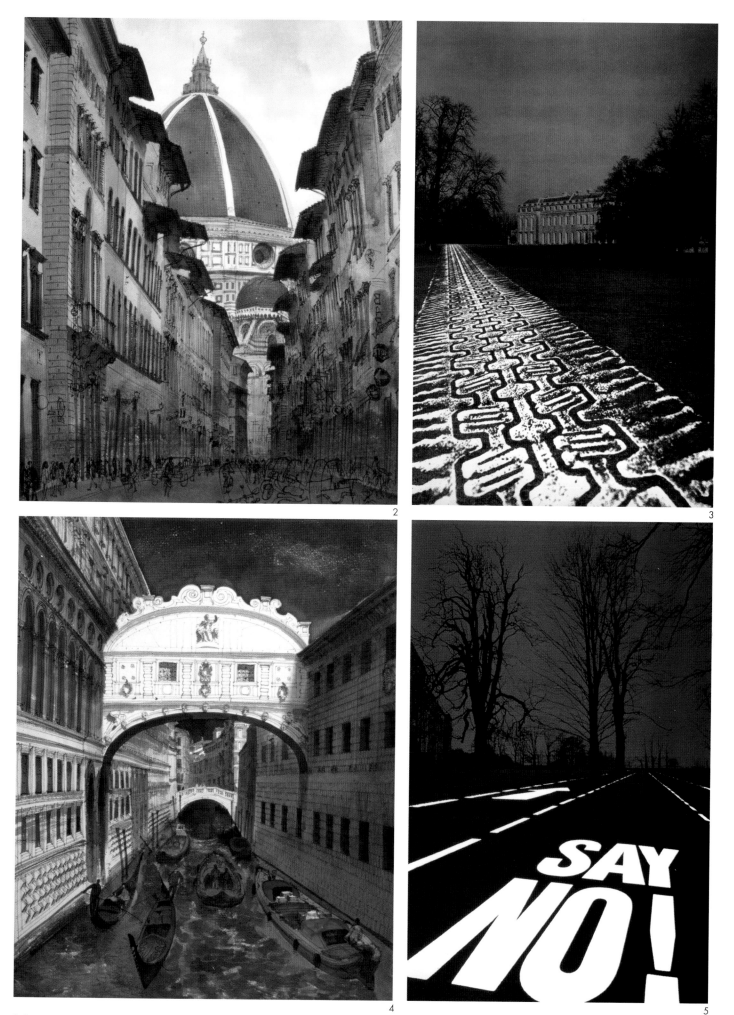

2,4
Watercolour of Florence and of Bridge of Sighs, Venice from David Gentleman's Italy

3,5
Posters campaigning against an environmentally insensitive road project

人ッ子一人イナクナッテ
カラ。誰が平和条約二
調印スルニイウ—ダ

The next time
nobody will be around
to sign the peace treaty

1

2

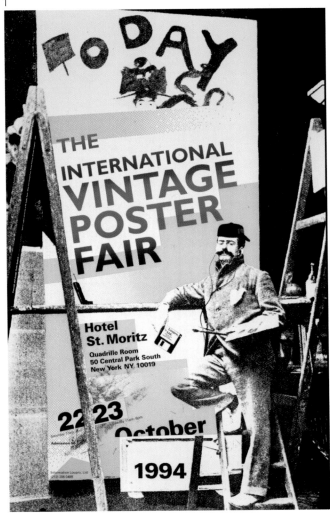

3

4

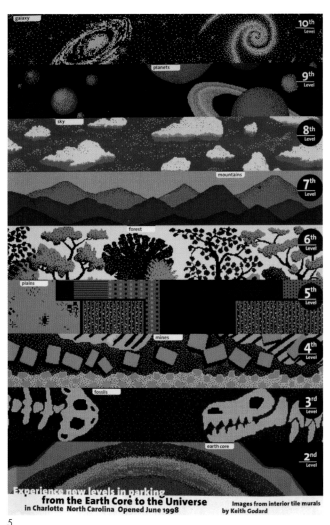

5

6

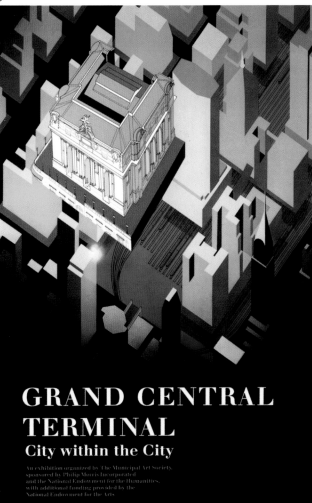

7

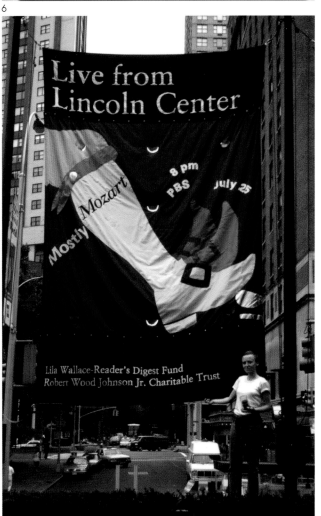

8

1
Poster for the 40th
anniversary of the
bombing of Hiroshima

2
Poster for a seminar at
Parson School of
Architecture,
organised by
Karen von Langen

3
The International
Vintage Poster Fair,
1994

4
Poster for the Cooper
Hewitt Museum
in collaboration with
Robert Manguarian

5
Poster for a parking
deck, in Charlotte,
North Carolina

6
Poster:
Expanding horizons

7
Grand Central
Terminal.
Poster for an
exhibition
'City within the City'

8
Lincoln Center banner

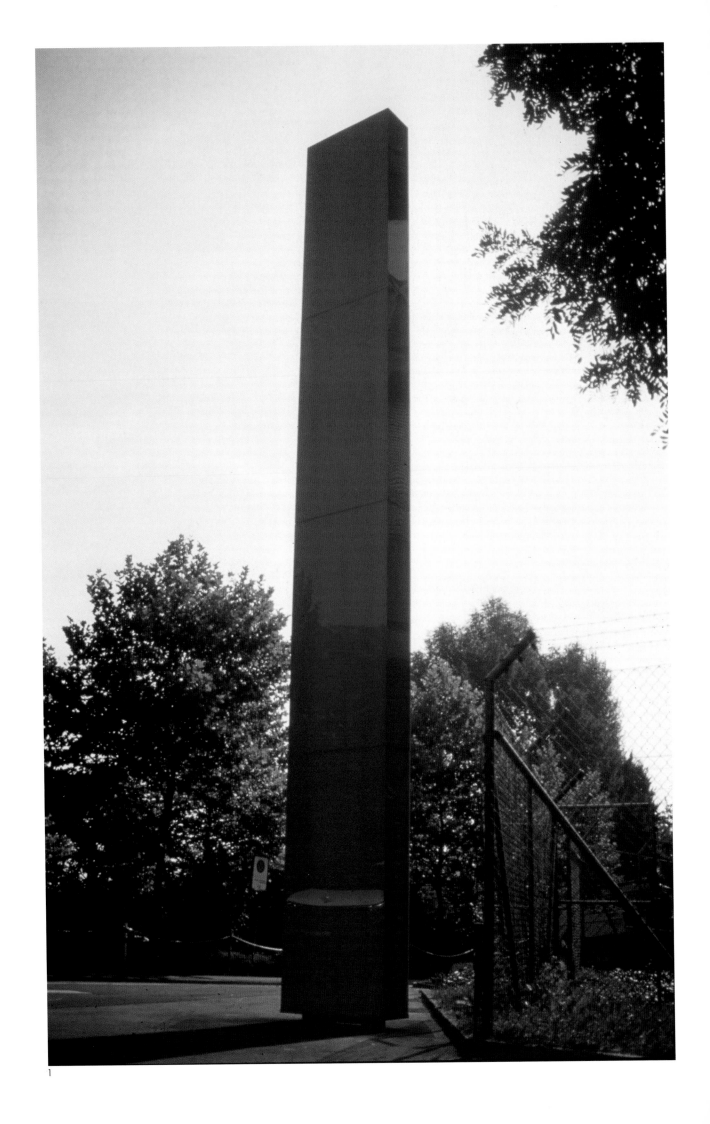

2

3

1
Coloured pylon used for identification of building sites for Contraves Space, an electronic firm producing payload fairings for the Ariane launchers

2
Coloured pylon used for identification of building sites for Oerlikon Contraves Defence, a defence firm involved in the production of air defence systems

3
Bank Hofmann AG
Corporate Identity and publication system for a Private Bank system

4
Bank Hofmann AG
Window display at bank's headquarters announcing their 100th anniversary

5
Swiss passport
Design of Swiss passport expressing themes of topography, crystal and alps, incorporating all of the latest required security elements

4

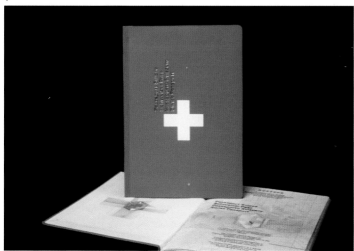

5

1

3

4

2

1
Out-take for Proms 2000 brochure/poster

2
Absolut Vodka alphabet
Exhibition promotion 'A for A cowboy'

3
Turandot poster, unpublished

4
Out-take for Proms 2000 brochure/poster

5
Den Norske Bank, Oslo
Christmas card

5

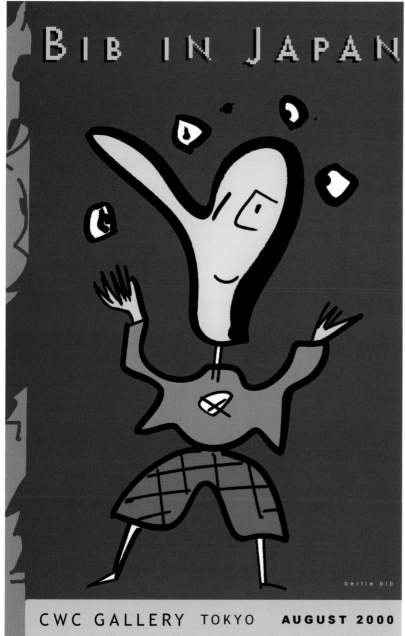

6

7

8

9

6
Bertie Bib, a pseudonym used by Grimwood
Poster for first exhibition in Japan

7
Full page image depicting Spain for
Den Norske Bank World Guide Book

8
Postcard image of Spain for
Den Norske Bank World Guide Book

9
Proposed stage set for Chinese State Circus,
promotion for Walt Disney's film Mulan

1

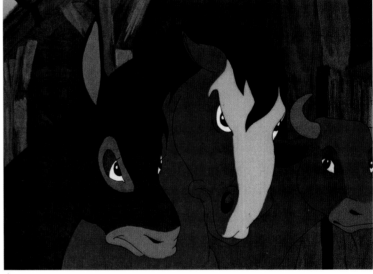

2

1,2,3,5,6,8
From the film 'The Moving Spirit', 1954

3

4

4,7
From the film 'Animal Farm', 1954

5

6

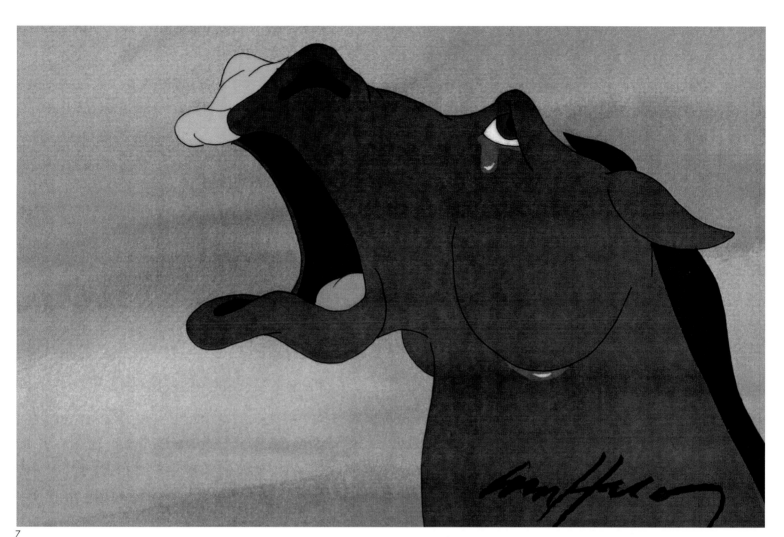

7

8

1

Personality and Psychotherapy
An Analysis in Terms of Learning, Thinking, and Culture

John Dollard
Neal E. Miller ($3.25)

McGRAW-HILL PAPERBACKS

2

Varieties of Mystic Experience

Elmer O'Brien, S.J.

3

Conflict and Creativity
Control of the Mind, Part 2
edited by
Seymour M. Farber
and
Roger H.L. Wilson

($2.95)

McGRAW-HILL PAPERBACKS

4

1
Design program for 127 John Street, N.Y. City
1979 Entry Tunnel, ringed in neon

2,4,7
Book cover 1963 to 1964. McGraw-Hill Book
Company, N.Y. City, USA

3
Book cover

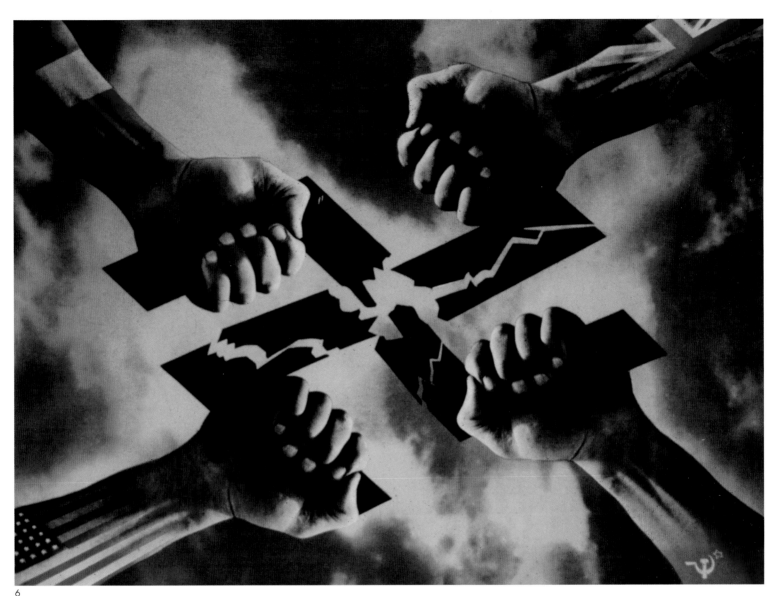

6

7

8

1
Nuclear Disarmament
poster, 1960

2
Poster, 1943

3
Poster, 1942

4
Harpers Bazaar
magazine cover, 1943

5
Poster for an exhibition
designed by FHK Henrion

6
Poster for The Office of War
Information, 1943

7
Poster for Philishave
campaign, 1950

8
Poster for
Olivetti Lettra 22, 1960s

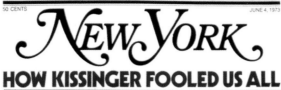

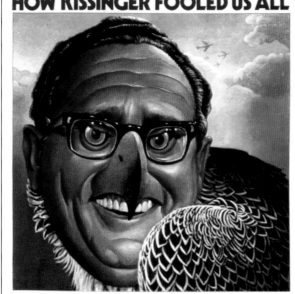

1

3

4

5

7

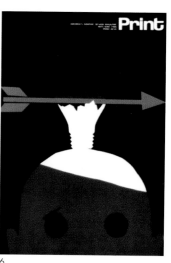

6

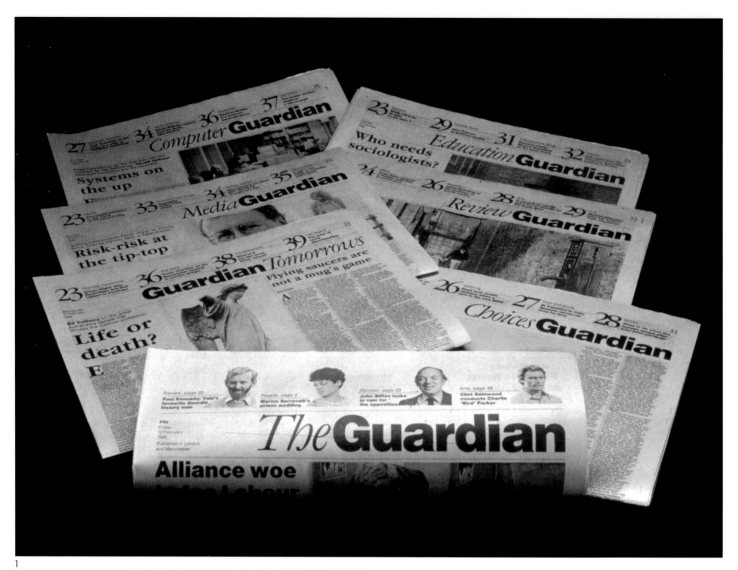

1

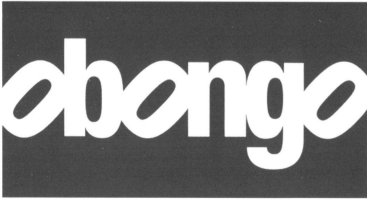

2

3

1
Client: The Guardian
Job: Newspaper design
Date: 1988
Designer: David Hillman (Partner)
Design Assistant: Leigh Brownsword

2
Client: Smartport
Job: Obongo identity
Date: 1999
Designer: David Hillman (partner)
Design Assistant: Debbie Osborne

3
Client: Interior Design International (IDI)
Job: Identity and poster series
Date: 1992
Designer: David Hillman (partner)
Design Assistant: Lucy Holmes

4
Client: Time Products
Job: Marcus identity
Date: 1999
Designer: David Hillman (partner)
Design Assistant: Simon Pickford

5
Client: Nova
Job: Design of monthly magazine
Date: 1968-1975
Designer: David Hillman (partner)

6
Client: The Napoli '99 Foundation
Job: Poster for the Napoli Foundation,
established in 1984 to combat the
deterioration of the city's cultural assets.
Date: 1986
Designer: David Hillman (partner)

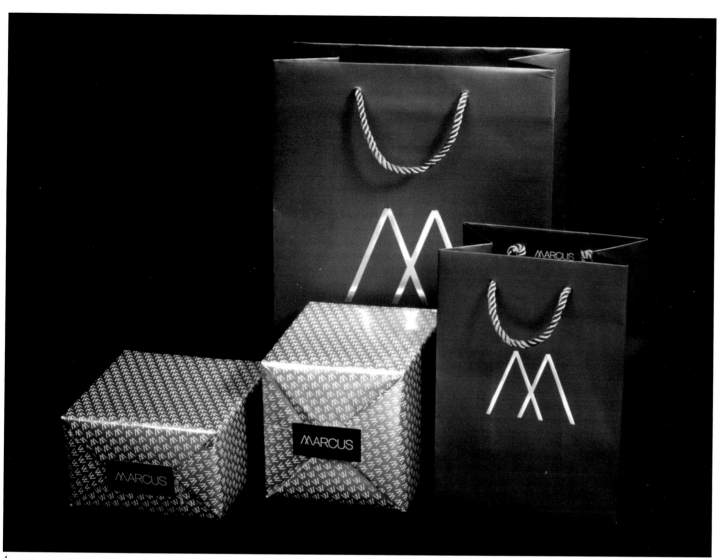

4

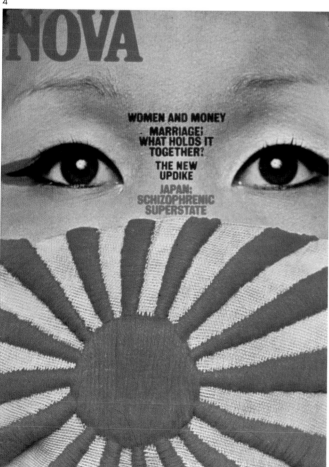

5

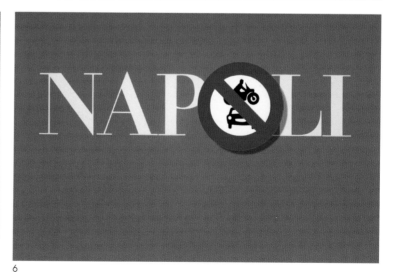

6

2

1

3

4

5

6

7

8

1,2,4
Fly Paper illustrations for a novel by
Dashiel Hammett, publisher: Zweitausendeins

3
'On triviality' published by
Frankfurter Allgemeine Magazin

5
'The wallflower' published by
Frankfurter Allgemeine Magazin

6
An article on detective stories
published by Frankfurter
Allgemeine Magazin

7
"Bonny & Clyde" published by
Frankfurter Allgemeine Magazin

8
Article on the French Revolution,
published by Frankfurter
Allgemeine Magazin

1

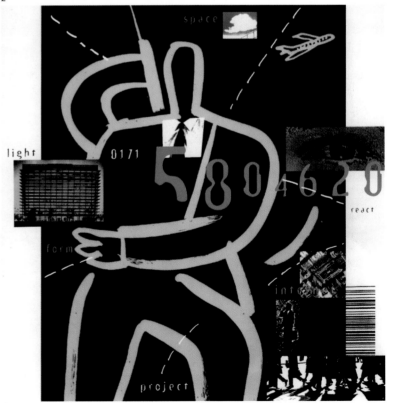

2

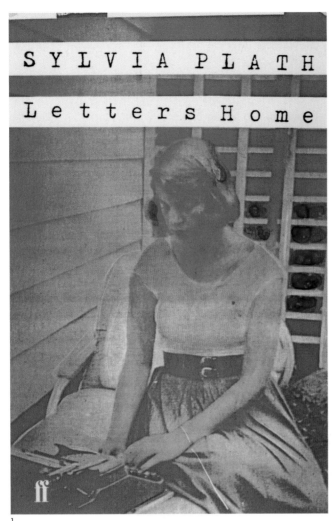

3

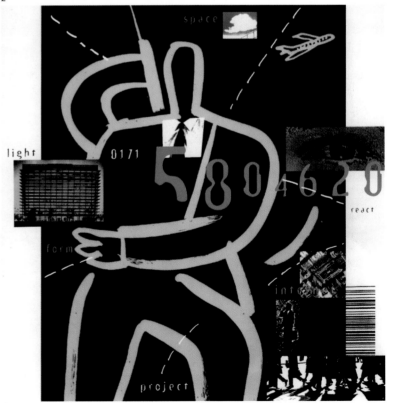

4

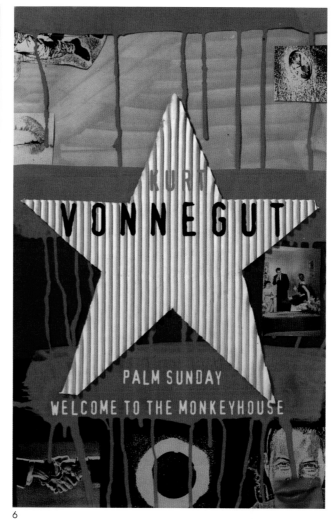

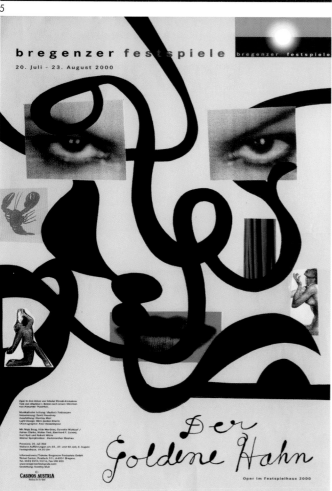

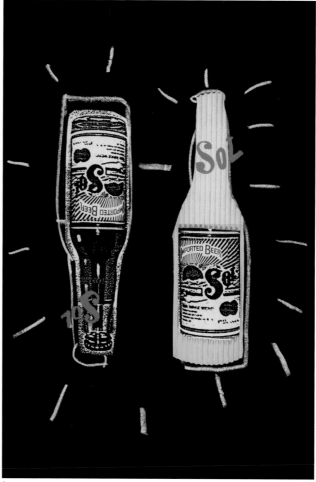

5

6

7

8

1
Letters Home.
Sylvia Plath
Book cover
Faber and Faber,
1983

2
Design Magazine,
1997

3
Ciudad Lunch
Menu, 1999

4
Self Promotional
Piece, 1996

5
Border Grill
Las Vegas
Dinner Menu,
1999

6
Palm Sunday
Kurt Vonnegut
Book cover
Vintage, 1994

7
Bregenzer
Festspiele poster,
2000

8
Sol Beer ad for
Harari Page
agency, 1997

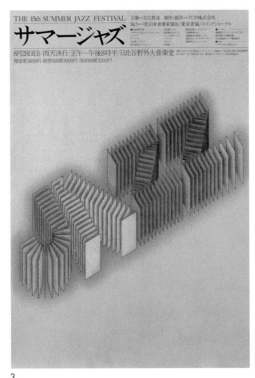

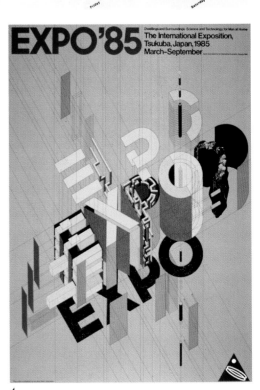

1
Calendar, MOMA, New York

2
Poster, Idea magazine

3
Poster, Summer Jazz Festival

4
Poster, Expo '85

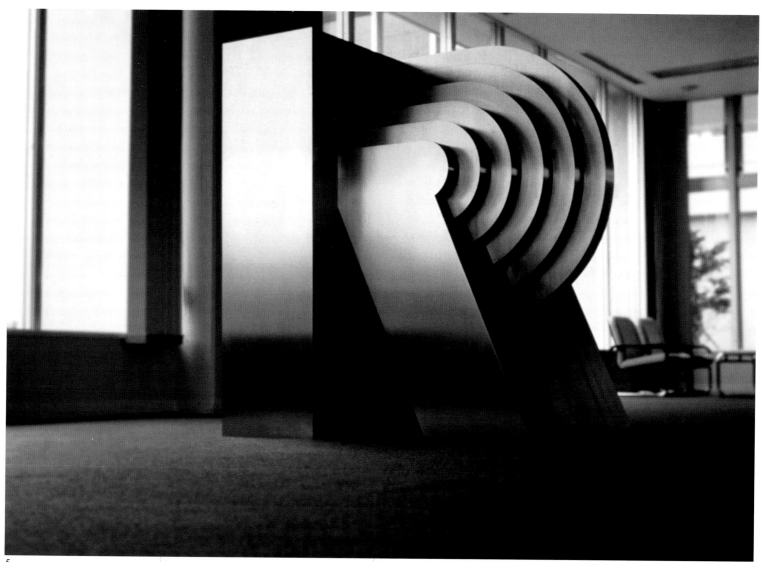

5

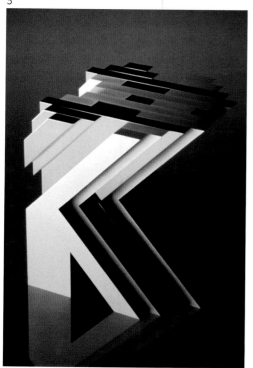

6

7

8

5
Alphabet sculpture, Ricoh Co. Ltd.

6
Logo sculpture, Kokuyo Co. Ltd.

7,8
Alphabet sculpture, Igarashi Studio

ISBN: 2-9508442-3-5

BENOIT JACQUES BOOKS

1
'Facts &
Figures' poster
for English
Heritage, in
collaboration
with John
Powner of
Atelier, 1997

2
'Brazilian Rain
Forest' edition
print, 1999.
For *Projects*
magazine,
Sau Paulo,
1999

3,4
Y-Millennium
stamp for Royal
Mail, 1999

5
'Kew Gardens'
poster
commissioned
by TBWA
Advertising,
1999

1

Design and Art Direction '66

2

3

PreTZeL fACe

ABCde)2345
EDHIJK 67890
LMNOP &,'()"
QRSTU
VWXYZ
ry

4

the tree

by Lou Klein

Not long ago, a tree grew on the side of a mountain. One day a butterfly saw it and decided to make the tree her home. Some birds saw the tree and perched on it. Fairies heard about the tree from the birds, and told some goblins. They all came to live in the tree. Even flowers loved it and decided to grow on it. Rabbits came and an alligator and an owl. Creatures that had been enemies lived together peacefully there. The tree grew full of colour and life; and its branches curled one into the other, making resting places for all the lovely living things. One night a man came. He climbed next to the tree. In the morning he heard chirping and tweeting and smelled the fragrance of flowers and leaves. He pinched himself, but it wasn't a dream: it was real and he was delighted. Of all the wonders of the world this seemed to him the most wondrous. What a pity it was that everyone couldn't see this marvellous tree! He went back to the city and raised enough money to buy the side of the mountain. He formed Tree Ltd and constructed an access road that climbed slowly up the steep grade, with four lanes, properly banked turns and sturdy guard rails. Now everyone could enjoy the tree. Signs were posted along all main roads. "See the Tree" was advertised in all the leading papers. Tourists came by the hundreds. They passed the word to other travellers. Tree Ltd built a vast car park and leased out land to a petrol station to accommodate cars, motorcycles, scooters and caravans. Another petrol station offering clean rest rooms opened opposite the first. Overnight visitors were accommodated at Tree-Top Lodge, centrally heated and recommended by gourmet clubs and fraternal societies. It had a fresh water swimming pool and air conditioning. A bus service conducted three-language guided tours. A youth hostel opened next to Tree-top Lodge. Tree pendants were given away free to all children who took the lift to the observation tower erected next to the tree. A kiosk sold plaster models of the tree, post cards in full colour, comb cases, key rings, badges, charm bracelets, ash trays, alligator handbags, tree emblems for men's blazers, and pillow cases with "Tree" gaily printed on genuine silk, and glass balls, which, when turned upside-down, made snow fall on the tree. Visitors carved their names on the tree, and four-letter words began to appear. Branches were taken as souvenirs. Soon the tree grew drab. The rabbits left. The birds didn't come any more. The fairies and goblins disappeared. All the creatures went away, one by one. Slowly the tree rotted, and it too eventually disappeared . . . but no one noticed.

1
Cover for Interiors magazine

2
Cover for D&AD Annual

3
Horse's Head. Wood sculpture

4
Pretzel Typeface and complete` alphabet (all nibbled out of the 'B')

5
'The Tree'. Story and illustration for Town magazine

6
Design of original D&AD pencil award

7
Poster for printing paper for Reed Paper Group

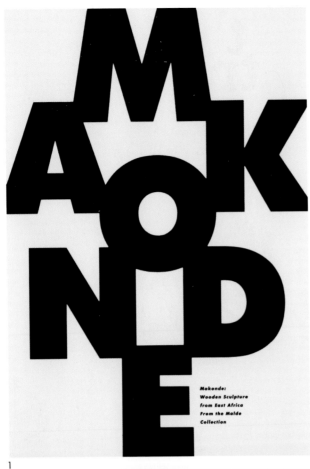

Makonde:
Wooden Sculpture
from East Africa
From the Malde
Collection

1

the book

2

3

4

5

ARMISTICE FESTIVAL

An exhibition showing
for the first time
British, French, German
and Russian artists
who lost their lives
in the First World War
6 November 1988-
15 January 1989
The Museum of
Modern Art Oxford
30 Pembroke Street
Oxford OX1 1BP
Recorded information
01865 728608
Admission £1.00
concessions 50p
and friends free
This Armistice Festival
exhibition was organised
by The Museum of
Modern Art Oxford
The exhibition
was sponsored by
The John S. Cohen Foundation
The Cultural Department of
the French Embassy, London
Deligraverk
The Foreign Office of the
Federal Republic of Germany
Frankfurter Allgemeine
Zeitung
The Henry Moore Foundation
Otto Versand
The Museum of
Modern Art Oxford
receives financial
assistance from
The Arts Council of
Great Britain
Oxford City Council,
Oxfordshire
County Council and
Visiting Arts

THE FALLEN

6

GOLDEN
DAYS IN
COPEN
HAGEN

9-18 SEPT 94

7

1
Poster for
exhibition of
sculpture by
Makonde Tribe,
East Africa

2
Cover of
photographic
catalogue for
Image Bank

3
Detail from Earth
Flag Design Project
for Polish Pavilion,
Expo '92, Seville

4
Contribution for
fund raising event
in New York

5
Introductory spread
for 'People' section
in photographic
catalogue for
Image Bank

6
Poster for exhibition
of the work of artists
who lost their lives
during the first
world war

7
Identity programme
for annual festival in
Copenhagen which
celebrates the
Golden Age of
Denmark

143

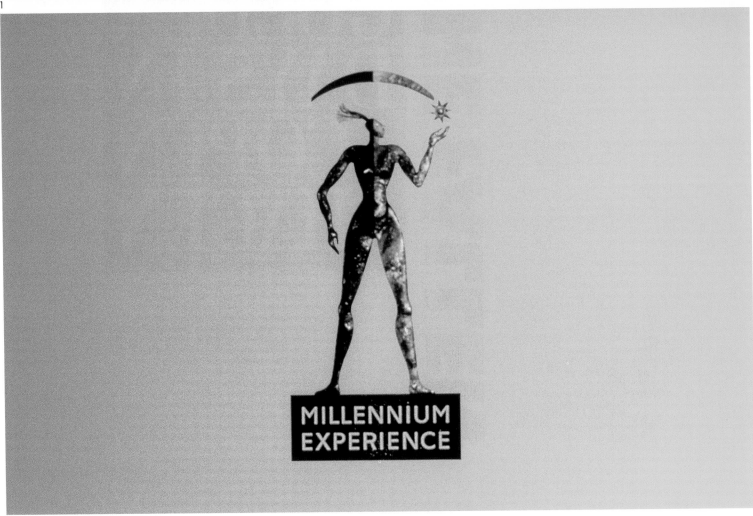

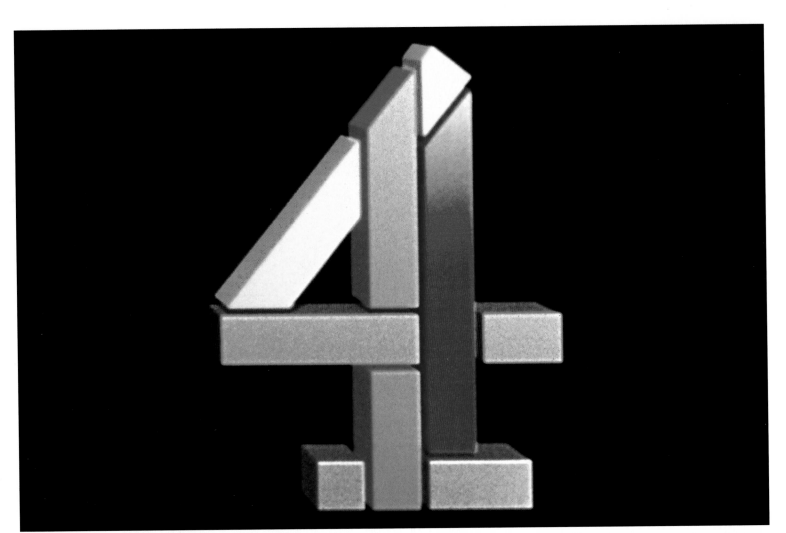

1

2

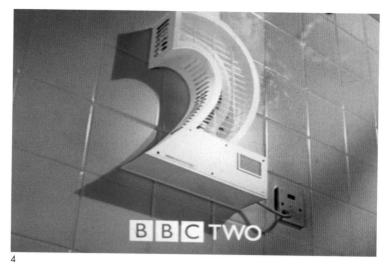

3

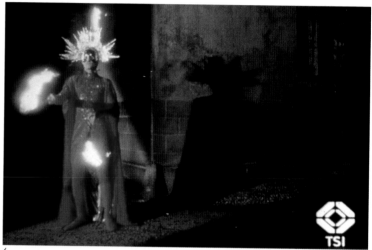

4

5

6

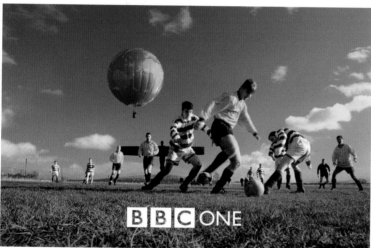

7

8

9

1
Brand identity for Channel 4 which launched in 1984, offering British viewers the first new channel since the sixties

2
Corporate identity created for the New Millennium Experience Company, the company responsible for London's Millennium Dome

3
Brand identity created for the launch of Orange, Sky New Zealand's entertainment channel

4,5,7,8,9
Redesign of the BBC1's corporate identity, unifying its many constituent businesses under the new BBC logo. Personality for each brand is conveyed by brand properties such as the BBC1 balloon and the performing 2s

6
Brand identity created for theSwiss-Italian arm of the Swiss Broadcasting corporation, TSI

1

2

3

4

1,4
Sicilian Carousel - Taormina, Sicily - two frames
from a multiscreen AV show about the island,
at a tourist attraction. Shows a street festival

2,3
Bangkok Science Centre - six design styling
visuals for a 3-screen video programme
about energy

5
Wellcome Videowall - a still frame from an
entrance lobby 9-screen videowall - 1995

6,7
Dynamic Earth, Visitor Centre,
Edinburgh - two design styling visuals
for a 3-screen video programme

VINOPOLIS
CITY OF WINE

1

2

3

4

5

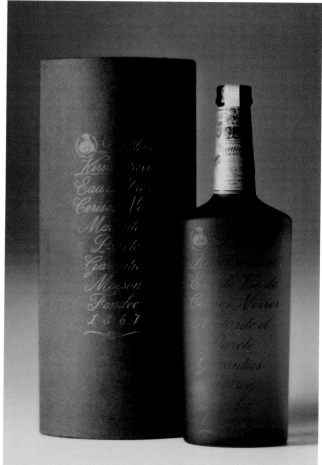

7

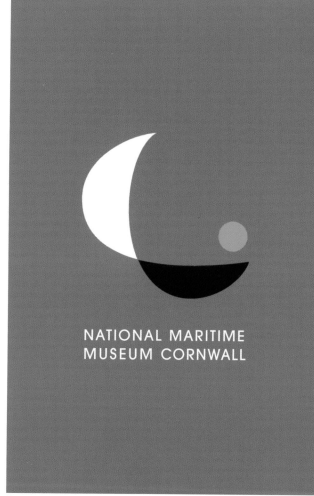

NATIONAL MARITIME
MUSEUM CORNWALL

6

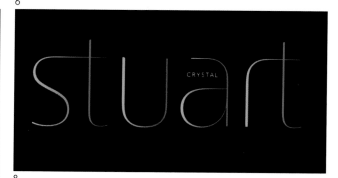

stuart CRYSTAL

8

1,3
Identity, signage,
literature and
packaging design.
Wineworld London Plc
Design Director:
Mary Lewis
Designers:
Nin Glaister,
Mary Lewis,
Ann Marshall

2
Distillery branding,
graphics, bottle design
and copywriting.
United Distillers (UK)
Designer/copywriter:
Mary Lewis
Illustrator:
Bill Sanderson

4,7
Bottle & carton design,
graphics.
Arnold Dettling
Designer:
Mary Lewis

5
Graphics.
Vinhos Sogrape de
Portugal SA
Designer:
Mary Lewis
Photographer:
Charlie Waite

6
Identity and literature.
National Maritime
Museum of Cornwall
Design Director:
Mary Lewis
Designer:
Paul Cilia La Corte

8
Identity and
packaging design.
Stuart & Sons Limited
Design Director:
Mary Lewis
Designer:
Paul Cilia La Corte

1

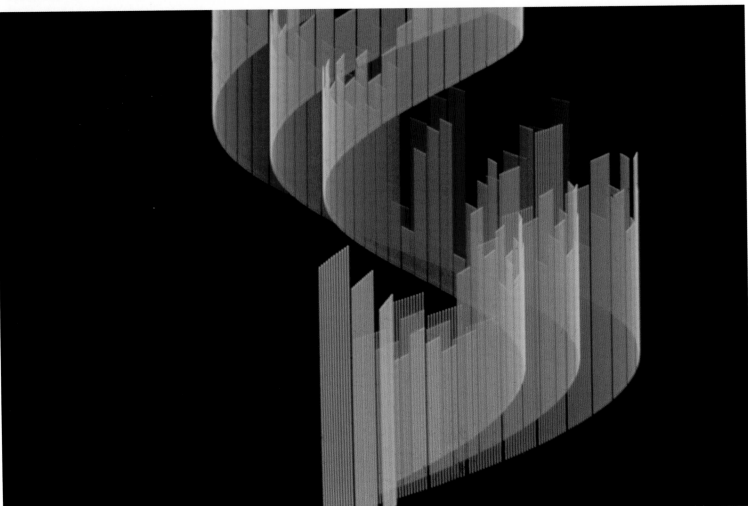

2

4

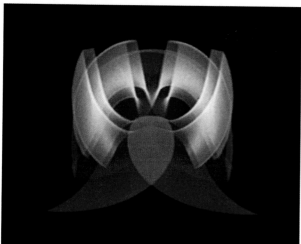

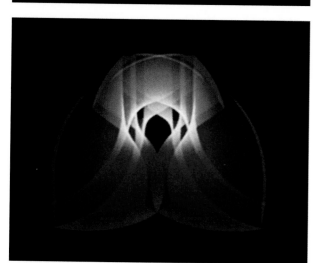

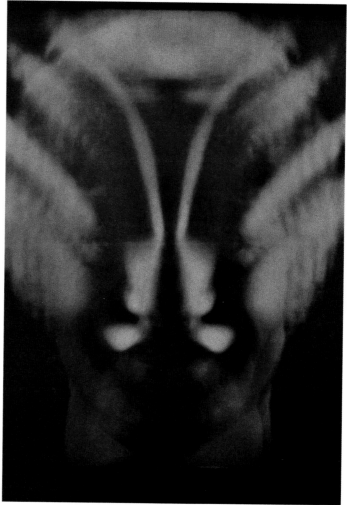

3

5

1,4
The Mind Beyond
Title sequence for a drama series
on the paranormal
for BBC TV

2
Man And Music
Title sequence for a series on the
history of music.
Lillyville Productions for Channel 4

3
Atari
Animated sequence using a motion
control camera set-up

5
Doctor Who, 1969 version
Title sequence for sci-fi serial for BBC TV

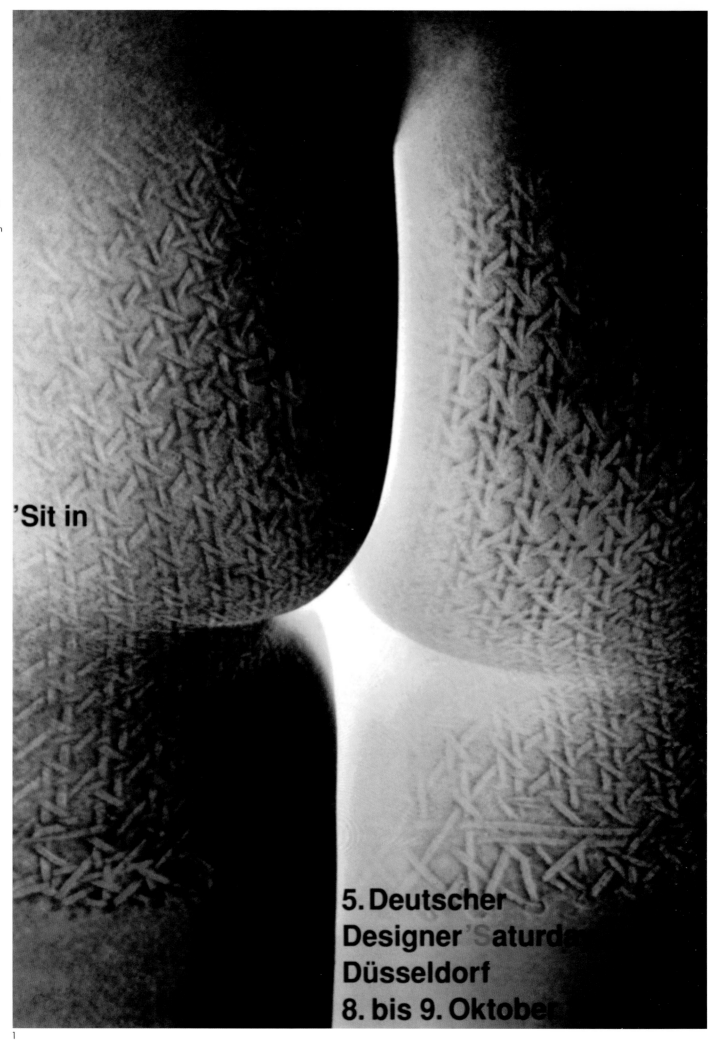

1
Title:
'Sit in'
5th
German
Designer
'Saturday
Düsseldorf
Client:
Design
Centre,
Nordrhein-
Westfalen,
Essen
Date of
Issue:1993
Size:
84 x 119cm

'Sit in

5. Deutscher
Designer 'Saturda
Düsseldorf
8. bis 9. Oktober

1

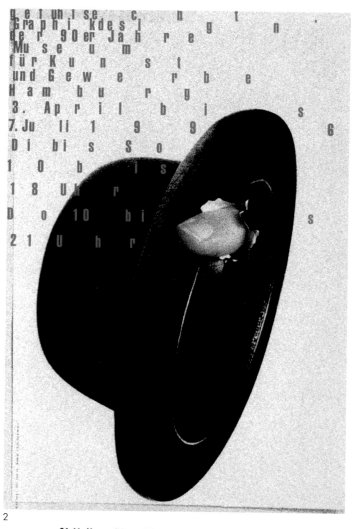

2

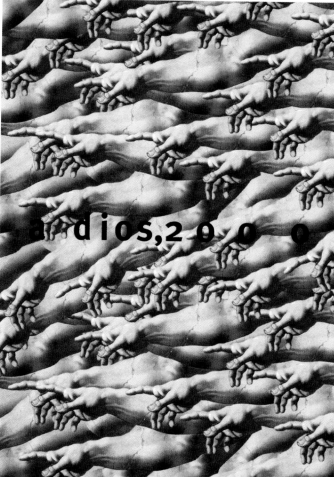

3

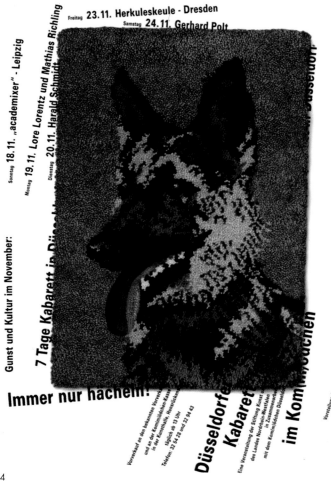

4

5

2
Title:
'Real
Emotion',
Graphic
Design of
the past
90 years
Client:
Museum
für Kunst
und
Gewerbe,
Hamburg
Date of
Issue: 1996
Size:
84 x 119cm

3
Title:
'The New
City'
Client:
Duisberger
Akzente
Festival of
Culture of
Nordrhein-
Westfalen
Date of
Issue: 1999
Size:
84 x 119cm

4
Title:
'Just keep
panting!'
Client:
The
political
theatre
'Kom(m)-
öd-chen'
Düsseldorf
Date of
Issue: 1991
Size: 119
x 168 cm

5
Title:
'a dios',
2000
Context:
Millennium
exhibition
in
Santiago,
Chile
Client:
Goethe
Institute
Date of
Issue: 1999
Size:
84 x 119cm

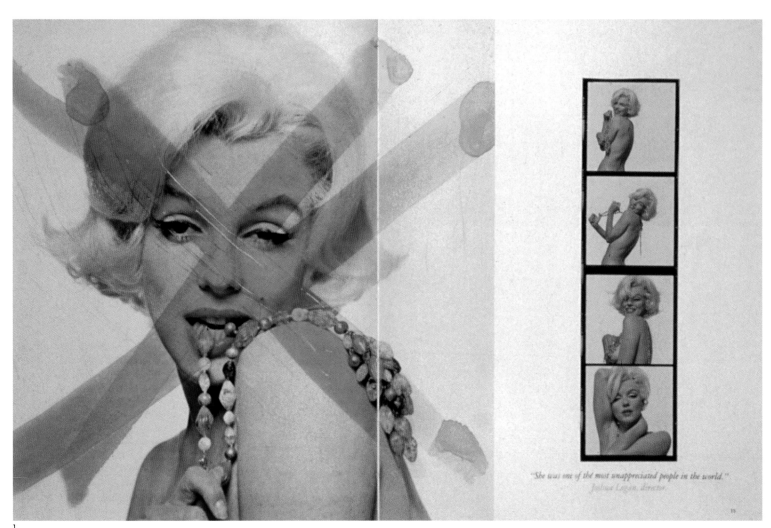

"She was one of the most unappreciated people in the world."
Joshua Logan, director

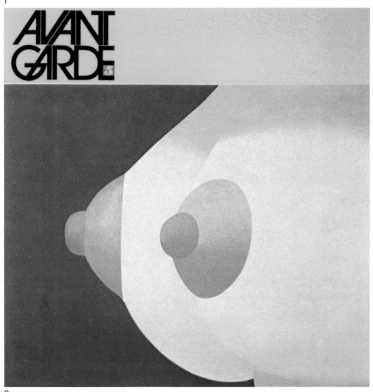

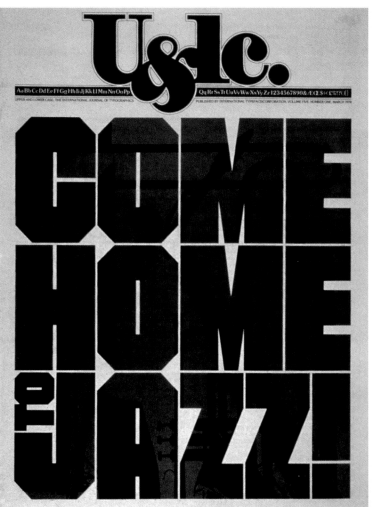

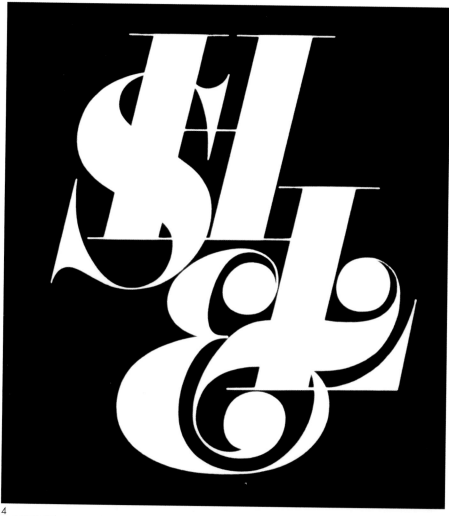

4

He blow: he don't worry●●●
There's this cat he knows:
Wingy from way back.
But he's a sadistic and
a square, not that it
matter to Wingy
Manone, he got
only one arm.
He blow: he
don't worry.
Each year this
guy send Wingy
Manone his Christ-
mas present in a
fancy box: 1 cuff link

PARABOLIC BORE:

OLD JAZZ NEED
NOT BE BEST BUT
STILL IT'S TRUE
THAT SAXOPHONES
WERE FEW AND FAR
BETWEEN IN GOOD
KING PORTER'S MERRY
TIMES. THOSE WHO DO
NOT LOVE THE SOUND
THAT ISSUES FROM THE
BLEND OF BRASS.
BENT HORN WITH
WOODEN REED
ARE THREATEN-
ED IN THESE
PARTS, BUT
THEY'RE
AROUND!

5

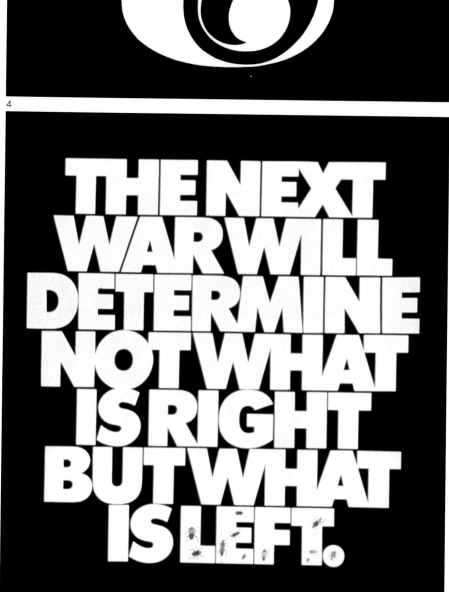

THE NEXT WAR WILL DETERMINE NOT WHAT IS RIGHT BUT WHAT IS LEFT.

6

1
Spread from Eros, a Ginzberg publication

2
Cover for Avant Garde

3,5
Page from U&lc magazine for an article on American jazz

4
New logo for Sudler, Hennessey & Lubalin

6
Anti war poster for an American Institute of Graphic Arts exhibition

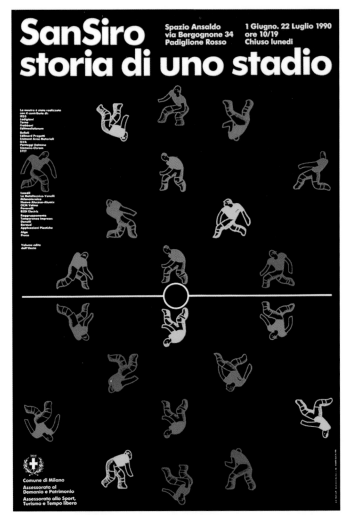

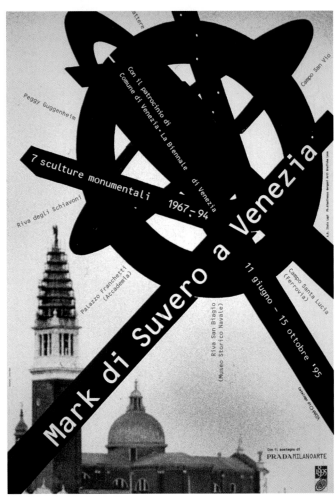

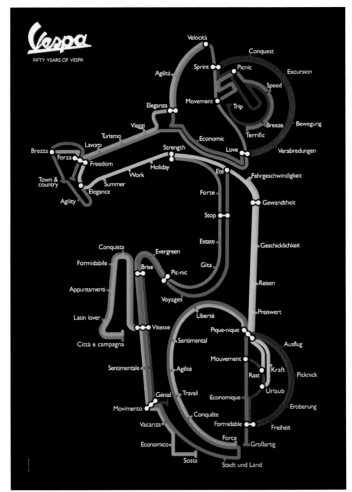

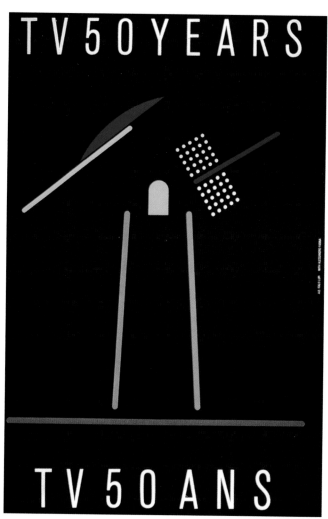

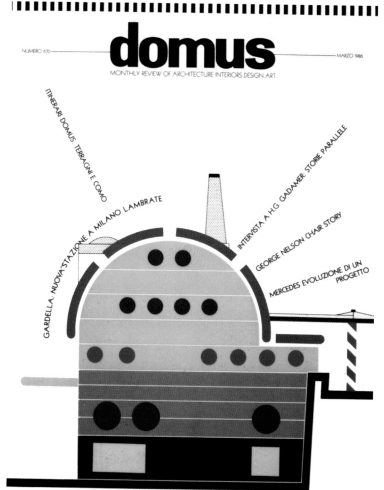

1

2

3

4

5

6

7

8

1,2,6
Known faces

2,7
Bild Alphabet

4,8
Today's Hieroglyphs

5
Schrift Bilder

From the books
by Hans Rudolf Lutz
as listed on page 311

1

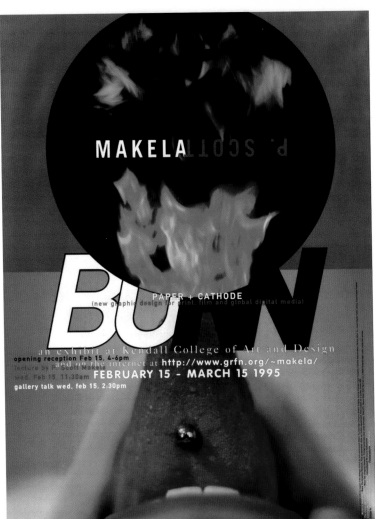

2

3

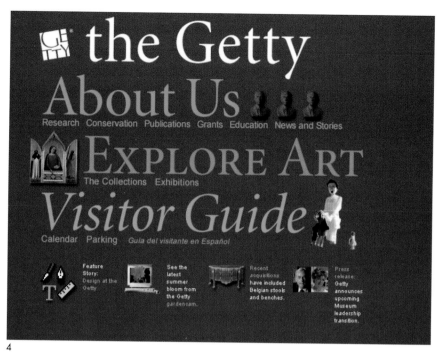

1
Preliminary sketch for new home page for Planet Sabre, one of several metaphorical treatments and styles explored by AM+A, 1994-95.

2
Home Screen for multimedia-rich CD-ROM-based learning product from Cogito Learning Media. AM+A designed the user-interface for the series of Eye-to-Mind® products and implemented the products, which received awards for multimedia product design, 1997.

3
Prototype opening screen for Prodigy online service. AM+A designed several prototypes to show possible innovative changes in the home screen as well as developing user-interface guidelines, 1994.

4
Final prototype for website home page for the Getty Museum, Los Angeles, 2001. AM+A designed typographic and color themes for the website's contents.

5
Scene from interactive learning game for travel agents to learn new Planet Sabre user interface, 1997-98. AM+A used the movie Casablanca as a basis for the scenes.

6
Air travel booking application. AM+A designed the user interface for Planet Sabre, a major overhaul of one of the world's three largest online travel services, including this screen for travel agents to review possible itineraries before booking flights, 1999.

4

5

6

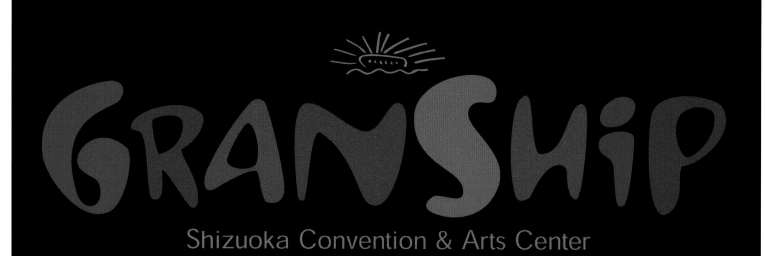

1

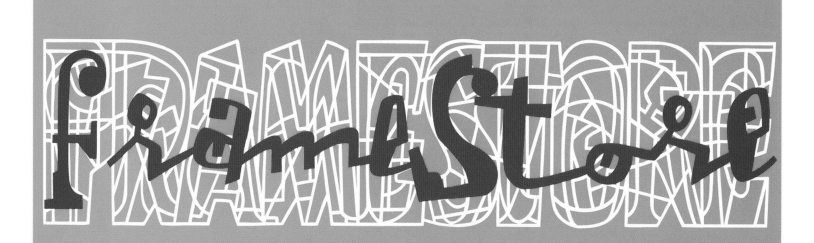

2

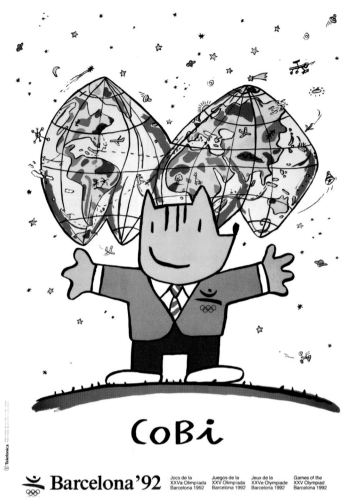

CoBi

Barcelona '92
Jocs de la
XXVa Olimpiada
Barcelona 1992

Juegos de la
XXV Olimpiada
Barcelona 1992

Jeux de la
XXVe Olympiade
Barcelona 1992

Games of the
XXV Olympiad
Barcelona 1992

3

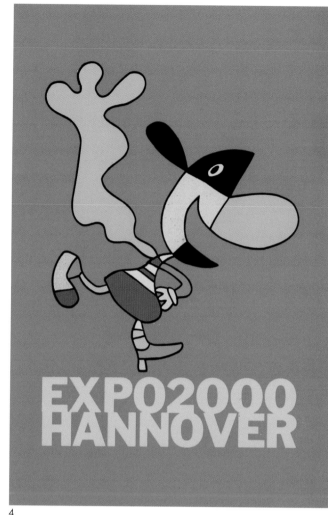

EXPO2000
HANNOVER

4

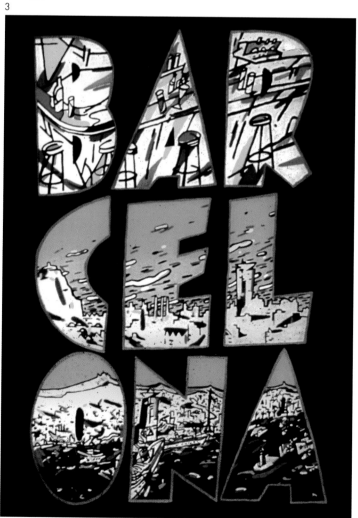

5

6

JAVIER MARISCAL

1
'Granship'
Shizuoka
Convention
and Arts
Centre Logo

2
Framestore
Logo

3
'Cobi'
Mascot
Olympic
Games,
Barcelona
1992
Official
Poster

4
'Twipsy'
Mascot
Expo 2000
Hanover
Official
Poster

5
Illustrated
Alphabet
Barcelona
Poster

6
Illustrated
Alphabet
Barcelona
Pin

167

1

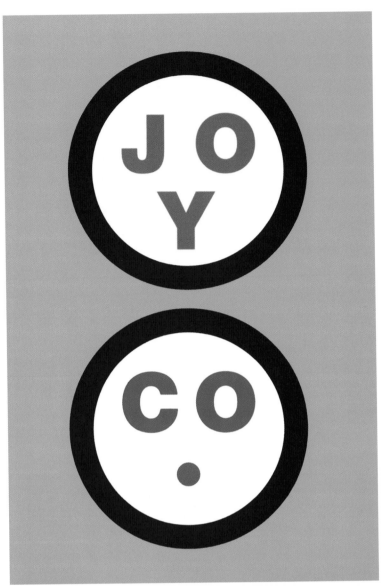

3

4

2

5

7

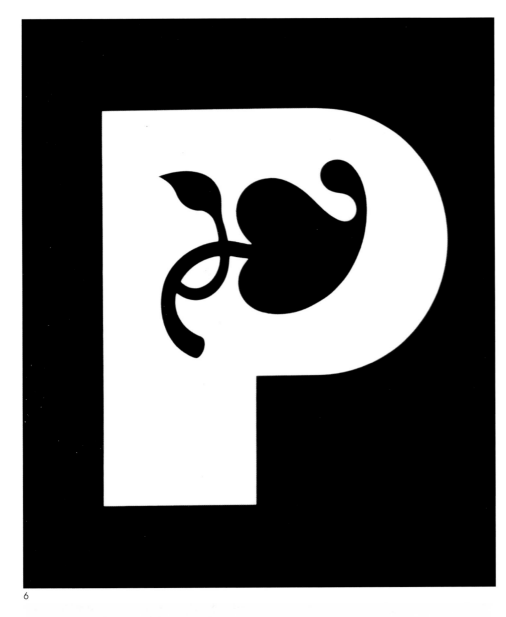

6

8

1,3
Client: Pentagram
Job: Christmas Book
Date: 1995
Partner: John McConnell

2,5
Client: Joyco
Job: Naming and brand identity
Date: 1999
Designer: John McConnell (Partner)
Design Assistant: Hazel Macmillan
Illustrator: Javier Mariscal

4
Client: Faber and Faber
Job: Corporate Identity
Date: 1981
Partner: John McConnell
Designers: John McConnell, Keren House

6
Client: Editions Payot
Job: Symbol
Date: 1988
Designer: John McConnell (Partner)
Design Assistant: Laurence Dunmore

7
Client: Biba
Job: Corporate identity
Date: 1963
Partner: John McConnell
Designer: John McConnell

8
Client: Classic FM
Job: Identity
Date: 1992
Partner: John McConnell
Designers: John McConnell, Jason Godfrey

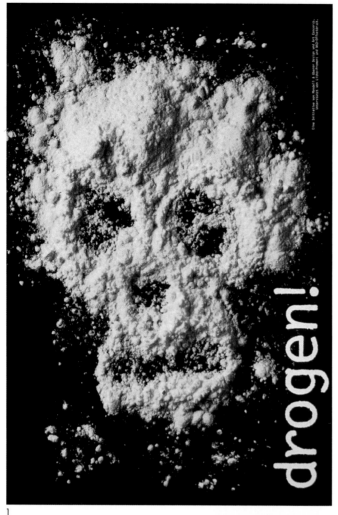

1

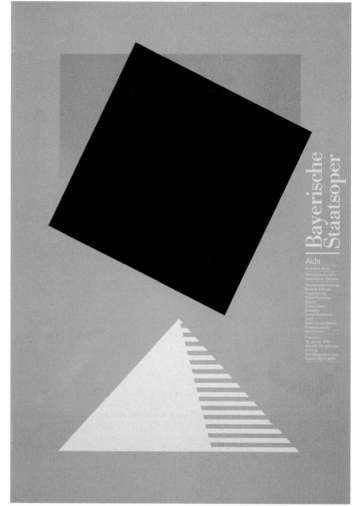

2

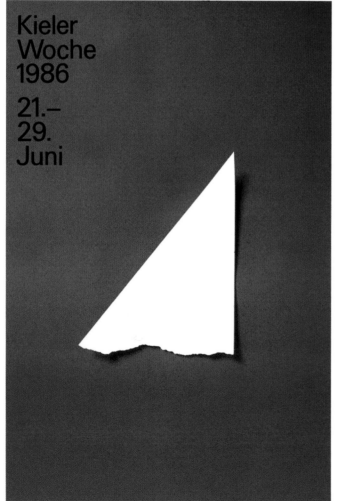

3

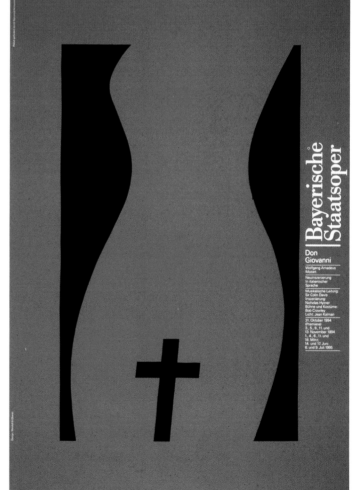

4

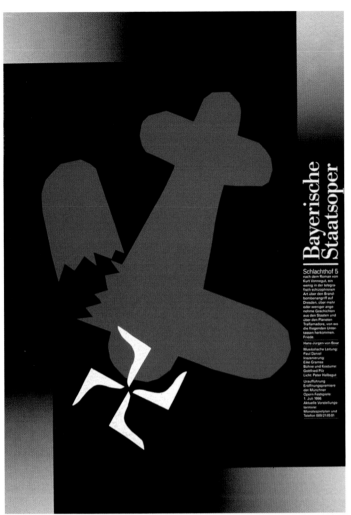

5

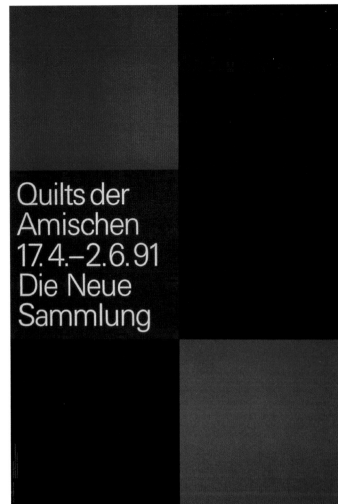

6

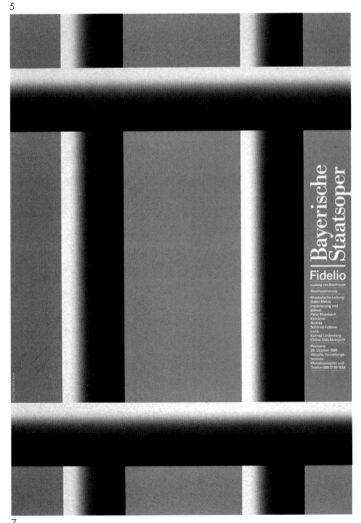

7

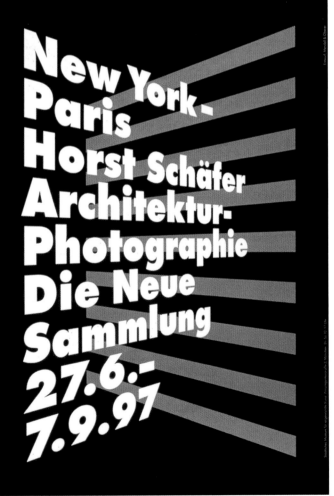

8

1

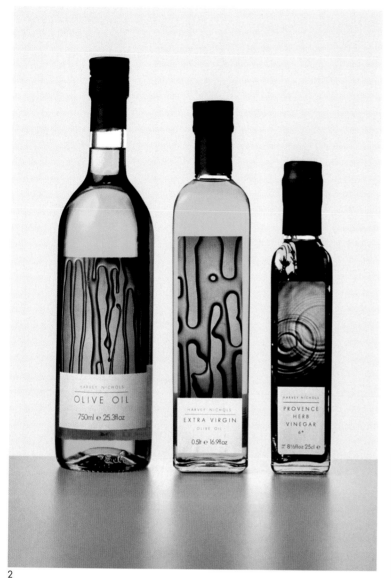

2

3

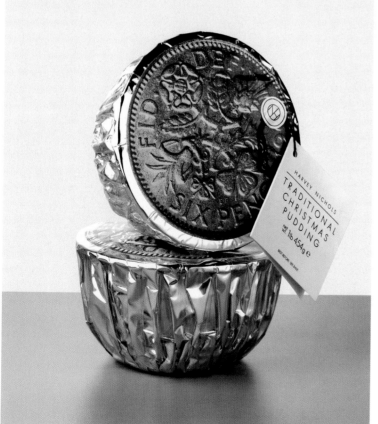

4

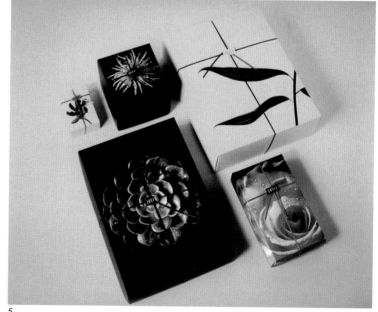

5

1
Space NK Apothecary, Beauty products

2
Harvey Nichols, Oils and Vinegar

3
Joy Retail, Fine Olive Oil

4
Harvey Nichols, Christmas pudding

5
Joyce boxes, Hong Kong retail store

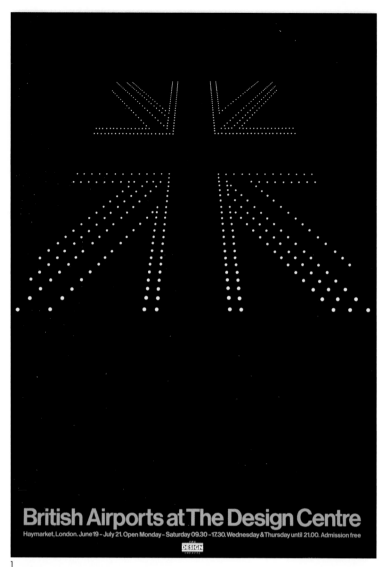

British Airports at The Design Centre
Haymarket, London. June 19 - July 21. Open Monday - Saturday 09.30-17.30. Wednesday & Thursday until 21.00. Admission free

1

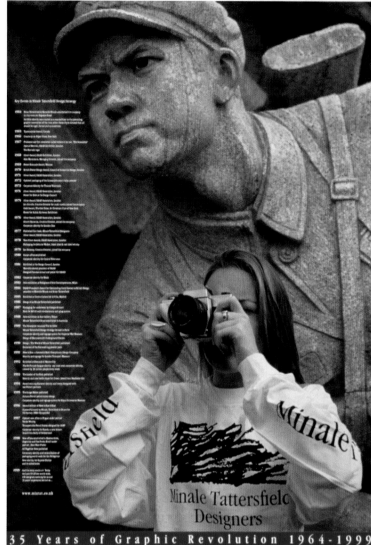

2

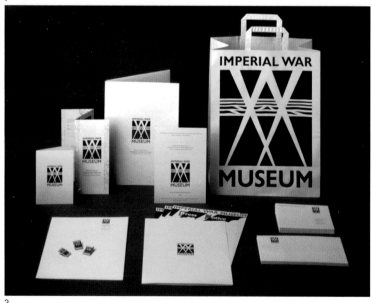

3

4

1
Poster for exhibition of British Airports

2
35 years' graphic revolution poster

3
Identity for the Imperial War Museum

4
'Cut it out' advert for Italian State Tourist Office

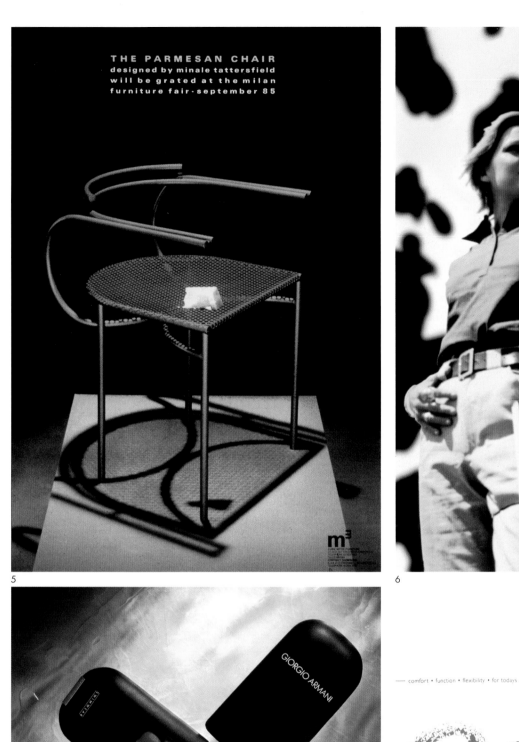

5

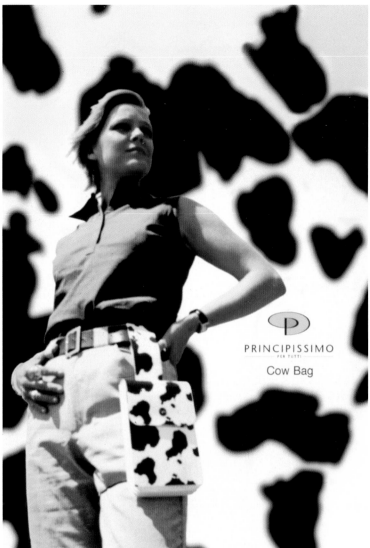

6

7

8

5
Parmesan chair poster

6
Principe poster

7
Packaging for Armani

8
Campaign for Exedo, Bally

OSL 3

1,2
A highly versatile mark for Danish National
Television Channel I, which is nothing but
a shape. The shape can be solid, outline,
striped, dynamic and whatever. Only the shape
remains the same, 1993

3
The new Oslo Airport has OSL as its international
abbreviation. The trademark takes its point of
departure in the abbreviation, adds perspective
and an 'o' with aircraft, 1997

home 4

4
A chain of about 120 real estate agents
specialising in private residences, 1990

5
A manufacturer of contract furniture, specialising
in chairs, 1993

Schiang 5

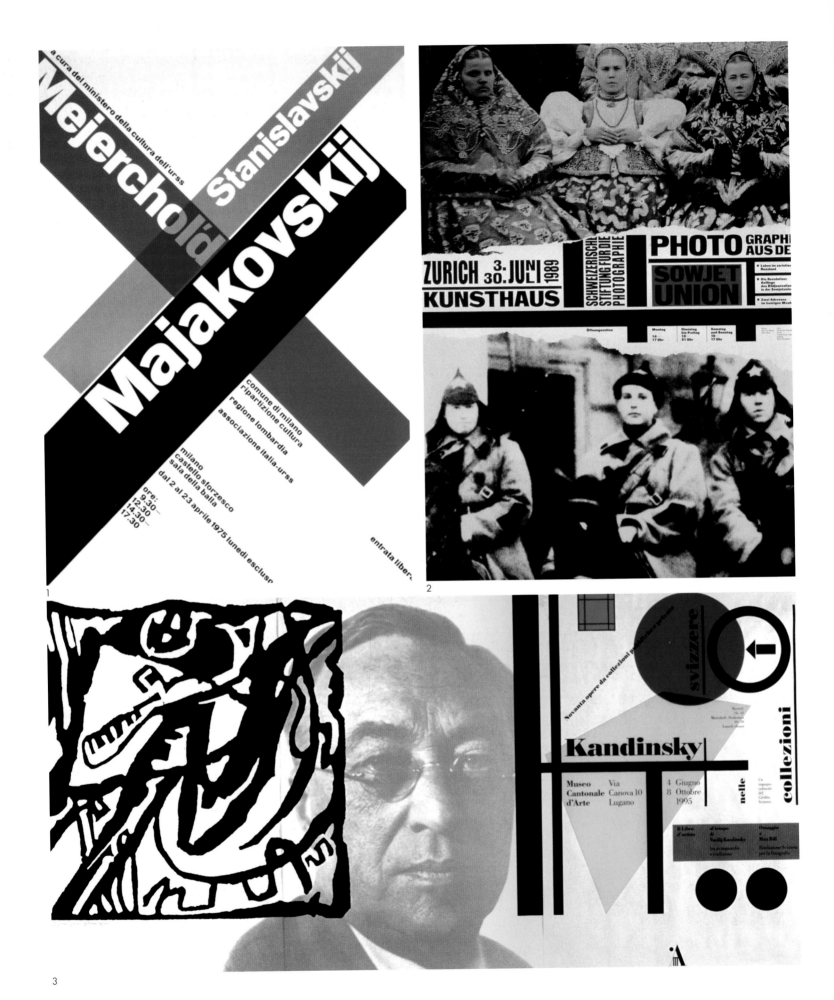

1
Majakovsky, Mejercholtd, Stanislavsky
Castello Sforzesco, Milan
Poster, 1975
90.5 x 128 cm

2
Photography from the Soviet Union
Kunsthaus, Zurich
Poster, 1989, Photos S.C. Raoult, Piotr Orup
90.5 x 128 cm

3
Kandinsky in the Swiss Collections
Museo Cantonale d'Arte, Lugano
Poster, 1995, Photo Florence Henri
90.5 x 271.5 cm

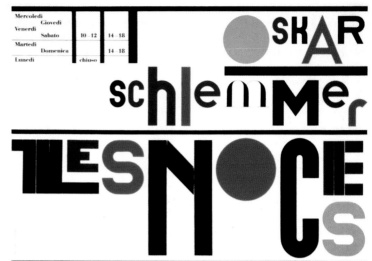

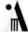

4

5

6

4
What has spring got to do with me
Al Castello Film Productions, Arzo
Poster, 1988, Photo Bruno Monguzzi
90.5 x 128 cm

5
Les Noces
Museo Cantonale d'Arte, Lugano
Poster, 1988
90.5 x 128 cm

6
Jean-Baptiste Camille Corot
Museo Cantonale d'Arte, Lugano
Poster, 1994
90.5 x 128 cm

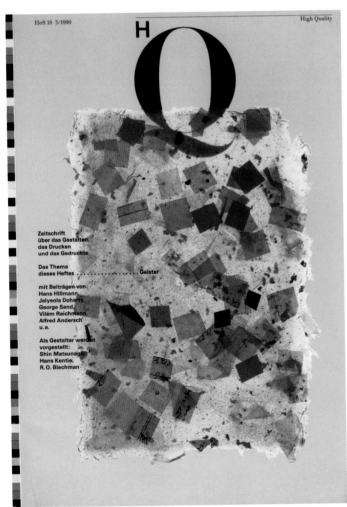

H
Q

Zeitschrift
über das Gestalten,
das Drucken
und das Gedruckte

Das Thema
dieses Heftes Geister

mit Beiträgen von:
Hans Hillmann,
Jaiyeola Doherty,
George Sand,
Vilém Reichmann,
Alfred Andersch
u. a.

Als Gestalter werden
vorgestellt:
Shin Matsunaga,
Hans Kentie,
R. O. Blechman

H
Q

Zeitschrift
über das Gestalten,
das Drucken
und das Gedruckte

Das Thema
dieses Heftes:
Rezepte

Als Gestalter
werden vorgestellt:
Ken Cato,
Isolde Monson-Baumgart,
Edgar Reinhard

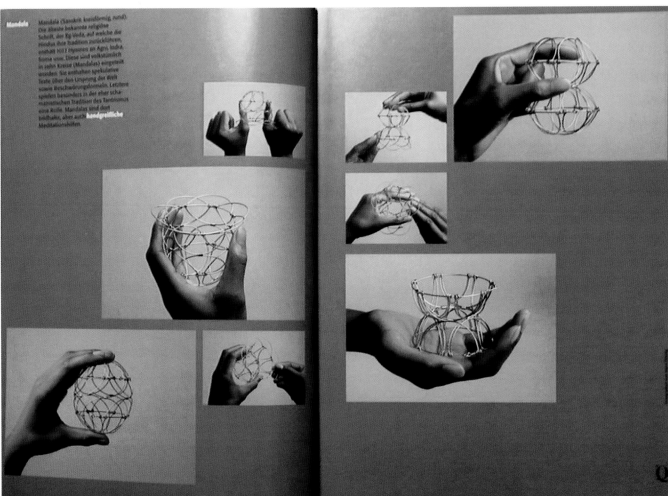

Cover and
spreads from
HQ Magazine.
Art direction:
Rolf Müller.
Editorial offices,
design and
production:
Büro Rolf Müller

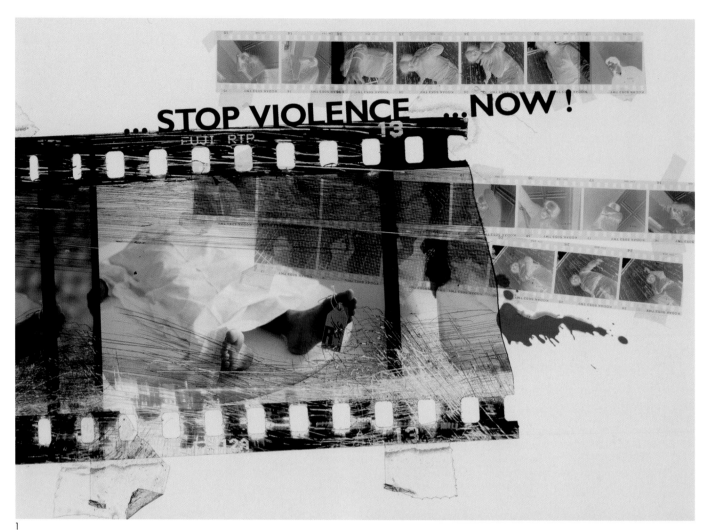

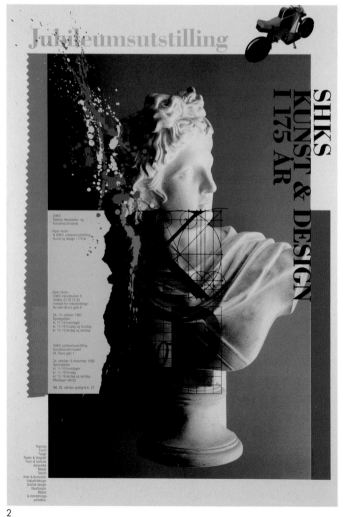

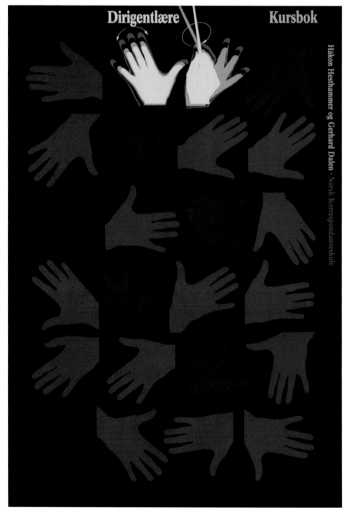

1

2

3

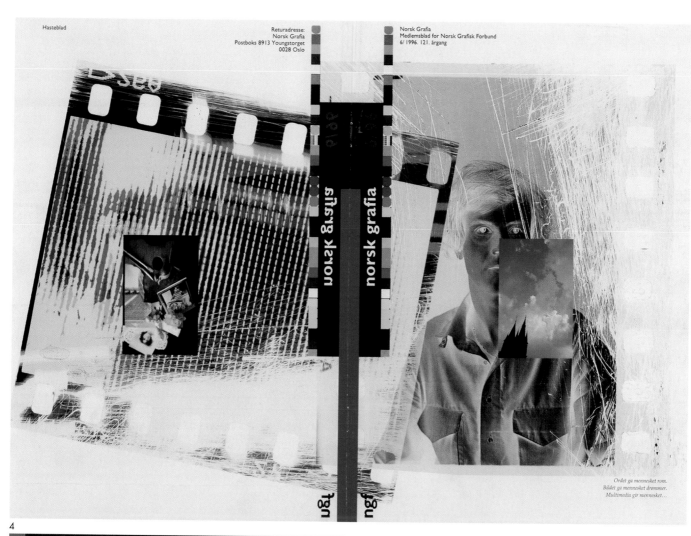

1
Competition
entry for
Posters
Against
Violence
Worldwide,
New York

2
Jubilee poster
for SHKS,
National
College of
Art and Design,
Oslo

3
Cover design,
paperback,
for NKS
Foundation,
Oslo
The Art of
Conducting –
a course book

4
Photocollage
Front cover,
Norsk Grafia
6/97
Norsk Grafisk
Forbund
Graphic Trade
Union Oslo

5
Front cover
for Bokklubben
Nye Bøker
Oslo
Book club
magazine
Book of
the month:
'En hunndjevels
bekjennelser'
'Lives and loves
of a she-devil'
by Fay Weldon

6
Jubilee poster
for Westnofa,
Sykkylven,
Norway,
Furniture sales
organisation

4

5

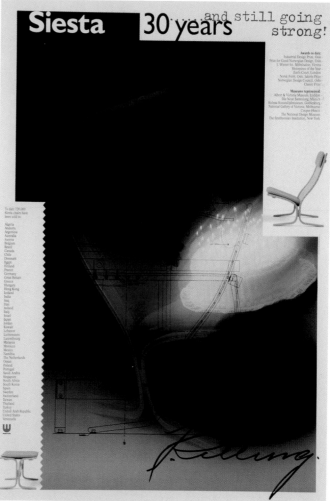

6

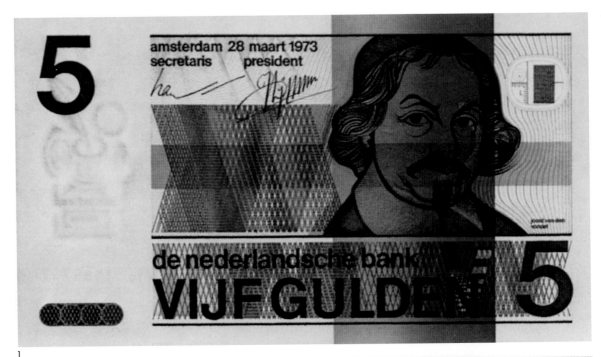

1

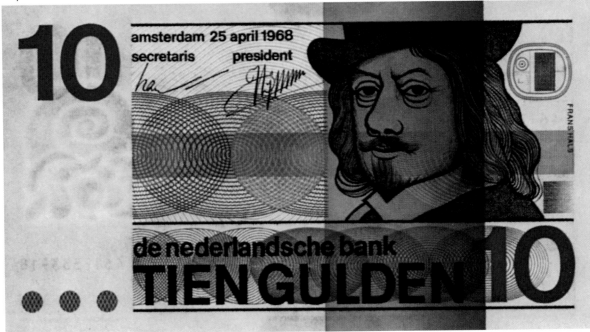

2

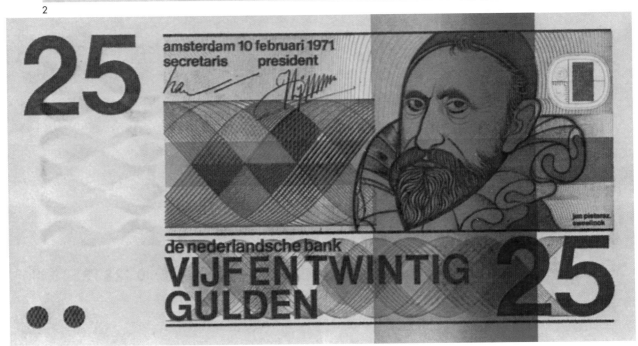

3

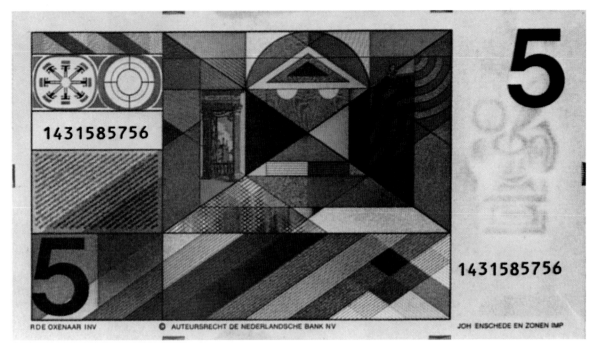

1,4
Recto and verso of
the 5 guilder note

4

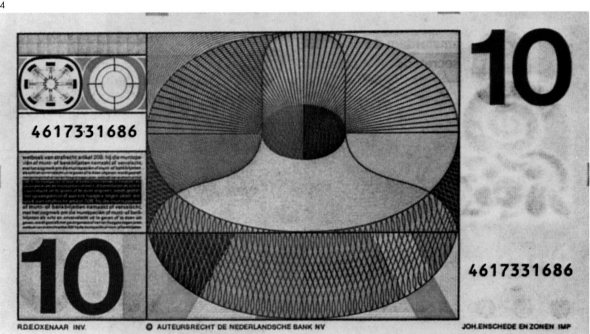

2,5
Recto and verso of
the 10 guilder note

5

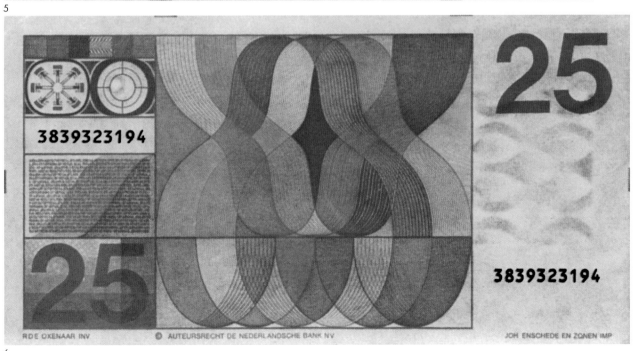

3,6
Recto and verso of
the 25 guilder note

6

1 2 3

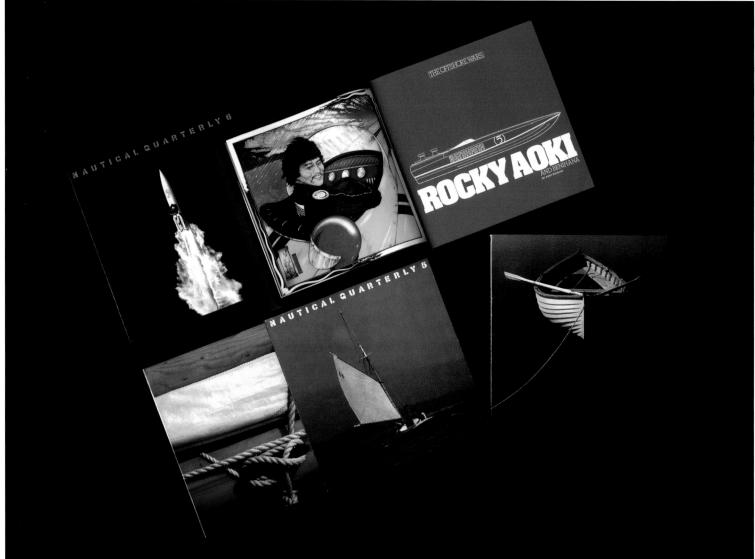

4

1,2,3,12
Graphis Magazine, 1999, 1995,
1999, 2000

4
Nautical Quarterly, 1979

5, 7
Graphis Nudes 3 1999,
Graphis Nudes 2, 1996

8
Graphis Advertising Annual, 2000

9
Graphis Brochures, 1996

10
Graphis Poster Annual, 2000

11
Graphis New Talent Design Annual, 2000

13
Animal by Jim Balog, 1999

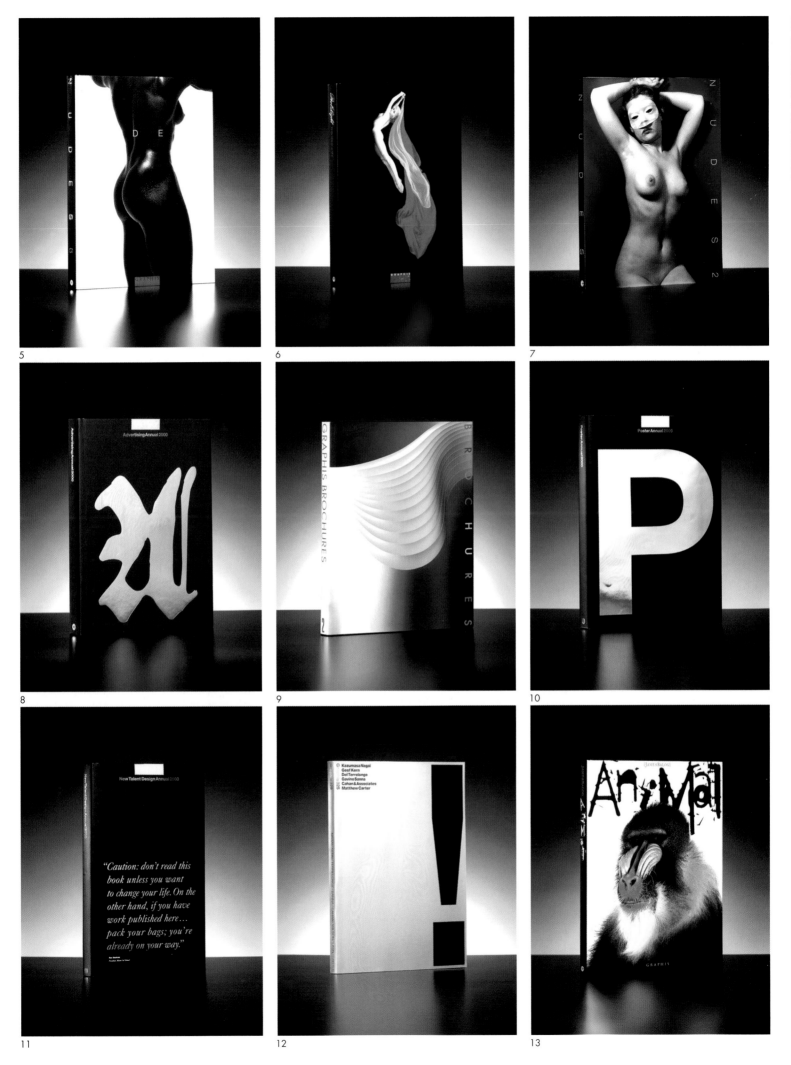

5

6

7

8

9

10

11

12

13

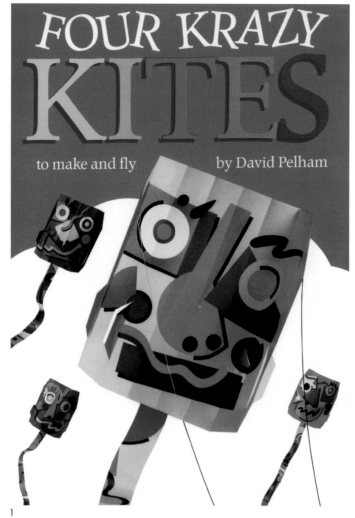

1

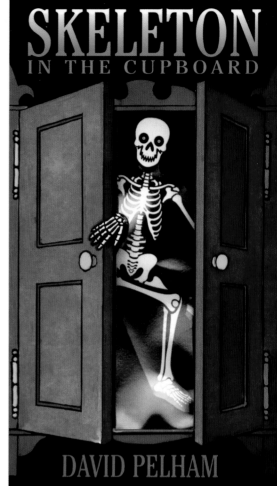

2

1

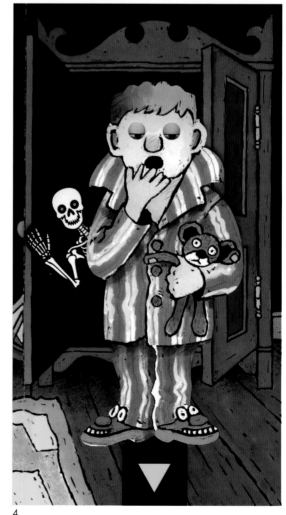

HEDGEHOG BOOKS

3

1
A children's book containing four easy-to-make, easy-to-fly paper kites. Published by Macmillan Children's Books 1993. Dutton Children's Books, New York 1993

2,4
A pop-up novelty book with a moving skeleton situated inside the cover. Published by Jonathan Cape, London 1998. Dutton Children's Books, New York 1998

3
Logo for a book packaging company, 1993

4

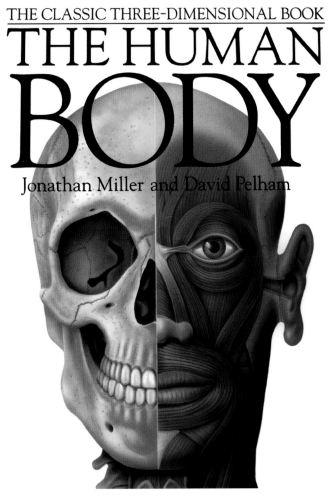

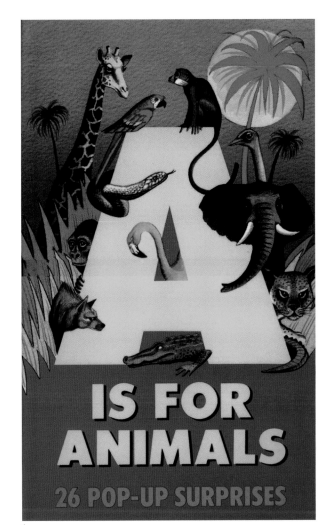

5

6

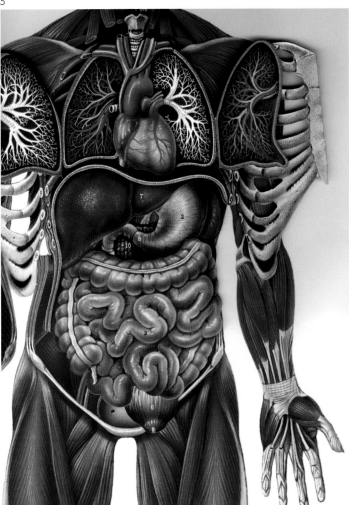

8

5,7
An educational pop-up book devised in association with Dr. Jonathan Miller. Published by Jonathan Cape, London 1983. Random House, New York 1983

6
A pop-up alphabet book for children. Published by Macmillan Children's Books, London 1991. Simon & Schuster, New York 1991

8
Logo for a yacht named Brigand, 1981

7

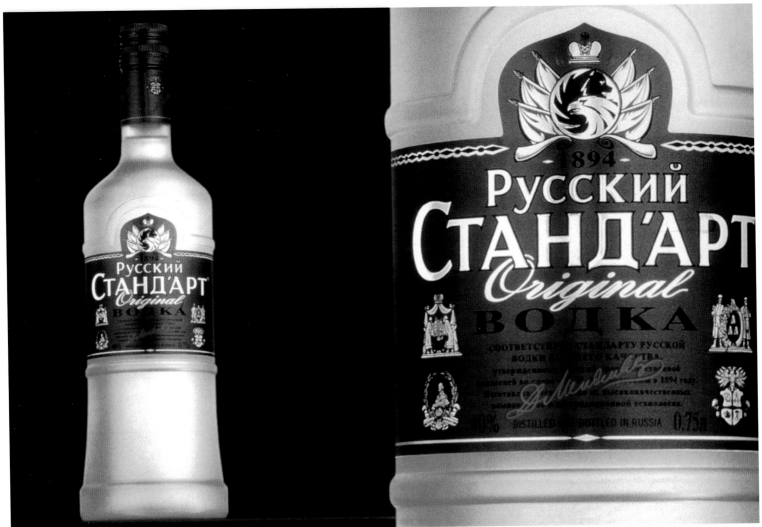

1

2

3

4

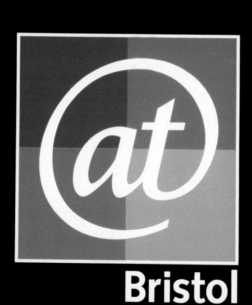

5

1,4
Roust Inc., the leading distributor of alcoholic
beverages in Russia, approached Identica to
create a super-premium vodka brand. While the
organisation possesses a formidable distribution
capability, a strategic objective of the business is
also to become a brand owner. Russian Standard
is the first brand in Roust's planned portfolio; the
product will initially be sold in Russia and then
launched in both Europe and America

2
Johnnie Walker is United Distillers' flagship
global brand. With mounting competition in
the international spirit market, they approached
Identica to revitalise and reposition the world's
most famous whisky brand. Brand development
has breathed new life into the Johnnie Walker
brand and created additional revenue streams
for the business

3
In the early nineties, Inmarsat embarked on a
mission to provide a global mobile phone service.
Identica was briefed to create a name and a brand
identity which would announce the company's
existence to policy makers, regulators, financiers,
and competitors. Strategically, the identity also
needed to be consumer-oriented in preparation
for the global launch in 2000

5
at-Bristol, formerly Bristol 2000, is an imaginative
Millennium project designed to boost tourism and
investment in Bristol. Identica developed the name
at-Bristol for the destination, and created a brand
identity that is state-of-the-art but warm and
approachable in tone

1

2

1
Poster for Communication Graphics Show,
February 1994
Partner/Designer/Illustrator: Woody Pirtle
Designer: Ivette Montes de Oca

2
Call for entries poster, January 1995
Partner/Designer: Woody Pirtle
Illustrator: Woody Pirtle

3
Chrysler/Corn poster, 1990
Partner/Designer/Illustrator: Woody Pirtle
Typographer: Monogram

4
Identity, packaging, 1995-96
Partner/Designer/Illustrator: Woody Pirtle
Associate/Designer: John Klotnia
Designers: Seung il Choi, Sha-Mayne Chan
Design Assistant: Patricia Choi

3

4

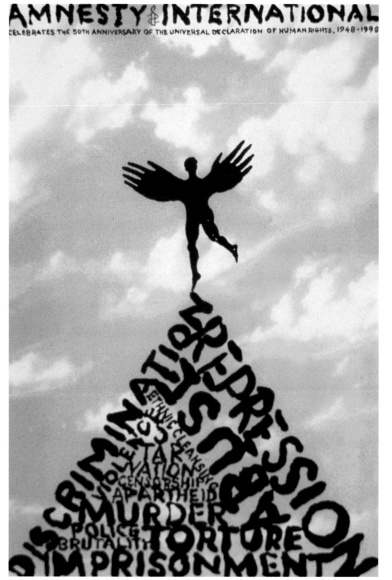

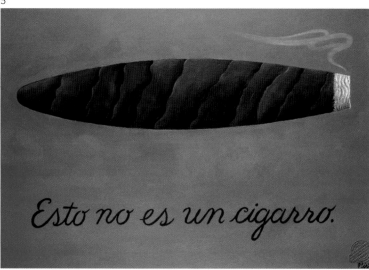

5

6

7

8

5
Poster for 'Anniversary of the Declaration of Human Rights'
Partner/Designer: Woody Pirtle

6
Identity, 1997
Partner/Designer: Woody Pirtle
Designers: Sha-Mayne Chan,
Macarena Leiguarda

7
A poster announcing a design lecture entitled 'The Treachery of Images', in Tampa, Florida, April 1992
Partner/Designer: Woody Pirtle

8
Alphabet poster series,1994-95
Series Art Director: Paula Scher
Designer: Woody Pirtle
Clients: Ambassador Arts, Inc.

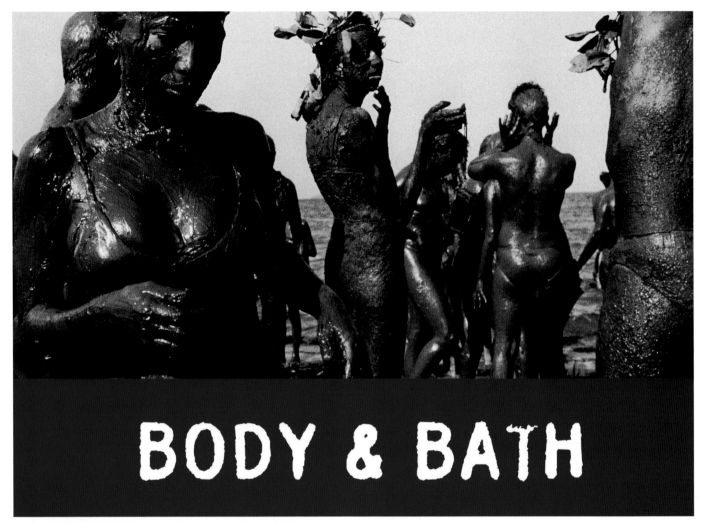

BODY & BATH

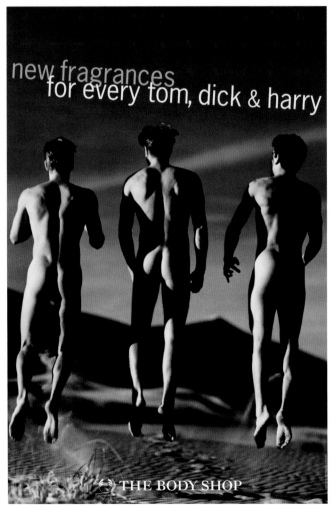

new fragrances
for every tom, dick & harry

THE BODY SHOP

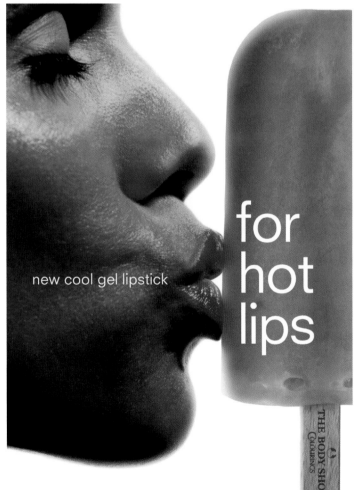

new cool gel lipstick

for
hot
lips

THE BODY SHOP

194

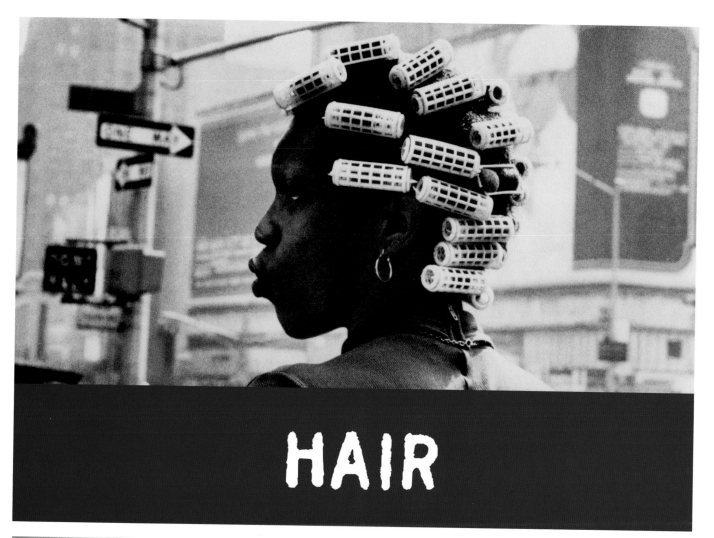

HAIR

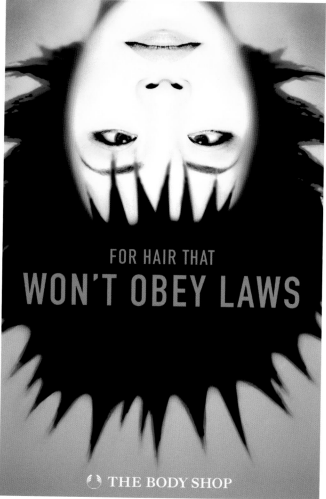

FOR HAIR THAT
WON'T OBEY LAWS

 THE BODY SHOP

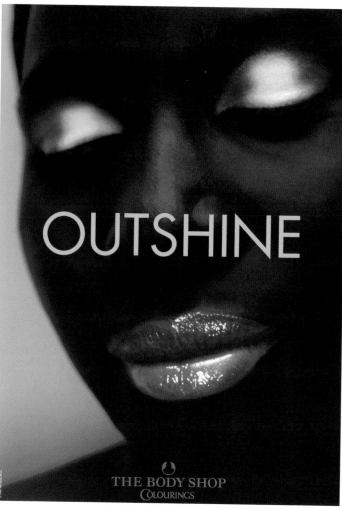

OUTSHINE

THE BODY SHOP
COLOURINGS

Promotional
posters for
The Body Shop

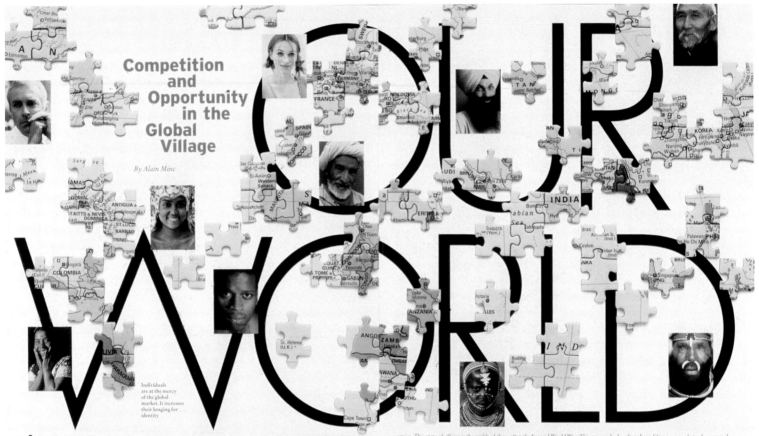

Competition and Opportunity in the Global Village

By Alain Minc

Individuals are at the mercy of the global market. It increases their longing for identity

In times of great tranquillity, politics yields to economics, and globalization seems to be the natural order of things. Today it determines the rules by which capitalism functions, just as Fernand Braudel's concept of the world economy did in the 16th century. But the slightest tremor will cause this hierarchy to be reversed, economics to take second place once more, and the process of globalization to be thrown out of joint. Then, however, one bright star will continue to shine in the sky: the American economy will once again have the advantage of youth on its side, remaining unthreatened by disturbing historical memories, for it lies outside of history. The triumph of the market brings with it an enormous risk: a cycle of increasing inequality, which for many puts its very legitimacy in question. This inequality does not exist between nations, for with the exception of central Africa, and one or two other forgotten regions, the nations of the earth are moving towards greater equality. The inequality referred to exists between the citizens of individual economies. This state of affairs is the result of the insufficiently appreciated revolution that took place in the West in 1982, when negative real interest rates suddenly turned positive. Up until that point, the advantages enjoyed by borrowers of capital and the disadvantages suffered by owners of capital had contributed to the equalization process initiated after the Second World War. This process had created a powerful middle class that had absorbed all other classes, from skilled workers striving to own the houses they lived in, to the dispossessed members of the upper middle class whose family inheritance had been liquidated. Imperceptibly at first, a colossal reanimation of capital occurred, which finally, after about fifteen years of steady accumulation, reached its full, enormous extent.

Reinforced by too low volumes of savings, positive real interest rates in Europe soared within a few years as a result of the reconstruction of eastern Germany. This situation was aggravated by a steady decrease in capital taxation, since in a globalized economy capital

Food, glorious food: mouth-watering maybe, but healthy too?

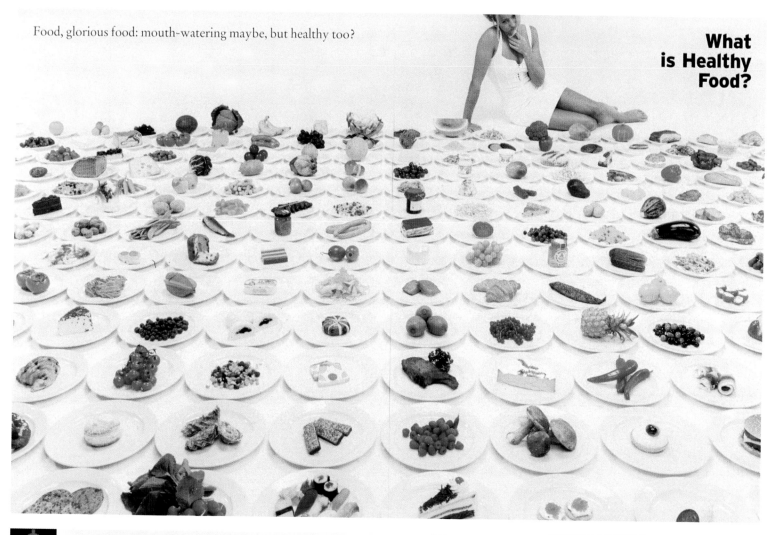

What is Healthy Food?

Visual Literacy – or Every Picture Tells a Story

Paintings, drawings, prints and photographs can speak more beautifully and eloquently than words and numbers. They also offer metaphysical insight into the human condition

By Ferdinand Protzman

1

2

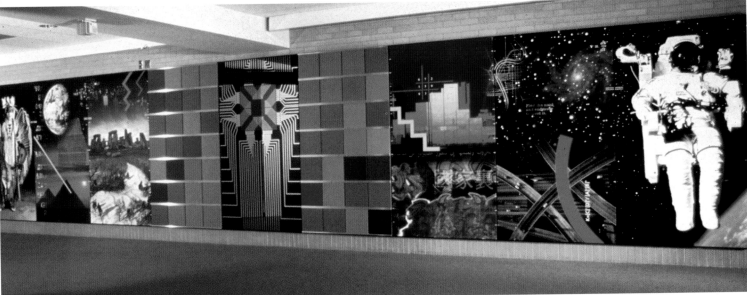

3

4

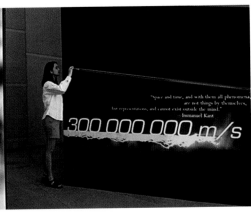

5

1,2
Cincinnati Zoo identity and wayfinding system, 1985
(Design Collaborators: Heinz Schenker, Mark Barensfeld,
Alison Probst)

3
Arts and Science Building, Sinclair Community College,
Dayton, Ohio, mural, right side

4,5,9,10
Work conducted with students of the University of Cincinnati

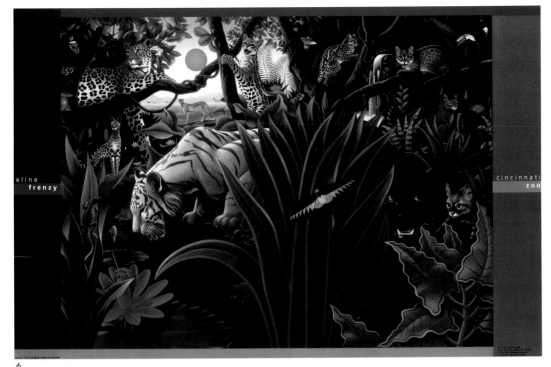

6

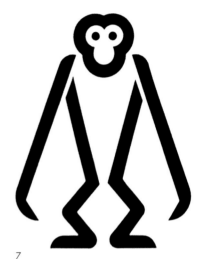

7

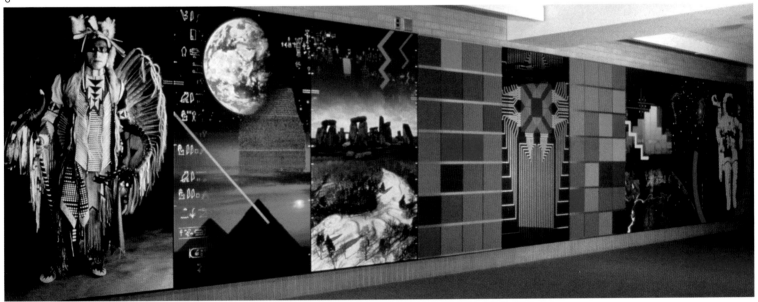

8

9

10

6
Poster for Cincinnati Zoo, 1987
Design and Art Direction: Robert Probst,
Mark Barensfeld

7
Icon system for Cincinnati Zoo

8
Arts and Science Building, Sinclair Community College,
Dayton, Ohio, mural, left side

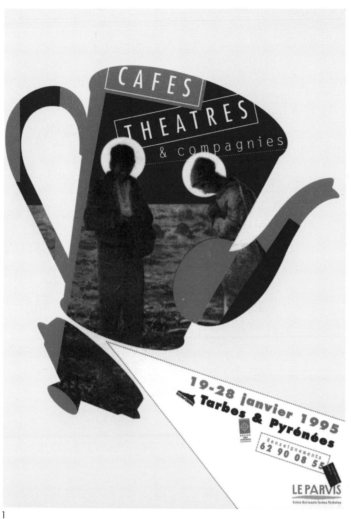

1

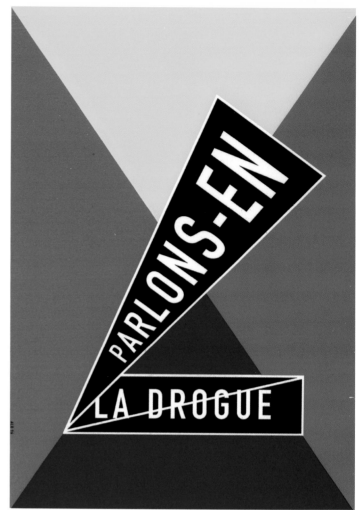

2

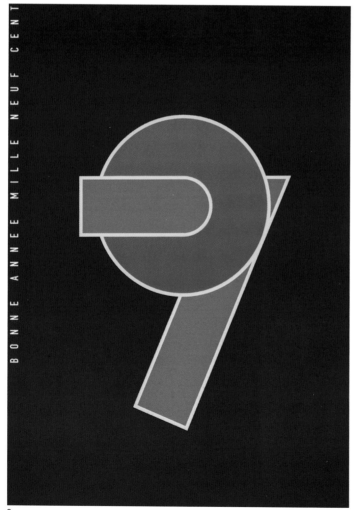

3

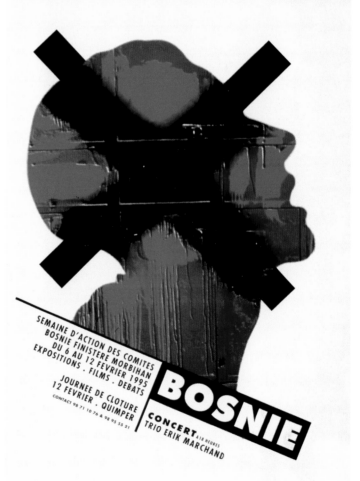

4

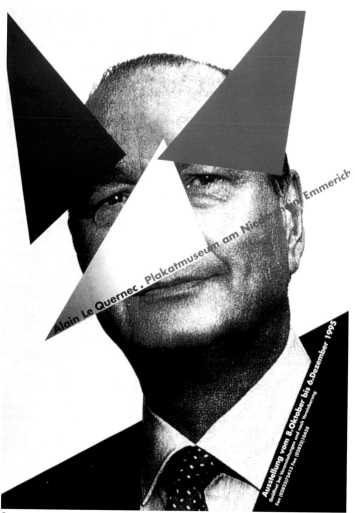

5

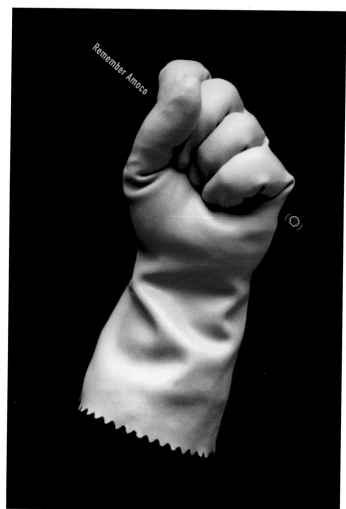

6

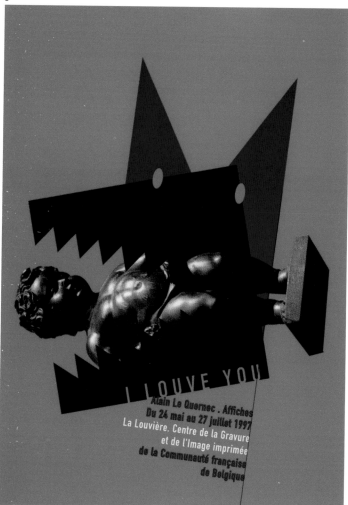

7

1
One of a series of posters for Cafés Theatres

2
Poster for conference on drugs

3
New Year card

4
Concert poster

5
Poster of the artist's work at Plakatmuseum om Niederrhein, Emmerich

6
Protest poster

7
Poster for exhibition of the artist's work at La Louviere, Belgium

DER ZAUBERER VON OSS

Hessisches StaatsTheater Wiesbaden

ONKEL WANJA

Hessisches StaatsTheater Wiesbaden

RAMBOW BACK TO BLACK

Das Museum Wiesbaden zeigt Theaterplakate von Gunter Rambow für das Hessische Staatstheater Wiesbaden 1998 23. September 1998 bis 11. Oktober 1998

2. Oktober bis 2. November 1998 in der Ginza Graphic Gallery, Tokyo

BOBBY FISCHER WOHNT IN PASADENA

Hessisches StaatsTheater Wiesbaden

THE PROLI FERAT ION OF STUFF

Observing the fantastic possibilities open to manufacturers today is sometimes almost enough to give one the surreal sensation of being a time traveller from the past observing a sci-fi vision of the future. The car industry feels more and more like that. A car can now be built from one lightweight piece of aluminium like the Audi A8, or held together by glue inside a racy shell like the Lotus Elise. And ground-breaking vehicles such as the Smart car have heralded the arrival of a new breed of vehicle that is as user friendly and as accommodating to personal taste as the mobile telephone.

It is hard not to be excited by the enterprising spirit of the times. We are after all a generation that was brought up to view choice as a metaphor for progress. Today, choice has simply never been wider. Even British manufacturing – usually viewed as an eccentric anachronism – got the bug in the 1990s. From PCs to tea bags, consumer products are being rethought from scratch, and at the centre of it all is a new unfamiliar breed of entrepreneur. In the wake of James Dyson's world-conquering 'bagless' vacuum cleaner, designers are popping up to propose new and improved versions of products that have remained almost untouched for years: the pushchair, the washing machine, even the radiator.

It would have been hard to imagine this happening a decade ago. Designers have been telling us for half a century that they can make products more distinctive, useful and profitable, but at the beginning of the 1990s they seemed as far from winning the argument as ever. It sounded laughable on this side of the Atlantic when business magazines suggested that design would mean megabucks.

Britain has not, of course, become as enterprising and successful as California's Silicon Valley overnight, but the truly significant change is that alongside the people at the forefront of cutting edge thinking, the world's conservative establishment has bought into design culture. Increased efficiency, restructuring, downsizing and cost cutting were the values of the early 1990s, but increased efficiency alone is now viewed as yesterday's business solution. Today, the words design, innovation and creativity trip off the tongues of managing directors, spin doctors and, perhaps most importantly of all in Britain, politicians who support that New Labour import, the Third Way.

Why is creativity a buzzword and why do designers suddenly seem to have both the confidence and credibility they previously often lacked? It seems that the opinion formers and analysts have taken a hard look at the commercial world and decided that there simply is no alternative. With competition continuing to intensify and companies finding ever cheaper places to manufacture their products, price is no longer a selling point for many goods.

Multinational makers of consumer products don't need to be told this, of course. They are already on the case. Take toys, for example. The global giants that dominate this business are now ready to spend tens of millions of dollars a year on design and fast-track new product development programmes that court and anticipate the tastes of their young consumers.

4

5

(the best of) NewOrder

6

4
Christian Dior Autumn/Winter 1997/98
Art Direction: Peter Saville
Photography: Nick Knight

5
Pulp album 'This is Hardcore' 1997
Art Direction: Peter Saville & John Currin
Photography: Horst Diekgerdes
Design: Howard Wakefield & Paul Hetherington

6
New Order album 'The Best of' 1994
Art Direction: Peter Saville
Photography: Trevor Key
Design: Howard Wakefield

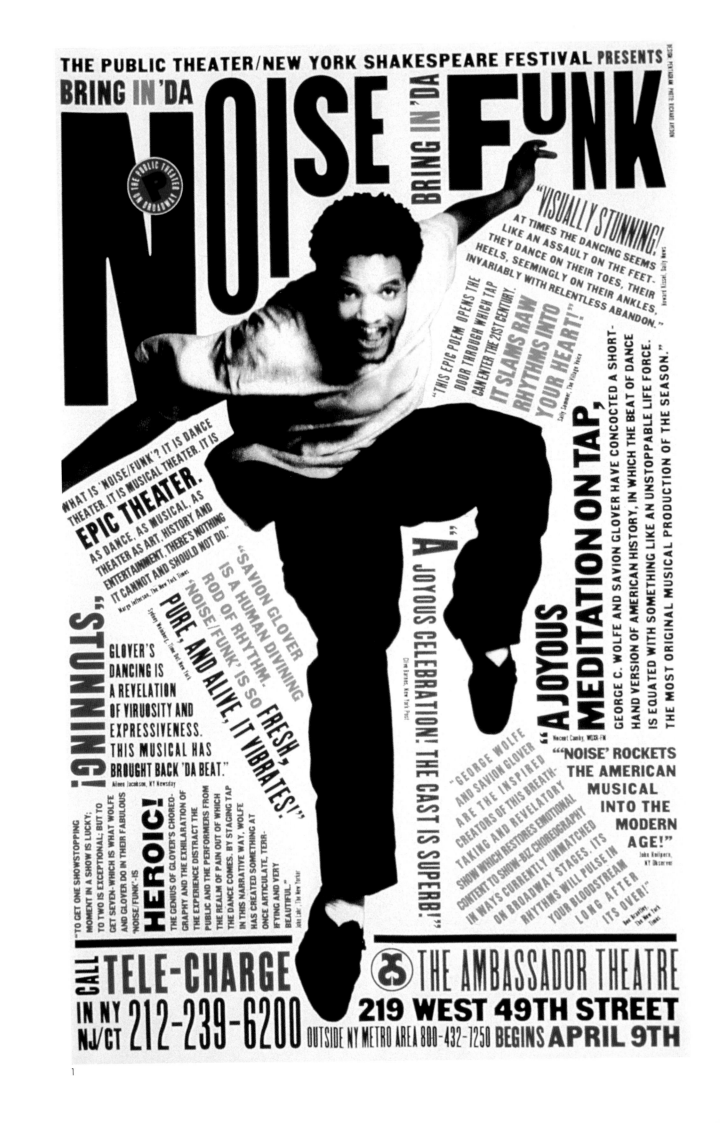

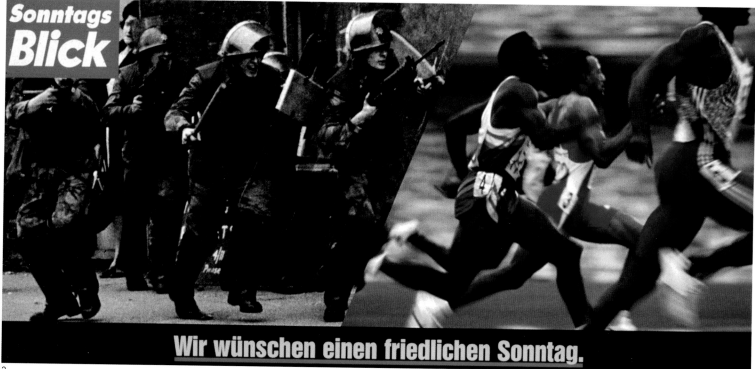

3

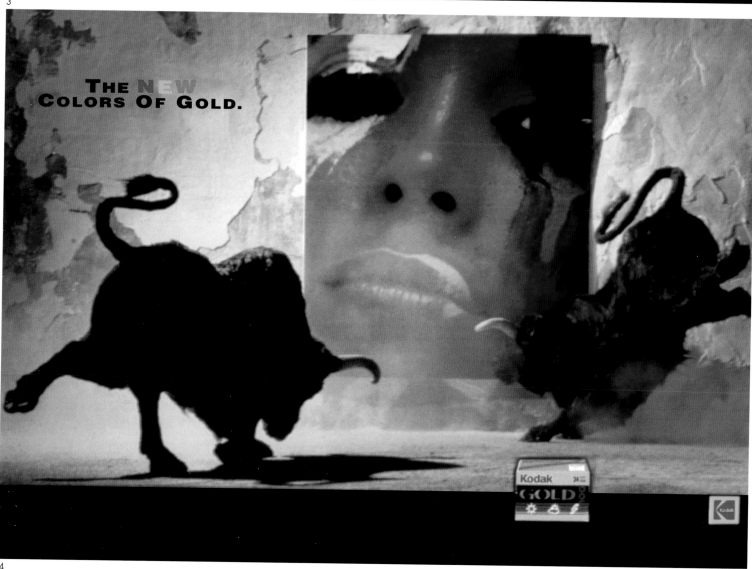

4

3
Outdoor advertising for Sontags Blick, copywriter: Andre Benker

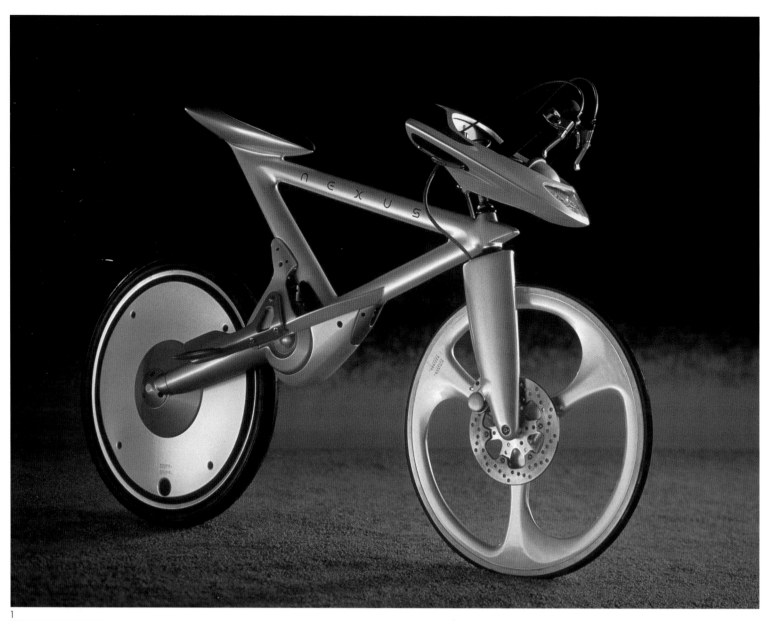

1

2

3

1
Nexus, Seymour Powell

2
Ideal standard bath mixer, Seymour Powell

3
Ideal standard basin mixer, Seymour Powell

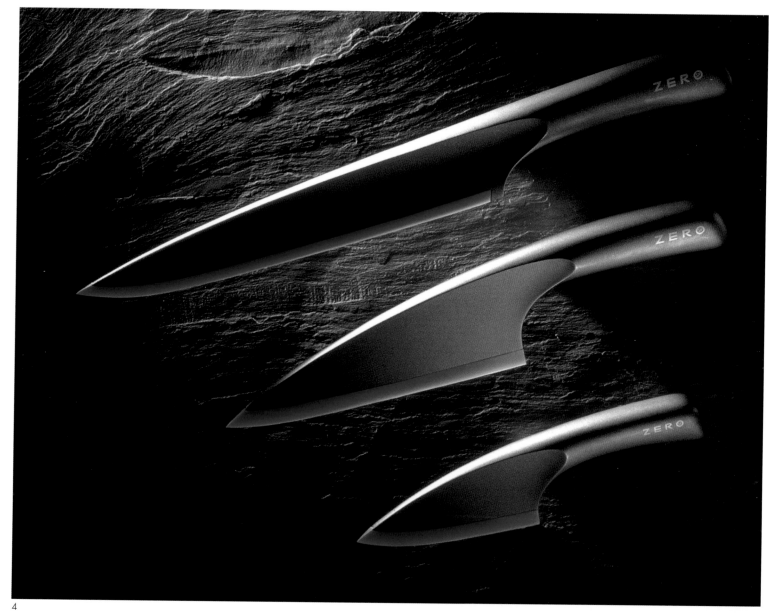

4

5

6

4
Knives, Seymour Powell

5
Csterna, Casio, Seymour Powell

6
Baby Gs, Seymour Powell

1

2

3

4

5

1
Study guides,
RMIT University, Melbourne, Australia,
1998-99,
Photography: John Bodin

2
Annual report 5RO,
Victoria, Australia, 1997,
with Jody Fenn and Prue Marks,
Photography: John Bodin

3
Scholarship application kit and poster,
RMIT University, Melbourne, Australia, 1998

4
Annual information brochure,
RMIT University, Melbourne Australia, 1999,
Photography: John Bodin

5
Stationery
Humanities Australia,
with Jody Fenn and Prue Marks, 1999

MetaDesign

Brand values
Motivated, innovative,
personal

Core brand values
Connecting ideas

Brand category
Size, technology (rail) reliability

Brand foundation
Tradition, transport, solidity

RailioN

Connecting ideas

---> straight-lined/simple ---> personal/creative ---> borderless

Brochures

Stationery

Corporate Guidelines

Frutiger Roman
Frutiger Roman Italic
Frutiger Bold
Frutiger Bold Italic
Frutiger Black
Frutiger Black Italic

Frutiger Condensed
Frutiger Condensed Bold
Frutiger Condensed Black
Frutiger Condensed Extra Black

Utopia Regular
Utopia Regular Italic
Utopia Bold
Utopia Bold Italic

1

2

3

1
Design programme for Railion

2
Design programme for Heidelberg

3
Design programme for Audi

4
Design programme for VIAG Interkom

4

Stop being so English

IKEA®

1,2
Ikea 'Beards' Bristol Store Opening
Press & Poster
Art Director: Simon Friedberg
Copywriter: Andy Drugan

3
Ikea Downsizing
TV

4
Ikea Lord and Lady Muck
TV
Art Director: Julian Vizard
Copywriter: Alan Young

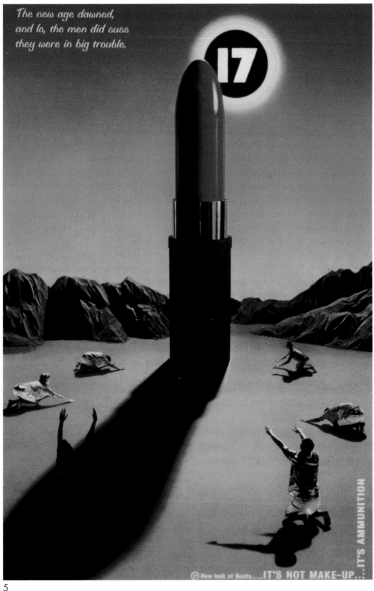

The new age dawned, and lo, the men did suss they were in big trouble.

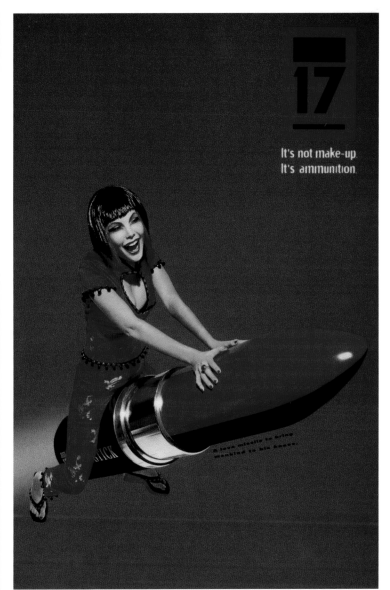

It's not make-up.
It's ammunition.

5,6
Boots 17 'Iconography'
Press
Art Director: Suzanne Hails
Copywriter: Alistair Campbell

7
Ikea Sunbather
TV
Art Director: Julian Vizard
Copywriter: Alan Young

8
Ikea Egg & Chips
TV
Art Director: Julian Vizard
Copywriter: Alan Young

DESIGN: HENRY STEINER © 1991

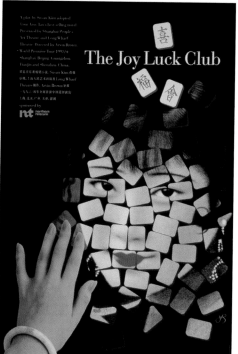

1
TYPE, Poster for a Japanese Typesetting
Company, 1991
The white letters are debossed to suggest the
stone engraving common to both Roman and
Chinese systems. The signature is coloured and
positioned in the manner of a Chinese seal

2
Cross Cultural Design, book jacket, 1995
To symbolize the book's subject, the cover
design juxtaposes images from two radically
contrasting civilizations: the painted eye of a
Chinese opera performer placed over a classic
Greek profile

3
Hi-Graphic no. 5, magazine cover, 1999

4
'The Earth Triumph in Plastic' poster, 1997
For the United Nations Climate Change
Conference held in Kyoto, Japan

5
'The Joy Luck Club' poster, Shanghai, 1993
Poster for the stage version of a best-selling
novel. The book describes a Chinese-American
woman's search for the truth about her dead
mother through a mahjong club

Muzeum Plakatu ma już **30** lat

1

niklaus troxier KOLOR i Dźwięk

· CZERWIEC 1998 ·

SPONSOR:
swissair

SPONSOR GŁÓWNY:
Roche

GALERIA GRAFIKI I PKAKATU.00 - 681 WARSZAWA. UL.HOŻA 40.TEL/FAX 621 40 77

2

WALDEMAR
ŚWIERZY

WYSTAWA
PLAKATÓW
GRUDZIEŃ 1996

BIURO
WYSTAW
ARTYSTYCZNYCH
W WAŁBRZYCHU

58-300 WAŁBRZYCH
UL.SIENKIEWICZA 6
TEL.FAX.(0-74)24 859

XV MBP

3

4

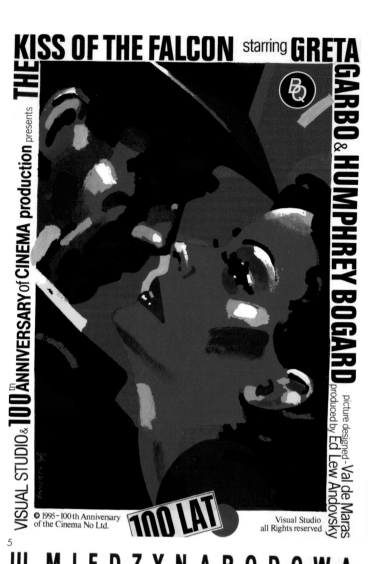

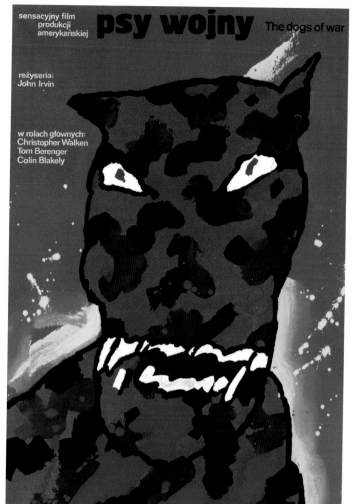

5

1
Museum poster

2
Exhibition poster, 1998

3
Museum poster for an exhibition of the
artist's work, 1996

4
'Jazz Greats', Count Basie, 1985

5
Film poster, 1995

6
Film poster, 1984

7
Poster for exhibition of non-commercial posters,
Museum Narodowa Poznan, 1998

7

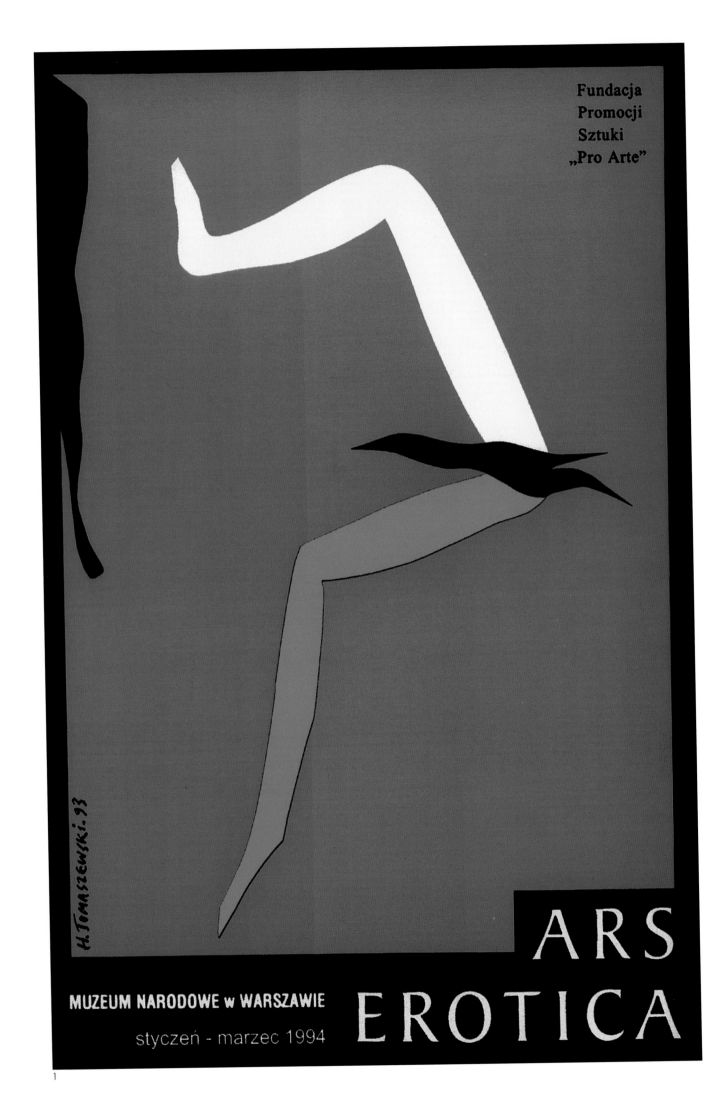

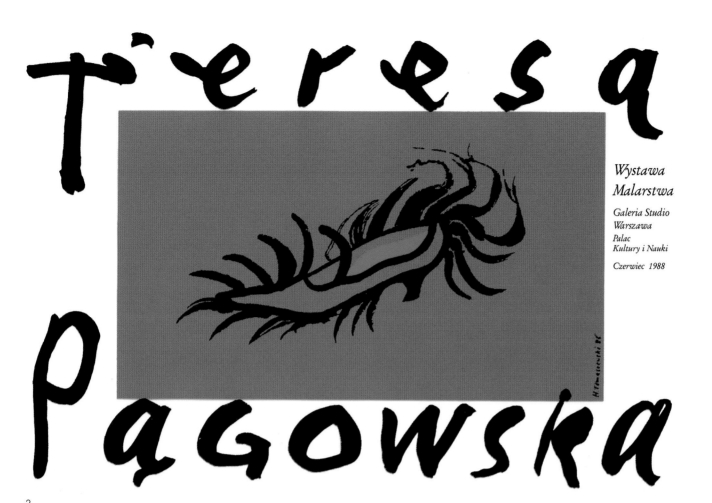

Teresa Pągowska

Wystawa
Malarstwa

Galeria Studio
Warszawa
Palac
Kultury i Nauki

Czerwiec 1988

2

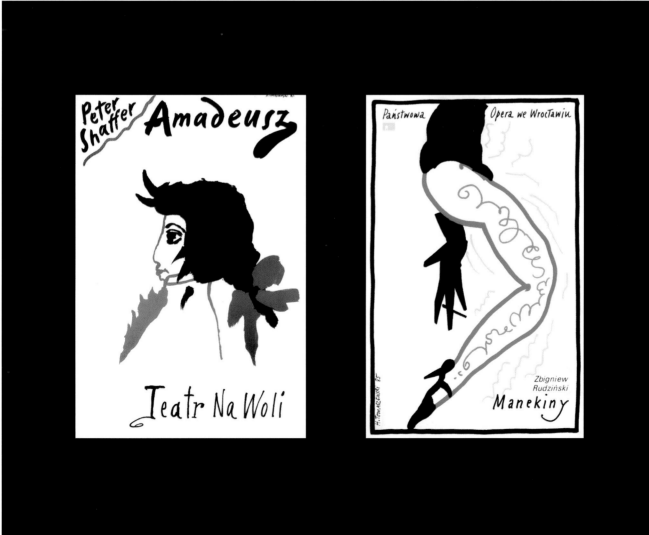

3,4

1
Ars Erotica
1993
Z kolecji Museum
Plakatu

2
Teresa Pągowska
1988
Z kolecji Museum
Plakatu

3
Amadeusz
1981
Z kolecji Museum
Plakatu

4
Manekiny
1985
Z kolecji Museum
Plakatu

1

2

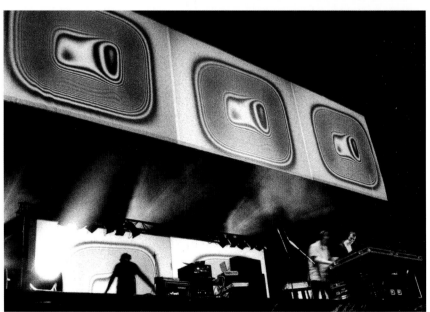

3

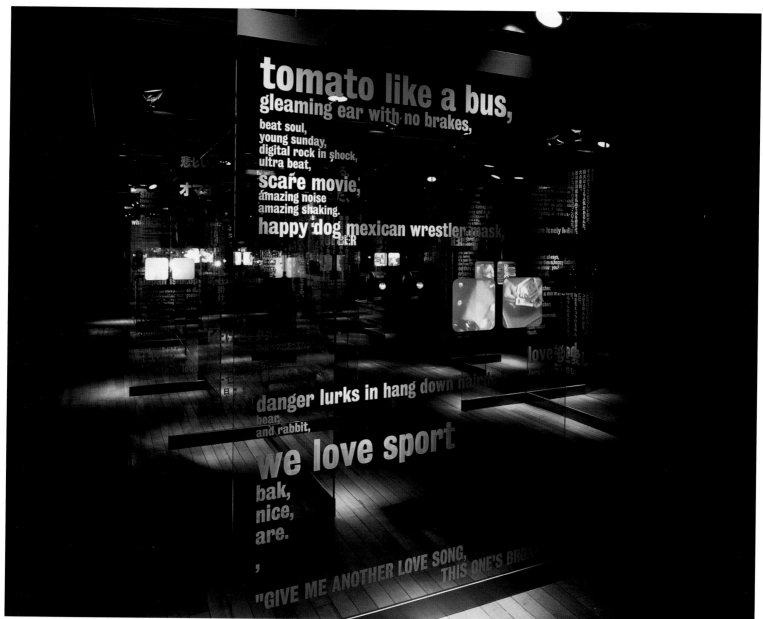

4

5

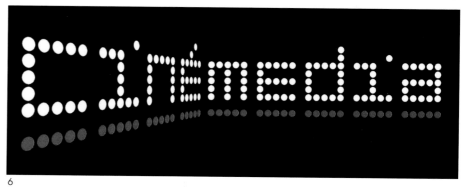

6

1,4
Tomato makes London=Tokyo @ the Ginza Artspace

2
SBS logo, solarised image

3
11x(Underworld)

4
Cover for design magazine

5
Cinemedia logo

Het Nederlands
Openluchtmuseum
Arnhem

1

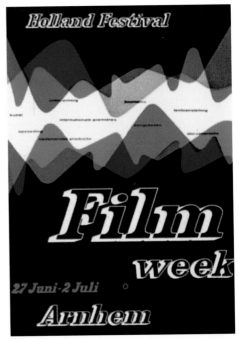

2

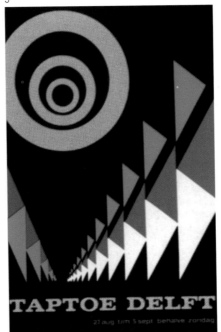

Nederlands
Openluchtmuseum
Arnhem

3

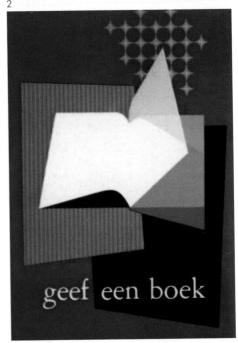

geef een boek

4

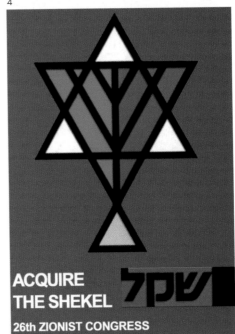

TAPTOE DELFT

5

ACQUIRE
THE SHEKEL
26th ZIONIST CONGRESS

6

Zwanzig emir Cigaretten der Kyriazi Freres Cairo *Hergestellt aus feinsten Orient-Tabaken* **Zwanzig emir Cigaretten** *der Kyriazi Frères* **Hergestellt aus feinsten Orient-Tabaken** *Zwanzig* **emir** *Cigaretten*

1

2

3

4

1
Client: Parlophone
Job: Pet Shop Boys
Compact Disc
packaging
Date: 1993
Designer:
Daniel Weil
(partner)
Design Assistant:
Arthur Collin

2
Client: Swatch AG
Job: Packaging for
Irony
Date: 1994
Designer:
Daniel Weil
(Partner)

3
Client: Superga
Job: Packaging
Date: 1996
Designer:
Daniel Weil
(partner)
Design Assistant:
Six Wu

4
Client: Tretorn
Job: Packaging
Date: 1998
Designers:
John Rushworth,
Daniel Weil
Design Assistants:
Leigh Brownsword,
Six Wu

5
Client: Swatch
Job: Timeship,
(New York)
Date: 1996
Designer:
Daniel Weil
(Partner)
James Biber
(Partner)
Design Team:
Jean Pierre
Genereux,
Stuart Oldridge,
Tom Lloyd,
Six Wu
Michael
Zweck-Bronner

5

John GlaGola

Exhibition of Photography

February 22-29, 1976

Kent Student Center

Kent Ohio

2

3

1
Handset Type,
Poster for a student at Kent State University
for a photography exhibition, 1975

2
Film layering, world format poster
'The Swiss Poster 1900-1984' red version,1982
(Image of the Matterhorn to commemorate E Cardinaux)

3
Catalogue cover, UCLA, 1998

4
Film layering, world format poster
'The Swiss Poster 1900-1983' blue version, 1982
(Image of the Matterhorn to commemorate E Cardinaux)

4

1

1
1977 Tate & Lyle Transport. (Wolff Olins)
Dick Whittington and his cat, drawn by
Kit Goper, was a design for Tate & Lyle's
distribution company

2
1978 Audi symbol. (Wolff Olins)
Designed with Gerry Barney

3
1982 Pilkington. (Wolff Olins)

4
1967 BOC. (Wolff Olins)
One of the first big UK Industrial
corporate identities

5
1976 Bovis. (Wolff Olins)
One of UK's biggest construction companies.
The hummingbird was drawn by Ken Lilley

2

3

4

5

P&O

6

7

8

9

10

6
1996 Our Price. (Newell & Sorrell)
Our Price symbol designed by Nick Thirkell
of CDT

7
1981 P&O. (Wolff Olins)
The P&O flag was painted by Larry Learmonth

8
1987 Zen. (The Consortium)
A restaurant symbol designed with
Howard Waller

9
1985 3i. (The Consortium)
The 3i symbol was painted by Phillip Sutton

10
1988 Addison.
The Goldfish identity was designed by
Michael Wolff, using photography by Tony Evans

SATOR
AREPO
TENET
OPERA
ROTAS

1

JOHANN GOTTFRIED HERDER
DIE TRADITION DER SCHRIFT
IST ALS DIE DAUERHAFTESTE,
STILLESTE
WIRKSAMSTE
GOTTESANSTALT
ANZUSEHEN,
DADURCH NATIONEN AUF
NATIONEN
JAHRHUNDERTE
AUF JAHRHUNDERTE
WIRKEN, UND
SICH DAS GANZE
MENSCHENGESCHLECHT
MIT DER ZEIT AN
EINER KETTE
BRÜDERLICHER
TRADITION
ZUSAMMENFINDET.

1
An Early Christian Palindrome
(circa Pompeii 79AD)

2
Exercises in Lettering Quotes
from Goethe

3
Exercises in Lettering Quotes
from Herder

4
H Zapf Typographic Alphabet
1938-1998

5
Handscript Typeface Zapfino

2 3

Die Alphabete von Hermann Zapf von 1938 bis 1998

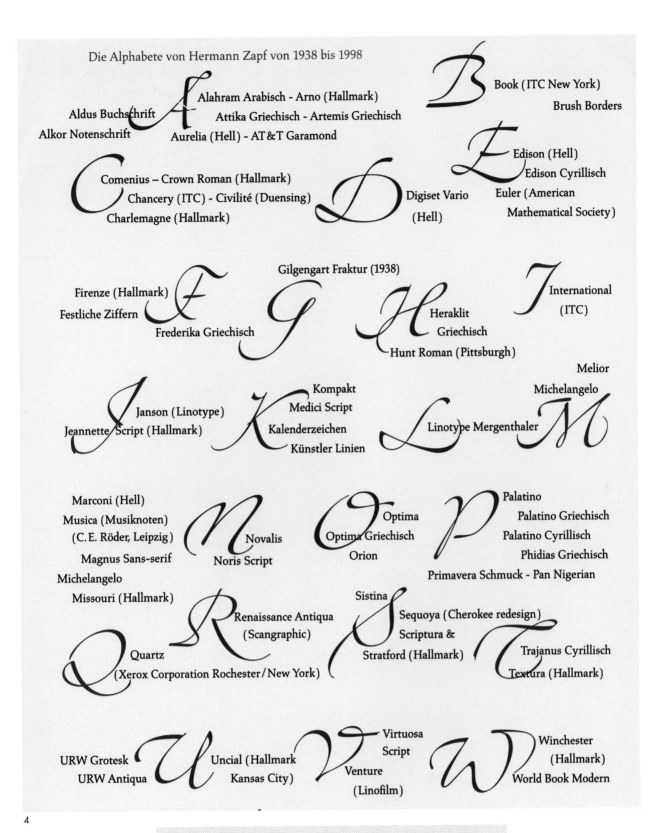

Aldus Buchschrift
Alkor Notenschrift
A
Alahram Arabisch - Arno (Hallmark)
Attika Griechisch - Artemis Griechisch
Aurelia (Hell) - AT&T Garamond

B
Book (ITC New York)
Brush Borders

C
Comenius – Crown Roman (Hallmark)
Chancery (ITC) - Civilité (Duensing)
Charlemagne (Hallmark)

D
Digiset Vario
(Hell)

E
Edison (Hell)
Edison Cyrillisch
Euler (American
Mathematical Society)

Firenze (Hallmark)
Festliche Ziffern
F
Frederika Griechisch

Gilgengart Fraktur (1938)
G

H
Heraklit
Griechisch
Hunt Roman (Pittsburgh)

I
International
(ITC)

J
Janson (Linotype)
Jeannette Script (Hallmark)

K
Kompakt
Medici Script
Kalenderzeichen
Künstler Linien

L
Linotype Mergenthaler

Melior
Michelangelo
M

Marconi (Hell)
Musica (Musiknoten)
(C.E. Röder, Leipzig)
Magnus Sans-serif
Michelangelo
Missouri (Hallmark)
N
Novalis
Noris Script

O
Optima
Optima Griechisch
Orion

P
Palatino
Palatino Griechisch
Palatino Cyrillisch
Phidias Griechisch
Primavera Schmuck - Pan Nigerian

Q
Quartz
(Xerox Corporation Rochester/New York)

R
Renaissance Antiqua
(Scangraphic)

Sistina
S
Sequoya (Cherokee redesign)
Scriptura &
Stratford (Hallmark)

T
Trajanus Cyrillisch
Textura (Hallmark)

URW Grotesk
URW Antiqua
U
Uncial (Hallmark
Kansas City)

V
Virtuosa
Script
Venture
(Linofilm)

W
Winchester
(Hallmark)
World Book Modern

4

5

Born out of frustration with the poverty of digital publishing and virtual shoot-em ups, antirom was formed in August 1994 as an opportunity to create multimedia outside the constraints of the workplace and as a critique of the hastily established faux-truths of new media. The emphasis lay in experimentation, innovation and fun.

In February 1995, antirom was launched at Camerawork Gallery in Bethnal Green. The CD-Rom was funded by the Arts Council and consisted of 70 different interactive toys. These ranged from ambient sound-based mixing toys to random proverb generators. The antirom CD-Rom encouraged the use of multimedia as a forum for drawing together diverse talents and interests, as well as experimenting with new forms of language made possible by non-linear and interactive media.

At the beginning of 1996, the nine members of antirom formed themselves as a limited company with the intent of continuing to experiment with and explore the possibilities of digital media. They are based in London and have established working relationships with a number of commercial clients, including Levi Strauss, the Science Museum, Toyota, the BBC, Caterpillar, Guinness, Tomato and many others.

Antirom have taken part in the following exhibitions: Burning the Interface (Sydney, Australia, 1995), Video Positive (Liverpool, UK, 1995), Jam (Barbican Art Gallery, London, 1996), Des Artifices, (Paris, France, 1996), Explore Europe (Pakhus 11, Copenhagen, Denmark, 1996), The world-wide video festival (The Hague, Netherlands, 1996), Music for Television (Musée des Beaux Arts, Brussels, Belgium, 1997), Rotterdam International Film Festival (Rotterdam, Netherlands, 1997) One dot Zero, (ICA, London, UK, 1997) The Power of Erotic Design (Design Museum, London, 1997), RGB Gallery (Howired.com, 1997) Resfest, (tour of the USA, 1997), FCMM, (Montreal, 1997), Sonar (Spain, 1997), Digital Days (Denmark, 1998), Videobrasil 1998 and Sydney design 99.

Anti-Rom was formed two summers ago and was intended as a critique of the poverty of contemporary multimedia. In particular, those CD-ROMS which fail to go beyond the traditional linear form – the kind of CD-ROM where shiny 3D buttons are grafted over packets of pointless information, the automatic vending machine type CD-Rom where you can press a button and have whatever you want, as long as it's Coke or Fanta (and there's no Fanta).

Anti-Rom worked towards creating a demo CD-Rom. They got a grant from the Arts Council towards this. Eventually, the Anti-Rom Suss Demo was

produced and was shown extensively. We found ourselves operating within a profoundly non-linear paradigm – it was hard not to think like a modernist. It was hard not to find an essence of non-linearity, a truth of interactive media – some approaches seemed intrinsically more suited to the nature of the medium than others."

"We found it was almost always easier and more successful to make things which were playful, rather than purposeful."

"When a medium is very young, what you find is that artists are pushing the boundaries and creating a language."

"Most of the people in multimedia come in from some other media and, as a result, they always assume that there isn't a language. In reality, it hasn't been formed yet, and that's what we're trying to achieve."

Anti-Rom are presently collaborating on separate projects with Underworld and Future Sound of London, developing an interactive framework for electronic music.

Nick: "I think people are just profoundly imaginative. They just have a really big problem, thinking about something that isn't an existing form. It's the fact that it's not film, it's not video, it's not a magazine. A lot of people have trouble thinking about what it is. Reformulations of old media never work."

Philippe Apeloig has been a full-time Professor in Graphic Design in The Cooper Union School of Art and Science since the Fall of 1999, when he was hired as an assistant professor after an international search. He teaches Experimental Typography and Graphic Design.

Apeloig grew up in Vitry, a suburb of Paris, and was educated at the Ecole Nationale Superieure des Arts Appliques and the Ecole Nationale Superieure des Arts Décoratifs. After graduation and two transformative training periods at Total Design in Amsterdam where he realized the extent of his interest in typography and graphic design, he began work as a designer for the Musée d'Orsay in Paris. From 1985-87, he applied concepts he had absorbed in The Netherlands. Although employed as a designer by a prestigious institution, he sought further education. In 1988 Apeloig received a grant from the French Foreign Ministry and left the Musée d'Orsay to work and study in Los Angeles with April Greiman. Later he became the first graphic designer to be honored with a research and residency grant at the Villa Medici in Rome by the French Academy of Art, which is housed there. In Rome Apeloig became aware of the deterministic relationship between typography and architecture in the city's ancient ruins and developed an architectonic alphabet in response. Architecture, old and new, continues to be a source for his work.

After Los Angeles, Apeloig returned to Paris to establish his own studio, Philippe Apeloig Design, and became the Art Director for Jardins des Modes. He was invited to return to the Ecole Nationale Superieure des Arts Décoratifs to teach typography and, more recently (1999), taught graphic design at the Rhode Island School of Design in the U.S. In 1997 Apeloig became a design consultant to the Musée du Louvre, a role he continues to play. Apeloig was originally interested in pursuing theater and stage design and, in addition to following contemporary dance, music and performance, supports these areas with his design work. Dance, in particular, has provided a wellspring of ideas and Apeloig admits that he thinks in choreographic terms about his use of typography, as well as the page or poster as a space to be sculpturally shaped and activated. He has produced acclaimed poster designs for the 'Festival Octobre en Normandie' and the 'Imprimerie Nationale' and created the visual identities of both Carré d'Art in Nîmes and the Musée d'Art et d'Histoire du Judaisme in Paris. Apeloig currently designs posters for the Fête du Livre in Aix en Provence, a literature festival.

Apeloig has shown his design work in solo and group exhibitions in Tokyo and Osaka at Dai Nippon Printing Galleries, in Bordeaux at the architectural center Arc en Rêve, and the Bibliothèque Nationale de France. He has lectured internationally at Icograda and the Society of Typographic Designers in London, Ecole Lacambre in Brussels, The School of Design in Tel Aviv, the University of Quebec, the Kunstgewerbeschule in Basel, as well as The Rhode Island School of Design, The School of Visual Arts, The Massachusetts College of Art, Cal Arts, The Art Center in Pasadena, The Maryland College of Art and The Cooper-Hewitt National Design Museum in the U.S. An exhibition of his graphic design work will be presented at The Cooper Union in January 2000.

Apeloig's work has been published in many books in Japan, Korea and Spain, as well as in such journals in France as *Le Monde, Etapes Graphiques, Jardin des Mode, Signes and Vogue*; in England, *Octavo, Eye, Hot Graphic Design and Zoo*; in Germany, *Novum, Form, Die Zeit and Typo*; and in the U.S., *Emigre, Graphis, Cool Type Two and Print*. He won the 1992 Silver Prize in International Computer Graphic Arts in Japan, a 1996 Gold Award from the Tokyo Type Directors Club, a 1997 Merit Award from the New York Art Directors Club, a 1998 Certificate of Excellence from the Society for Typographic Designers in England and the 1999 special juror's prize from the Tokyo Type Directors Club. During 1998 he was also elected a member of the Alliance Graphique Internationale.

The creator of over forty motion picture titles sequences, including 'Broadcast News', 'Big', 'War Of The Roses', 'Goodfellas', 'Cape Fear', 'Mr. Saturdat Night', 'The Age Of Innocence', 'Higher Learning', 'Casino', 'The Man With The Golden Arm', 'The Seven Year Itch', 'The Big Country', 'Vertigo', 'North By Northwest', 'Psycho', 'Walk On The Wild Side', 'It's A Mad, Mad, Mad, Mad World', 'That's Entertainment: Part 2'. Director live-action epilogue: 'West Side Story'; animated epilogue 'Around The World In Eighty Days'.

Director special sequences for feature films, including, shower sequence 'Psycho'; all racing sequences 'Grand Prix'; final battle sequence between slaves and Romans 'Spartacus'; others.

Director short films: Why Man Creates (Academy Award), The Solar Film, Notes on the Popular Arts, From Here to There, Quest, others. Director feature film, Phase IV.

Designer graphic symbols over sixty motion pictures, including Carmen Jones, Bonjour Tristesse, Saint Joan, Exodus, Anatomy of a Murder, Advise and Consent, The Victors, Seconds, Grand Prix, Such Good Friends, The Shining, others.

Designer numerous trademarks, corporate identification and signage systems for industrial enterprises, including Bell System, AT&T, The Getty Trust, United Airlines, Alcoa, Quaker Oats, Rockwell International, Warner Communications, Minolta, Girl Scouts, United Way, others. Designer packages for commercial products, such as Wesson Oil, Dixie Paper Products, Lawry's Foods, Hunts Foods, Quaker Cereals, others.

Designer of architecture and design of world-wide Exxon/Esso gasoline stations; British Petroleum (BP); Designer U.S. Post Office commemorative stamp for Art and Science.

Represented in the permanent collections of the Museum of Modern Art, N.Y.; Library of Congress; Smithsonian Institution; Cooper-Hewitt Museum, Prague Museum, Czechoslovakia, Stedelijk Museum, Amsterdam, Israel Museum, Jerusalem, and others.

Born in New York City in 1920, student Howard Trafton at Art Students League; Gyorgy Kepes at Brooklyn College; married Elaine Makatura, 1961; children – Jennifer, Jeffrey; children from first marriage – Andrea, Robert. Freelance graphic designer NYC.; proprietor Saul Bass & Assoc., Inc., Los Angeles, 1952-80; Bass/Yager & Assoc., Los Angeles, 1980-96.

The Saul Bass Collection is permanently housed at the Academy of Motion Picture Arts and Sciences Margaret Herrick Library.

Of his career, Bass had this to say, "You see, over the years I've had a foot in each of two worlds. I worked first as a graphic designer – then as a filmmaker – then as a graphic designer – and as a filmmaker. And it seems to me, that each has informed and shaped the other."

Michael Bierut was born in Cleveland, Ohio in 1957, and studied graphic design at the University of Cincinnati's College of Design, Architecture, Art and Planning, graduating summa cum laude in 1980. Prior to joining Pentagram in 1990 as a partner in the firm's New York office, he worked for ten years at Vignelli Associates, ultimately as Vice President of graphic design.

Michael's clients at Pentagram have included the Council of Fashion Designers of America, Alfred A. Knopf Inc., the Minnesota Children's Museum, the Walt Disney Company, Mohawk Paper Mills, Motorola, Princeton University and the Library of Congress. His projects have ranged from the design of "I Want to Take You Higher," an exhibition on the psychedelic era for the Rock and Roll Hall of Fame and Museum, to leading a team to redesign print graphics, interiors, product design and uniforms for United Airlines.

He has won hundreds of design awards and his work is represented in the permanent collections of the Museum of Modern Art and the Metropolitan Museum of Art in New York, and the Musée des Arts Décoratifs, Montreal. He has served as President of the New York Chapter of the American Institute of Graphic Arts (AIGA) from 1988 to 1990 and is currently the president of AIGA National. He also serves as a Vice President of the Architectural League of New York.

Michael is a Visiting Critic in Graphic Design at the Yale School of Art. He writes frequently about design and is a contributing editor to I.D. magazine. He is also co-editor of *Looking Closer: Critical Writings on Graphic Design*, the third volume of which was published by Allworth Press earlier this year. Last year he co-edited and designed the monograph *Tibor Kalman: Perverse Optimist*.

In 1989, Michael was elected to the Alliance Graphique Internationale. In 1991, he and his partner Paula Scher chaired the AIGA National Conference in Chicago. His recent activities include developing a new identity for New York's Cathedral of Saint John the Divine, coordinating all promotional material and environmental graphics for the Brooklyn Academy of Music, and creating a new graphic program for the Yale University School of Architecture.

"One of my favourite movie scenes is in 'Do The Right Thing' by Spike Lee. It is a pointless scene, it doesn't advance the plot, it has nothing to do with anything, but I know exactly why it's there. It's a speech by Love Daddy, the DJ who forms the 'Greek Chorus' for the whole thing. At about the mid-point of the movie, the camera pans through the neighbourhood,

and shows him doing a rap, and all he does is say the names of Black artists and Black musicians. It's so thrilling because there's absolutely no aesthetic or ideological consistency between the names he's saying: " Run DMC, John Coltrane, Parliament, Funkadelic, Ella Fitzgerald, Prince, Sam Cooke, Steel Pulse..." It goes on and on – the names of rappers, the names of jazz musicians, the names of every possible artist from the past, from the future, just naming all of them, one after another. He never says at the beginning: "These are African-American musicians who have made a contribution" or "and now you realise how rich our field is". There's something about this recitation of names, and the differences between them, and the fact that a single idea embraces them, even the idea of ethnicity in this case. I always thought that if graphic design is an idea, what makes it powerful is the thought that you can have a litany that goes: Alexey Brodovitch, David Carson, Jilly Simmons, Alex Isley, Laurie Haycock Makela, Lester Beall, Don Trousdell, Woody Pirtle. You could go on and on and on. And I swear to God, I could list more graphic designers' names than anyone else in America. If we had to fill blackboards, I could fill more blackboards. Everyone else would have to quit, everyone else would be lying dead on the floor, and I would still be writing. So what makes the field thrilling, and what always gives it a sense of possibility, is not just what I am going to do tomorrow, but what someone else is going to do tomorrow."

Pierre Bernard was born in Paris in 1942. After graduation from the Ecole
Nationale Supérieure des Arts Décoratifs in 1964, he received a scholarship
to study poster design with Henryk Tomaszewski at the Academy of Fine
Arts in Warsaw and completed his studies in 1971 with graduate work at
the Institut de l'Environnement in Paris.

In 1970 he founded Grapus with François Miehe and Gérard Paris-Clavel,
whom he had met during the May 1968 student movement; Alex Jordan
and Jean-Paul Bachollet joined the group in 1976. Grapus sought to
'change life' through a twofold dynamic of graphic arts and political action.
From 1978 on, Grapus showed its work in major exhibitions at the Musée
de l'Affiche in Paris, the Stedelijk Museum in Amsterdam, the Aspen
Conference in Aspen, Colorado, and the Museum of Contemporary Art
in Montréal.

It also received numerous awards and prizes: at the Warsaw Bienniale in
1978 and 1980, the Brno Bienniale in 1978 and 1982, the Lahti Bienniale
in 1983, the Colorado Bienniale in 1983, Agraf in Zaghreb, the Art
Directors Club in New York in 1987, and the Toyama Triennial in 1988.
In 1990, the year that Grapus decided to end its activities, it was awarded
France's National Grand Prize for Graphic Arts.

Pierre Bernard then founded the Atelier de Création Graphique with
Dirk Behage and Fokke Draaijer and was responsible for, among others,
the visual identities of the Musée du Louvre and the French national parks.
He now heads the Atelier de Création Graphique, which responds to a wide
variety of commissions in the fields of publishing, poster design, signage,
and visual identity systems with the conviction that graphic design fulfills
a cultural mission in the public interest. A member of the International
Graphic Alliance since 1987, he currently teaches graphic design at the
Ecole Nationale Supérieure des Arts Décoratifs in Paris.

David Bernstein is as old as Mickey Mouse.

Went from Oxford to advertising. Copywriter, TV producer, and then Creative Director of three international agencies, McCann- Erickson, Garland Compton (later Saatchis) and Ogilvy and Mather, before founding The Creative Business. Its client list was called a 'who's who of British marketing'.

Is now managing partner of Kelland Communication Management, a consultancy which advises companies, mostly multinational, on communications, internal and external. It also runs seminars on creativity in Europe, America and South East Asia.

Author of six books on advertising, marketing, corporate communications, presentation, the environment and the poster.

Company Image and Reality was translated into six languages and is a standard textbook on corporate communications.

Working for Customers, a primer on marketing, was commissioned by the Confederation of British Industry and remains their top selling publication.

Advertising Outdoors Watch This Space! was published in October 1997.

David Bernstein edits an internal magazine for Unilever.

Ex-president of the Advertising Creative Circle and the Solus Club.

Awarded the Advertising Association's Mackintosh Medal for professional and public services to advertising.

All great ads surprise. Surprise is of two sorts:
(1) WOW!
(2) Of course! Why didn't I think of that?

The creative's task is to turn the prose of the proposition into the poetry of an idea.

"Matter is frozen energy." Einstein
"The brief is a frozen idea." Bernstein

Communication begins at the end.

End has two meanings:
(1) End of the communication process i.e. the receiver, consumer.
(2) Purpose.
Both have to be focused on before communication begins.

The great posters are triumphs of imagination set free by limitation.

"Less is more." Mies van der Rohe
"Half less is Demi Moore." Bernstein

Creativity is the ability to see things in a new way and articulate that insight.

An idea is criticism.

Advertising is a bastard art in the middle of an inexact science.

An idea makes the strange familiar or the familiar strange.

'One picture is worth a thousand words.' OK, but how many are relevant? And, incidentally, how would you draw that thought?

Karen Blincoe is a graphic designer and educationalist. She is Danish. Educated in graphic design in England 1982. Established KB Design (graphic design consultancy) in London 1984 and 02 UK in 1989 (environmental design). While in London she was also Chairman of the Gynaecology Cancer Research Fund. Became a Fellow of the CSD in 1990.

She was appointed Head of Department for Visual Communication at Danmarks Designskole, Copenhagen, 1991 and has been a member of the Arts Council, Vice Chairman of the Design Fund and is currently Chairman of the Educational Council for the Arts, Architecture, Design and Conservation for the Ministry of Culture (Copenhagen).

Design awards include: Trade Mark II Award, USA, New York Art Directors Club, Immy Award, USA, Minerva Award, London, The Danish Arts Council (research award).

Clients include: Reuters Ltd., Safeways, J Lyons., Marks & Spencers, The Henley College, The Body Shop, The Council of Equality (Cph), The Danish Technical University, Den Danske Bank, Virago Press, Macintyre Schools Ltd. etc.

Karen Blincoe lectures extensively in England, Denmark and the other Scandinavian countries on subjects relating to visual communication, design education and sustainable development in the area of design.

Professionally Karen's main interest is design in the context of creativity and sustainability. Over the past few years Karen has spent time with UNEP SPD (Sustainable product development at the United Nations Environment Programme) in Amsterdam and Schumacher College in Dartington, England.

She has organised events and master classes dealing with design and sustainability both in England and in Denmark. The latest took place over one week in Rødding, Denmark, on development, sustainability and paradigm shift, involving designers, architects, and economists.

Karen is at present dedicated to establishing a centre for creativity and sustainability which will encompass both graduate and postgraduate teaching/research /information.

Privately she is married to Mervyn Kurlansky, lives in Denmark and is, when not working with design and education, involved in self-development courses/training and practices in intuition and meditation.

Thoughts /ideas /opinions

"If I were to start a design college today, at the beginning of the 21st century, it would look something like this:
A college created around the following core elements: creativity, imagination and intuition mixed with ancient knowledge, also called wisdom. Sustainability would be an integral part of the curriculum. Community and face to face interaction would be as important as human/computer interaction. Evaluation of the consequences of the design produced on society, environment and economy would be an essential part of the problem solving criteria."

"The design teacher's role is to help the student express who she/he is and not the other way round."

"Much of design today has little content!"

Graduated with honours at the Amsterdam Graphic School and
Rietveld Academy, Amsterdam.
Art director at Ahrend, Amsterdam (1954-62).
Joined Total Design, Amsterdam in 1963; Creative Director 1966-91,
specialized in corporate identity and symbols/trademarks.

Creator of logotypes/identity programmes for Ahrend, Gwinner & Ulrich
BRD, ECT Rotterdam, City of Capelle aan den Ussel, Kluwer Publishers,
Misset Publishers, Elsevier Business Information, Randstad, Furness Group,
KiT (Royal Institute for the Tropics), de Gruyter, FIIB Netherlands
Investment Bank, Interlabor, Generale Bank {Belgium),
Middle East Bank UAE, etc.

Designer/consultant for Randstad Staffing Services, in the Netherlands,
Europe and USA since 1966.

Currently private practice as a designer and corporate identity consultant,
teacher and international lecturer.

President of AGI (Alliance Graphique Internationale),
Dutch Chapter Founder/past president of NAGO,
Dutch Graphic Designers' Archive.
Honorary member of Arc en Rêve, Bordeaux and Biennale
of Graphic Design, Brno.
Honorary member of Brno Biennale, Czech Republic
Honorary member of BNO, Dutch designers association

Author of several books/publications on graphic design profession,
corporate identity and design management.

Many national and international publicity and design awards, such as:

Frans Duwoer Prize for Typography, City of Amsterdam, 1973
Three awards for Logotypes, Typomundus 11
Bronze Medals Biennale Brno 1970, 1986
Winner Kieler Woche design competition 1991
Grafische Cultuurprijs 1994, for corporate identity Randstad
Staffing Services
Special Golden Forma, Novi Sad, 1994
World Logotype Design Award, 1998

Philosophy

I see the task of the graphic designer as a 'translator',
a mediator between the sender of information and the recipient.

I come from a school of modernists and functionalists.
Adding visual attractiveness to the informational content is for me part
of the functionalists' task.

I find accessibility of the information most important and therefore I
always strive for good legibility. I only work with a limited number of top
class typefaces.

I do not attempt to make too expensive works. My designs are rather
straightforward. I hate work that is inaccessible because the designer is
working in too many layers or has no respect for the reader/spectator.

I use a lot of photography, and quite often black/white; I try to be the
director of photography or to inspire the people I work with.

As far as the computer is concerned: it is a great tool that helps me to see
numerous variations and to carry out perfect artwork. I hate computers
where they overrule the original 'handwriting' of the designer.

In the early eighties Neville Brody was Art Director of The Face and City Limits magazines before setting up a design studio in 1986 with Fwa Richards. In 1994 the design studio changed its name to Research Studios, soon after creating Research Arts & Research Publishing.

The design team has remained a tight working unit throughout with a high emphasis on creativity. The level of work that Research Studios produces has remained constant and ground breaking while at the same time keeping abreast of the ever changing graphic and technological environment. Research Studios creates solutions in all media from print to electronic communication.

Research Studios clients include: Men's Bigi, Nike, The Body Shop, The British Council, Parco, British Airways, The National Theatre, Katherine Hamnet, Swatch, Haus der Kulturen der Welt, Barfield Marks, Thames & Hudson, Armand Basi, The Museum of Modern Art, Maceo, Channel Four, AGFA, Allied Dunbar, ORF, Premiere Television, Vitsoe, The Guardian Newspaper Group, Reuters, Dentsu, Young & Rubicam, Scitex, Calman & King, Electrolux, Macromedia, Ricoh, Vauxhall, Salomon, Fiorucci, Camper, Sony, Martell, Zumtobel, Deutsche Bank, Armani, Max Magazine, Domus Magazine, BMW, Leopold Hoesch Museum, United Artists, Turner Network Television and N.B.C.

In 1994 Research Arts was formed as a subsidiary studio under the Research name. Research Arts specialises in film work which has included interactive film sequences and film titles for Hackers, Judge Dredd, Heat, Secret Agent, Mission Impossible, and the forthcoming movie The Avengers. Our clients include: Paramount Pictures, United Artists, Capital Films, Lion Brand Films, Warner Brothers, Ginergi Pictures Entertainment Incorporated, Turner Network Television and N.B.C.

Research Publishing specialises in the more digital aspects of studio work including creating and publishing their own CD-Roms, typefaces and designing websites for the internet. The fall of 1996 saw the first general release on the independent label Laboratory titles by Giles Rolleston 001 Urban Feedback and Chris Hales 002 Twelve. Further titles to be produced are David Crow & Cosmontage.

Peter Brookes was born in Liverpool, educated at various schools around the UK, as his father was in the RAF, studied art at Manchester School of Art for a year, moved to Central School of Art and Design in 1966 and turned freelance in the early 70s.

He taught at the Central School of Art and Design, 1976-78; tutored at the Royal College of Art from 1978, contributes work on a regular basis to *Radio Times* and *The Listener* and has contributed to *New Society*, *New Statesman*, *L'Expansion*, *Marie Claire* and *Cosmopolitan* in France. He has worked in Germany and the USA; illustrates books for Hutchinson Folio Society, W. H. Allen; bookjackets for Penguin, Fontana. He had a one-man show at Mel Calman' Workshop Gallery, 1978; he has had work shown in 'European Illustration', 1976-81; Association of Illustrators, 1976-81; Scottish and Welsh Arts Council shows; Art Work exhibition, National Theatre; British Illustrators, Belgrave Gallery, 1978 and has exhibited at Illustrators' Art and Mel Calman Workshop Gallery, London.

From a feature interview in *The Art of Radio Times* by Peter Harle published by BBC Publications

The introduction of a supplement dedicated specifically to the creative industry highlights a change in opinion towards the design industry as a whole. Increasingly, through government support and ongoing promotion by the Design Council, the value of design to industry in its many forms has started to become more widely recognised. However, there is still some way to go before the business community accepts design as a tangible business asset, adding value to the bottom line. As an industry, the onus is on us to work towards changing this opinion and position design on the same level as other professional practices and convince business that creativity adds real financial value.

This will become easier as business and designers understand more about how creative ideas are born. For too long, creativity has been viewed from a purely aesthetic perspective. Aesthetics are the packaging of an idea. The real equity lies in the idea itself and creative big ideas only come from one source: identifying the specific commercial issues a business is trying to solve. And to do that we, as creatives, have to be able to understand business and how it works.

There are several elements of management and business practice we can draw on to help achieve this, not least the very language of business itself. As an industry we need to learn to talk in the same language as our clients, and present creative thought and output in a more strategic manner. If creativity is always driven by knowledge and understanding, fine, but big ideas still need to be communicated and evaluated so clients can recognise the commercial benefits to them.

The Partners already does this internally through a unique process called Third Brain Thinking™. By involving both creative and strategic minds in all parts of the design process, we can establish a creative collaboration between the left brain and right brain within the agency. By recruiting strategists as well as creatives, our results are highly innovative, because they are always based on solid business reasons that our clients can understand.

The industry also needs to learn to be more entrepreneurial in the way we gain our business understanding and get closer to our clients. In the past, The Partners has loaned agency people out, to work in-house alongside our clients. In doing this, we become better able to identify how design will add value to their business, and better equipped to express this using their language.

The ability to embrace growth is another business quality we would do well to adopt, bearing in mind that 73 per cent of design businesses earn less than £1m in fees per year. Too many agencies still fear the prospect of expansion, associating it only with a loss of creativity. But to keep up with the pace of our clients, and to support their changing needs, we need to learn to view growth as an opportunity.

Growth is not just about more money, but about developing people. There is a war for talent out there, and we need to offer our people opportunities to develop their skills and flourish or someone else will. We also need to implement the processes that go hand in hand with growth, such as better financial controls and people development skills.

Successful businesses embrace change, making it part of their culture, the design industry must do the same. Ironically, creative people are often the most intrinsically conservative, but to stand still in business is the biggest danger of all. If we are not as flexible as our clients in adopting change fast, then how can we expect them to really value us as business partners?

The design industry as a whole is reminiscent of a teenager on the brink of adulthood, looking to management and business for guidance in its evolution. In the UK, only 25 per cent of the design industry accounts for 80 per cent of the total country's design fee income. If our industry is to develop and this ratio become more balanced, we need to address these elements of business and start aligning ourselves more closely with the role of consultants, selling design as a serious, professional, results-orientated activity. Likewise, clients need to learn from creatives to allow their own people to take more creative risks, which is, for us, a daily affair. And a lot of fun.

Aziz Cami is founding and managing partner of The Partners, voted the UK's No. 1 creative design agency for 14 years. From its offices in London and Sydney, the 90-strong brand design consultancy works with clients around the world, including Anglo American, Clifford Chance, Granada Media, Pirelli, Telstra, Unilever, Wedgwood, and Warner Bros. In July 2000, The Partners joined the Young & Rubicam Group.

Ivan Chermayeff's work as a designer, painter and illustrator has been exhibited throughout the United States, Europe, the Soviet Union and Japan. A member of the Industrial Designers Society of America and the Alliance Graphique Internationale, Mr. Chermayeff is a Benjamin Franklin Fellow of the Royal Society of Arts and has served as Andrew Carnegie Visiting Professor of Art at Cooper Union, and as Visiting Professor at the Kansas City Art Institute. In 1973 he was co-chairman of the First Federal Design Assembly sponsored by the National Endowment for the Arts and Humanities. He is the author of *Observations on American Architecture* (Viking Press, 1972) and *Ellis Island* (MacMillan, 1987).

Ivan Chermayeff's work has received numerous awards from the Type Directors Club, the American Institute of Graphic Arts, the Society of Illustrators, and the Art Directors Club of New York. In 1967 the American Institute of Architects honoured him with its Industrial Art Medal, and in 1971 the Philadelphia College of Art awarded him the Gold Medal. In 1974 the Fifth Avenue Association gave him a special award for his contributions to the visual environment of New York City. In 1979 Ivan Chermayeff and Thomas Geismar received the Gold Medal of the American Institute of Graphic Arts.

In 1981 Ivan Chermayeff received the President's Fellow Award from the Rhode Island School of Design and received an honorary Doctor of Laws from the Portland School of Art. He was named to the New York Art Directors Club Hall of Fame in 1982. In 1985 Ivan Chermayeff and Thomas Geismar both received the Yale Arts Award Medal. In 1991, Ivan Chermayeff received a Doctorate in Fine Arts (Honorary) from both the Corcoran Museum of Art (Washington, D.C.) and The University of the Arts (Philadelphia). He has received the title Royal Designer for Industry of the Royal Society of Arts and Commerce (RDI Hon) in recognition of his achievements in graphic design.

Ivan Chermayeff is a past President of the American Institute of Graphic Arts and former Vice President of the Yale Arts Association. He was a member of both the Yale Committee on Art and Architecture and the Harvard University Board of Overseers Committee on Visual and Environmental Studies. In addition, he was a trustee for the Museum of Modern Art in New York for 20 years and has been a member of the Board of Directors of the International Design Conference in Aspen since 1967. In 1990, Ivan and Jane Clark Chermayeff co-chaired the 40th International Design Conference in Aspen on the subject of children. He is a member of the Board of Trustees of New School University and the Board of Governors of Parsons School of Design, and has been a National Trustee of the Smithsonian Institution. He is a past President and past Vice President of the American Institute of Graphic Arts.

Ivan Chermayeff studied at Harvard University, the Institute of Design (IIT) in Chicago, and graduated from Yale University, School of Art and Architecture.

Heather Cooper was born in Lincolnshire, England in 1945 and moved to Canada in 1948. Influenced by her parents to paint as a young child, by the time she was 14, she knew what her career would be. At 18 with a decade of experience she began a design apprenticeship which would mark the beginning of her dualistic roles of idealist and realist, or painter and designer.

In 1966 she gained initial wide-spread public recognition, by creating a series of collages for the Canadian Centennial Commission, depicting the history of Canada from 1867 to 1967.

In 1967 she left on a sabbatical tour to study the art and folkways of European and Scandinavian culture, and upon resuming in 1968, began her own design practice.

"The quandary of dualism rears its head many times and in many ways during an artist's development. To gain experience and insight – not to mention the clients who keep you in business – an artist must be outgoing and worldly. Yet finding the time required to create, demands a lifestyle that borders on monastic."

"The greatest works of commercial art are never properly rewarded and likely never will be. This is because in order to achieve that greatness the artist leaps beyond the commercial boundaries, and applies talent and imagination that far exceed everyone's original expectations. Only by giving from the heart in this way will an artist summon the inspiration, ideas and insight that kindle the finest work."

To many, the name Heather Cooper conjures visions of finely detailed paintings in mythical and romantic themes. As posters and prints, her works have become a medium of their own in celebrating North America's performing arts. But the work of Heather Cooper goes much further, with a range that takes in the design of packaging, postage stamps, corporate trade marks, magazine design, book design, annual reports, in-store promotion and display and print promotion.

"It is my opinion that a successful client/designer relationship is developed from a mutual recognition that both the client and the designer are experts in their own field. This respect and understanding requires us to work very closely with the client, bringing considerable expertise and extensive resources to each project. Good design is not a superficial application of graphic components. It is a well-planned and integral part of the positioning and marketing of the product."

Recognized internationally as one of Canada's foremost artists, Heather Cooper has been commissioned by numerous foundations, corporations and private collectors in Canada, Europe and the United States.

In 1975, a retrospective exhibition of her work entitled "The Art of Heather Cooper" was staged in Toronto and sponsored by Olympia and York and by Abitibi Price Ltd. Her work has been shown in New York, Prague, Brno in the Czech Repbulic, Munich, Germany, Japan, the Soviet Union and Toronto.

In 1987, Heather published a 160 page full-colour book of her paintings and design entitled *Carnaval Perpetuel*. She also held an exhibition entitled 'Carnaval Perpetuel' which displayed an extensive collection of original oil paintings. This exhibit was staged in Toronto and sponsored by Provincial Papers Ltd.

The year 1990 marked the launch of the ongoing publication and distribution of limited edition prints, reproduced from Heather's personal paintings.

Heather's work has been reproduced in numerous international publications such as *Graphis, Idea Magazine, Communication Arts Magazine, Heidelberger Qualitat, Applied Arts* and Canadian publications such as *Macleans, Chatelaine* and *Art Impressions*. She has lectured extensively to student and professional audiences throughout Canada and the United States, at such institutions as the Harvard Science Centre, The American Institute of Graphic Arts, the Ontario College of Art, the Rochester School of Technology, the Art Centre in Pasadena, California, the Houston Art Directors Club, the Dallas Art Directors Club, the Bankers Club of Cincinnati, the Ontario Dairy Council, Toronto, and the University of Montana.

Heather has been awarded gold and silver medals from the New York Society of Illustrators, the New York Art Directors Club, and by the Toronto Art Directors Club, a bronze medal by the Brno Bienale in the Czech Republic, a Peace Award from the Soviet Union, the Les Usherwood Award from the Toronto Art Directors Club, The Design Effectiveness Award, and international packaging and design awards.

Heather Cooper is a member of the Alliance Graphique Internationale the Association of Registered Graphic Designers of Ontario, and the Royal Academy of Arts.

Wilm Hendrik (Wim) Crouwel

Born 21 November 1928 Groningen, The Netherlands

1946-49 Art Academy Minerva, Groningen

1949-51 Military service 1951-1952 Amsterdam Art School IVKNO

1952-54 Designer with an exhibition company, Amsterdam

1954-56 Free-lance designer, Amsterdam

1954-57 Teacher at the Royal Art Academy,

1955-63 Teacher at the Amsterdam Art School IVKNO

1957-60 Design-studio together with interior designer Kho Liang le, Amsterdam

1960-63 Freelance designer, Amsterdam

1963-80 Co-founder and partner Total Design, Amsterdam

1965-72 Lecturer Technical University, Delft (industrial design)

1972-78 Professor extraordinary Technical University, Delft

1980-82 Lecturer Technical University, Delft

1980-85 Consultant Total Design, Amsterdam

1982-85 Full professor Technical University, Delft

1981-85 Visiting professor Royal College of Art, London

1985-93 Director of the Boymans van Beuningen Museum, Rotterdam

1987-93 Private chair Erasmus University, Rotterdam (art and cultural sciences)

From 1994 Freelance designer and consultant, Amsterdam

One man exhibitions: Stedelijk Museum, Amsterdam 1979; Museum Wiesbaden 1991; Design Centre, Stuttgart 1992. Took part in many group-exhibitions in the Netherlands, and abroad. Speaker at many congresses, symposia, and workshops. Published in newspapers, magazines, and books about design. Received many awards, among others: the Werkman prize 1958, the Duwaer prize 1965, the Piet Zwart prize 1991, and the Stankowsky prize 1991.

1957 Knight of the Order of Leopold ll, Belgium

1980 Officer of the Order of Orange Nassau

1989 Officer of the Most Excellent Order of the British Empire

1993 Knight of the Order of the Dutch Lion

1994 Doctor Honoris Causa, Technical University, Delft

Honorary Royal Designer for Industry, UK

Honorary Fellow of the Society of Typographic Designers, UK

Honorary member and honary chairman of the BNO, the Dutch Design Organisation. Netherlands

Honorary member of the Deutsche Werkbund, Germany

The total designer.

Obviously, there's hardly an aspect of the visual communications business that has escaped Lou Dorfsman's attention. There is no word to describe his labours on behalf of CBS. He shuns the word 'designer' because it has the connotation of 'cosmetician', a person who pretties things up. But he accepts the title 'designer' if it implies the fullest sense of the word – master planner. That is the area in which he feels his talent lies. He has been an initiator of projects and an innovator. He was ahead of the field in creating environments for newscasters. He pushed to make weather reports a scientific learning experience. He was the first to use film for on-air promotions and TV spots for radio promotions. As far back as 1952, he was using *The New York Times* as a trade paper to influence clients, ad agencies and government policies. His long arm even reached into programming when he revived Walter Cronkite's slipping rating by engineering (with the help of publicist Sid Garfield) a guest appearance on 'The Mary Tyler Moore Show.'

To be sure, Dorfsman did not bat a thousand in getting his ideas approved. Among his favourite unfulfilled schemes for the TV network was his plan for an 'on air' sweepstake to induce audiences to tune in and sample CBS's new fall line-up. Another, was his proposal for a national election, in which audiences would cast votes for the pilot shows they wanted kept on the air. But topping the list of favourite rejects, was his institutional campaign idea for CBS, Inc.

In 1960, while the new building was still at the excavation stage, it occurred to Lou that most people had no idea of the diversity of CBS's activities. It was known mostly as a broadcasting company. "What a marvellous opportunity," he thought, "to let the public (and the stockholders) know what CBS is all about – the entertainment function, the record division, the publications, the electronics – all related to American culture."

Lou visualized a series of ads with the construction site as a stage set. The gist of the campaign would be: on this site a building was being constructed, dedicated to information, education and entertainment. As the building progressed from floor to floor, each ad would demonstrate a specific CBS property and function. For starters, he would have the New York Giants scrimmaging in the excavation, as a reminder of CBS's NFL broadcasts. When the building reached the record division floor, he planned to photograph Leonard Bernstein conducting the New York Philharmonic there. For Programming, he envisioned an ad with the 90 people of the department lined up on a beam and Jackie Gleeson operating a derrick. For Research, another photograph crammed with people from that floor...

...and so on, continuing his ads until the building was completed. As it happened, the building was scheduled to be finished by Christmas, so for the final ad in the campaign, Lou planned to photograph the traditional 'topping off' ceremony with a Christmas tree and the simple message: "Merry Christmas Everybody, from CBS Inc." Sweet as the idea was to him, and even with the staunch support of Frank Stanton, Lou could not get the campaign budget approved. It remains a memory, albeit a fond one. Which proves there's no Utopia for designers, not even at CBS.

From *Dorfsman and CBS* by Dick Hess and Marion Muller published by American Showcase.

Jaap Drupsteen, 1942 Hasselt, Netherlands.
Study: graphic design at the Academy for Arts & Crafts, Double bass at
the Music Lyceum, Enschede.
1964-70 Graphic designer at NOS-television.
Design of title sequences and leaders.
Jazz musician/composer in spare time.
1970-71 Senior designer at Tel Design, The Hague. Design of corporate
identity programmes and audiovisuals.
1971-79 Designer/director VPRO Television.
Corporate identity programme for TV with leaders and station calls. Design
and direction of TV music and drama productions based on videographic
techniques.
1980-85 Free lance graphic designer and TV director.
Design of leaders, art-objects, interiors, stamps and coins.
Direction of music videos and advertising films.
1985-88 Creative director at Signum (BBDO group).
Concepts and direction of corporate video's and information projects.
1988-99 Design of a new series of banknotes for the Netherlands Bank.
1000, 100, 25 and 10 guilder notes.
Freelance graphic designer and director of video- and interactive
information projects, corporate videos, documentaries and musico-dramatic
TV programmes.
Graphic design of websites, interface design.
1999 Assignment of the Dutch Government for design of the new
generation of identity documents for the Netherlands.
Co-founder of MUZT (editors of music-television programmes).
Jaap Drupsteen incidently composes and produces music for his leaders
and some of his videographic productions. His TV work is internationally
distributed by RM Associates London, and has been broadcast worldwide in
more than 20 countries.

Awards include:
TV critics Nipkow Award 1976. Werkman Design Award 1980.
Sikkens Award 1981. Prix Italia for 'The Flood' 1987. L J Jordaan Award
for banknotes documentary 1988. Alblas Award and Holland Video
Award 1990.

Gert Dumbar (1940) studied painting and graphic design at the Royal
Academy of Fine Arts in The Hague. He studied in the post graduate
graphic design programme at the Royal College of Art in London.

In 1977 Gert Dumbar established Studio Dumbar. With his team at Studio
Dumbar he completed numerous extensive corporate identity programmes
for many major national and international clients including: the Dutch
Postal and Telecom Services (PTT), the ANWB (Dutch Automobile
Association), the Dutch Railways, the Dutch Police and the Danish Post
(together with Kontrapunkt a/s, Denmark). Currently Gert Dumbar is
working on the corporate identity programme for the Czech Telecom.
Studio Dumbar won numerous national and international design awards.
Among these were two D&AD golden pencils – a prize that has never been
won twice by any other graphic designer in the world.

As a visiting professor, Gert Dumbar headed the graphic design department
of the Royal College of Art. Since 1980 he has periodically taught and
lectured at the University at Bandung, Indonesia. From 1996 until 1998
he was visiting professor at the Hochschule der Bildenden Kunste Saar
in Saarbrucken, Germany. Since 1998 he has been a board member at
DesignLabor in Bremerhaven, Germany. In addition to this he frequently
lectures at art schools and international design conferences.

Gert Dumbar has been the Chairman of the Dutch association of Graphic
Designers (BNO). In 1987/1988 he was the President of British Designers
and Art Directors Association and was a member of the design board of
the British Rail Company until 1994. Gert Dumbar is a member of the
Alliance Graphique Internationale (AGI). In 1994 the Asociacion de
Disenadores Graficos de Buenos Aires (ADO) appointed Gert Dumbar
to be an Honorary Member and in 1995 the English Southampton Institute
honoured Gert Dumbar with the title of Honorary Doctor in Design.

Gert Dumbar is the initiator of the travelling exhibition Behind the Seen
about the work of Studio Dumbar. This exhibition has been shown in the
Netherlands, Germany, Japan, the USA, China and Australia.

Education:
School of Visual Concepts, coursework in design and illustration
Indiana University, BA Ethnomusicology
University of Washington, BFA(Hons) Industrial Design 1993
Royal College of Art, MA(RCA) Industrial Design 1995

Design career:
Senior Associate, Hollington
1997-present Head of interaction design for industrial design firm.
Interaction and toy design clients include Science Museum, Ericsson, BP,
Electric Planet (Interval Research), Hasbro. Areas of design and design
management include digital product, toys, software, interactive exhibit and
exhibition design, new media and inter/intranet design.

Associate Lecturer, Ravensbourne College, Chislehurst
1996-98 Product design specialist and visiting lecturer within school
of design for all three year groups of undergraduate course. Areas of
speciality included digital product and interaction design, human
factors, and CAD.

Media Specialist, Kingston College, Kingston-upon-Thames.
1996 Macintosh lab management and software tutoring for students and
staff in and Communications, and Environmental Studies.

Interaction Designer, Miller-Hare, London.
1995-96 Interaction design for architectural software consultancy, including
development and prototyping of architectural/site maintenance software;
development of Director environments for architectural QTVR documents.

Assistant Designer, Dillon Studio, London.
1994 Jane Dillon on children's furniture, textile and product designs.

Interaction Designer, Microsoft, Redmond, Washington, USA.
1993 Interaction design on development of Encarta Atlas; project
development of educational software packages; research and review of
existing software.

Design Intern, NBBJ, Seattle, Washington, USA.
1992 Design support for interior and retail architecture studio.

Designer/Art Director, University of Washington Publications, Seattle,
Washington USA.
1992-93 Graphic design and art direction for University.
Designer/Art Director, Nordstrom, Seattle, Washington, USA.

1988-90 Graphic design and art direction.

Principal, Tory Dunn Design.
1987-present Product design, graphic design, interaction design, project
management & client liaison.

Clients include: Interval Research, Aldus, University of Washington, Alaska
Airlines Magazine, Meng Associates, On the Boards, Royal College of Art
Multimedia Lab, DesignAge. Current products in development include:
preschool toys, electro-acoustic instruments; library & domestic furniture;
internet and multimedia projects

Awards, Exhibitions, Publications, Lectures:
1999 Speaker, British Interactive Group annual general meeting
1999 Member, OU Validation Committee of BA (Hons) Communications,
Northbrook College
1999 Visiting lecturer and external tutor, Central St Martins School of Art
and Design, Product Design, BA (Hons) and MA courses
1998 Speaker, Icograda London Seminar
1998 Merit Award: One Show Interactive, One Club, New York
Participant, Netherlands Design Institute Smart Materials Workshop
1998 Speaker, Icograda London Seminar
1996 ID Design Revi
1995 British Standards Institution Award for design and materials
innovation
1995 Matthews Wrightson Industrial Production Award
1994 D&AD Silver Award, Exhibition Design (signage component)
1994 Ian Karten Trust Scholarship
1994 Shortlist, Overseas Research Student Awards
1993 Table, Lamp & Chair, Portland, Oregon
1992 Ned and Jane Gough Memorial Scholarship
1992 Issacs Scholarship
1992 Shortlist, Koizumi International Student Lighting

At the time we left college there seemed to be two routes to take, either you work for the mainstream – Michael Peters, Fitch, DDA, etc – or you do trendy stuff for record companies and 'style' mags. We were more interested in doing something unusual with seemingly normal clients – Andy was hell bent on designing soap powder packaging. That seemed like a much bigger challenge than doing the cover of an album where you really just do what the hell you want.

The first time I used a Mac was for an illustration for Letraset. I went back to the RCA and Richard Doust showed me through the program and I thought bloody hell, get one of these. So we went and bought one, five grand, just for the box. We've spent a fortune on technology because we never waited until it got cheap. You have to get on the bandwagon, so we've always tried to get the best we can, first.

A key moment for Why Not was designing the Queen's anniversary stamps. We knew there were certain areas we couldn't stray into but we desperately wanted to solve 'the problem', which was to make a series of stamps about the Queen that didn't look kitsch, that represented her various roles, that looked as they had been designed by us and that we could be proud of, but that your Mum would like, so we had to step outside what we were doing. It's all in the way the type and image merge and the emotional strings that can be pulled. We used a conventional typeface, but did something slighty odd with it – the little key lines and the use of gold and silver to lend a regal touch to a modern layout. We were under pressure to create a uniform type treatment for every stamp, so we kept ignoring that request until the deadline meant it had to go to print as it stood; it was Rick Poynor in Eye magazine, who said that we had the "popular touch", we just try to think into the client's, and more importantly the audience's head.

Because our client list is so varied we're able to indulge in different levels of madness – knowing where to pitch it on a sliding scale between complete clarity and bloody mayhem. When Next asked us to design them a few sections of the directory we looked at it and thought, it's pretty difficult to produce anything very different from what they already had because it's such a tight selling space. So we contacted them and suggested our talents would be better used designing the cover and intro pages. Thankfully they agreed and the only brief was "take us in a new direction". The Next directory got us noticed by other designers, and it helped us get jobs we'd never have been considered for. Before that we were thought of as a trendy little graphics outfit. Doing that typography for Next really excited us because we were hitting a whole different audience. It got to a lot of people and felt like we were achieving something new.

Text except from *Why Not* by David Ellis and Liz Farrelly published by Booth Clibborn

Germano Facetti, Graphic Designer. Germano was born in Milan and trained there as an architect. In 1953 he moved to London where he worked as a graphic designer and art editor for several publishers. Between 1957 and 1960 he worked in Paris as an architect, returning to London to become Art Editor for Penguin Books from 1960 to 1972. Since 1973 he has been dividing his time between Milan and London as a consultant for book and magazine publishers including TimeLife, Jonathan Cape, and Rizzoli.

Germano has taught at the Bath Academy, Manchester Polytechnic, The London College of Printing, Chelsea College of Art, the Catholic University of Valparaiso, and the Grafiska Institute of Stockholm. He is a member of Alliance Graphique Internationale, and served as president from 1967 to 1969. He is the author, with Alan Fletcher, of Identity Kits, a pictorial survey of visual symbols, London 1971. Germano has been teaching at Yale since 1983 and is currently Senior Critic in Graphic Design.

Willy (Wilhelm August) Fleckhaus was born on 21 December 1925 in Velbert, a small city located east of the Rhineland.

After the war he started his career as a journalist for a catholic youth magazine, but soon changed from writing to layout. In the 1950s he worked for L. Fritz Gruber's 'Photokina', the well-known fair for photography in Cologne, designing catalogues and exhibitions.

In 1959 Fleckhaus edited the first issue of *Twen* which established the basis of his internationally famous magazine style, a development of the design style of Alexey Brodovitch and the New York School. The magazine, *Twen* soon became famous for its large-scale pictures from the world's finest photographers and illustrators and for its minimal but spectacular typography. The magazine ceased publication in 1971.

In 1980 Fleckhouse became the founding art director of *Frankfurter Allgemeine Magazine*, a post he held until his death in 1983. The magazine, until its closure in 1998, was one of the visual leaders in Europe. Fleckhaus also designed the magazines *Quick*, *Merian* and many others.

In 1959 Fleckhaus came into contact with Siegfried Unseld from Suhrkamp Publishing house and was soon engaged as a book-cover designer. In 1959 Bibliothek Suhrkamp appeared, followed in 1963 by the rainbow-series Edition Suhrkamp. He also worked for the publishing houses Piper, Insel and others. One of his most famous illustrated books is the monumental issue *Die 10 Gebote heute* (The 10 commandments today).

Willy Fleckhaus was one of the founders of the German Art Directors Club in 1965 and from 1972-74 served as President.

He taught in Essen from 1974-80 and in Wuppertal from 1980-83. His students have since shaped German magazine design.

Willy Fleckhaus died on 12 September, 1983 in his villa in Castelfranco di Sopra in Italy.

Alan Fletcher's international design reputation is reflected by his commissions from major corporations and cultural institutions around the world. He began his career in New York where he worked for Fortune magazine, the Container Corporation and IBM. He moved back to London and in 1962 co-founded Fletcher/Forbes/Gill, which served such clients as Pirelli, Cunard, Penguin Books, BP and Olivetti. He co-founded Pentagram in 1972 and created design programmes for Reuters, Lucas Industries, The Mandarin Oriental Hotel Group, The Victoria and Albert Museum, Lloyd's of London, Daimler Benz, Arthur Andersen & Co and ABB. In 1992 he left Pentagram to work alone in his own studio. Among his clients are Domus Magazine, Dentsu, London Transport, Toyota. He is the design consultant to Phaidon Press.

He has received gold awards from the British Designers & Art Directors Association (D&AD) and the New York 'One Show'. In 1977 he shared the D&AD President's Award for outstanding contributions to design with Pentagram partner Colin Forbes. In 1982 the Society of Industrial Artists and Designers awarded him their Annual Medal for outstanding achievement in design. In 1993 he was awarded The Prince Philip Prize for Designer of the Year.

He served as President of the Designers & Art Directors Association in 1973, and as President of the Alliance Graphique Internationale from 1982 to 1985. He is a Royal Designer for Industry, a Fellow of the Chartered Society of Designers, Senior Fellow of the Royal College of Art. In 1994 he was elected to the 'Hall of Fame' of the American Art Directors club.

Beware Wet Paint, a book on 35 years of his work, was published by Phaidon in 1996. He has co-authored *Identity Kits* – a pictoral survey of visual signs (Studio Vista), *Graphic design: visual comparisons* (Studio Vista), *A Sign System Manual* (Studio Vista) and four publications on the work of Pentagram; *Pentagram - the work of five designers* and *Living by Design* (Lund Humphries), *Ideas on Design* (Faber and Faber), *The Compendium* (Phaidon).

Alan Fletcher trained at the Central School of Arts and Crafts, The Royal College of Art in London and the School of Architecture and Design at Yale University.

Colin Forbes was born in London and studied at the Central School of
Arts and Crafts. After a period as a freelance designer and lecturer at the
Central School he became an art director with an advertising agency.
He was subsequently appointed Head of the Graphic Design Department
at the Central School.

In 1960 Colin established his own practice, having been appointed design
consultant to Pirelli in England, and soon afterwards joined with designers
Alan Fletcher and Bob Gill to form the partnership of Fletcher/Forbes/Gill.
In the early 1970s the development and expansion of the partnership
resulted in the formation of Pentagram. In 1978 Colin moved to New York
to establish another Pentagram office.

Colin has been the partner responsible for corporate identity programmes
and other design projects for clients including Lucas Industries, British
Petroleum and Kodak in the United Kingdom; American Standard, Neiman
Marcus and Melville Corporation in the United States; and Nissan, Hankyu
and Kubota in Japan. He has written many magazine articles and lectured
in the United States, Europe and Japan on the organization of Pentagram,
corporate identity and corporate communications.

Colin's work and contributions to the advancement of the design
profession have been recognized with numerous awards and honorary
appointments. From 1972 to 1975 he was a member of the British Design
Council, in 1973 he was elected Royal Designer for Industry by the
Royal Society of Arts, and from 1976 to 1979 he served as International
President of the Alliance Graphique Internationale. In 1977 he was granted
the President's Award of the Designers and Art Directors Association in
London for his outstanding contribution to design. He served as national
President of the American Institute of Graphic Arts (AIGA) from 1984 to
1986 and is on the Committee of Advisors to the Art Center College of
Design (Europe). In 1992 he was awarded the AIGA Medal in recognition
of his distinguished achievements and contributions to the field, and in
1993 was named Honorary Member of the Board of Directors of the
American Center for Design.

In 1988 Colin was Chairman of the Stanford Design Forum sponsored
by Stanford University and the National Endowment for the Arts. In 1989
he taught a master class at Yale University's School of Art as Senior Critic in
Graphic Design, and he has edited a Design & Business column in Graphis
magazine. Colin resigned full-time partnership in Pentagram as of October
1993 but continues to work with the Pentagram partners and his own
clients on a consulting basis.

Nancy Fouts is rarely happier than when she's up to her elbows in resin, surrounded by her collection of found objects and producing her lifelike models. She has made the lot – from a dancing banana to a dog-shaped briefcase. For the past 25 years Fouts has built a reputation as one of the industry's leading modelmakers. Through agencies including Saatchi and Saatchi, GGT and Collett Dickenson Pearce, she has worked on campaigns for such clients as Silk Cut, BMW and British Airways.

Until October of last year, Fouts worked in partnership with her husband, Malcolm Fowler in Shirt Sleeve Studio, the company they founded in 1967, but the couple now work separately.

Throughout the eighties, Shirt Sleeve was responsible for a huge array of the famous Silk Cut Models – among them the Swiss army knife and the rhino with the hat. One of Fouts's favourites is the purple silk thread wound on to a spool, art directed by Alex Taylor and shot by Graham Ford.

Another memorable project involved keeping banana skins looking fresh for three days on a BMW shoot, also with Ford as the photographer.

"We could have made a model, but that would have cost a lot. Instead, I found a low-melting-point wax and dunked the skins in it to keep them a good bright yellow."

More recently Fouts has combined modelmaking with photography – one of her proudest achievements was the Benson and Hedges grasshopper: "The end result was extremely satisfying, that's certainly the direction I'd like to take in the future."

Malcolm Fowler was born in Romford, Essex. He left school at 14 to study art at South East Essex Technical College and School of Art, Dagenham. After graduation he worked as an Art Director for several years, with leading advertising agencies including J.Walter Thompson, in both London and Milan.

Although enjoying the power of Art Director and having learned the skill of presenting ideas quickly under Edward Booth-Clibborn he felt the need to carry the ideas through to final creation. Right at this time he met Nancy Fouts and they formed a dynamic team opening Shirt Sleeve Studio together in 1967. Shirt Sleeve quickly became well known for illustration and three dimensional work and was used by most of the ad agencies, magazines, design groups, record companies and publishers in London and Europe. They were experts at using a wide range of media to put across 'the message' in a direct and original form and their many awards bear testament to this:

Music Week's award for best record sleeve design, Best British Environment award for their contribution to Cofferidge Close in Milton Keynes. They were chosen by the Japanese magazine Idea to represent England for an issue on European designers. Several awards for the Best Outside Poster from the Council of Industrial Design, the Design and Art Directors' Association three silver and one widely acclaimed gold award for best advertising illustration. Several silver awards from the American 3-Dimensional Art Directors and Illustrators' Award Show. Their work has been exhibited in the British Designers' Exhibition, the Louvre, Paris, at the Richard Demarco Gallery, Edinburgh, Top Drawer Gallery, Amsterdam and a selection has also been purchased by the Victoria and Albert Museum.

Their enormous collection of creative work and their desire to share this work with a larger audience led to the opening in 1990 of the Fouts and Fowler gallery, just off Tottenham Court Road. Malcolm spent three years converting an old leather shop in Tottenham Street into the gallery space. It had real charm, in sharp contrast to many galleries at that time, and was the natural result of his strong belief that well designed spaces full of visual delights, lift the human spirit.

It quickly became a showcase, not just for their personal work but for a wide range of interesting and successful artists, including photographers, wood carvers, illustrators etc., all of whom though commercially successful, were looking for the opportunity to 'show their dreams.' The gallery rapidly established itself as a desirable venue for Art School Dip. Shows, Fashion

Designers shows, book launches and the annual show of the American 3-Dimensional Art Directors and Illustrators Awards. After an exciting three years Malcolm and Nancy decided that running it and promoting the careers of other artists, although fun, wasn't really what they wanted and so in 1993 decided to sell the gallery, so they could start up again, but this time on their own.

Since that time Malcolm has managed to achieve a good balance between work and his own projects. He continues to work on advertising, film and architectural projects and is often brought in to create the desired effect. He works a great deal in Greece and in 1995 mounted in Athens and Thessalonica, to great acclaim, an exhibition of all the Silk Cut models made.

He now lives and works for part of the year in South West France, drawing and painting for his series 'Fowler in France' and in 1998 held an exhibition of paintings and drawings in his local town. His love of buildings 'easy to draw because they don't move' is currently involving him in a series of the 'blue plaque' houses in Primrose Hill and a delightful project on 'my favourite London buildings.'

Malcolm recently completed a big Arabic project of some 40 drawings and realised that he was looking forward to sculpting in clay or making something in wood, or just the pure pleasure of applying paint to canvas and experiencing the richness of the colour. To quote him "I love it, I love it all."

Swiss book, graphic, symbol, calligraphic and typographic designer. Born in Interlaken, 24 May 1928. Apprentice type-compositor, under Ernst Jordi and Walter Zwerbe, Otto Schaefli AG, Interlaken, 1944-48. Studied illustration, engraving and sculpture under Walter Kaech and Alfred Willimann, Kunstgewerbeschule, Zürich, 1949-50. Typeface designer, Deberny et Peignot printers and typefounders, Paris, from 1951; also freelance typeface and symbol designer, working for Sofratype, Lumitype, Monophoto, Bauer typefoundry, D. Stempel Ag, International Business Machines (IBM), Mergenthaler-Linotype, Facom Tool Company, Brancher printing company, Electricité de France, Gaz de France, Metro de Paris, Orly Airport, Charles de Gaulle Airport, British Petroleum, Air France, National Institute of Design in Ahmedabad, and National-Zeitung newspaper, Basel, from 1959; established own typography and advertising design studio, with Andre Gürtler and Bruno Pfäffli in Paris, 1962, and with additional associates Syvain Robin, Nicole Delamarre, Suzi Curtlin, Hansjürgf Hunziker, and Brigitte Rousset in Arcueil, 1965; art director, Editions Hermann publishers, Paris

1957-67; design consultant with J. F. Leblanc, IBM typewriter faces, from 1963; also architectural sculptor from 1962. Designed typefaces President, 1952; Phoebus, 1953; Ondine, 1953; Meridien, 1954; Univers series, 1954-55; Opera, 1959; Concorde, 1959; Egyptienne, 1960; Appollo, 1962; Alpha-Bp, 1965; Serifa, 1967; OCR (Optical Character Recognition), 1968-73; Dokumenta, 1969; Facom, 1971; Iridium, 1972; Brancher, 1972; Frutiger series,1974-76; Glypha, 1978-79; Icone 1980; Breughel, 1981; Versailles, 1983. Instructor, Ecole Estienne, Paris, 1952-60; Ecole Nationale Supérieure des Arts Décoratifs, Paris, 1954-68. Recipient: Design Prize, Swiss Federal Department of the Interior, Berne, 1950. Decoration de l'Etal Français: Chavalier des Arts et Lettres, 1968. Honorary Member, Double Crown Club, London; Type Directors Club, New York.

Exhibitions
Monotype House, London, 1964; Gallery Pierre Berès, Partis, 1968; Gewerbe Museum, Bern, 1973; Gutenberg-Museum, Mainz, 1977. Address: Atelier Frutiger-Pfäffi, 23 Villa Moderne, 94110 Arcueil, France.

Designing alphabets for text, signage, typewriter, phototypesetters and computers, Adrian Frutiger has made an essential contribution to every typographic field in which he has worked. His typographic design includes more than 20 alphabets and several adaptions for different typesetting technologies; he has used these technologies wisely to meet the visual needs of legibility and tradition.

His systematic approach implemented in the design of Univers (1954-55), which includes twenty-one variations based on weight, proportion, and slant, set new standards for type design in terms of systems, of technological understanding, and of optical quality. His adaption of Univers for the IBM Composer (1966) revolutionized typewriting quality, and his exceptional improvement of typeface design for computers led to international standardization (1973) of his OCR-B typeface for optical character recognition. His alphabet for the Charles de Gaulle airport resulted in the development of the Frutiger series, possibly today's best signage typeface in terms of legibility.

Shigeo Fukuda is five years old – maybe six. He has the innocent eye, the spontaneous enthusiasm, the curiosity and the creativity of a child who imagines randomly and makes improbable analogies.

Shigeo Fukuda is a mirage. The power of optical illusions lies in their untranslated immediacy. They can be artificially contrived like Peppers Ghost, a Victorian stage effect of smoke and mirrors which created an appearance of reality that completely convinced audiences. They can be a natural phenomenon like the Fata Morgana. A mirage often seen in the Straits of Messina (Italy) when ships, oasis and cities are seen suspended in the sky, right-side-up or upside-down. They can also be figments of the imagination However there are no illusions which fool us all of the time, or even most of it – because if there were they would be a reality. With Shigeo they probably are.

Shigeo Fukuda is a dreamer. The creation of illusions is not necessarily deception; it can be an expression of man's fundamental creative principle to change the world along the lines of his dreams Whereas it is the obligation of the scientist to correct error, it is the role of the artist to court illusion. In other words, to manipulate our perceptions to see the world in a new way.

Shigeo Fukuda is a doughnut. He uses shapes to shape other shapes. Shapes enable the eye to distinguish objects within space or areas in a pattern. They can also exist independently, in a visual vacuum as it were, like the letters on this page. Although we have the option to see the doughnut or the hole we usually settle for the doughnut. However, the bit we don't usually look at is just as relevant as the bit we do. One cannot exist without the other.

Shigeo Fukuda may be Jules Verne. He not only travels to strange and exotic places in his mind, he also pops up in random places around the world. I've seen him searching through stalls in Hong Kong, rocking and rolling at the top of the CN tower in Toronto, coping with Raclette in Paris, photographing trompe-l'oeil in Florence, wearing funny hats in Toyama, lecturing without words in London. Looking, observing, absorbing and giggling with excitement everywhere.

Shigeo Fukuda is a design. He sports jumpers embroidered with bow ties and cameras. Unique shirts assembled from other shirts – collaged with sleeves, cuffs, collars, fronts and backs. He wears sartorial combinations garnered on his travels from boutiques, street markets and department stores. He probably buys his shoelaces in Tokyo.

Shigeo Fukuda is a star in the design firmament – on second thoughts maybe he's more of a comet.

Alan Fletcher, London

Abram Games was born in Whitechapel, London on July 29th 1914, one of three children born to Joseph Games, a photographer from Latvia and Sarah Games, nee Rosenberg from the Russo-Polish border. Abram attended Millfields Road Primary School until July 1925 then Grocers' Company School (later to be renamed Hackney Downs Secondary School); he left in July 1929. Aged 15, he went to St. Martin's School of Art as a fee-paying day student but left after two terms, attending life-drawing evening classes only. Whilst working as an assistant to his father, he also prepared showcards for local tradesmen and specimens of poster designs for his portfolio.

Abram joined the commercial art studio, Askew-Young in 1932 as a studio boy and continued evening classes four nights a week, spending lunch hours drawing in art galleries, museums and the Royal College of Surgeons for anatomy studies. He continued to prepare new poster design specimens working from home in the evening and weekends. In 1935, at the age of 21, Abram won 2nd Prize for a Health and Cleanliness Council Poster Competition and won 1st Prize in a London County Council Poster Competition to promote evening classes.

Dismissed from Askew-Young for independent views in 1936, he placed his portfolio with Warding and Giles, artists' agents. After 18 unproductive months, he began calling personally on agencies and studios, without success. In 1937, with the help of Ashley Havinden from Crawfords Advertising Agency, Abram was given a double page spread in *Art and Industry* and sent over 50 copies to potential clients. Eventually the Co-operative Permanent Building Society, London Transport, Shell, GPO and ROSPA commissioned posters. By the time he was called up for Army Service in June 1940, 24 posters had been published.

Serving in the Warwickshire and Herts Infantry regiments until June 1941, Abram was then posted to the War Office to design military posters. Promoted to Lieutenant in 1942, he was appointed Official War Office Poster Designer; the only person in the history of the army to be given the title. By the time he was demobilised in 1946, he had designed 100 educational and instructional posters, many were adapted for civilian use by the Ministry of Information.

Resuming his freelance practice, Abram designed nearly 200 posters between 1946 and 1992. He also designed numerous emblems (the Festival of Britain and the Queen's Award for Industry), stamps, book jackets and murals. He was also a painter, cartoonist, product designer (the Cona Coffee machine) and an inventor. From 1946 until 1953, he was a visiting lecturer in Graphic Design at The Royal College of Art. In 1945 he married Marianne Salfeld (1919-1988), a textile designer born in Mainz, Germany. They had a son and two daughters.

"Maximum meaning, minimum means" became his axiom.

Abram was awarded over 40 international and national awards including First Prizes for;
London County Council Evening Classes poster 1935
Festival of Britain emblem 1948
BBC Television emblem 1952
British Tourist posters 1952-4
British Trade Fair poster competitions at Helsinki (first four prizes), Lisbon, New York, Stockholm, Barcelona 1957-64
International Philatelic Competition for tourist stamps, Italy 1976

He had many one-man exhibitions and examples of his work are held in museums all over the world

He was appointed:
Royal Designer for Industry in 1959

He was awarded:
Order of the British Empire for graphic design work 1957
The Design Medal of the Society of Industrial Artists and Designers 1960
Royal Society of Arts Silver Medal 1962
Design and Art Direction President's Award 1991
Honorary Fellow of the Royal College of Art 1992
Doctor of Letters, Stafford University 1994

"Every single day since I started work as a graphic designer in 1955, I have gone to my studio in the morning with the keenest sense of pleasure and anticipation. It has always delighted and intrigued me that my clients have been prepared to pay me for doing that which I enjoyed most: what splendid indulgence! What luck!

At the same time, paradoxically, I have to record an almost continuous sense of disappointment in the results of my work. Why could I not have done better? It was not, I believe, for want of trying, nor for the lack of sympathy and support from clients, and certainly not for lack of money since I think that is rarely the determining factor in matters of design quality.

It may be that the paradox is insoluable – an occupational syndrome perhaps but I would dearly love, some time in my working life, to produce one substantial piece of work which has been well conceived, well handled, well finished and well received; something of which I could feel unreservedly proud.

In the meantime, I look forward to getting to the studio tomorrow, regardless of the results."

Ken Garland: curriculum vitae
Born Southampton, UK, 19 February, 1929
Educated Barnstaple Grammar School, North Devon, 1939-46
Studied Commercial Design at West of England Academy of Art, Bristol, 1946-47
Military service as conscript, 1947-49
Studied for National Diploma in Design (NDD) at Sir John Cass College, London, 1950-52
Completed NDD in graphic design at Central School of Arts & Crafts, London, 1953-54
Art Editor for The National Trade Press, London, 1954-56
Art Editor of Design magazine, Council of Industrial Design, London, 1956-62
In practice as Ken Garland and Associates since 1962. Design consultancies for: James Galt (Galt Toys), 1962-82; Ministry of Technology, 1962-67; Borough of St Pancras/London Borough of Camden, 1964-67; Dancer & Hearne, 1962-64; Barbour Index, 1962-73; Race Furniture, 1963-66; Butterley Group, 1963-69; University of Aston, 1967-68; Toy Works, 1970-73; Corinthian Group, 1971-73; Polytechnic of North London, 1973-77; Central Bureau for Educational Visits & Exchanges, 1975-76; Cambridge University Press, 1973-75; Robert Matthew, Johnson Marshall & Partners, 1981-84; Derbyshire College of Higher Education, 1984-85; Wildwood House, 1974-81; Infoline, 1978-90; Keniston Housing Association, 1984-86; Derwent Publications, 1985-87; Skola, 1983-84; Texas A&M University, 1988-89; Heinemann Educational Books, 1988-91. Design work for: Penguin Books; Jonathan Cape; Architectural Press; BBC TV; RCA Records; Arts Council of Great Britain; Paramount Pictures; Harper & Row; Metrication Board; Japan National Tourist Association; William Heinemann; Lucas Furniture; Otto Maier; Institute of Mechanical Engineers, Sumach Press; Lund Humphries/Design Press; IOP Publishing; John Murray; National Museum of Photography, Film & Television; The London Institute; Aurum Press; Royal Parks Agency

TV appearance on: Panorama, 1960; Tonight, 1964; The Visual Scene, 1969; Making Toys, 1975; Omnibus, 1976; Design Classics (London Underground Diagram), 1988; Tales from the Mapping Room, 1993

Exhibitions:
Linescape, Lithoscape, Landscape, University of Reading, 1987; Ken Garland and Associates, 1962-89, Dundee, 1989, Stoke on Trent, 1991, Cardiff, 1991, Coventry, 1991, Falmouth, 1991, Lincoln, 1992

Harry Beck's Last Stand, University of Reading, 1994, Coventry, 1995, London, 1995, Falmouth, 1996, Brighton, 1996, Dundee, 1997

Ken Garland: A Retrospective, University of Reading, 1996, University of Sunderland, 1997

Ken Garland: Work and Play, Riverside Studios, London, 1959

David Gentleman was born in London in 1930 of Scottish parents, both Glasgow trained painters. He studied at St Albans School of Art and at the Royal College of Art, where he was taught by Edward Bawden, Edward Ardizzone, John Nash, Abram Games and FHK Henrion. His work includes painting in watercolour, illustration, graphic design, lithography, and wood engraving. His commissions include the Eleanor Cross mural designs at Charing Cross underground station, 1979; illustrations and designs for many publishers; and over a hundred postage stamps for the Post Office, including the issues for Shakespeare, Churchill, Battle of Hastings, Darwin, Ely Cathedral, Swans, Millennium Timekeepers, etc. He designed the British Steel symbol and the Bodleian Library colophon. His posters include Victorian London for London Transport and a number of award winning graphic and photographic posters for the National Trust. He has also designed wallpapers, textiles and ceramics.

His own books include the texts and watercolours for *David Gentleman's Britain*, 1982; *David Gentleman's London*, 1985; *David Gentleman's Coastline*, 1988; *David Gentleman's Paris*, 1991; *David Gentleman's India*, 1994, *David Gentleman's Italy*, 1997; four books for children, *Fenella in Greece*, *Fenella in Spain*, *Fenella in Ireland*, and *Fenella in the South of France*, 1967; *Design in Miniature*, 1972; and the satirical A *Special Relationship*, 1987. Books he has illustrated include *Plats du Jour* for Penguin, 1957; *Bridges on the Backs*, CUP 1961; *The Swiss Family Robinson*, 1963 (USA); *The Shepherd's Calendar*, OUP 1964; *Poems of John Keats*, 1966 (USA); *The Pattern Under the Plough*, Faber 1966; thirty engraved covers for the New Penguin Shakespeare, 1968-78; *The Jungle Book*, 1968 (USA); *Robin Hood*, 1977 (USA); *The Dancing Tigers*, Cape, 1979; *Westminster Abbey*, 1987; *The Crooked Scythe*, 1993; *The Poems of John Betjeman*, 1995; and *Where all the battle is*, by Alun Lewis, 1997.

He has had ten solo exhibitions of watercolours from 1970-97 at the Mercury Gallery in London, of South Carolina, Kenya and Zanzibar, the Pacific, Britain, London, the British coastline, Paris, India, and Italy; and he has published many editions of lithographs, mostly of architecture and landscape, 1967-90. His watercolours and lithographs are represented in public collections including the Tate Gallery, the Victoria and Albert Museum, the British Museum and the National Maritime Museum, and in many private collections. He was elected a Royal Designer for Industry (RDI) in 1970, and he has been a member of Alliance Graphique Internationale since 1972.

Articles on his work appear in the *Penrose Annual*, 1976; *Communication Arts*, Palo Alto, USA, March/April 1979; *Art and Graphics*, by Willy Rotzler and Jacques N Garamond, *ABC Verlag*, Zurich,1983; *HQ* magazine, Heidelburg, 6/1985 and 2/1995; and in *Abitare*, Milan, in 1997.

Inventiveness, wit and originality are hallmarks of the output of Studio Works, based close to Union Square, New York. Studio Works principal Keith Godard has developed a reputation, especially for exhibit design, which has led to commissions for projects, outstanding for their design structure and content.

Godard's application of typography, often to unusual surfaces, or in playful, unexpected contexts, reflects a solid grounding in the structuring of information, and the essentials of good layout. Conversation with him reveals the influences which guide his work.

Keith Godard was born in England, to parents whose appreciation of art, craft and design would determine his early interests: "My father was an engraver, who cut graphic things in three dimensions. (Godard shows a collection of engraved sealing rings which show intricate detail and a high level of craftsmanship.) I used to watch him for hours, seeing his great skill and patience." In turn Godard would draw for hours, gaining an early appreciation of detail.

First design influences, significantly, were from large-scale graphics. "My father took me to the Festival of Britain in 1951. I think that FHK Henrion's designs were outstanding. All that colour, just after the misery of the war, and the use of Playbill type on those kidney shaped cutouts."

Godard studied at the London College of Printing, which, he has come to appreciate, provided the special opportunity to study design and typography. In a practical atmosphere, removed from the over-influence of 'art'. While there his interest in three-dimensional aspects of design was consolidated. "It came about because I enjoyed making things and photographing them. I found by looking through the camera that I could discover different aspects of the images."

After the LCP he went to work for *Town* magazine (working on typographic layout with Dennis Bailey). Godard also designed for the *Weekend Telegraph* magazine. "It was a great time for magazines. Legibility was considered important, and the typography reflected this."

This stint in the sixties typographic layout ended when Godard moved to America to study further at Yale University. His college was part of the School of Architecture. Now Godard teaches exhibit design at Yale. In his student days he remembers exploring the use of different materials, initially for use in publication design. "I remember making a silver mylar cover for an architectural prospectus. It created a terrible binding problem, which needed some inventiveness and tracking down the right adhesives, to solve."

From Yale, Godard joined the Partners, working as the graphic designer with architects Greg Hodges and Lester Walker, at the 33 Union Square building occupied at the time by, among others, Saul Steinberg and Andy Warhol's company. "This was the crazy sixties when we all thought that design was going to change the world. Our first job was for the Creative Playthings store. I did the graphic components, but I found a guy who could do all sorts of things with neon." From the outset he sought the original, innovative solution, often based on the use of unexpected materials and surfaces.

Although his architect partners eventually moved away Godard had made many connections in the architectural field. As he explains, he was "slow to cotton on" to the advent of computers in design, and there were not many designers "to do the exhibit thing". There was an inevitability that most of his work, as he developed his business, first called Works, then Studio Works, would revolve around exhibit design.

But within his exhibits, such as the history of the subway: Steel, Stone and Backbone at the Brooklyn Transit Museum, and signage systems for the Lincoln Center and Cornell University, is the structured approach to information which stems from his early training in typography: "Most graphic designers, when it comes to exhibits, tend to do books on walls. I frequently say, 'If God wanted us to read standing up he would have given books legs'. There is the initial problem of trying to get rid of the words, to get down to the essentials, then to structure what is left. I try to show the title well, then the secondary information, the major introductory text needs to grab the attention. Then the labels, the nitty-gritty of credits. There has to be a hierarchy, the words have to work, in this order of reference."

Godard describes how the concept for the exhibits evolves, usually from the space itself. "Sometimes the ideas come very quickly just looking at the space. I remember that they were renovating a boat house at the New Jersey Nature Center and the idea of putting the typography on sails for the exhibit came along. I printed the type on large pieces of canvas although in this case I did hang them on the wall like pictures."

1944-54 Primary and Secondary Schools in Zurich.

1954-58 Apprenticeship as Typographic Designer with Orell Fussli Grafische Betriebe AG Zurich and School of Design HFG (Hohere Fachschule für Gestaltung).

1959 Paris, Maquettiste at Atelier Typographique and Freelance Graphic Designer.

1959-62 London, Graphic Designer at London Typographic Designers.

1962-63 Post Graduate Studies in Visual Communication, Basel School of Design HFG (Hohere Fachschule für Gestaltung).

1963/64/65 Three Awards for Excellence in the field of graphic design by the Swiss Department of Interior Affairs, Bern.

1963 Moved to Canada.

1963-66 Head of Graphic Design at Paul Arthur & Associates. Design of comprehensive signage system for Expo '67 World Exhibition, Montreal.

1966 Founding of Gottschalk+Ash Ltd with partner Stuart Ash, Montreal.

1972 Opening of Toronto office.

1976 Opening of New York office.

1978 Return to Switzerland. Opening of Zürich office.

1985 Divestiture of New York office (now Carbone Smolan Associates).

1985-91 Secretary Treasurer for AGI (Alliance Graphique Internationale).

1985-92 In charge of Milan office.

1990 Graphis Publishing, Member, Board of Directors.

1994 Key Note Speaker at 'Intersections', Seattle, SEGD (Society of Environmental Designers).

1995 Jury Member of FAW (Fachverband Aussenwerbung e.V.), Frankfurt.

Major Projects and Company Highlights

1967 Expo 67, Montreal, Architectural Graphics

1968 Exhibition of Gottschalk+Ash Int'l, Montreal Museum of Fine Arts.

1972 Design of four commemorative stamps for the International Congress of Geology, Cartography and Photogrammetry in Canada.

1975/76 In charge of the Office of Design on behalf of Comité d'Organisation des Jeux Olympiques 1976, Montreal. Design coordination of all visual aspects of worldwide Sponsor Programmes.

1975 Juror of Spectrum '75, the Royal Canadian Academy Art Exhibition on the occasion of the 1976 Olympic Games in Montreal.

1975 Exhibition of G+A at Container Corporation of America, Chicago

1976 Design of Official Ticket for the Olympic Lottery.

1985 Design of new Swiss Passport.

1990 Design of Official Symbol for Ice Hockey World Championship in Switzerland.

1991 Exhibition of G+A in Frankfurt, Galerie von Oertzen.

1990-93 Design and Implementation of a new outdoor advertising concept for the City of Zürich.

1993 G+A Retrospective Exhibition, Centre de design de l'Université de Quebec à Montreal, First Canadian Place, Toronto.

1995 G+A Retrospective Exhibition, Coninx Museum, Zürich.

1995 Participant, Corporate Design Seminar organised by AGI (Alliance Graphique Internationale), Peking, China.

1997 Participant, Exhibition „The World of Graphic Design", Frankfurt. Approximately 100 Awards at various International Design Shows.

Membership

AGI Alliance Graphique Internationale. 1984-92 Member of International Executive Committee and Secretary General.

AIGA American Institute of Graphic Arts

RCA Royal Canadian Academy.

SGV Schweizer Grafiker Verband (Association of Swiss Graphic Designers).

SGQ Société des Graphistes de Quebec.

Advisor to Art Center College of Design (Europe)

Member of Board of Directors Graphis Verlag AG, Zürich and New York

There are few illustrators whose names endure from one decade to another.
Brilliantly inventive and constantly evolving, Brian Grimwood is one of
Britain's most successful illustrators.

Grimwood was born 28 March 1948 and, as a teenager, attended Bromley
Technical High School. He was taught by Owen Frampton who ran a unique
three year graphics course. He left school in 1964 and joined Pye Records.
After five years working for various advertising agencies/design groups as
an art director/designer he became a freelance illustrator.

Based in Covent Garden, London he developed a seemingly effortless style
that catches the moment.

By the eighties his clever designs were in demand all over the world.
He travelled extensively to the Far East lecturing in Singapore Australia
and Japan.

In 1983 he founded The CIA illustration agency representing most of the
best illustrators in the UK.

In 1999 with Louisa St Pierre he opened the successful multimedia
agency C11A.

He has been commissioned by everyone from The Beatles to Asda.

Steven Heller (*Print* magazine) has been quoted as saying
"Grimwood has changed the look of British Illustration"

As well as numerous group exhibitions one man shows are as follows:

1978 Animal Banquet, Thumb Gallery, London
1980 Behind the Screens, Thumb Gallery, London
1982 Drawn from Scratch, Thumb Gallery, London
1993 First works on canvas, Portland Gallery, London
1999 Inside her Heart, Coningsbury Gallery, London
2000 Going Dutch, De Brandwacht Gallery, Amsterdam

John Halas was born in Budapest, Hungary, 16 April 1912. As a young man in Budapest he trained with the animator and puppeteer George Pal. He was deeply influenced by the Hungarian Bauhaus movement, that included Moholy Nagy and Victor Vasarely. This influence helped to form his vision of animation.

In 1936 he went to London where he met Joy Batchelor whom he married in 1940. In the same year they established Halas & Batchelor under the auspices of the J. Walter Thompson advertising agency. During the Second World War their early work was mainly making documentary and propaganda films for COI and MOI. This set the pattern of much of their work: applying animation techniques to a wide variety of subjects other than entertainment.

By 1945 they were the largest animation studio in Europe.

They flourished for nearly 50 years training countless young people to become talented animators. John Halas could truly be said to be 'the father of British animation'.

Their biggest success was Europe's first animated entertainment feature film Animal Farm (1954). It broke new ground for the British animation industry and the studio went on to produce over 2000 animated films winning more than 200 awards internationally.

John Halas was a pioneer in his field always seeking to embrace new techniques as they became available. He was one of the first to embrace computer animation not just as a labour saving device but as a creative force. He believed that animation was a kinetic art form which could set the human mind free from the confines of reality. For this reason he always sought to collaborate with the best artists, designers and composers of the time.

He was President and founder member of ASIFA the International Animated Film Association from 1960 to 1985. He involved himself with all aspects of design and was associated with Icograda from its inception. He was awarded the OBE in 1972 and the Pro Cultura Hungaricus in 1992.

With boundless energy and enthusiasm he went on producing films, articles and books as well as involving himself in conferences and festivals, until his death in 1995 aged 82.

"The Halas and Batchelor studio was formed by myself and Joy Batchelor in 1940 and during its long period of activity produced some 2000 shorts and seven feature-length animated films. We discovered early on that flexibility and adaptability were essential in order to survive the difficult periods in the film industry (which occur every five years or so in Britain) and the changes in trends, fashions and tastes of both clients and public. The market in Britain is very small in comparison with that in America, which means that it is far more difficult here to create a popular, identifiable character along the lines of Mickey, Donald or Popeye as well as maintaining the momentum of a studio. Nevertheless, if we did not succeed in creating an 'immortal' character, we were able to create certain trends in animation and invent a number of new systems.

I was born in Budapest, Hungary, in 1912 and came to England in 1936, after a period of extensive study in graphic design with Alexander Bortnyik and Moholy-Nagy, both former tutors at the Bauhaus. Joy Batchelor was born in 1914 in Watford, North London, and was a pupil at the local Art College. After joining up as a graphic design team at the beginning of the war we were asked by the J. Walter Thompson agency to make long advertising cartoons for some of their clients, such as Kelloggs, Lux and Rinso. The Ministry of Information came across our work and virtually commanded us to produce information and propaganda films for the remainder of the war.

The animated version of George Orwell's 'Animal Farm' was released in 1954 and was the first animated feature-length film made in Britain. One of our most difficult assignments came in 1953. We were asked to act as art directors for the feature 'Cinemara Holiday' and to animate the bridging sections between episodes of this gigantic feature which stretched across the screen at 142 degrees.

Another innovation, the film Ruddigore (directed by Joy Batchelor in 1964), was the first cartoon opera, adapted from Gilbert and Sullivan's original.

During the mid-seventies, Joy Batchelor retired from active production. I continued to make a number of experimental films using the new technique of computer animation such as 'Autobahn' in 1979 and 'Dilimma' in 1981. I then went on to direct and produce a series of films about the lives of the great masters of art such as Leonardo da Vinci, Michaelangelo, Botticelli, Toulouse-Lautrec and Hieronymus Bosch, again using computer animation."

John Halas died in London, 20 January 1995.

In the late forties, as a beginning commercial artist in Los Angeles, I attended two lectures that introduced me to modernism and had a profound effect on my life. The first was a lecture by Will Burtin entitled 'Integration, the New Discipline in Design.' Burtin not only spoke about design and communications, but also presented an exhibition of his work, which guided the viewer through a series of experiences that were described as the four principal realities of visual communications. They were the reality of man, as measure and measurer; the reality of light, color, and texture; the reality of space, motion, and time; and the reality of science. He was the first person I had heard use the term 'visual communications'.

A short time later, I heard Gyorgy Kepes speak. At the time, I didn't fully understand everything he was saying, yet I knew that his words were very important to me. I recall my excitement, as I was able to draw parallels between what he was saying about the plastic arts and what Will Burtin had said concerning the realities of visual communications.

It was the beginning of my realization that it was possible to communicate visual information that transcended common conventions and could become art. I discovered the possibility of having a viable vocation and at the same time to be able to experience deep fulfillment. These lectures were so important that they inspired me to leave my job as a mechanical artist and commit myself totally to design.

As I became more involved with this profession, I realized that my deepest concerns with design were centered on what I felt were the mysteries of form – discovering new forms and using them to construct creative and meaningful solutions to design problems.

I attempted to evolve forms that covered the entire emotional spectrum and were also impeccable in their sense of order. This, to me, was the essence of modernism, and toward that end, I wanted to create constellations so rich that they could communicate content. I was searching, for what I called 'the hidden order'; trying to find some common principle or scheme inherent in all things that would answer questions that maybe I hadn't yet asked.

The Bauhaus was perhaps the most profound example of modernism in its break with the rigid ideologies of 'grand manner' art education. Dedicated to research and instruction, its objective was a social reconditioning through a synthetic curriculum. Simultaneously, all the arts were examined in the light of contemporary conditions.

Modernism is also exemplified in the International Style of design that developed following, World War II. Its mostly Swiss contributors included such notable designers as Max Bill, Josef Müller-Brockmann, Armin Hofmann, Max Huber, Richard Lohse, Hans Neuberg, Siegfried Odermatt, Emil Ruder, and Carlo Vivarelli. These modernists breathed new life into design, cutting, away all unnecessary graphic appendages and leaving only the essentials. Their work, which manifested itself in this timeless style, was thoughtful and systematic. The work was beautiful, thoroughly crafted, and communicated complex information quickly and simply. Like the Bauhaus, it was an essential development and a strong reflection of its time.

In the forties and fifties, I believed that modern design was a means to precipitate reactions and new actions. At that time, there was a sense of urgency – a design revolution that was alive and aimed at developing openness to what many considered radical forms of communication. The goal was to create a platform for design from which could be communicated bold, new graphic ideas. I think that platform today is firmly rooted, thus expanding the possibility of producing intensely creative, dynamic, and even bizarre ideas. There is now much more awareness and acceptance of good design.

As times changed, so did my design philosophies. Now I am more interested in the process of problem solving. This is not to say I don't want my design to be beautiful. But, in the past, I was preoccupied with finding something profound and revealing within a form. Today, I am much more concerned with the clear, direct communication of an idea.

Trained as a graphic designer at St Martin's School of Art and the Royal College of Art, London, George Hardie has worked for thirty years as a jobbing illustrator.

He is commissioned to solve problems and make illustrations for a variety of clients in many countries (13 to date). His work primarily involves ideas, carefully composed and crafted into graphic art.

George Hardie is a Professor of Graphic Design at the University of Brighton and a member of the Alliance Graphique Internationale. He has won a number of British and European awards and had many articles written about his work. He also lectures at art schools and to professional bodies in Britain and abroad.

Current Post
Principal Lecturer – School of Design; Lecturer and Teacher in Illustration and Graphic Design; Subject Leader, PGDip/MA Sequential Design/ Illustration and MA Design by Independent Project

Teaching Experience
Much visiting teaching; before 1986 (appointment at Brighton). Since 1986 teaching or lecturing at the following institutions (sometimes several times) (pre-university titles):
Bath, Kingston, Bournemouth & Poole, Escola Massana (Barcelona), Canterbury, School of Visual Arts (New York), Newcastle upon Tyne, Liverpool, Parsons (New York), Hereford, Royal College of Art (Graphics), Brighton Illustrators Group, Royal College of Art (Illustration), Bryanston School, Derby, Bedales School, Gwent, Sunderland, Cardiff, Wimbledon (Foundation), Tyneside, Southampton, Nene, Denmarks Designskole (Copenhagen), IDEP (Barcelona), Auckland Institute of Technology (New Zealand)

Current Professional Practice and Research
George Hardie is a practicing Designer/Illustrator. His clients include advertising agencies, pop groups, magazines, publishers, major corporations, national institutions, the Post Office and design groups both in the UK and abroad. Has been commissioned by many clients in 12 different countries. Recent work includes one of the 48 Royal Mail Millennium stamps by British imagemakers to illustrations in the Radio Times.

Hardie has also lectured or taught on many D&AD workshops in Graphic Design and Illustration, Association of Illustrators professional practice seminars, CSD Real World seminars, and at two American Illustration Weekend Studio Visits in New York. Apart from commercial work Hardie is mainly working on artists books and in areas of batch production on 'graphics without clients'.

Sam Haskins is a Designer/Photographer. He lived his youth on the African veldt, far removed from all the cultural traditions of Europe that would eventually have such a profound influence on his life. Art courses at school and colleges culminated in a three-year sojourn in bomb scarred, post-war London. Here he very soon immersed himself in the study and appreciation of the available aesthetic wealth.

As an escape from the strictures of a career in advertising and editorial illustration he later embarked on a range of personal projects – an extension of his inveterate passions. As a dedicated bibliophile, his new activities then naturally gravitated towards creating books. Books of images. Some told a story, others documented people and places. They all strove to share Sam's visual thoughts.

His first book, *Five Girls*, created a stir when it appeared in the early sixties. It swept like a fresh breeze across the still waters of figure photography, he stripped the nude of all hesitancy, cliché, pretension and vulgarity, making it a natural aspect of life. His second book, the story of a gun-toting young woman called Cowboy Kate became an instant international best seller and was awarded the Prix Nadar. This was followed by *November Girl*, a book employing the multiple image techniques that developed into an ongoing enthusiasm. The Haskins photographs reflected the contemporary ideal of life, offering much excitement, amusement, freedom, frivolity and beauty. His images, like the popular songs of the time, voiced the sentiments of a generation. The exploration of all these ideas was further developed in *Haskins Posters*, a collection published in 1973. It was awarded the Gold Medal of the New York Art Directors Club.

The early seventies saw the first of the 'Apple and Eve' montage photographs, the debut of an ongoing series of graphic exercises that explore the many permutations that become possible by combining these two elements. The image manipulation in this series was accomplished.

Haskins, Sam(uel Joseph).
British. Born in Kroonstad, South Africa, 11 November 1926. Educated at Helpmekaar High School, Johannesburg; studied graphics at the Witwatersrand Technical College, Johannesburg, and photography at Bolt Court (London College of Printing) School, 1948-50. Married Alida Elzabe van Heerden in 1952; sons: Ludwig and Konrad. Freelance photographer/designer, Johannesburg, 1952-68, London, since 1968; established Haskins Studio and Haskins Press in London. Engaged in an international lecture programme since 1970. Recipient: Prix Nadar (for *Cowboy Kate*), France, 1964; Silver Medal, International Art Book Competition (for *African Image*), 1969; Gold Medal, Art Directors Club of New York (for *Haskins Posters*), 1974; Book of the Year Award, Kodak, (for *Photo Graphics*) 1980. Address: 9A Calonne Road, London SW19 5HH, England.

"The designer is not an artist – yet he can be one" Walter Gropius.

At the extreme ends of the spectrum there is a clear difference between art and design. They do not have an interface where they meet; they overlap in a wide grey area.

Historically, as I shall show, designers came first – then builders, artisans, sculptors and painters.

In the Renaissance there was a long and heated argument between Leonardo and Michelangelo. The former claimed that only the painter is an artist and the sculptor a mere artisan. This argument seems settled today. Both painters and sculptors are considered equally 'fine artists'.

What needs discussion today, especially in respect of art and design, practice and education, is to find out where these two disciplines differ and where they overlap. If it proves possible to define these areas clearly it will be easier to decide where and when joint art- and design-courses seem appropriate and where separate and independent courses are likely to obtain better results.

I shall not produce cookbook recipes, how and what to teach – I shall merely attempt to stimulate further talk and discussion based on the clear differences between art and design which I shall endeavour to identify and show possible directions for further exploration to avoid some of the confusion from which we have been and still are suffering in all educational and professional institutions.

Obviously I stand on firmer ground talking about design as I have practised it as well as attempted to teach it and organise it as a profession for over 45 years. Yet many of my best friends are painters and sculptors, and I have no doubt that the study of art and art history have benefited me greatly in my career.

I shall therefore try to define what design is and what art is not. In doing so I shall quote from Rudolph Arnheim's *Visual Thinking* and Herbert Simon's *The Sciences of the Artificial*, authors whose books I have found particularly relevant and helpful.

Arnheim states "…superior performance may be obtained if the principles inherent in it have been identified and then absorbed again in intuitive application. Professional skills require this sort of preparation," and "Man exploits his mental endowment more fully if he not only acts intelligently – but also understands intellectually why he acts as he does and why his procedures work."

This means a body of theoretical knowledge helps the designer in his work, and that thinking is an essential part of his work. Thinking begins with the task of modifying a given order for the purpose of making it fit the requirements of the solution to a given problem. It can be said that all design activity is an ordering process, an attempt at reducing chaos, or, as Norbert Weiner put it, negative entropy. Entropy is an elementary law of nature, based on the fact that everything organic and inorganic is gradually running down, being reduced and dissolved. It is the second thermo-dynamic law which has been expressed colloquially as 'you cannot win'. It is like rowing against the current of a river, where the strength put behind the oars must be greater than the strength of the current in order to move up-river. A pause, however short, allows the current to take over and undo previous strokes: the quantity depending on the length of the pause and the strength of the current. Designing is therefore rowing upstream (negative entropy) and, in so doing, replacing the chaos found by at least a measure of order. This measure of order depends on the amount of simplification and unification achieved in given circumstances.

Mies van der Rohe put it "Design is doing more with less". This often-quoted maxim holds a lot of general truth and can almost always be used as a valid criterion when comparing design solutions and when rejecting one alternative in favour of another which is simpler, which in fact does more with less. It could be applied to textile design, posters, typography, package design and equally to a locomotive, a space rocket or a wrist-watch, an electric shaver or a building – but not necessarily to a painting or a sculpture.

To design is to have a plan, a concept in one's mind before it is carried out.

Wearing many hats was second nature to Richard Hess (1934-1991). From a real desire to be a full-time painter, he eased into positions of advertising art director, graphic designer, magazine art director and illustrator – in no particular order. An open mind and adaptability allowed him to work in all aspects of visual communications. "Some people have expressed surprise at the broad spectrum of my work," he said, "but I view it differently. I think it's strange for anyone not to work in the complete language of the visual world."

After his early start in advertising with such agencies as J. Walter Thompson; N. W. Ayer; Benton & Bowles; Fletcher, Richards, Calkins & Holden, Hess opened his New York design office in 1966. After three years of working on his own with editorial, advertising and corporate clients, Hess and Sam Antupit (art director of *Esquire*) formed a 'compatible partnership' with Hess And/Or Antupit. After some time, their partnership dissolved and Hess continued to work on his own.

"Design, typography and communication graphics are a more severe discipline because of the need to cater to legibility and reading habits, and it most often requires a certain anonymity of authorship," he said. "But the satisfaction derived from working within these limits can be very great indeed."

"I had always intended to be a painter," he said. " I became an art director to earn a living, but I found I could not pursue both activities at the same time. I resolved to stop painting and concentrate on design, until I could become successful enough to afford to go into painting full-time. I was close to my goal when some financial problems depleted my nest egg. I decided to try a different approach and solved a few assignments by doing a painting myself instead of assigning someone else to do it. These were seen and I started getting assignments from other art directors."

"My other experience was helpful. Being trained as an art director entails a certain skill in analyzing problems and isolating the useful solution."

Dick painted 14 covers for Time magazine. Among the best known were Deng Xiaoping Man of the Year in 1979 and a gatefold showing a cross-section of Americans for the 1987 special issue of the 200th anniversary of the constitution.

As the fields of graphic design and advertising evolved, so did Hess's work. He was able to stay on top, to work with the times in a relatively young field, where things quickly changed.

1958 Born in Brussels, Belgium.
1975-1978 Studies drawing at the Royal Academy of Fine Arts, Brussels.
1978-1979 Studies illustration and graphics at the Ecole Nationale Supérieure des Arts Visuels de la Cambre, Brussels.

Late 1979 Moves to London and works at Pentagram Design.
1981 Travels to the USA and works with R.O. Blechman in New York.
Late 1981 Social service in Belgium until 1983.

Late 1983 Moves back to London. Works in London as a freelance illustrator until 1991.
Late 1991 Following a shift of interest towards painting and etching, moves to a small village in France with his wife and two children.

Drawings have appeared in the international press (The Times, The Sunday Times, The Observer, The Sunday Express, The Telegraph, The Guardian, The New Yorker, The New York Times, Die Zeit, Vogue Germany, Libération, Le Monde, Télérama, Le Soir, Internazionale, El Pais,...).

Since 1989 Publishes his own books of drawings.

Personal Exhibitions
November 1991 Librairie Peinture Fraîche, Brussels, Belgium. Etchings.
February 1994 Galerie Michel Lagarde, Paris, France. Paintings, drawings, etchings and small sculptures.
October 1994 Librairie Page d'Encre, Amiens, France. Book illustrations.
December 1994 Actes Sud, Arles, France. Paintings, etchings, drawings and small sculpture.
April 1995 Librairie Eupalinos, Marseille, France. Paintings, Etchings, drawings and small sculpture.
May 1995 Exhibition 'Charivari', Le Patio, La Cambre, Brussels, Belgium. Paintings, books, original drawings, lithographs and small sculptures.
October 1995 Exhibition 'Charivari', Old Lille Town Hall, Lille, France.
February 1996 Pierre Hallet Gallery, Brussels, Belgium. Paintings.
May 1996 La Petite Fabrique d'Image Gallery, Rouen, France. Paintings, watercolours, etchings.
November-December 1996 Maison de la culture, Namur, Belgium. Etchings, linocuts, lithographs, original drawings from books.
February 1997 Erlecke Gallery, Saint Paul 3 Chateaux (Drôme), France. Paintings, etchings, drawings.
March 1997 Exhibition 'Charivari', Bibliothèque Municipale de Saint-Quentin (Aisne), France. Paintings, sculptures, drawings, etchings, lithographs and books.

April 1977 L'Attente-l'Oubli, bookshop, Saint Dizier, France. Drawings, paintings, etchings.
November 1997 Pierre Hallet Gallery, Brussels, Belgium. Paintings.
January 1998 Galerie BFB, Paris, France. Drawings.
February 1998 Exposition 'Charivari', Bibliothèque Municipale d'Amiens, France.
February 1998 Galerie de la Dodane, Amiens, France. Peintures, gravures.
February 1999 Pentagram Gallery, London, England. Paintings.
February 1999 CNBDI, Angoulême, France. Book illustrations.
March-April 1999 Ombres et Lumières, Rennes, France. Paintings and etchings.

Published books
Benoît Jacques Books:
Play it by Ear 1989
Le Bestiaire Expressionniste 1990
Made in England 1991
Oiseaux-Lire 1992
Collection *Brie de Livre*
Combat de ligne 1993
Bestiaux et Bestioles Texte de Jean-Louis Jacques, 1993
Rêveries Agricoles 1993
Navarin 1993
Partir Texte de Jean-Louis Jacques, 1994
Eclats, Bouts, Sons Texte de François Rollin, 1994
Cambriolage 1984
The Owner's Manual 1994
La Sorcière et Arlequin Texte de Jean-Pierre Blanpain, 1996
Le voleur et la diseuse de bonne aventure Texte de Jean-Pierre Blanpain, 1996
L'enfant de Marie et le typographe Texte de Jean-Piene Blanpain, 1996
La logeuse et le charcutier Texte de Jean-Pierre Blanpain, 1996
L'avaleuse de sabre et le taxidermiste Texte de Jean-Pierre Blanpain, 1996
Small puzzles, Carnet de liaison, Le double, Labyrinthe 1998
Le Jardin du Trait 1995
Jeux de plumes Texte de France Borel, 1996

Le Chêne publishers (Paris)
La Genèse 1995

Albin Michel publishers (Paris)
Elle est ronde 1997

Larry Keeley is a strategic planner who has specialised in creating systems of innovation for over 20 years. Larry is president and co-founder of Doblin Group, an innovation strategy firm known for pioneering new methods for research, innovation development, and prototyping, all used to help make powerful new business concepts easy to understand and pursue.

Keeley has worked with a wide variety of companies since 1979, among them Aetna, Amoco, Apple, Citicorp, Diego, Hallmark, McDonald's, Monsanto, Motorola, Shell, Steles, Texas Instruments, Whirlpool, Xerox, and Zürich Financial Services. In addition, he also lectures frequently and publishes regularly on innovative approaches to strategy and design as a strategic business tool. He is currently completing a book on innovation leadership to be published soon by Harvard Business School Press.

Larry teaches graduate innovation strategy classes at the Institute of Design in Chicago, the only design school in this country with a Ph.D. program, where he is also a board member. He is also a board member for WBEZ-FM, Chicago's public radio station, where he is active in charting strategy for what has become one of the most innovative stations in the nation's public radio network.

When Alan Kitching first learned letterpress typography, aged 15 in his native County Durham, the wood and metal letters with which he makes his art were the tools of a ubiquitous and powerful trade. During his career in design (own practice and Omnific Studios Partnership with Derek Birdsall) – and in art education (Watford School of Art with Anthony Froshaug, Central School of Art and Design and Royal College of Art) – as photosetting, then computers made the art and artifacts of letterpress increasingly redundant, Kitching continued to use the medium and materials.

In 1989 he decided to concentrate on this tactile technology and established The Typography Workshop in Clerkenwell, London. Printroom and studio are filled and perfumed by wood type, papers and presses, inks and books. Foot high letters printed in vibrant colours on sheets up to A1 size, hang in racks from the low ceiling.

Kitching's prints explore his fascination with words and with the character and constraints of letterpress. Images which seem to dance, come from lead locked in a steel grid; clear, pure colours come from wood impregnated by a century of black-only use; light plays with letterform and texture on Japanese paper for window displays.

Commissions for corporate identities, advertising, publishing, packaging and exhibition are also created as prints and the chosen image scanned for reproduction.

Kitching's workshops in Clerkenwell and for students of all disciplines at the RCA, have reached a new generation. Skilled in new media and inspired by the old. Almost destroyed, but now liberated from its former role, letterpress is a creative and expressive medium in its own right. Alan Kitching is one of its most versatile exponents.

He is widely respected as one of the foremost practitioners and teachers of letterpress typographic design and printmaking. He has conducted his workshops and given talks on his work to industry, art schools and design conventions in the UK and Europe.

He became visiting lecturer in typography at the Royal College of Art in 1988 and began his workshops there in 1992. In 1994 he was elected Royal Designer for Industry (RDI) and member of Alliance Graphique Internationale (AGI). An award winning member of British Design & Art Direction, he has served as a jury member several times.

Alan is profiled in Eye magazine no15 vol 4 1994; Visuelte, Norway 1997; Étapes graphiques, no 48 France 2/99, Page Magazine, Hamburg 1999; Projeto, Brazil 4/99; Baseline: International Typographics Magazine, no 29 99/00; and New Design: London, 1999 Rockport Publishers Inc. His work has appeared in numerous international publications. His own publications include: *Typography Manual*, 1970; *Broadside*, an occasional publication devoted to the typographic arts, first published, 1988; and *Typecases*, 1995, published in partnership with Pentagram Design.

He has exhibited in London at Pentagram Gallery in 1992 and 1997; the Royal College of Art in 1993, the Coningsby Gallery in 1988 and the London College of Printing in 1999. He has contributed to various exhibitions in the UK and Europe, including the Crafts Council, Pompidou Centre and Powerhouse UK. Alan's millennium stamp design for the Royal Mail in 1999 (Magna Carta, 64p July) won a silver award at D&AD 2000 and the artwork was exhibited at The British Library in 1999.

After graduating from The Cooper Union and Yale University, Lou Klein was an art director for Interiors magazine and Time Life International in New York.

He moved to London to work for Grey Advertising. He returned to New York to form Gips & Klein design group. He later came back to London as creative director of Grey Advertising, subsequently forming his own design group.

Consultant to Time Inc in New York, he became Design Director for Time Life Books International in London. He was later appointed Design Director for Time Life Books Inc in the USA developing new products, supervising the visual content of hundreds of books on computers, space, history, DIY and creating promotion for many of these series.

He was an executive member of The Designers and Art Directors Association and designed the 'pencil award', the UK's design Oscar. He is a Fellow of The Royal College of Art, was a Fellow of The Society of Industrial Artists & Designers and was a member of Alliance Graphique Internationale.

Lou Klein's work covers a wide range of design for print, corporate identity programmes, advertising campaigns, magazine styling, book design and editorial consultancy to publishers. He wrote articles for design magazines and illustrated magazine articles and children's books. He was invited to hold a one-man show at the Institute of Contemporary Arts in London entitled The Private & Public Art of Lou Klein showing drawings, sculpture, illustration and commercial design.

Concurrent with commercial work, he conducted degree courses at The School of Visual Arts, New York, The Royal College of Art, London and was visiting professor at Syracuse University in London and New York. He was a tutor in graphic design for five years and head of department for a further five years at The Royal College of Art. He was a visiting professor and acting head of the graphic design department of Yale University.

In Britain he was a visiting critic at The Royal College of Art, Hounslow Borough College, Nene College and was a senior lecturer in graphic design and advertising at Buckinghamshire College.

Mervyn Kurlansky was born in Johannesburg, South Africa in 1936. He trained in London at the Central School of Art and Design then spent three years in freelance practice. This was followed by five years as graphics director of Planning Unit, the design consultancy service of Knoll International. In 1969 he joined Crosby/Fletcher/Forbes and in 1972 co-founded Pentagram from which he resigned in 1993 to live and work in Denmark.

He is equally at home designing corporate identities, sign systems, annual reports, brochures, catalogues, books, book jackets, posters and packaging. His clients have included the Reuters International News Agency, Penguin Books, Macmillan, Faber and Faber, United Distillers, Solaglass, Lyons Tetley, Barclaycard, British Telecom's viewdata service 'Prestel', Roche, Rank Xerox, ICI, Olivetti, Shiseido, Barclays Bank, L'Oréal, Inchcape, Wilkinson Sword, Dow Corning, Novo, Kenwood, STC, Mazda, Solaglas, the British Library, the Museum of Modern Art, Oxford, The Royal Borough of Kensington and Chelsea, Danmarks Designskole, Glasmuseum, The Golden Age annual cultural festival in Copenhagen, Export Promotion Denmark and The Image Bank. He is currently consultant to Sculpture at Goodwood (Britain's leading Sculpture Park) and Sappi fine papers Europe.

He has won a number of important awards, including a bronze medal from the Brno Biennale of Graphic Design, a gold award from the Package Designers Council, silver awards from the Designers and Art Directors Association, a silver award from the New York Art Directors Club, a gold award from Japan's Minister of Trade and Industry, first prize in the Gannett Outdoor 'Posters Against Violence Worldwide' competition, 1995, the Gustav Klimt prize 1995 and the Danish IG design prize 1996.

His work is in the permanent collection of the Museum of Modern Art, New York and has been featured in several publications and exhibitions in the UK, South Africa, Spain, France, Germany, Austria, Israel, Japan and the USA. He conceived and designed the book *Watching My Name Go By*, a celebration of New York's colourful graffiti, with text by Norman Mailer and photographs by Jon Naar. He was also a co-author of four books about Pentagram: *Pentagram*, *Living by Design*, *Ideas on Design* and *The Compendium*.

Mervyn Kurlansky is active in design education, he was chairman of the Icograda Design Seminar from 1996 to 1999 (an annual event in London, attended by students from all over the world). He lectures extensively and serves on design juries both for students and professional organisations internationally. He is a Fellow of the Chartered Society of Designers, the Society of Typographic Designers, the Royal Society for the Encouragement of Arts, Manufacturers & Commerce and a member of Alliance Graphique Internationale and the Association of Danish Designers.

Martin Lambie-Nairn has worked as a designer and director specialising in the communications industry for 28 years. Beginning in 1965 as the youngest graphic designer working in television, he spent the first ten years of his professional life with the BBC, Rediffusion, ITN, and London Weekend Television before founding his own company, Lambie-Nairn in 1976. In 1981 Martin developed the original idea for Spitting Image and Lambie-Nairn financed the development of the programme. The company's early work was focused mainly on branding for television, creating groundbreaking identities for Anglia, BSB and the award-winning original Channel 4 identity. From the eighties onwards, it became a substantial overseas exporter of talent and expertise, working with clients worldwide, from France to New Zealand. In recognition of this, the company was awarded the Queen's Award for Export in 1995.

Most recently, Martin and his team have been involved in designing the new corporate identity for the BBC as it prepares itself for the digital age. The identity has been implemented across all the BBC brands, from radio and television to on-line and personnel. The identity has won several awards, including a Silver D&AD in 2000. With the impact of new technology and convergence in media at the beginning of the new millennium, Lambie-Nairn has once again continued to lead the way in creating strong brands for interactive media with companies including Elmsdale Media, ITN and Flextech.

Martin is an RDI (Royal Designer for Industry), has been President of D&AD and has been given numerous awards for creative excellence, including a Gold D&AD for the Channel 4 Brand Identity and a Silver D&AD and a BAFTA for his work for BBC TWO. In 1995 he received the Royal Television Society's Judges Award and in May 1997 the D&AD President's Award for Lifetime Achievement. In October 1998 he was awarded the Prince Philip Award for Design Excellence to Business and Society.

Martin has given frequent lectures in the UK and abroad on corporate design and brand identity. He has also made several appearances on British and European television and radio as well as publishing his first book, *Brand Identity for Television: with Knobs on* in 1997.

In 1999, Lambie-Nairn became part of the global communication group, WPP.

Malcolm Lewis studied fine art, followed by film-making at the Royal College of Art (1963-66). After graduation he helped to create the first section of the British Pavilion at the World's Fair in Montreal 1967, an immersive audio-visual experience encapsulating 5000 years of Britain's early history.

In 1969 he set up Media Productions to apply mixed-media to both the West End theatre and 'Industrial Theatre' for the launch of new products. Everything from cars and computers to shampoo and shoes was presented with a variety of theatre, projection and special effects.

Malcolm became an exponent of the multi-image medium, creating landmark programmes for clients around the world. It was during this period that he was asked to speak at the Odeon Leicester Square for Icograda. The session was marked by a failure of technology that amused the audience as they watched a frantic shadow play on the large screen as technicians sought to resolve the problem!

He formed Media Projects International in 1986 to develop a greater volume of international work and embrace the innovations of new technology, particularly those of sophisticated computing.

Since then some of the notable projects have included: the main show for the British Pavilion at the World's Fair in Seville. A live actor performed in mime in sync. with film projection, a large videowall, animatronic characters, mechanics and lighting.

The Hong Kong Telecom visitor centre used a full range of IT, multimedia and AV. Visitors used smart cards to 'instruct' exhibits which language they preferred.

The launch of the Rover Freelander demanded an immersive environment in a space that changed from rural to urban, from hot to cold, from dry to wet.

Recently life has been dominated by three large and different projects, The Dome, The Centre for Life and Terra Mitica.

For the Dome, an extensive IT and AV consultancy, specifying the IT infrastructure, broadcasting strategy and approaches to talent and hardware resourcing was carried out. Working with HP:ICM concepts for the Shared Ground Zone, (subsequently cut for lack of budget) and the experience inside The Body, (cancelled just prior to production for political reasons), were carried out. Life is still hazardous.

In contrast, producing audio-visual and interactive elements for the Centre for Life 'Life' exhibition in Newcastle-upon-Tyne, has been a joy. Two major mixed media shows in dedicated theatres, The Secret of Life and The Big Brain Show, together with a range of smaller videos and interactives, has been intellectually and creatively stimulating.

In southern Spain, Terra Mitica is a new theme park. Media Projects is designing and producing a complete attraction, Secrets of the Pyramid, a thrill ride and immersive experience inside a huge pyramid that uses the full spectrum of theatrical, film and mechanical effects within a surprisingly authentic environment. If you could read the hieroglyphics, they would make sense!

In a career that spans over 30 years and still continues, the range of work remains diverse and continually challenging. Technology has changed at a frightening pace, yet reassuringly the fundamental creative and communication skills to use it effectively, have not.

Mary Lewis grew up in Shropshire and attended Shrewsbury School of Art Foundation Course. She studied graphic design at Camberwell School of Art and then as a post graduate at the Central School of Art.

At college she became increasingly drawn to fine art. Her career began as a fine art print maker. She exhibited her work and supported herself as an art school lecturer using the college print-making facilities during the vacation.

She returned to graphic design by chance, helping out a friend in advertising. Her interest returned "through the inspiration of designers like John Gorham" and she founded Lewis Moberly with her partner Robert Moberly in 1984.

The consultancy is London based with a small Paris office and works internationally in the brand and corporate identity sectors.

Mary has won numerous design awards, including the British Design and Art Direction Gold Award for Outstanding Design, and the Design Business Association Grand Prix for Design Effectiveness.

She was honoured at the Women's Advertising Club of London 75th Anniversary as one of '75 Women of Achievement', selected for their outstanding achievement or pioneering work in the field of communications.

Mary has chaired the BBC Graphic Design Awards and was the 1995 President of British Design and Art Direction of which she is an Honorary Member. She is a member of the Royal Mail Stamps Advisory Committee, the British Food Heritage Trust, the Wedgwood Design Policy Group, the Marks & Spencer Design Forum, and a fellow of the Royal Society of Arts.

She has been a guest speaker at the San Francisco Museum of Modern Art, the President Nelson Mandela, Independent Creative Conference in Johannesburg, the Ideas '96 Conference in Melbourne and the Fiat Conference 'I Colori Della Vita' in Turin. She was the keynote speaker at the Chicago Brand Identity Conference, and at Johnson & Johnson's Senior Management Seminar on Brand Equity.

Projects she has been responsible for include special stamps for the Royal Mail, corporate identity for Heals and Vinopolis, brand identity for United Distillers Classic Malts, the Prince of Wales organic product range, 'Duchy Originals', Champagne Bollinger and Jasper Conran.

She is co-author of the book *Understanding Brands*, has contributed to Radio 4's Food and Drink programme and the Afternoon Shift on the subject of colour.

Mary lives in London and on her farm in Shropshire. She has a daughter, Scarlett.

I studied graphic design at Canterbury College of Art and the Royal college of Art, London.

From 1960 until 1977, except for a two year break in advertising films, I was a designer in the TV Graphics Department of the BBC. Work there included the design of title sequences for the first five series of 'Doctor Who', the graphic sequences for 'The British Empire" and 'The Mind Beyond' series, all of which won design awards.

Towards the end of the BBC period, I became increasingly involved – especially for 'Doctor Who' – with experimental techniques, and in 1977 I left the corporation to freelance and develop motion control animation. During this period I produced graphic effects for Ridley Scott's 'Alien.'

In 1997 another ex-BBC colleague Colin Cheesman and I set up Lodge Cheesman Productions. Over a period of seven years, we worked on a wide variety of advertising assignments. Our clients included Amoco, Panasonic, Michelin, Atari, Deutsche Bank, and we continued to create title sequences for television programmes, one of which, for The Spice of Life' series, won us the Design and Art Direction gold award. I also designed the graphics for the monitor sequence for Ridley Scott's 'Bladerunner'. The partnership was dissolved in 1986.

From 1986 to 1991 I worked as designer/director for The Moving Picture Company, almost exclusively on advertising films.

After that period I made a complete break with film and television design and by contrast, began a career as a writer and illustrator of children's books. To date I've produced ten books which include:
There Was An Old Woman Who Lived In A Glove
Prince Ivan and The Firebird
The Half-Mile Hat
Tanglebird Mouldylocks
Cloud Cuckoo Land

What are the impulses that shape one's choice of design discipline? As a student, I had initially decided to pursue a career as a 'fine artist', until I discovered that graphic design students worked with a richer mixture of techniques and imagery. They were having more fun. I suppose that the seeds were sown at this time, of a resolve to entertain myself while entertaining others.

The resolve was somewhat undermined during my student days at the Royal College of Art by some of the theorising then current, partly influenced by the calvinistic purity of much Swiss graphic design, that the graphic designer could be a kind of typographic architect and 'problem solver'. The transient guilt I felt at not being drawn to 'socially useful' graphic design evaporated when soon after leaving college I joined the BBC. It could be argued that I was in a career that in terms of social usefulness had a low priority. But I was in show business and happy.

During my 14 years in the corporation I coped with a kind of dichotomy. My work was guided by a design brief, albeit unstated officially: that my purpose was to entertain, to divert and claim the viewer's attention, yet at the same time to solve a particularly subtle kind of problem. For apart from the technical problems and the timeframe constraints of television design, the great challenge was to create something that was true to the spirit of the 'parent' programme to which my design was a contribution.

In the early sixties, when TV graphic design, then in its infancy, had few preceding models, my colleagues and I steered a course through the narrows of stylistic fashion and fast-changing technology. We were mutually critical and much of that informal criticism stressed the importance of a 'good idea'. Although I mentally subscribed to this approach, i.e. to the invention of a clear and easily definable visual concept, uncluttered by stylistic irrelevance, I found that in practice I often produced work that contradicted it. My title sequences for Doctor Who were prime examples. Here was a science fiction series that required, more than anything, the creation of a mood. The title sequences contain no 'ideas', and what little content they offer – the face of the actor and the tide of the programme – is obvious. The sequences consist primarily of style and technology, or rather style created from technology.

If I have a design philosophy, then it is built around the importance of designed relevance. Relevance is an obvious consideration in the early conceptual stages of the design process, but can be overlooked during later stages of execution, whereas the criterion should, I feel, be maintained to include the finest details of a design. In much the same way that William Goldman, the screenwriter, stresses the importance of maintaining the 'spine' of a story at all times, I feel that the function and relevance of a design should guide every aspect of its creation.

Uwe Loesch was born 1943 in Dresden, Germany and studied Graphic Design at the Peter-Behrens-Academy Düsseldorf, 1964-68.

He belongs to the leading international poster-designers. His work is represented in all important museums and collections such as The Museum of Modern Art New York, The Israel Museum Jerusalem, Le Musée de la Publicité Paris, The Library of Congress Washington DC and the Library of Fine Arts of the foundation Staatliche Museen Preußischer Kulturbesitz Berlin.

More than 30 one-man exhibitions showed his minimalistic poster design worldwide, in 1994 in the DDD-Gallery Osaka, in 1996 in the Museu de Artes Brasileira São Paulo, the Museu Light Rio de Janeiro, in 1997 the Museum für Kunst und Gewerbe Hamburg and in 2000 in the Galerie Anatome, Paris.

The numerous awards he was honoured with include the Grand Prix of the International Poster Bienniale in Lahti/ Finland in '83, Gold Medal in '87, the First Prize at the International Invitational Poster Exhibition Fort Collins/Colorado, USA in 1987, Winner of the Internationale Litfaßkunst-Biennale München in 1989 and 1992, the Grand Prix of the international competition German Prize for Communication-design Essen in 1995, the Gold Medal of the International Bienniale of Graphic-design Brno, Czech Republic in 1996, the Silver Medal of the Festival d'Affiches de Chaumont, France in 1996 and in 1997 two Bronze Medals of the Triennial of Toyama, Japan. Gold Medal by the ADC of Europe in 1996 and Silver Medal by the ADC New York in 1998.

He is a member of the AGI (Alliance Graphique Internationale), the TDC (Type Directors Club) New York and the ADC (Art Directors Club) for Germany. Since 1990 he has held a professorship for Communication-design at the University of Wuppertal.

Uwe Loesch on the spiritual difference between black holes and black outs in typography:

The typographical scene of today is like a kind of church synod shortly before the schism into crypticians and agnostics: This is a message which is just about still readable. Alternatively: this signifies a message which you don't want to be able to read.

More than 15 years ago I published the end stage of font development in Point – The European Type Magazine: *Transvestita* – a combination of

Helvetica and Times. Since then, these hybrid typefaces have achieved world-wide popularity.

The new media have provoked the furthest reaching non-political cultural revolution. The method of (self) exclusion is, however, indicative of something going beyond the usual generational conflict. But dismissing design as a pleasure factor, as surface decoration does justice neither to the energy and serious intentions of this new operator generation nor to the aesthetic challenge posed by the new media. Everything indicates that, irrespective of the technological quantum leap of recent years, a kind of vacuum is discernible in society, politics, art and design. And that this attracts the superficial among the peripheral arts due to lack of substance.

Typography today: giant, dwarf or black hole? Or simply a beautiful image which falls for itself.

Herbert Frederick Lubalin was one of America's foremost graphic designers, an internationally honoured giant in a giant industry. He was an innovative graphic communicator whose intelligence responded to the world he lived in, a great man with a capacity to be provocative, an artist of unexpected wit and sensitivity. Lubalin would have agreed that 'to catch a mouse, make a noise like a cheese'.

In his graphic concept, he employed art, copy and typography, and he used available production methods to underline the drama inherent in the message. Impeccably professional, his low-pressure personality thrived on long hours of work in the high-pressure environment of graphics wherein he made his irrevocable contribution.

Lubalin's multi-faceted role was to package ideas visually and exquisitely. His intricate design range encompassed postage stamps, packaging and advertising; it was apparent in the preparation of travelling exhibitions for the United States government and it rose to physical heights with skyscraper signage for the Ford Foundation building in New York City.

He was 17 in 1935 when he entered the Cooper Union, where he was seduced by typography and by the myriad of typefaces that existed. He was intrigued to see that the same word set differently created a different image. As he advanced professionally he became fascinated by the look and sound of words and he expanded their message with typographic impact.

He became a tenacious typographer who left-handedly wielded a razor-blade on type proofs to juggle hairline spaces between letters, to shorten or lengthen serifs and to adjust ascenders and descenders to his finicky satisfaction. He demonstrated the resilience of type. He stretched it, pulled it, tore it apart-and when it resisted he re-designed it.

In 1945, Lubalin became art director at Sudler & Hennessey, a studio specializing in pharmaceutical ads and promotions. Here he created a prestigious art department. His laid-back manner encouraged superb team-work; people who worked for him wanted to please. They knew he sought the best and they produced award-winning graphics.

He loved working with people who understood ideas. Always, with Lubalin, idea preceded design. As a conceptual designer he was never satisfied, ever searching, willingly accepting ideas from others. "A great art director knows when somebody else has a better idea." He pushed a thought until he could say, "That's it. It's beautiful".

In advertising, Lubalin's magic-marker roughs were as decisive as his colleagues' compositions. About advertising he once said, "I think more about creating an idea and writing a headline, than in designing the ad. The most intriguing thing is writing the headline." He became adept devising copylines before he drew. This procedure gave him a hook on which to hang a design.

Lubalin's passion for design was diverse. "Advertising alone isn't enough for me. I live to create ads, but in the right amounts, with the right people. It's the area I'm most interested in, as long as I don't have to do it all the time."

In 1964 he gave himself the fluidity he craved. As president of Herbert Lubalin Inc., and through a succession of partnerships, he designed logos, letterheads, books and book jackets, packaging and typographies for architectural, editorial and industrial clients.

Excerpt from *Herb Lubalin – Art Director, Graphic Designer and Typographer* text by Gertrude Snyder published by Graphis

Italo Lupi lives and works in Milan where he graduated in architecture.
He designs for editorial graphic, visual identity programmes, exhibition
layouts for museums and cultural institutions. He is Editor in Chief and
Art Director of Abitare magazine (after having been Art Director of
Domus magazine).

He is a member of the AGI (Alliance Graphique Internationale). He was
awarded of the Compasso d'Oro for the editorial graphics and first prize
at the Italian Art Directors Club of which he is also an honorary member.
He has been in charge of the image of the Triennale of Milan and IBM Italia.

Laureato in architettura al Politecnico di Milano. Già Art Director di
"DOMUS" é ore Direttore Responsabile e Art Director della rivista di design
ed architettura "ABITARE".

Compasso d'Oro per il Graphic Design 1998. E'stato responsabile di
immagine della Triennale di Milano e della comunicazione IBM Italia.

Vive e lavora a Milano, dove progetta per l'editoria, per la comunicazione
e per allestimenti museali (Triennale di Milano, Palazzo Grassi, Pitti
Immagine, Museo di Storia Contemporanea di Milano, Pinacoteca
Nazionale di Parma).

Design philosophy:
L'arte é lemozione ricordata nella pace della razionalità. Perché se é la
prima intuizione che porta un bagliore creativo nella formazione di un
nostro progetto, é poi il lavoro lungo, assiduo, silenzioso che fa maturare
e lievitare in opera conclusa questa intuizione.

Questo vuol dire guardare le cose e tradurle in opere, attraverso il filtro
della propría memoria e culture senza che queste appaíano troppo evidentí,
con generosità funzionale verve gli altri che devono guardare, ma senza
nulla togliere alla nostra faziosità formale.

Amore per la regola e la sue infrazione, per il modernismo e la classicità,
sono caratteri contraddittorí, ma sono quellí che trasformano il graphic
design forse non in arte, ma in vera conunicazione.

Hans-Rudolf Lutz was born in Zürich in 1939. After completing a four-year typesetting apprenticeship with the Orell Füssli printing company in Zürich, and continuing a career in the industry with the typographer Arthur Kümin and later the printer Anton Schöb, he left Switzerland in 1961 to travel through Europe and North Africa. In 1963, he resumed his education in typography and design at the Schule für Gestaltung in Basel where his teachers included Emil Ruder and Robert Büchler. From 1964 to 1966, Lutz was the leader of the Expression Typographique group in Paris, at Studio Hollenstein, producing a range of graphic design. Hollenstein had developed the first photosetting machine, and the group responded by trying to produce an aesthetic that, in its modernity, matched the new technology. On his return to Zürich, Lutz set up his own studio and publishing company, Lutz Verlag. He wrote, illustrated, typeset and produced nine books about visual communication. The last ones that he published, *Typoundso* and *Ausbildung in typografischer Gestaltung* archive his own design work from the last 30 years. He also published 16 titles by other designers and writers.

From 1983 to 1994, he was Visual Director of the avant-garde electronic music and multimedia performance group UnknownmiX. After the group disbanded, he continued to provide slide shows and visual contributions for live events. But Lutz was first and foremost an educator. He taught at the schools of design in Zürich and in Lucerne for over 30 years, and founded the typography department in Lucerne in 1968. He also carried out assignments at colleges from the Hochschule für Künste in Bremen to Rhode Island School of Design. Hans-Rudolf Lutz died on 17 January 1998.

Publications
Hans-Rudolf Lutz, Grafik in Kuba, 1972
Hans-Rudolf Lutz, Edmonton Journal, 1977
Hans-Rudolf Lutz, 1979, eine Art Geschichte, 1980
Hans-Rudolf Lutz, Die Hieroglyphen von heute, 1997
Hans-Rudolf Lutz, Ausbildung in typografischer Gestaltung, 1996
Hans-Rudolf Lutz, Typoundso, 1996
Alex Sadkowsky, Der Titel, 1994
Alex Sadkowsky, Malerei, Band 1 und 2, 1974
Dieter Meier, 26 Werke, 1975
Konrad Farner, José Francisco de Goya, 1970
Konrad Farner, Tod der Kunst? 1972

BilderBücher 1 bis 7, 1997
Menschen
Gesichter
Bildtext
Known Faces
LoveLove
BildAlphabet
SchriftBilder

As one of the world's most influential designers in print and video, P. Scott Makela's early attraction to emerging medias led naturally into electronic display theory, digital imagery and typography for print, film and music videos. With his wife and partner of 15 years, Laurie Haycock Makela, he created the internationally recognized design studio Words + Pictures for Business and Culture, and was an artist-in-residence and co-chair of 2D design at the highly influential Cranbrook Academy of Art in Michigan.

During an intensely prolific period in the mid-90s, Scott explored digitally driven motion typography for the late Miles Davis, Life, Sex and Death, 10,000 Maniacs, Urge Overkill, and Michael Jackson's $7.5 million video 'Scream'. His print, film and video work for clients such as 20th Century Fox, Ray Gun Publishing, Nike, MTV, MCI, Prudential, Kodak, Lotus Software, Warner Bros Records, and Propaganda Films have been exhibited worldwide. His collaboration with David Fincher and Jeffery Plansker for the opening title animatic for the feature film 'The Game' garnered the 1998 ID Annual Design Review award, and led to doing the titles for Fincher's new film, 'Fight Club'. His latest work included an immersive video environment demonstrating the connections of the universe for the Cranbrook Institute of Science, as well as a series of graphic commercials for MTV, and an uncannily mystical campaign proposal for Rossignol Ski and Snowboards, produced just days before his death.

Scott often accompanied his video work with his own 'industrial soul' music, 'AudioAfterBirth'. Laurie and Scott were beginning work on their third 'AudioAfterBirth', after the 1997 release of 'Addictions + Meditations', with co-producer Keith Lewis, available on Emigre' Music.

Scott was born in St. Paul, Minnesota, taught at California Institute of the Arts, received his MFA from Cranbrook Academy of Art in 1991, and then returned to Minneapolis to design the infamous Minneapolis College of Art and Design catalogues, various magazine covers such as Eye, How, and Idea, and iconic typefaces such as Dead History. Scott was an associate professor at ECPL in Laussane, Switzerland, and was recently the youngest and most controversial member inducted into AGI (Alliance Graphique Internationale).

Scott and Laurie lecture internationally, from Norway to New Zealand, Germany to Brazil. Their work, individually and collaboratively, has been published repeatedly by virtually every major international design magazine, most notably Emigre, Eye, I.D, Idea, Creative Review, and Graphis. With co-author Lewis Blackwell former publisher of Creative Review), the Makelas released the book and website 'WhereIsHere' in fall 1998, published by Calman + King in London, exploring the idea of position and obsession in contemporary movements in film, design and photography. (WhereIsHere.com)

Scott's untimely death at age 39 on May 7, 1999 shocked and saddened his many friends, students and collegues around the world. In the words of Rick Poynor, P. Scott Makela "was a warm, big-hearted man, and one of the most gripping designers of the last decade." (Eye 32)

P. Scott Makela, in partnership with his wife, Laurie Haycock Makela were awarded the Highest Medal of Achievement for ten years of professional practice in the year 2000 by the American Institute of Graphic Arts.

Born in New York in 1943, A T (Tad) Mann received a B.Arch. from Cornell University School of Architecture in 1966. He has been an astrologer since 1972 and has written 12 books (translated into 14 languages) on sacred architecture, sacred sexuality, calendar systems, astrology, psychology, healing, tarot, prophecy and reincarnation.

He was a practising architect in the sixties, having worked for influential offices in New York City and for The Architect's Collaborative in Rome. He is an author, painter, architect, graphics and DTP designer, and has designed layouts, covers and illustrations for many books, companies and products.

He lived in England from 1973-91. He was a founder partner of Phenomenon Publications in London for eight years, taught and practiced astrology throughout that time. He has lectured and taught at Manchester Metropolitan University Architecture School and the Danish Design School. He has participated in major info-eco design conferences as a group leader and facilitator: Doors of Perception 2 in 1995 in Amsterdam and Mind Over Matter in 1996 in Copenhagen. In 1997 he presented a paper Sacred Architecture: The Essential Astrological Component at the Making Sacred Places conference sponsored by the University of Cincinnati School of Architecture and Planning and Hebrew Union College. In 2000 he was a panelist and exhibitor at Cornell University's Cornell's Catalyst for Creativity.

In 1998 he moved back to the USA after living 26 years in England and Denmark. He is a founder member of Universal Quest (http://www.universalquest.com), an Internet content provider and web portal based in New York City which focuses upon spiritual aspects of the quest. He lectures and teaches widely in the USA and Europe on sacred design, feng shui, and is a practising astrologer, architect, graphic designer, author and feng shui consultant. He is available for consultations and private education.

In 2001 he will be consultant to Shakespeare & Company, planning their new 140-acre campus in Lenox, MA. And he will be doing architectural design for the Universitas Educational Foundation on Grand Bahama Island, Bahamas.

Personal Details
Single. 28-year-old daughter. US citizen, Resident of England (1973-91) and Denmark (1991-98)

Education
B. Arch, Cornell University College of Architecture, 1966
(Member of L'Ogive, Architectural Honor Society)

Organizations
Member, Author's Guild (USA), Member, National Writers Union (USA), Past Member, American Institute of Architects, Past Member, Society of Authors (UK), Past Member, American Federation of Astrological Networkers (AFAN)

Bibliography
Sacred Sexuality, Element Books, Shaftesbury, Book of the Month Club (US), Barnes & Noble (US), German, Dutch and Danish, 1995, Chrysalis Books, 2001. The Elements of Reincarnation, Element Books, Shaftesbury; seven foreign translations. The Elements of the Tarot, Element Books, Shaftesbury. Subsequently translated into German, Brazilian Portugese and Danish, 1994. Thorsons/HarperCollins, 2001. Sacred Architecture, Element Books, Shaftesbury, Book of the Month Club (US), Barnes & Noble (US), Denmark and Germany, Chrysalis Books, 2001. Millennium Prophecies, Element Books, Shaftesbury; translated into German, Dutch, Hungarian, Spanish, Danish, Japanese, Norwegian and Brazilian Portuguese, Thorsons/HarperCollins, 2001. Alp Action: The Roof of Europe (1991, wrote chapters and co-edited), Newsweek International (Later published by Random House, New York, 1993.). Astrology and the Art of Healing, Unwin Hyman, London, 1989; translated into Brazilian Portuguese and German. The Future of Astrology, (Editor), Unwin Hyman, London, 1988. The Mandala Astrological Tarot, Macmillan, London; Harper & Row, San Francisco; Interbook, Hamburg; Agostini, Torino, 1986 & 1991. The Divine Plot: Astrology, Reincarnation, Cosmology and History, Allen & Unwin, London (1986), Element Books (1991), Scherz (1993), Thorsons/Harper Collins, 2001. Life*Time Astrology, Allen & Unwin, London (1984); Harper & Row, San Francisco (1986); Sphinx Verlag, Basel; Veen, Amsterdam; Bork, Copenhagen; Element, Shaftesbury, (1991), Thorsons/HarperCollins, 2001. The Round Art: The Astrology of Time and Space, Dragon's World, London (1979 & 1991); Mayflower Books, New York; L'Arte Rotunda, Gemese Editore, Rome. The Phenomenon Book of Calendars 1979-80, Simon & Schuster, New York; Dragon's World, London; 1975-1979, The Phenomenon Book of Calendars (yearly book), Anchor Books/ Doubleday, New York; Dragon's World, London.

Aaron Marcus is the founder and President of Aaron Marcus and Associates, Inc. (AM+A). A graduate in physics from Princeton University and in graphic design from Yale University, in 1967 he became the world's first graphic designer to be involved full-time in computer graphics. In the seventies he programmed a prototype desktop publishing page layout application for the Picturephone™ at AT&T Bell Labs, programmed virtual reality spaces while a faculty member at Princeton University, and directed an international team of visual communications as a Research Fellow at the East-West Center in Honolulu. In the early eighties he was a Staff Scientist at Lawrence Berkeley Laboratory in Berkeley, founded AM+A, and began research as a Co-Principal Investigator of a project funded by the US Department of Defense's Advanced Research Projects Agency (DARPA). n 1992, he received the National Computer Graphics Association's annual award for contributions to industry. He was the keynote speaker for ACM/SIGGRAPH-80, and the organizer and chair of the opening plenary panel for ACM/SIGCHI-99.

Aaron Marcus has written over 100 articles and written/co-written five books, including (with Ron Baecker) *Human Factors and Typography for More Readable Programs* (1990), *Graphic Design for Electronic Documents and User Interfaces* (1992), and *The Cross-GUI Handbook for Multiplatform User Interface Design* (1994) all published by Addison-Wesley. For the last five years, he has turned his attention to the Web, helping the industry to learn about good user-interface and information-visualization design, providing guidelines for globalization/localization, and focusing on challenges of 'baby faces' (small displays for consumer information appliances) of ubiquitous devices and cross-cultural communication. Aaron has published, lectured, tutored, and consulted internationally for more than 20 years and has been an invited keynote/plenary speaker at conferences of ACM/SIGCHI, ACMSIGGRAPH, and the Human Factors and Ergonomic Society. He is a visionary thinker, designer, and writer, well-respected in international professional communities, with connections throughout the Web, user interface, human factors, graphic design, and publishing industries.

Relevant recent publications include the following:
Baecker, Ronald and Marcus, Aaron, 'Printing and Publishing C Programs', Software Visualization: Programming as a Multimedia Experience, John Stasko, ed., MIT Press, Cambridge, MA, 1998, pp. 44-61, ISBN: 0-262-19395-7.

Baecker, Ron, and Marcus, Aaron, 'Human Factors and Typography for More Readable Programs', Addison-Wesley, Reading MA, 1990, ISBN 0-201-10745-7.

Marcus, Aaron, 'Global User-Interface Design for the Web', in Stephanidis, Constantine, Ed., User Interfaces for All, Lawrence Erlbaum Associates, Inc., 2000, pp. 47-63.

Marcus, Aaron, 'Designing the User Interface for a Vehicle Navigation System: A Case Study,' in Bergman, Eric, editor, Information Appliances and Beyond: Interaction Design for Consumer Products, Morgan Kaufmann, San Francisco, 2000, ISBN 1-55860-600-9, http:www.mkp.com, pp. 205-255.

Marcus, Aaron, 'Globalization of User-Interface Design for the Web,' in Proceedings, 1st International Conference on Internationalization of Products and Systems (IWIPS), Girish Probhu and Elisa M. Delgaldo, eds., 22-22 May, 1999, Rochester, NY, Backhouse Press, Rochester, NY, USA, ISBN: 0-965691-2-2, pp. 165-172.

Marcus, Aaron, 'Metaphors in User-Interface Design,' ACM SIGDOC (Special Interest Group on Documentation), Vol, X, No. Y, May 1998, pp. MM-NN.

Marcus, Aaron, 'Principles of Effective Visual Communication', in Baecker, Ronald, et al, HCI 2000, Morgan Kaufmann, San Francisco, 1998, http:www.mkp.com, pp. tbd.

Marcus, Aaron, Chapter 19: 'Graphical User Interfaces,' in Helander, M., Landauer, O T.K., and P. Prabhu, P., Eds., Handbook of Human-Computer Interaction, Elsevier Science, B.V., The Hague, Netherlands, 1997, ISBN 0-444-4828-626, pp. 423-44.

Marcus, Aaron, 'Graphic Design for Electronic Documents and User Interfaces', Addison-Wesley, Reading MA, 1992, ISBN: 0-201-54364-8 (also available in Japanese).

Marcus, Aaron, and Emilie W. Gould, 'Crosscurrents: Cultural Dimensions and Global Web User-Interface Design,' Interactions, ACM Publisher, www.acm.org, Vol. 7, No. 4, July/August 2000, pp. 32-46.

Wildbur, Peter, and Michael Burke, Information Graphics: Innovative Solutions in Contemporary Design, Thames and Hudson, London, 1999, ISBN 0-500-28077-0. Contains extensive AM+A project figures, including Sabre.

Painting, drawing, designing, decorating, filming, sculpting, making collages, publishing, writing – when all is said and done, creating images.

Images for your dreams, for your eyes, for your mind, for your heart. Javier Mariscal is, above all, a creator of images. Images that look at you, ensnare you. Passionate images that move you, repel you, embrace you. Multiplied images that trap you, free you, overwhelm you. Images that rescue other images for you, images that transport you to the experiences of others, images that pierce you.

But this is not all. From the beginning, advertising, media, objects, messages, art and every day life had a profound impact on him. He creates his world on the basis of these three key features: the choice of images and their media; art and everyday life; the messenger and the receiver.

He does not construct a unidirectional discourse, nor is he stuck in an unambiguous groove. He constructs his world in the age he lives in, and he uses all the tools and possibilities at his command. It is about 'communicating' in the thousand different ways that it can be done today, and to do it in a total way. Thus, all is one and one is all.

Javier Mariscal is not a great specialist in anything, but he has worked in almost every area. He is interested in what is interactive, didactic, alive, participative, in feed-back, in learning, collaboration, movement ...

He constructs his language with many languages. He structures his discourse with many discourses. And even so, his is not an inward burrowing, but rather an outward explosion. It is transferring the abstract to everyday life and turning everyday Life into the abstract.

Javier Mariscal is, in the end, a creator of images, a craftsman of symbols, a communicator.

Javier MARISCAL nace en Valencia en 1950.

Con 19 años le vemos en Valencia publicando El Señor deL Caballito, su primer personaje. En 1971 se traslada a Barcelona, estudia en la escuela Elisava y funda El Rrollo Enmascarado, un comic underground que se vende en la calle. En 1977 realize su primera exposicion individual, Gran Hotel, en la que transforma el espacio en un Hotel multidisciplinar, pudiéndose encontrar cristales pintados, jerseys hechos a mano, objetos de cartón piedra, producto editorial o canapés de colores.

En 1989 es elegido Cobi como mascota olimpica de Barcelona 92 y monta la exposición 100 anos con Mariscal, producida por el mismo. Un barco desguazado y vaciado por dentro sirve de caja pare proponer un recorrido global por los miles de soportes que componen la obra de Mariscal. Aqui ya podemos percibir una mirada, una actitud que nos trace de hilo conductor, de nexo, de crave. Al final, unos ordenadores donde puedes realizer e imprimir tu propio Mariscal da al visitante la posibilidad de llevarse su propia aportacion.

Este mismo año nace Estudio Mariscal.

Junto a un pequeno equipo de colaboradores se instala en una antigua fabrica de curtidos de la época del "vapor". Se comienza a trabajar con los primeros Mac's. Se disenan logotipos, se decoran bares de mode, se investiga en 3D. En 1993 el equipo suma más de 30 personas. Se diseña, junto con Alfredo Arribas, el área infantil Acuarinto, dentro del parque Huis ten Bosch en Nagasaki (Japón). En este proyecto se combine la arquitectura, el interiorismo, la imagen gráfica, la animacion, el merchandising y los nuevos soportes multimedia.

En 1996 Twipsy es elegida mascota de la Exposición Universal Hannover 2.000. Se realize el desarrollo del proyecto corporativo y el de merchandising. En 1998 se funda Muviscal, empresa dedicada a la producción audiovisual. Se produce la serie de dibujos animados Twipsy, que consta de 52 capítulos de 15 minutos. Se trabaja en 3D y animación tradicional, a partir de guiones de Patty Marx. Twipsy es un mensajero de internet que, a través de la confrontacion del mundo real y el ciberespacio, pretende visualizer las nuevas realidades a las audiencias más jóvenes.

En 1999 Estudio Mariscal produce Colors

Este es un espectáculo visual en donde conviven una pantalla de retroproyección, un protagonista-narrador que es un robot (Dimitri), 7 actores que son gimnastas, hacedores de sombras, bailarines y tramoyistas, 4 robots cantantes, una banda sonora y un equipo de luces. Es un cuento en tono de humor en donde se narra la historia de los colores. Actualmente está desarrollando varios proysctos audiovisuales propios en diferentes formatos, un parque tematico y varios proyectos graficos y editoriales. Nunca ha abandonado el aspecto mas artístico de su carrera y su obra ha sido expuesta en numerosas exposiciones individuales y colectivas durante todo este período. También imparte conferencias en distintas partes del mundo, muestra su obra y explica su experiencia profesional a estudiantes de distintas disciplinas.

John McConnell trained at Maidstone College of Art. He began his career in the advertising industry and then spent two years with the design group Tandy Halford Mills.

Between 1963 and 1974 he ran his own practice, serving such clients as British Aluminium, Mitchell Beazley Wates, and the immensely successful fashion store, Biba, whose corporate identity he designed. In 1967, he co-founded the typesetting company Face Photosetting.

He joined Pentagram in 1974. With the partnership, his work has included major corporate identity programmes for clients such as Faber and Faber, Watneys, the Confederation of British Industry and the National Grid Company.

A series of successful design projects has resulted in consultancy appointments by major clients, such as Boots the Chemist and Faber and Faber. As a main board director in charge of design and production at Faber and Faber, he undertakes the planning and commission of more than 300 book jackets a year. His appointment in 1984 to the Boots Company involves him in the production of packaging for the entire range of own-brand, pharmaceutical and optical products and he is now also a member of their Design Executive which controls all other aspects of design.

He is a co-author of two books about Pentagram, *Living by Design* and *Ideas on Design*, and is editor of *Pentagram Papers*, a series of limited edition books on a diverse range of topics. He has won ten silver and two gold awards from the Designers & Art Directors Association (D&AD) and a gold award from the Brno Biennale Graphic Design. In 1985 he received the D&AD President's Award for outstanding contributions to design.

He is a member of the Royal Mail Advisory Committee which selects the designs for pictorial and commemorative British postage stamps, a member of the Alliance Graphique Internationale and a Fellow of the Chartered Society of Designers. He is a past President of D&AD and in 1987 was elected Royal Designer for Industry by the Royal Society of Arts.

Pierre Mendell was born in 1929 in Essen, studied Graphic Design with Armin Hofmann at the College for Design in Basel, and founded the Studio Mendell & Oberer in Munich, Germany with Klaus Oberer in 1961.

The work of the Studio encompasses the development of corporate identity programmes, poster design, book and packaging design and architectural graphics.

He has been awarded the Gold Medal from the Art Directors Club, Germany, the Gold Medal from the Art Directors Club, New York, Best German Poster Grand Prix International de l'Affiche, Paris and the German Poster Grand Prix, among others. His work is represented in the permanent collection of the Museum of Modern Art.

An international exhibit 'L'art pour l'art' Design for Cultural Institutions sponsored by the Goethe Institut is being shown around the world now.

Pierre Mendell is a member of the Alliance Graphique Internationale.

Discovering the essence.
There are only two kinds of graphic design. In the same way as there are only two kinds of art, good and bad. In a sense, even bad graphic design or bad art doesn't exist because badness doesn't count in either sphere. Let us speak only of excellence and what it is that makes it so. I mention graphic design and fine art together not because they are confused sisters – they are not. They do, of course, have a lot in common. Their roots are often intertwined, their effect on knowing eyes similar, their methods of construction occasionally close.

Art and design are simply not the same thing at all. There are many who hold the naïve belief that graphic design which superficially looks like good art in any of its forms must be good graphic design. Not so. Worse is the assumption that graphic design which most closely reminds the viewer of the accepted forms of painting and drawing or sculpture must be the best of graphic design. Not so.

Graphic design is concerned primarily with communications. It demands attention and provokes contemplation about a subject. But the subject is thrust upon the graphic designer by a client in need. The product must be sold, the play attended, the candidate elected. It is not the graphic designer's charge to change direction or invent something arbitrary or irrelevant.

Graphic design is to discover the essence of a client's problem and to then present this essence to the appropriate public without confusion and to command their attention.

Pierre Mendell's posters are remarkable in several respects. It can be said without question that they are good. They are good all the time. They are also quite frequently superb. Why? The work of the Mendell & Oberer Studio is not art. It has no pretensions in this regard. It is not even illustrative in the fine arts sense. Their posters for cultural institutions are simply design at its best.

The most remarkable quality is that Pierre Mendell's design solutions are so interesting and yet so simple. He has managed time and time again to find an essence and then to present that essence without getting in the way.

Pierre Mendell's ability to pinpoint something about a product or subject that is fundamental and visually interesting appears commonplace for him. But this is appearance. It takes deep searching, time, intelligence and talent to be so straightforward.

What makes the results of his work so memorable is that each graphic presentation begins with an idea that grows out of both the subject and a graphic design concept. He recognizes in the subjects for which he is developing a poster the basic forms of design. He then exploits these forms masterfully. Pierre Mendell and the Studio Mendell & Oberer begin with the obvious, finding fresh and original means to do so. But when the obvious is not there to be exploited, then they instinctively know how to turn to the right typeface and strong, clean colours and then how to manipulate them into some of the most visionary graphic arts of our time.

Ivan Chermayeff
Chermayeff & Geismar, New York

Stephanie Nash and Anthony Michael studied Graphic Design at St. Martins School of Art (1978-81). They formed the partnership Michael Nash Associates 12 years ago.

Early work was based around the music industry as Stephanie Nash had worked at Island Records as an in-house designer after graduating. Projects include: Seal, Massive Attack, Bjork, Lisa Stansfield, Neneh Cherry, INXS, The Spice Girls, Skunk Anansie and Finlay Quaye.

The client base soon developed to include fashion. Clients included Jasper Conran, Issey Miyake, Jil Sander, Philip Treacy, Joyce Ma, Patrick Cox and Margaret Howell.

In 1993 the company was commissioned to design the own brand food packaging for the London store Harvey Nichols, an association which continues and has included both the 'Fifth Floor' and 'OXO' restaurants.

In 1996 Stephanie Nash was commissioned by the Royal Mail to design a set of postage stamps commemorating Women of Achievement.

Work continues within the music and fashion industries and the client list has diversified further to include – The National Portrait Gallery, The Globe Theatre, Louis Vuitton, Marc Jacobs, egg, Joy, Models 1, Space NK, Ruby & Millie, Flos, Cassina, Clarks Shoes, Boots, Phaidon, 4th Estate Books and Ian Schraegar Hotels.

Teaching
External assessor to St. Martins M.A. Communication Design; Freelance tutor/Special projects St. Martins B.A. Graphics; Guest Speakers at Croydon College Seminar; Speaker at Icograda Seminar; Guest speakers in Hong Kong for Chartered Society of Designers; Regular D&AD panel judges

Exhibitions
1996 Work included in Design Museum travelling exhibition of British Design
1996 Work included in Glasgow 'Objects of Desire' show
1997 Work included in The British Council travelling exhibition for 'Design In Metal.'
1998 Work included in the British Council travelling exhibition 'British Packaging.'
1998 Work included in 'Powerhouse UK' Exhibition
1999 Work included in 'The Art of Design' - Glasgow Art Fair 99

Awards
D&AD Gold (Harvey Nichols packaging)
D&AD Silver (Individual Christmas pudding Harvey Nichols)
D&AD Silver (Massive Attack CD packaging)
Chartered Society of Designers Minerva Award for Graphic Design
European Art Directors Awards
New York Festivals Grand Award for Graphic Design

Membership of professional bodies
D&AD
AGI

Michael Nash Associates – Client List

Fashion: Louis Vuitton, Marc Jacobs, Jasper Conran, Issey Miyake, Jil Sander, Philip Treacy, Joyce Ma, Patrick Cox, Margaret Howell, Models 1, Byblos

Retail: Harvey Nichols, egg, Boots the Chemist, Clarkes Shoes, Monsoon, Space, NK, Ruby & Millie Joy

Interior Design: Cassina/Philippe Stark Flos

Music: Virgin Records, EMI Records, Sony Records, WEA Records, Polydor Records

Corporate - Art: National Portrait Gallery, Walsall Art Gallery, The Globe Theatre, Royal Mail

Publishing: Phaidon- *Venice & It's Architecture*, *Baroque Baroque*
4th Estate – *The Fifth Floor Cookbook*

Restaurants: Fifth Floor, Oxo, Cafe Milan

Hotels: Ian Schraegar - St. Martins

Marcello Minale, chairman and senior design partner, Minale Tattersfield Design Strategy Group, came to London in 1962 where he joined Young & Rubicam for two years as design director. In 1964 he founded Minale, Tattersfield & Partners with Brian Tattersfield, becoming one of the pioneers of the concept of the multi-disciplinary design consultancy.

A regular jury member and past President (1981-2) of the Designers & Art Directors Association, London, his consultancy has won 13 Silver Awards from the Association and a Gold Award from the Art Directors Club of New York. Together with Brian Tattersfield he was awarded the President's Award from the Designers & Art Directors Association, for his outstanding contribution to British Design. He is a fellow of the Chartered Society of Designers.

Minale Tattersfield's work has been the subject of many prestigious solo exhibitions world-wide, in locations as far flung as Madrid, Milan, Mexico and Tokyo.

Minale has published nine books on design in recent years all of which have become sell-out successes. These include, *The Image Maker*, *The Leader of the Pack*, *How to keep running a successful design company* (now in its third edition) and, *All Together Now*.

Marcello Minale has been described in The Times as "A true force in the design world" and his company, in the Financial Times as, "One of London's brightest practices. Consistent, design-orientated ... execution excellent."

"One should first understand the problem and then allow the solution to develop to a point where it surprises the designer and client alike."

"That true Minale Tattersfield style: though the solutions may be different, the means of arriving at that solution has always been the same – a combination of both intellectual and creative input. Only together can a successful and functional design be achieved."

"It is Minale Tattersfield's philosophy that design should be used to communicate ideas with wit, simplicity and intelligence."

Education
Doctor of Philosophy of Architecture. University of Lund, Sweden, 1995.
MBA. (organization) The Århus School of Business Administration, 1968.

Business
Editor and publisher of Mobilia Design Magazine, 1974-84.
Editor and Publisher of Tools Design Journal, 1984-88.
Founder and sole proprietor of Per Mollerup Designlab A/S, a design firm
specialising in visual communication.

Literature
Design for Life, 1986 (new issue in Sweden 1996), *The Corporate Design
Programme*, 1987 (also published in Finland), *Rational Letter Design*, 1989,
Good Enough is not Enough, 1992, *The Visible Company*, 1993 (also
published in Sweden and Germany). Marks of Excellence (thesis),
London 1997.

Contributions to anthologies
Articles in newspapers and trade journals in several countries.
Planning of and participation in programmes on radio and TV.
Lectures in several countries.

Honorary offices
National chairman for the Danish Society of Book Crafts 1988-93.

Prizes and grants
The IG prize, Danish Design Council's prize for excellent graphic design
1987, 1998, 1991, 1992, 1993 (twice), 1994, 1995 and 1998.
Grant in memory of Knud V. Engelhardt 1986.
The Thorvald Bindesbøll Medal 1996
The Year Prize of Danish Society of Book Crafts 1998.
The Swedish/Danish Cultural Prize, 2000

Perhaps the greatest turning point in Monguzzi's career was his encounter and subsequent relationship with Antonio Boggeri and Studio Boggeri in Milan. It was here that the true maturation of Bruno Monguzzi as a bona fide visual communicator took place. He encountered an environment that tested and melded all his natural and intellectual skills into a potent tool. "It was still in London that, in the second issue of the Neue Grafik magazine, I was struck by the works of the Milanese Studio Boggeri, a design office that was run by a musician. I had to meet this man. The day I was 20 (I do not like birthdays), I flew to Milan. The elevator of Piazza Duse 3 was tiny, slow, and shaky. During the long ascent to the fifth floor I felt a bit uneasy. This sensation was to last for the following two years. I had fallen in love with the man, his ideas, the office overlooking the public garden. The first weeks were difficult. I used to work also at home at night, trying desperately to be good enough to be kept there."

Studio Boggeri, before Monguzzi, had been staffed by famed Swiss designers like Max Huber, Carlo Vivarelli, Walter Ballmer, and Aldo Calabresi. While many Swiss designers of his generation looked to German-speaking northern Switzerland to start careers, Monguzzi looked to Italy, a country with which he had a shared language and culture. From the first day, Boggeri gave him real projects demanding real problem solving skills. Boggeri chose his staff because he believed in their ability to solve problems swiftly and effectively. He never gave ideas and opinions to his designers; instead he presented the objective and the priorities needed to solve the problems at hand. The designer had the task of figuring out the solution while communicating effectively and artfully. Designers were rarely called into his office except for project reviews and the dispensing of information. One afternoon not long after he started working, Boggeri summoned Monguzzi for a little chat. Not to his surprise, thoughts of impending doom and the 'shortest career ever' ran through his mind. Boggeri had sometimes complained about Swiss designers being slow.

For Monguzzi, due to his unfulfilled quest for clarification about graphic design and visual communication, Studio Boggeri represented the last check before deciding whether to pursue another profession. Understandably he was apprehensive about stepping into the 'office,' but what he heard from Antonio Boggeri was the answer he had been looking for all along. "Lowering his thin face (he was very tall) and lifting his lean, long hands the most beautiful hands I have ever seen – he began to talk about spider webs, all kinds of spider webs. I thought that this was a strange introduction to fire someone. He went on and on for quite some time, or at least so it seemed to me, and finally he mentioned that Swiss graphic design was often as perfect as any spider's web. But often of a useless perfection. The web, he

stated, was useful only when broken by the entangled fly. It was so that, upon Boggeri's instigation, began for me the slow, long, difficult hunt, in the sterilized universe of a Swiss education, for an improbable fly."

"Perfection was not enough. The desterilization of Calvinist rigour was an additional problem I hadn't anticipated. To the construction of anonymous information, so diligently learned and pursued, I now had to integrate a need that was alien to me at the time, the need for the Cassandrian 'spectacle dans la rue' that Boggeri, a refined man, required at all times."

Working beside the seasoned Aldo Calabresi at Studio Boggeri, Monguzzi learned quickly and properly, providing exquisite, meaningful, and lasting solutions to projects that crossed his table. Calabresi, who is Swiss with family origins from Ticino, had studied design in Zürich. He was instrumental in the growth of Monguzzi as a visual communicator, showing him by example how to weave his very person, culture, and learned principles to communicate effectively. "Before me, behind very thick lenses and surrounded by a constant buzz, sat Aldo Calabresi. To my great admiration and envy, myopic as he was, he was a master of massacring flies. His work sharply marked the fusion of the two cultures – the Swiss, logical and constructive, and the Italian, poetic and anarchical. It was primarily because of Aldo that a fly or two began to buzz in my direction, at last breaking my painstakingly constructed web. Leaving the shattered grid to the Freudians, the fly seems to be the identity I have sought in my work ever since. This identity, perhaps, is innate or ingrained in this little triangle of Helvetian earth infiltrating the soil of Lombardy, where the people are too Italian to be really Swiss, but too Swiss to be considered truly Italian."

From the essay A Poet of Form and Function by Frank Nunoo-Quarcoo, published in *Bruno Monguzzi. A Designer's Perspective*. Issues in Cultural Theory 2, University of Maryland, Baltimore County 1998

Year of birth 1940.
Study of communication design at the College of Design in Ulm (Germany);
From 1967 to 1972.
Co-designer of Otl Aicher and deputy chief of the corporate design for the
Olympic Games in Munich in 1972.
since 1972 owner of the studio 'Buro Rolf Müller'.

Member of the Deutsche Werkbund (German Board of Arts and Crafts)
and member of the board of Werkbund Bayern, member and co-founder
of the Design Zentrum München (Centre of Design in Munich), member
of AGI (Alliance Graphique Internationale) and its International President
in the period of 1991 to 1993.

Posters exhibited in: Museum of Modern Art, New York; German Museum
of Posters in Essen; Neue Sammlung München.

First prizes
Kieler Woche 1972 (special week of events in Kiel),
information and signage system of the University of Regensburg,
information and signage system of the city administration centre in Bonn,
logo for the German Chamber of Commerce,
logo for the 3rd Television channel in Hessen,
BA (International Exhibition of Architecture) Emscherpark,
EXPO 2000 Pfad, EXPO 2000 Sachsen-Anhalt,
corporate design of the city of Kufstein.

Other prizes and awards
Graphic design Germany 1978.
Stuttgarter Buchwoche 1982 (Exposition of Books in Stuttgart), Triennale '83
German Museum of Posters.
Exhibition of Calenders in Stuttgart (Germany), 1983.
Biennale Exhibition of Posters in Warsaw, 1984.
International Gallery of Superb Printing, 1985.
Golden Medal of the Art Directors Club of New York, 1989.
German Prize for Communication Design, 1993.
Award for the Highest Quality of Design, Institution of Bookart: The most
beautiful books of the year 1995.

One-man exhibitions
Academy of Graphic Design in Munich, 1982;

Travelling exhibitions
Typography and visual identity in Munich, Berlin, Frankfurt, Düsseldorf,

Bielefeld, Leverkusen, Hamburg and Stuttgart in 1985;
Participation in exhibitions e.g Zgraf 2, Zagreb Exhibition of Graphic
Design with international participation, 1978,
AGI Posters Montreal, 1982;

Worked as teacher
College of Graphic Design in Zürich (Switzerland) and College of Design
in Schwäbisch-Gmünd (Germany) - several times for both institutions,
Rhode Island School of Design, Providence, USA.

Seminars, lectures, events
1st German Day of Designers, 1977, IDZ Berlin; (International Centre
of Design), 1982; Design and Art College, Halifax, Canada, 1982;
Icograda Students Seminar, London, 1983; IDCA (International Design
Conference Aspen), 1983 and 1996; Public Design, (Frankfurt) 1985;
Zgraf 7: Zagreb 1995.

Publications
Typography today, Tokyo 1983
Idea special edition: Graphic Design in Germany,
Form (German design magazine) (several times),
Novum (German graphic design magazine)(several times);
Ruedi Rüegg/Godi Frohlich:
'Typographische Grundlagen' (Basics of typography)
Rudolph de Harak
Posters by Members of AGI,
Rizzoli New York

Jury member
Graphic Design Germany,1974,
Kieler Woche (special week in Kiel, Germany), 1974,
'Gute Form' 1984
Zgraf 7, 1995, Zagreb

All awards, exhibitions and lectures, which are in context with the work as
a deputy chief for the corporate design of the Olympic Games in Munich in
1972, are not mentioned.

Bruno Oldani has exerted a major influence on developments in graphic design in Norway, both as a practitioner and as a teacher at the National College of Art and Design. Oldani, who was born in Switzerland in 1936, settled in Norway in 1958.

In its nomination, the Jacob Prize jury described him as a talented orchestrator and communicator, i.e. capable of creating the basic conditions for his design activities and getting his message across. He is original, startling, unpredictable, unconventional and uninhibited in his form of artistic expression. His work bears the stamp of psychological insight and empathy, and he undoubtedly ranks as one of the leading figures in the field of graphic design.

Bruno Oldani was awarded a diploma in communication design by the Kunstgewerbeschule in Zürich, where he also took supplementary courses in fashion, illustration and chromatology. He has also studied industrial design at the National College of Art and Design in Oslo.

During the period 1958-64 he worked as a graphic designer, art director and creative director at a number of advertising agencies. In 1965 he established his own design practice, which has, since then, had an average of 4-6 employees. During the period 1980-84, he taught communication subjects in the industrial design section of the National College of Art and Design. Later (1988-94) he taught, as a professor, at the College's Institute for Graphic Design. Bruno Oldani works within the fields of communication design, graphic and typographic design, illustrations, book covers, record/album covers, corporate identity, packaging, editorial design for newspapers, magazines and journals, signs and information systems, TV graphics, exhibition design, etc. His work also extends to industrial design, interior design, AV programmes and photography.

Oldani was awarded the Norwegian Marketing Federation's Golden Pencil in 1966; the Federation of Norwegian Industry's prize for book design in 1969; the Spelemann Prize for record cover design in 1980; and the Municipality of Oslo's cultural grant in 1987; Gold Medal for FlyToget (Airport Express Train) Oslo, 1998 and The Norwegian Design Council's Classic Award for Excellent Design 2000. He has also won numerous national and international design prizes for book design and postage stamp design, logotypes, posters, TV graphics, ski design, etc.

His work has been f featured in international journals, such as Graphis (both in its US and Swiss editions), and in presentations such as Top Symbols and Trademarks of the World, Italy; AGI Posters, Italy; World Trademarks and Logotypes II, Japan; World Graphis Design Posters, Japan;

Campaign 'European Report', England; Creative Review, England; High Quality, Germany; and Novum, Germany.

Bruno Oldani's work has been displayed at exhibitions in Kiel, Amsterdam, Munich, Rio de Janeiro, Ljubljana, Lyons, Lahti, Seoul, at the Henie-Onstad Art Center and at the Museum of Applied Art in Oslo. He has delivered lectures and presented his work in organisations and at seminars, including UNEP (United Nations' Environment Programme), Nairobi; Icograda's student seminar in London, under the theme 'Sequential Design'; the ICSID seminar in Takaoka/Toyama, Japan; and at the American Institute of Graphic Arts under the theme 'Globalism'. He has been a member of the Alliance Graphique International (AGI) since 1976, was a board member from 1988 until 1993. He was the driving force behind the AGI Congress held in Oslo in 1992, and he is an honorary member of Grafill (the Norwegian organization for graphic designers and illustrators).

Bruno Oldani has served as a jury member for several competitions; the Most Beautiful Books of the Year, Form (selected Norwegian advertising work), and others. He was an LOOC member of the advisory project group (design) for the Winter Olympics in Lillehammer. He has been a member of the diploma jury at the Ecole Supérieur in Paris, a jury member at the Children's Book Fair in Bologna, and a member of the international jury for the 6th International Award Competition of the Art Directors Club Inc., New York. He is a jury member for Norsk Form, Oslo.

A new set of banknotes designed by R.D.E. Oxenaar for the Netherlands Bank in close co-operation with the printers Joh. Enschede en Zonen Imp. strikes a more modern note than almost any other paper currency. The colours are fairly bright, especially in the lower values, to permit easy distinction; typography and layout are of exemplary clarity. The whole series forms an unmistakable unity, especially as the notes are all of the same height to facilitate wallet storage and machine quality control. The fine linear patterns were made with a computer-controlled drawing arm. The printing process is a combination of offset, letterpress and gravure. The portraits of famous Dutchmen (such as Frans Hals or Spinoza) are produced with fine computer lines and coarser engraved lines and are near caricature in expression to underline their individuality. Relief points in the white margin to enable visually impaired users to distinguish the values were here used for the first time.

B. Martin Pedersen was born in 1937, raised in Norway and came to the United States a few years after the war. Upon graduating from Brooklyn Technical High School his intent was to become a civil engineer, however after apprenticing in an engineering firm he decided to change his professional interest towards advertising and design. He started as an apprentice at Benton and Bowles Advertising Agency wrapping packages and in the evenings studied advertising at the School of Visual Arts.

After having worked in a number of advertising agencies, he then joined the celebrated design and advertising department of Geigy pharmaceuticals. In 1966, he was made Corporate Design Director of American Airlines. Two years later, he opened his own firm, Pedersen Design Inc., gaining early recognition for award-winning work in all categories of design.

In 1976, Mr. Pedersen joined forces with Kit and Linda Hinrichs and Vance Jonson; the arrival of Neil Shakery in 1978 marked the beginning of the Jonson Pedersen Hinrichs & Shakery design association with corporate offices in New York and San Francisco. In this same year, Mr. Pedersen also initiated and developed a new publication and publishing venture called Nautical Quarterly.

In 1986 Mr. Pedersen purchased Graphis Press, an international publishing firm that produces a high quality magazine, as well as books and annuals, for the communications industry.

Mr. Pedersen has received over 300 major awards for his creative work from the American Institute of Graphic Arts, the New York Art Directors Club, the Society of Publication Designers, the Society of Illustrators and The Type Directors Club of New York amongst others.

Some of these include the first Herb Lubalin Memorial Award for contribution to editorial design from the Society of Publication Designers, the Columbia University National Magazine Award for the best designed magazine in the industry, awarded by the American Society of Magazine Editors, numerous gold and eight silver awards from the New York Art Directors Club and Best of Show award two years in a row from the International Editorial Design Awards Show.

His work over the years has included annual reports, corporate identity and sales literature for Dow Jones & Co., Eastern Airlines, American Airlines, McGraw Hill, Henson Assoc. (Muppets), Seagrams, Volkswagen, Champion Paper, Hopper Paper, Martex, Bell Labs, Syracuse University, American Express, IBM, Citicorp Venture Capital, and numerous magazines.

Some of the magazines were new ventures and most were consistent award winners. 'Nautical Quarterly', a magazine Mr. Pedersen started, achieved every award the industry had to offer. 'Business Week's re-design for McGraw Hill increased sales by an astounding 30 per cent. Mr. Pedersen has also been a consultant for numerous publishing firms and new ventures in publishing.

Mr. Pedersen has taught at schools and universities throughout the United States and has been a frequent lecturer at design conferences and seminars. He has also served as chairman and juror for numerous major design shows and graphic competitions. Mr. Pedersen is a past President of the Type Directors Club and has also served on the Board of Directors for the New York Art Directors Club and The American Institute of Graphic Arts.

Some exhibitions of his work include a one man show at the Charlottenberg Museum in Copenhagen, Denmark, the Herning Kunst Museum, Herning, Denmark, and the Klostertorv 9 Gallery for Design and Architecture, Aarhus, Denmark.

His work has been also shown in The Whitney Museum, New York, Art From 50 Top International Designers (sponsored by The American Institute of Graphic Arts).

In 1997 he was elected to the Art Directors Hall of Fame and is also a member of AGI (Alliance Graphique Internationale), The Society of Illustrators, and is listed in Who's Who in Graphic Design as well as Who's Who registry of Business Leaders Worldwide.

Mr. Pedersen's interests also expand into flying and sailing with numerous Bermuda passages. He currently has a 50 Ton Masters License from the U.S. Coast Guard for sail and powered vessels and is also a Licensed Instrument Rated Airplane Pilot.

Born in Gloucestershire, England, in 1938, David Pelham studied at Glasgow School of Art and St Martin's School of Art, London. After graduating he began his career in the late fifties, designing magazines and books. Appointed Art Editor of the art magazine Studio International in 1962, he worked closely with many of the leading painters, print-makers and sculptors of the day.

After a five-year spell as Art Director of the European edition of Harpers Bazaar he was appointed Art Director of Penguin Books. During his 12 years with Penguin he wrote and designed his award-winning international best-seller *The Penguin Book of Kites*. This was translated into nine foreign language editions. Leaving Penguin in 1980 to concentrate on writing and designing his own books, in 1982 he was awarded the Gold Award for book design by the Designers and Art Directors Association of London.

In that same year, in collaboration with Dr Jonathan Miller, Pelham co-authored and designed the hugely successful pop-up book *The Human Body*. Essentially the first seriously intentioned pop-up book, it appealed to a new and wider market, inspiring many imitators. *The Human Body* won him many awards, including the Gold Award of the Art Directors Club of New York, the Book of the Year Award at the 1983 Frankfurt Book Fair, and has gone on to sell over two million copies world-wide.

In 1984 Pelham pursued his interest in pop-up and novelty books by accepting the position of creative director with Intervisual Books in Los Angeles. A number of well-known titles resulted from this collaboration, including 'The Universe', written by Heather Couper, and which is still considered to be the most complex pop-up book ever devised.

After three years or so commuting between his offices in Los Angeles and the UK, Pelham spent some time in the USA and Mexico, creating the largest pop-up ever made. This was his very popular anatomical figure 'Dimensional Man', a life-size wall chart which is to be seen in doctor's surgeries and medical establishments the world over.

The author of over 30 titles, he now works exclusively in London, where he continues to write and design a wide variety of books for children, among the most popular of which is his 'Sam' series. This includes such titles as *Sam's Sandwich* and *The Sensational Sam-burger*. He is currently working on a sequel to his latest success, *Say Cheese!*

In his work as a designer and strategist Michael Peters has demonstrated that design is a proven means to increased profitability. He has consistently emphasized the importance of aesthetic quality applied to the highest standards of creative thinking. His work has revolutionized the relationship between design and business.

He graduated from Yale with a Master of Fine Arts Degree, having studied under tutors such as Paul Rand, Alvin Eisenann and Josef Albers. After Yale, he worked for CBS television in New York. Returning to London in 1965 he set up the design department for the advertising agency Collett, Dickenson and Pearce, taking over the reins from David Puttnam.

In 1970 at the age of 29, Michael Peters set up his own company, Michael Peters and Partners, which revolutionized the role of packaging in the marketing of consumer products. In 1983 he changed the perceptions of design by leading the company onto the USM, and by 1989 the company had an annual turnover in excess of £45 million. Clients included the BBC, British Airways, the Conservative Party, Redland, ITV, United Distillers, Unilever and many more.

In November 1990, Michael Peters was awarded the OBE (the Order of the British Empire) by the Queen for his services to design and marketing.

Michael Peters founded The Identica Partnership in 1992 in the belief that brands are fundamental to the success or failure of businesses as they approach the next century. Identica specializes in the creation, development, management and design of brands. Clients include among others Boots, Bristol 2000, Co-op, One 2 One, Seagram and United Distillers.

Michael Peters has lectured world-wide and written numerous articles on design and its importance as a marketing tool especially in the development of export markets.

Graphic design consultant Woody Pirtle's logos, posters, environmental graphics and corporate communications are often published as some of the best examples of their kind.

Woody's identity and publication designs deliver corporate messages with visual elegance and inventiveness, and his economical and witty logotypes, packaging, and posters demonstrate a refined graphic sensibility. His current and past clients include Amnesty International, Allen & Company, Neiman Marcus, Nine West, United Technologies Corporation, Upper & Lower Case magazine, Rizzoli Publishing, Mohawk Paper Mills, Pfaltzgraff, the Rockefeller Foundation, and the World Cup 1994 Organizing Committee. Woody's recent projects include signage for Fuji Television's new headquarters building on Tokyo Bay, Japan, and the identity for 1998's Greater New York Centennial Celebration.

As his influential work has continued to set new standards for design excellence, Woody has been appointed to design advisory boards of several corporations and has been consultant to Pantone, IBM and Champion International.

His work has been exhibited worldwide and is in the permanent collections of the Museum of Modern Art and Cooper-Hewitt National Design Museum in New York, the Victoria and Albert Museum in London, the Neue Sammlung Museum in Munich, and the Zürich Poster Museum. A book on his work was published in 1999 by China Youth Press. Woody has taught at the School of Visual Arts, is a member of the Alliance Graphique Internationale, and has served on the board of HOW magazine and the American Institute of Graphic Arts.

Ten years after leaving Dallas for New York, this remarkably talented designer still relies on this basic impulse to 'keep it simple' by cutting through the extraneous, so that the idea comes through as though it were inevitable.

Actually, Pirtle is not originally from the Lone Star State. A native of Shreveport, Louisiana, he studied fine art and architecture at the University of Arkansas before moving back to his hometown to begin his design career. In 1968 he moved to Texas where he worked in an advertising agency in alias for a year, before landing a job with the Richards Group. It was during the nine years he spent in Dallas with the Richards Group that his work began to be recognized internationally. In 1978 he decided to go out on his own and founded Pirtle Design. By then his reputation was firmly in place, and he was in demand. The renowned Pentagram Design Office asked him to join their team.

After a ten-year courtship, Pirtle took them up on their proposal. In 1998 he left the wide country and moved to the tall city, as a partner in Pentagram's New York office. Pirtle was a natural choice for Pentagram. Since its inception the partners in the firm have always been celebrated for their ability to create work that is appropriate to the problem at hand without regard for design movements or fads. Pirtle is in that mode. There is nothing trendy about his work. Rather, it has a classic feeling. "I've always been very conscious about trying to do work that is timeless", he says, "I don't want to have a date pinned on it simply because it fits into a particular style. I'm not suggesting that style isn't a major component of my design. It certainly is. But I believe the style should fit the client".

According to Pirtle, this process begins with relevance. First he forges an idea that is relevant to the client's needs. Then comes a style that is driven by the concept. "I'm lucky enough to be able to draw and create my own images. With my ability to visualize in different ways, the style can be driven by the concept and not by my limitations. It gives me a number of ways to realize the same idea". An obstacle to relevance, according to Pirtle, is the computer. "A lot of younger designers seem to be using technology as a substitute for ideas. Technology has somehow become the idea. I'm hoping our familiarity with computers will grow to where we can concentrate again on simple, clear-thinking communication, unencumbered by bells and whistles."

Pirtle feels that being at Pentagram keeps his battery charged, not only by being surrounded by young people, but because of the competition and nurturing between the partners. "I like the collaboration, the mix of old and young. As I get older I've found that age makes you ... no, forces you, to make changes. You have to make changes to allow you to continue, to be relevant."

Paul, who's originally from Gibraltar, studied Art & Design both in London and Madrid before joining Fitch Design Consultancy London, in 1988, as a designer.

After two years he moved to Imagination, designing many high-profile international projects, from book design to the award-winning Dinosaur Gallery at the Natural History Museum in London. In 1995 he moved to The Body Shop as Creative Manager, and deputy Creative Director.

His brief there, from Jon Turner, has been to bring The Body Shop brand up to date: this has included the introduction of photography, where once only illustration was used. The stores now have Magnum reportage images for signage, and their make-up is promoted using the latest international photographic talent.

Outside the retail environment, he has worked on many high-profile campaigns with Amnesty International on human rights and, most recently, in support of the farming and use of marijuana's controversial cousin, hemp.

At this year's Icograda talk, Paul was invited to speak about Global Responsibility in Design. The talk covered not only the campaigning designs for which The Body Shop is well known and respected, but also the more subtle issues surrounding designers' ethical responsibilities.

The images and words created in The Body Shop Design Studio in London by his design team are seen all over the world, in 23 countries, in 45 languages, by millions of people. The work shows their commitment to celebrating people through design. The 'real people' policy used, for example, in the make-up images, means that the 'models' are always street-cast, and are not from agencies. They always challenge perceptions of race and sexuality, which has often lead to controversy, and they always try and communicate with a sense of humour.

11.12.1955 geboren in Essen
1976-1981 Studium der 'Visuellen Kommunikation'
1979-1980 Grafiker in der Redaktion 'Architektur und Wohnen',
Tahreszeiten Verlag, Hamburg
1980-1983 Assistent des Art Directors
'Frankfurter Allgemeine Magazin',
Frankfurter Allgemeine Zeitung GmbH
1983 Mitarbeit im Push Pin Studio, New York
1983 Art Director
Redaktion 'Petra',
Jahreszeiten Verlag, Hamburg
1983-1994 Art Director
'Frankfurter Allgemeine Magazin',
Frankfurter Allgemeine Zeitung GmbH
seit 1994
Professor an der Staatlichen Akademie der Bildenden Künste Stuttgart
seit 1996
Chefredakteur und Art-Director der Zeitschrift 'Future'
1998 rundung der Agentur 'Lettera'

Mitgliedschaften
Alliance Graphique Internationale (AGI)
Deutsche Gesellschaft für Photographie (DGPh)
Art Directors Club New York
Art Directors Club Deutschland

Auszeichnungen
Dr. Erich Salomon Preis
Preis des International Center of Photography (ICP), New York
Gold- und Silbermedaillen sowie Auszeichnungen des Art Directors Club
New York
Silber- und Bronzemedaillen, Art Directors Club Deutschland
Gold- und Silbermedaillen, Society of Publication Design (SPD), New York
Silbermedaillen, Art Directors Club Kanada
Goldmedaillen, Society of Illustrators, New York
Medienmann des Jahres 1984
Preis des Kultusministeriums der Tschechoslowakei (CSSR)

Robert Probst has been a professor of Graphic Design at the College of Design, Architecture, Art, and Planning, University of Cincinnati since 1978. He is also one of four principals in the multi-disciplinary design collaborative Firehouse Design Team.

The scope of his work spans a wide range: from two-dimensional graphics, promotional and identity design, multi-dimensional interpretive exhibition work, architectural signage and environmental design to wayfinding systems and product development. His more than 20 years of professional experience is based on work for cultural, historical, zoological, educational and municipal institutions as well as for the private industry sector.

Robert Probst's academic and professional work is featured in numerous national and international publications. He has received many awards from professional organizations. He has lectured at institutions and international conferences in the United States, Mexico, England, Spain, Germany and Switzerland. His work is included in the permanent collections of the Ohio Arts Council, the Cooper-Hewitt National Museum for Design in New York and The National Museum of Modern Art in Tokyo. He has served on the Board of Directors of the International Society for Environmental Graphic Design for four years and as President of its Education Foundation for two years. In 1996 he was named Fellow of the SEGD. In 1997 he was elected a member of the AGI (Alliance Graphique Internationale).

Robert Probst is a graduate of the University of Essen, Germany and the College of Design, Basel, Switzerland. He began his professional career in the renowned studio for visual communication of Otl Aicher in Germany in 1975.

What separates design from fine arts is its interdependence with commerce. The magnitude of commercial information accessible today makes an irrefutable case for why designed communication is critical. In my research, creative and scholarly work I have focused on the general area of information design with the objective of reducing noise in the communication channels, by eliminating extraneous content, by simplifying formal options and by narrowing possible interpretations. To understand contemporary visual language, many projects must be explored. I have specifically investigated issues concerning identity design for corporations, institutions, spaces and places. I have also explored the complex issues concerning wayfinding and environmental design relative to architectural settings and urban landscapes. Exhibition design is another topic of interest. The thematic area of pictorial imagery, icon design, has been the focus of personal investigations throughout my professional career and has been a recurring subject in almost all of my work.

I hope you will forgive me my poor English, for I decided to use it rather than a good translation, to keep the communication between you and me as straight as possible.

I'm coming from a nowhere place, a little town at the very end of Britany in a department called Finistère, from the latin finis terrae that means land's end. That means in fact 600 miles from Paris and 700 miles from the next border.

I settled there in 1972 with the aim to develop what I believed would be a graphic design of my own, or more precisely a poster design of my own.

To do this in France did not look serious especially when you know how centralised this country is, but in my mind this decision was very logical regarding my theories about poster design.

1. Poster design is not just an illustration of a concept decided by somebody else, you have to follow. I wanted to develop and control the creation of the work from the beginning to the end.
2. Poster design is free. The subject of a poster can't be bad. Only your answer can be, and no one can oblige you to make a bad answer. But no one can oblige the client to accept your proposition.
3. Poster design is art, the aim is not the client to be satisfied by your proposition. The aim is to make you satisfied, and that is much harder. If you are asked for a bicycle, don't be afraid to sell a Rolls Royce.

So if you feel you are making art, don't care about the price of your work, the main thing is to make it exist. Don't care about the size of your client the main thing is that he understands you.

Thinking like this, I was following a kind of utopia based on a physical love for the street poster. I was attracted by the power to colour a town with a message of my own. This media was adapted to my exhibitionist nature, obliging people to see my work to read my message. I enjoyed its cheap paper, that you can tear or destroy so easily, I enjoyed its short lived nature.

I used to compare a poster to a butterfly. In summertime, you are lying on the grass when you see a beautiful butterfly flying around you.

You want to get closer to look at it better but when you do it flies away. So the next you bring a net to catch it and when you have it pinned up in your living room, you have plenty of time to admire it, but it is dead. A poster in a museum is a dead butterfly.

So, during 25 years I have been fighting very hard to make that utopia a reality. In my nowhere land. With a total blind faith and a childish romantic spirit.

Twenty years after I started, one could say I succeeded in my task, but this relative success is nothing but a poisoned gift and with the age my judgement about my work is becoming more and more critical. I have the strange feeling that my whole action was a failure from the beginning.

1. To choose Poster as the media of my expression was wrong. Poster is a vanishing media from the past century. And today nearly nobody cares seriously about it.
2. Graphic design can't be free, it is connected to the command and the intelligence of your work depends on the intelligence of your client who allows it to exist or not?
3. Graphic design is a stream you need to be in, at the right time, at the right place. You may imagine modifyimg the direction of the stream only if you are in it.

The will of creating a graphic design out of nothing was a utopia. I wanted my work to be revolutionary and I discover that it is in the continuation of the tradition out of which I wanted to escape.

Thank you to the Icograda for the honour of inviting me. Whether you will like my work or not I would like you to look at it as a perfect example not to follow. And I mean it very seriously.

My situation is hopeless, and the only way for me is to keep going on fighting for this utopia in this wrong way until my near end.

There are few great poster artists – it's not an easy thing to do. It requires more than just skill, because it's a matter of communication, and for that, concept counts no less than virtuosity of form. Rarely are the two combined.

Gunter Rambow is among the greats, with what he calls his visual metaphors, where the chosen object becomes a symbol magnified by the mastery of execution.

After the ink drawings of his beginnings, Rambow turned to photography. He has run the gamut of its possibilities, from the crystal clarity of his street scenes for the Frankfurt theatre to the most sophisticated montage works, like those for S. Fischer Verlag.

But Rambow's originality is the art of constructing object-symbols, which he photographs after assembling them in his mind. He creates poetry, introduces drama into banal objects. An excellent example is his treatment of the potato, the archetype of German food (Museum Wiesbaden).

Stripped of everything superfluous, the posters have a dramatic intensity that cannot be ignored. They are immediately and clearly legible. The broken pencils forming a swastika for 'Pen in Exile', the spot of blood on a bandaged hand for 'Südafrikanisches Roulette', are unforgettable images.

The rigour of his thinking – and therefore of his system – hews increasingly to essentials. The latest creations I have seen bear witness: the cut T-shirts of 'BA-TSU" and the faces enclosed in the obsessional typography of 'Deutschland den Deutschen' are at once minimalist and inescapable. Rambow has attained that which goes beyond all commentary and is probably the summit of graphic art: sheer visibility.

Alain Weill on Gunter Rambow

Gunter Rambow was born in Nuestrelitz, Germany in 1938. He studied glass painting at the National Glass Technical School of Hadamar from 1955 to 1958. He graduated from the Fine Art College of Kassel in 1963. He taught graphic design at the Comprehensive College of Kassel in 1973 and graphic communication at the University of Kassel from 1987. Currently, he is a professor at the Hochscule für Gestaltung Karlsruhe. His major awards include the Gold prize at the Warsaw International Poster Bienniale (1981), the Grand Prix at the Lahti International Poster Bienniale (1985), the Gold Medal at German Designer Club for television design (1992) and the Gold Prize from the Tokyo ADC (1996). His works are among the permanent collections of the Museum of Modern Art, New York, the Stedelijk Museum, Amsterdam and the others.

David Redhead is a writer, author, curator and consultant and one of Britain's leading authorities on the design industry. A former editor of the Design Council's magazine *Design*, and Managing Editor of *Blueprint*, his articles have appeared in newspapers and magazines including *The Guardian*, *The Independent* and *The Independent on Sunday*, *The Sunday Times*, *The Daily Telegraph*, *The Sunday Telegraph*, *The Scotsman* and *Later*. In 1999, he curated *Identity Crisis*, a major exhibition which marked the finale of the Glasgow 1999 Festival of Design and Architecture. Redhead's book *Products of our Time* (August Birkhäuser), a history of the nineties in objects was published in 1999.

Dan Reisinger was born in Yugoslavia and has lived in Israel since 1949.

He graduated from Bezalel Academy (Jerusalem) and Central School of Art (London) and has worked in Brussels, London, Paris and New York. He has had a permanent studio in Tel Aviv since 1966.

Reisinger began his career as a poster artist and painter. His design activities expanded to include corporate identities for leading companies and national institutions in Israel as well as award-winning calendars and environmental design. As a painter he is best known for the series of 53 paintings, 'The Scrolls of Fire', which are on permanent view at the Diaspora Museum in Tel Aviv.

Reisinger previously taught at Bezalel Academy of Art and Haifa University and currently functions as vice Dean and head of the department of design in Ort College of Architecture and Design, Tel Aviv.

He has served as consultant to the Bank of Israel; Society of Beautiful Israel; Israel Air Force; Mayor of Tel Aviv; Slim Fast (New York).

He is a member of AGI (Alliance Graphique Internationale), Art Directors Club of New York and the Academy of Design in Moscow.

Selected exhibitions
Israel Museum, Jerusalem, 1976
Tel Aviv Museum of Art, 1977
Beit Haffutsot Museum, 1978
Jewish Museum, N.Y., 1980
Mabat Gallery, T.A., 1986
Belgrade Museum of Contemporary Art, 1989
National Museum of Art, Tokyo, 1990
International Typeface Corporation, N.Y., 1991
Amalya Arbel Gallery, T.A., 1994
Mertopolitan Autonomous University, Mexico City, 1997
International Exhibition of Art and Design, Shanghai, 1999
Israel Museum, Jerusalem, 1999.

Prizes and awards
Israel Prize for Design, 1998 – the highest state honour for achievements in Sciences, Arts and Literature.
Gold medals – Stuttgart annual calendar competition.
Olympic Committee Award, 1992 – sports artist of the year.
Bezalel prize, 1984 – first alumni award for exellence in design.
Herzl prize, 1981 – for contribution to design in Israel.
Nordau prize, 1975 – for design.
Expo '58 Brussels, 1st prize – official poster for International Science Pavilion.
Struck prize, 1954 – outstanding Bezalel student award.

Peter Saville is one of the most important designers working today. Since making his name 20 years ago as art director and co-founder of Factory Records, the legendary independent record label, he has created iconic graphics for such bands as Joy Division, New Order, Suede and Pulp. Saville has also worked extensively in the fashion industry for designers including Jil Sander, Yohji Yamamoto and Christian Dior, as well as executing corporate identity projects for ABC Television, Mandarina Duck and Mercedes-Benz.

In the visual arts, Peter Saville's clients have included the Whitechapel Art Gallery and Natural History Museum in London and Centre Georges Pompidou in Paris. He now concentrates on his own creative projects and consulting for corporate clients on branding and identity issues, and the development of fashion multimedia.

Together with Nick Knight, Saville is co-founder and co-curator of SHOWstudio.com, one of the year's most talked-about internet projects. After its September launch, SHOWstudio will showcase fashion, art, design and entertainment projects created exclusively for the site by contributors such as Juergen Teller, Alexander McQueen, Sølve Sundsbø and Marc Newson. Saville conceives SHOWstudio.com as a multimedia workshop which will set new visual standards for the internet.

Paula Scher studied at the Tyler School of Art in Philadelphia and began her graphic design career as a record cover Art Director at both Atlantic and CBS Records in the seventies. From 1984, she co-founded and ran Koppel & Scher in New York for seven years, then joined Pentagram as a principal in 1991.

In the seventies and early eighties Scher's eclectic period-oriented typography for records and books became widely influential and imitated. She has often been credited as the major proponent of 'retro' design. However, her body of work is broader and more idea-based than this suggests. She uses historical design to make visual analogies, and for its emotional impact and immediate appeal to contemporary audiences.

Scher has developed identity and branding systems, promotional materials, environmental graphics, packaging and publication designs for a wide range of clients including The New York Times Magazine, the American Museum of Natural History, The Asia Society, Phillips-Van Heusen, Anne Klein, Citigroup, Herman Miller, Le Parker Meridien, and Children's Television Workshop.

Her 1994 identity for The Public Theater and New York Shakespeare Festival utilizes wooden typefaces in the tradition of old-fashioned playbills. The theater's posters juxtapose this bold type with simple photography, and have become a vital presence on the New York street. In 1996, Scher's identity for The Public won the coveted Beacon Award for integrated corporate design strategy.

Scher's work is represented in the permanent collections of New York's Museum of Modern Art and the Cooper-Hewitt National Design Museum, the Zürich Poster Museum, the Denver Art Museum, and the Centre Georges Pompidou, Paris. Retrospective exhibitions of her work were most recently shown at the Tyler School of Art in Philadelphia (February 1999) and at the DDD Gallery in Osaka, Japan (March 1999). A book on her work was published in 1998 by China Youth Press.

In addition to the Beacon Award, she has received hundreds of design awards including four Grammy nominations from the National Association of Recording Arts and Sciences. In 1998 she was named to The Art Directors Club Hall of Fame, and she is a member of the Alliance Graphique Internationale. She has taught at the School of Visual Arts in New York for several years, and in 1998 was elected President of the New York Chapter of the American Institute of Graphic Arts.

Since 1993 Paula Scher has influenced the visual landscape of New York City more than any other graphic designer with her big bright, bold identity programme for The Public Theater. Her posters are widely imitated, and they've become icons for New York in movies and TV shows.

Biography Jurriaan Schrofer
1926 born on 15 April, The Hague

Education
1932-3 primary school, Scheveningen
1934-42 Werkplaats Kindergemeenschap Bilthoven (Kees Boeke school), IVO-diploma
1942-45 Vrijzinnig Christelijk Lyceum, The Hague
1945-57 law studies, university of Leiden

Professional Career
1948-52 assistant Dick Elffers
1952-56 graphic designer at Meijer Printers, Wormerveer; founder and co-director Irispers nv (later Meijerpers bv)
1956-60 advisor Meijer Printers, Wormerveer
1957-74 independent designer, 1961-63 in cooperation with Kees Nieuwenhuijzen
1958-65 member editorial board 'Schrijvers Prentenboeken' (writers picture books)
1958-65 design advisor Hoogovens (blast furnaces)
1958-65 member editorial board Forum magazine
1962-71 design teacher Avondschool Gerrit Rietveld Akademie (evening programme Gerrit Rieteld academy)
1963-74 designer and advisor publicity agency NPO
1965-66 chairman typographical advisory board Lettergieterij Amsterdam bv
1971-80 member advisory board Kunstzaken Metro Amsterdam (art affairs Amsterdam underground)
1972-75 'Goederen als vormen van gedrag' (goods as shapes of behaviour), creation and guidance courses for purchasers and divisional managers, de Bijenkorf department store; in cooperation with Benno Premsela
1973-77 (staff) teacher graphic design, academy for the visual arts, Rotterdam
1973-79 design teacher Avondschool Gerrit Rietveld Akademie (evening programme Gerrit Rietveld academy)
1976-78 coordinator application percentage arrangement Psychiatrische Observatie Kliniek van het Gevangeniswezen (psychiatric observation clinic of the prison system), Utrecht
1978 'Ontwerpen is overbrengen' (to design is to convey), creation and guidance courses for editors of Misset's Vakbladen (Misset's Trade Journals); in cooperation with Anthon Beeke
1979-84 principal academy for the visual arts, Arnhem; in 1984 early retirement
1985-87 teacher academy for the visual arts, Rotterdam

Commissions since 1984
1985 Muzenboog, Heerlen
1985 reliefs in well of the staircase of regional hospital St. Jansdal, Harderwijk
1986 Möbius ring in the hall of the Hogeschool Windesheim, Zwolle
1987 three dimensional sign for the Jewish Historical Museum, Amsterdam
1987 glass relief in the new building Unie van Waterschappen, Den Haag

1987-90 works in his studio on his paper works

1990 Jurriaan Schrofer died on 1 July

Born 1936 in London, England, Arnold Schwartzman graduated from Canterbury College of Art and started his career as a graphic designer in network television working on the ground breaking pop music show, 'Ready, Steady Go!', and as an illustrator for the London Sunday Times. He later became an advertising executive, creating award winning television commercials and graphics for such clients as Coca-Cola and Philips Electrical. In 1968 he joined the Board of Directors of The Conran Design Group, London, where he was responsible for the company's graphics division. He is a recipient of three Designers and Art Directors Association of London Silver Awards. In 1974 he was elected to the Alliance Graphic Internationale, and is a Fellow of the Royal Society of Arts.

In 1978 he moved to Los Angeles to become the Design Director for Saul Bass & Associates, and in 1982 he was awarded an Academy Award for producing and directing 'Genocide'. That same year he was appointed the Director of Design for the 1984 Los Angeles Olympic Games.

In 1996 Schwartzman created a permanent eight-screen video exhibit as well as a 'Time Capsule' mural for the Skirball Cultural Center and Museum in Los Angeles.

Since 1997, he has designed the 'Oscar' commemorative posters and key art campaign, including producing the theatrical trailers announcing the Academy Awards.

As director, producer, and screenwriter, Schwartzman's feature length documentary films include 'Genocide', 'Echoes That Remain', and 'Liberation.'

As an author, his books include *Airshipwreck* with Len Deighton (1978); *Graven Images: Graphic Motifs of the Jewish Gravestone* (1993); *Phonographics: TheVisual Paraphernalia of the Talking Machine* (1993); *CodeName: The Long Sobbing (1994)*; and *Designage: TheArt of the Decorative Sign* (1998).

A former lecturer at London's Royal College of Art, he has also lectured extensively on graphic design and film at many of the leading art institutions in the USA, Australia and Europe.

Currently Schwartzman is Chairman of the British Academy of Film and Television Arts, Los Angeles (BAFTA LA), as well as Chairman of the Documentary Executive Committee of the Academy of Motion Picture Arts and Sciences. He is a member of the Western Region Board of London's

Shakespeare Globe Theatre, and serves on the Advisory Board of the American Institute of Graphic Arts Los Angeles.

Where there's an image...

In 1972, in a feature article on Arnold Schwartzman, the British arts magazine *The Image*, wrote: "... Schwartzman is 36 and so far has done the work of four lifetimes. His career in design and the graphic arts is phenomenal... where there's an image, there's a Schwartzman."

Almost three decades later, Schwartzman has added a few more achievements to his accomplishments. Having established an international reputation as a graphic designer, in 1982 he was awarded an Academy Award for producing and directing a feature length documentary film.

His multi-disciplined life has encompassed working as an illustrator, graphic designer, advertising executive, magazine editor, art director, art gallery director, photographer, commercials and documentary film director, author and educator.

Few designers are given the opportunity to design for two of the highest profile events in the world – the Academy Awards and the Olympic Games – Schwartzman has taken both in his stride. During his early years he created imagery for rock and roll groups such as the Rolling Stones and The Who, and later, as a film director, he worked with such luminaries as Orson Welles and Elizabeth Taylor.

Recent descriptions of Schwartzman range from 'a grand statesman of design', 'a legend', to being 'retro-hip'.

Roland Scotoni is a member of The Art Directors Club, Switzerland.

He attended art school in Zürich and has worked in advertising for more than 40 years. Since 1985 he has been an Art Director at Advico Young & Rubicam, Switzerland's biggest agency. Roland has won a few international awards at ADC New York, Eurobest, Epica, ADC Europe and in Cannes.

"Before I see your work I want you to tell me what problem the client had and how you have decided to solve it. Only after you have given me this information, will I look at your work and tell you whether the work is good or bad." This is what my first boss in my first job in advertising on my first day said to me.

From this early lesson, I came to the following conclusion:
I can not just present this man with a pretty layout.
I have to take time out to consider.
I have to start by thinking.

What is it exactly that one should think about? First place the product in question on a table. One should consider what the product or customer benefit is. What differentiates our product from all other products in the same field? Once this becomes clear, one knows what message to convey. Now comes the next step: who should receive the message? Who should we be talking to? Once this has also been discovered we can go on to the following step: how can this message be communicated in an interesting and surprising way?

In advertising speak we call this an idea. Putting it together I would say: a real advertising idea is the staggering dramatisation of a consumer benefit.

The more one thinks about an idea, the more one starts to understand how difficult it is to find a simple, straightforward idea. A new idea. Because if it is not somehow new, it is not creative.

And that is what one has to practise:

Thinking!

"I'm often asked which design I am most proud of in our portfolio and my answer is always the same: Seymour Powell. Designing a design group is a tricky thing to do. It takes years to do and requires constant modification and reiteration. The client is always dissatisfied, as he always thinks that things can be done better. To keep true to your founding principles requires you to follow the philosophy of the Red Queen in *Alice Through the Looking Glass* – you have to run very fast to stay in the same place.

We have always focused on two guiding principals: always start with the needs (psychological and physical) of the end-user, and always re-invent the wheel.

The world is full of inadequate design solutions, which merely build on conventional wisdom. But the problem with conventional wisdom is that it is often wrong. If you don't constantly turn over the same rocks, you'll never notice if something has changed.

Design is about being cheeky enough to question everything. The eyes of a child coupled to the instincts of a bloodhound. It's as much about feeling your way as thinking your way through problems. It's also a privilege. I still have to pinch myself sometimes to remind myself that I'm doing something that most people would give their eye-teeth for: being paid to do what you love."

Richard Seymour is one of Europe's leading product designers. Since forming Seymour Powell, with his partner Dick Powell, in 1984 the consultancy has risen to a commanding position on the international stage, with clients as diverse as Nokia, Dell, Yamaha, Tefal, Casio, Jaguar and BMW. The consultancy has received numerous international awards for its design work, especially in the field of transportation design. Richard's background (he has also worked in advertising, graphics, film production design and book design) complements his partner's highly-developed product design skills to present one of the very few effective product design partnerships in the world. He writes regularly in the British design press and has appeared on numerous TV and radio programmes on design, including BBC Design Awards, The Late Show, BBC Design Classics, The Works and even Woman's Hour. He has also produced two television series on design with Dick Powell for British television. He is an accomplished cellist, pianist, organist and supporter of Early English Music. Motorcycles provide an additional distraction.

In 1998 he was appointed President of Design and Art Direction Association, London.

Niko Spelbrink was born in The Netherlands in 1940 and practised design in Amsterdam, 1962-91 and in Melbourne, Australia from 1991. He was a founding partner of what is now Eden Design in Amsterdam, 1969 and of Ography, Spelbrink Fenn Marks Designers in Melbourne, 1995.

My working life is to change existing information into an object which communicates better than the original. This responsibility brings joy mixed with anxiety and is brought about by assignments big and small both here and in the Netherlands. At times I tackle a problem just for the fun of it. However, my work deals with graphic communication between people I can imagine to understand, and always in close co-operation with my colleagues, our clients and other people involved.

I do what I do while forever weighing my passion for transparency and exactitude against the needs of the job at hand; making a living out of this; sharing with my partners in Ography and my colleagues and students at RM IT; meeting people equally besotted with design through Icograda, BNO and AGDA as often as I can; and being intrigued by sustainability and the pitfalls/possibilities of technology.

I think the best is still to come.

Corporate philosophy
Clarity and quality in communication. Excellent know-how and qualifications. Complete CI/CD-service range – from consulting to service. Design quality – in all media areas. Distinctive and attractive company profiles and brands – development, implementation and upkeep. Strategic thinking and working in systems. User-friendly solutions. Greatest possible advantages for our clients.

Biography
1990 Erik Spiekermann and his two partners Uli Mayer (design) and Hans Ch. Krüger (finance director) open MetaDesign. Together with seven designers start in a new office at Potsdamer Platz. The company grows to 15 people by the middle of the year, and moves into larger offices at Bergmannstrasse 102. Clients include Berlin Transportation Authority, Herman Miller and Agfa.

1991 New clients include Grundkredit Bank, Philip Morris (Marlboro Design Shop), Einstein Cafe and Europäischer Filmpreis (European Film Award). MetaDesign wins German Design Award for customer information for the Berlin Transport Authority.

1992 Berlin office grows to 30 people. Founding of MetaLog for the development of multimedia systems; an early project is the interactive information system for Jewish Museum Frankfurt. MetaDesign San Francisco opens, with partners Terry Irwin and Bill Hill together with six employees.

1993 MetaDesign Berlin takes on increasing numbers of corporate identity and corporate design projects. Berlin's new clients include Springer publishers and Berlin local government.

1994 Berlin's new clients include TV and radio station Westdeutscher Rundfunk, Boehringer Ingelheim, Willy Brandt Haus. Berlin wins Beacon Award for Berlin Transport System identity.

1995 Berlin office implements new decentralized structure and becomes international corporate design led agency for Audi and VW. London office opens with partners Tim Fendley and Robin Richmond and a staff of four.

1996 Pia Betton, Charly Frech and Bruno Schmidt become partners in the Berlin office. New clients include architecture publisher Bauwelt and Düsseldorf Airport.

1997 MetaDesign Berlin becomes Germany's largest design company, with 150 staff. Berlin's new clients include Bosch, HEWI fittings, VIAG Interkom telecommunications, German Federal Government.

1998 Berlin's new clients include Heidelberg, Koch Dureco Group and Lamborghini. New premises for MetaDesign Berlin are found, move planned for late 2000.

1999 Berlin's new clients include Railion and Robert-Koch-Institut. Berlin wins a Gold World Medal for the Audi Web Event at The New York Festival. Berlin office grows to 185 employees and San Francisco works with a staff of 50. MetaDesign London leaves the MetaDesign network, and has been taken over by Icon Medialab. The transaction is expected to strengthen the ties between the two companies. The ownership structure of MetaDesign Berlin and San Francisco remains unchanged.

David Abraham likes amoeba. They're what his company's management structure is modelled on. And looking at the facts, it's difficult to question his taste or technique. St Luke's advertising agency – the company David co-created with Andy Law at the tail end of 1995, the company with a corporate development plan based on the reproduction mechanism of the simplest living organisms, the company whose methods and manners have been dismissed by traditionalists as way-out, wacky and wildly extreme – has a turnover of about £90 million. Which is big bucks. So those amoeba are obviously on to something.

St Luke's, it's fair to say, is radical both in space and structure. Most advertising agencies reserve their largest offices for senior executives, ushering clients in and out to be sold a concept and sign a cheque. At St Luke's Euston warehouse, well away from London's ad central Soho and Saatchi's Charlotte Street, no executive has an office. In fact, none of the 200 employees has a designated desk. Instead, the space is organised around the clients, each of whom have a 'brand meeting room' decked out with a particular theme. "We get paid for our ideas," explains David, a 35-year-old who oozes inner calm and outward capability. "So what we've done is create a working environment in which those ideas can emerge best." Thus Coca Cola marketing men meet their St Luke's partners in a see-through plastic tepee covered with stapled pockets full of 'cool' items (from Muji trinkets to spiritualised CD covers – like a Tracey Emin tent full of little presents from everyone she's ever slept with). Meanwhile Radio One bods meet in a blacked-out bedsit-cum-recording studio, and Eurostar executives stretch their legs in a mock-up first class carriage.

Throughout the rest of the three-storey open-plan building, staff share all physical resources, logging on to networked computer terminals whenever and wherever they need to. Most staff discussions take place in the basement cafe – a vast, fresh, cool and quiet arena, conducive to clear thoughts and creative work. It's here that St Luke's Monday morning meetings take place, where every single employee listens to a review of performance and an outline of prospects. And there's added incentive to ensure that they hear good news, given that every employee of St Luke's is also shareholder in the company.

St Luke's employee-owned approach demands that all staff take responsibility for decisions. One such decision was to adopt the amoeba concept for structuring personnel. Staff figured that a group of 35 people was about the maximum size if everyone was to produce optimum work while helping everyone else with theirs. Thus when the company reached a larger size, sections of personnel were split up to form two distinct groups, each with the same working philosophies but operating more or less autonomously – like

two living cells of the same DNA. Another employee decision came in the spring of 1997 when St Luke's was growing too fast. Staff decided to ease the pressure by refusing to take on new clients They called this their summer of love.

When the company was spawned (involving a complicated buy out from the American-owned Chiat Day agency, itself a radical company who first introduced the open plan office to advertising). David Abraham and Andy Law could have cashed in their chips to become millionaires. "By distributing shares in the way that we have it's possible that we might have lost out," admits David. "But that individual wealth would be nothing compared to the blast of energy we feel from watching the company grow for the wider benefit of a large group of people." Ideologically, this is all very impressive. But in industry, the ultimate measure is results. And St Luke's seem to have that sorted too.

Classical economic theory states that in times of recession it's companies at the high end of the market, those involved with quality goods, which survive. And if the work currently being produced by the fresh talent captured here is anything, it's quality. "We work every waking hour on our business – we can't get away from it" says Richard from Reverb. "But we're prepared to put in the hours because we believe in what we do. And if for some reason it doesn't work out then we're still young enough to get up and do it again. Youth is always a good weapon."

Henry Steiner was born in Vienna, raised in New York, and educated at
Hunter College, Yale University, and the Sorbonne. He moved to Hong
Kong in 1961 and founded Steiner & Co. (formerly Graphic Communication
Ltd) in 1964. His work has had a major impact on design in the Pacific
Rim and has received worldwide recognition. Past President of Alliance
Graphique Internationale, he is a member of many organizations including
the American Institute of Graphic Arts, the New York Art Directors Club
and a Fellow of the Chartered Society of Designers. He both lectures and
serves on design juries internationally.

Henry Steiner is co-author of *Cross-Cultural Design: Communicating in the
Global Marketplace*, published by Thames and Hudson (1995).

Steiner&Co. clients include CITIC Pacific, Dah Sing Bank, Gold Peak, Hong
Kong Bank, Hong Kong Jockey Club, Hong Kong Land, Hong Kong Futures
Exchange, IBM, Jardine Fleming, MTRC, Millenia (Singapore),
ShanghaiMart, Ssangyong Group (Korea) and WingTai Asia.

Waldemar Swierzy was born in Katowice in 1931. He graduated from the Cracow Academy of Fine Art/Graphic Art Department in Katowice in 1952. He is a freelance graphic and poster designer and author of more than a thousand posters.

Most important awards
1959 Toulouse-Lautrec Grand Prix
1962 Third Toulouse-Lautrec Award
1970 First Prize 'Prix X Biennale di Sao Paulo'
1972 Silver Medal in the International Poster Biennale in Warsaw
1976 Gold Medal in the International Poster Biennale in Warsaw
1977 First Prize in the Poster Biennale in Lahti
1975 First Prize in the Annual Film Poster Competition of Hollywood Reporter in Los Angeles
1985 Gold and Bronze Medals in the International Jazz Poster Exhibition in Bydgoszcz
1985 First Prize in the Annual Film Poster Competition of Hollywood Reporter in Los Angeles

Most important exhibitions
1960 Vienna, Galerie in der Biberstrasse
1964 Documenta Kassel
1965 Moscow
1969 X Biennale di Sao Paulo
1970 Caracas
1976 Stockholm
1978 Warsaw, Poster Museum Wilanow
1980 Mexico City, Poliforum Sigueros
1982 Copenhagen, Galerie Oxe
1984 Goslar, Museum in Zwinger
1984 Jacksonville
1985 Pecs
1985 Prague
1986 Poznan, Lodz, Szczecin
1987 Aosta
1989 Lahti, Taidemuseo
1990 Kassel, GHK
1991 Tokyo, Creation Gallery G8
1993 Chaumont, Festival d'Affiches
1997 Warsaw, Poster Museum Wilanow
1998 Dansk Plakat Museum, Aarhus

Bibliography
1962 Polnische Plakat Kunst
1976 1977 Graphis Nr.187
1982 Idea. Special Issue: Poster Exhibition by Ten World Artists
1982 Who is Who in Graphic Design
1986 High Quality nr.4
1991 Creation nr.8
1992 Idea nr 232
1992 Graphis Poster

Since 1965 professor at the Academy of Fine Art in Poznan and since 1994 professor at the Academy of Fine Art in Warsaw. Member of Alliance Graphique Internationale.

Waldemar Swierzy is truly a 'superstar' among Poland's poster artists. As a member of the Polish Poster School he has created more than 1,000 posters to date.

1914 Born in Warsaw, Poland.

1934-39 Studied painting at Warsaw Academy of Fine Arts.

1939 First award for design of Polish Industrial Pavilion at New York World's Fair.

1948 Five gold medals at International Poster Exhibition in Vienna.

1952-85 Professor at Warsaw Academy of Fine Arts.

1953 National Award from Polish Government.

1958 Polish Prime Minister's Award for illustration of children's books.

1963 1st Prize at 7th Biennale Sao Paulo, Brazil.

1965 Gold Medal, Leipzig.

1970 Gold Medal, International Poster Biennale in Warsaw.

1976 Designated as Honorary Royal Designer for Industry, Royal Society of Arts, London.

1979 1st Prize, 3rd Poster Biennale in Lahti, Finland.

1981 1st Prize, Colorado International Poster Exhibition.

1984 Alfred Jurzykowski Foundation Award, NewYork

1986 Special Prize, Icograda.

1988 Gold and Silver medals.Warsaw International Poster Biennale.

1991 Bronze medal, Toyama International Poster Triennal.

1994 Silver medal, Toyama International Poster Triennal.

His work is represented in:

Warsaw and Poznan National Museums; Muse de Arte Moderna, São Paulo; Museum of Modern Art, New York; Villa Hugel, Essen; Museum of Modern Art, Kanagawa, Japan; Stedelijk Museum Amsterdam; Colorado State University, USA; The Museum of Modern Art, Toyama, Japan.

"Method is the one thing that has actually empowered – one of the worst words – the notion of graphic design in the eighties. People believed in solutions. There's no such thing as a solution," contends John Warwicker, one of Tomato's founders. "The world moves, the world changes, the world will forever change. Heraclitus, the Greek philosopher, said, 'You can't step into the same river twice.' Well, he's wrong. You can't step into the same river once. It's not the same river. So how can you have a solution when the world is like that? The world is about process, about the things that are unpredictable, about the things that are contradictory. That's what gives the world energy. If things were certain, there would be no culture."

"Tomato's success does not come from a talent for solving, design problems or responding to marketing briefs," he continues. "What we do is simply a by-product of process."

The makers of Trainspotting had the group create the film's title sequence, and then heavily featured tracks from the hot United Kingdom techno band Underworld, whose three musicians include two Tomato participants. Tomato designed the catalogue for photographer Albert Watson's 1996 show in Düsseldorf, Germany; they delivered the Dalai Lama for a book they produced for MTV about the network's first European music awards.

That mix of projects is one reason the eight-year-old group prefers to call itself a media and arts collective, rather than a design firm. They are graphic designers, film makers, writers and musicians who believe their work is more interesting through loose association with one another than if they were to work solely on their own. Tomato members take on their commercial projects to underwrite personal and non-profit work.

The original Tomatoes – and yes, they call themselves that – are Warwicker, Steve Baker, Dirk van Dooren, Karl Hyde, Rick Smith, Simon Taylor and Graham Wood. Jason Kedgley joined in 1994 and Michael Horsham, in 1996. Hyde and Smith are the members of Underworld, which produced the big UK hit Bom Slippy made popular by Trainspotting, three years ago.

Their first album, duhnobasswithmyheadman, went silver in the UK. Their subsequent recording, Second Toughest in the Infants – with singing once described as "a weird mixture of Fifties Beat poetry and the abstract chanting of Buddhist monks" – went gold. Another Tomato also maintains a separate career. For the past ten years, Taylor has designed the Urban Action fashion line based in Tokyo and London. This year he launches a new collection called Pearl Diver.

Members of the group compare that overlap of identities to a moving Venn diagram of associations which influence the work created within Tomato, which in turn affects outside solo activities.

"What we are is a group of people who see greater potential through affiliation," muses Michael Horsham. "Tomato catalyses these connections. What we have tried to do is create a culture of ideas. It's a culture you can inhabit; you can feed off it; you can feed it."

The organizing element is the studio space itself with its vine-ripened name. Warwicker calls Tomato a nonsense choice, selected because of its Dada-esque sound – as echoed in the British pronunciation – which easily crosses linguistic and cultural boundaries. Fellow group member van Dooren, fed up with questions, made up his own definition: "The name Tomato comes from a family of (sub) beta hormones – T/O.m/TO. This hormone grouping is found within the cerebral cortex of people who are susceptible to visions, waking dreams, sensations and feeling of weightlessness." Small wonder Tomato members get miffed when reduced to the caricature of a salad ingredient.

"As a boy, I was allowed to go with my father to factories and houses that were being built. I've always wanted to be an architect. There's a lot in common between a typographer and an architect. Both of them are concerned with form and space. Look – this catalogue, the white spaces between the text are what I consider the most important thing. They're girders which hold everything together, as in a building.

"And just as an architect visits his projects when they're building, I myself go along to the printer's, the workshop. I think that a graphic designer whose work appears in thousands of copies ought to know what opportunities the printing machines have to offer and integrate them into his work. He ought to be in the printing shop when his things are being made. I don't make things at home that are copied by the printer. No, I make the preparations, I provide a prescription, and the printer makes it up.

"What I also do is to alter the copy if it's not quite in order. You see, faults it may contain become evident at the typographical stage. It's very important that there should be a purpose in what you make. In my profession, intelligence is as important as creative power. It's not just a matter of making beautiful things, fascinating things – that's not enough. What I'm always after is … well, how shall I put it? It's something to do with the thing Chaplin's films have. I'm always after a double meaning."

Otto Treumann in his attic in the Vondelstraat in Amsterdam, an attic which architects Benno Premsela and Jan Vonk have converted into a studio and little rooftop terrace. An efficiently organized space. On one of the interior walls a few of Treumann's recent posters. On the floor a poster dating from 12 years ago- just slid out of an overflowing portfolio and laid down there.

"Look at this one", Treumann says. "I made it for the Utrecht Trade Fair. I used ball bearings for it. Know why? They roll without any friction. My intention was to show that the Trade Fair makes it possible for the business world to roll along smoothly. The Fair's symbol is a letter U with Mercury's helmet on it. I illuminated those ball bearings with spotlights and in them I had a white paper U reflected. If you look into a ball bearing you see yourself reflected in miniature. So I had to make a very big U to get it reflected there in miniature. A photo was made of it and then that was enlarged many times over." Studies the result without speaking, then says resignedly "But despite all the effort, it looks too much like a telephone." Shows another poster. "This is for the Trade Fair too (it's really one of the few commercial organizations I've made posters for so far). These are cog-wheels which fit into each other. And above them you can see the drop of oil that'll lubricate the works. The U is reflected in the thick oil-drop."

And, as resignedly as before, "I don't think the drop of oil is thick enough. It could have been better. This is a good one as far as the idea goes."

A good hour later we've come to the last posters in the portfolio. Shy to begin with, unsure of himself, interrupting himself continually with, "It's too dry – if I'm boring you you must say so" he has become more and more impassioned. Has spoken of his doubts, the toilsome seeking via an endless series of sketches, comparing one of his posters with "your child which is looking at you from a long way off."

Here are a few examples I noted down, spring 1969. Treumann: "I made this one for an exhibition in 1959. The Heart of Brabant. The organizers insisted on having a heart on the poster. I couldn't manage it. The facile symbolism of it offended me. I objected but they were adamant. I then tried to find a symbol for it. No luck. Until I was on holiday in the mountains in Italy, and thinking about it, I drew a line through the heart. I suddenly saw it became a B, if you did that when the heart was lying on its side. That shows that the most trite of symbols can be used if you do something new with it. The trees and the reflections in the water create an atmosphere of summer, of all going out together to the exhibition and having a good time. That reflection was printed absolutely perfectly and then the greeny colour was laid over it. The printing press did the same as nature does."

"This one was for the international exhibition of sculpture at Sonsbeek in 1966. This (looks like the top of a fir-tree) is a small branch of a cypress slid under the magnifier. My aim was to use that one small branch to suggest nature in her entirety juxtaposed against the pieces of sculpture. I used photos of work by Moore for this. This was for the first Van Gogh Exhibition in 1945 in the Stedelijk Museum. It was commissioned by Sandberg who did a lot to help me along after the war. Look, I've used Van Gogh's silhouette taken from one of his paintings. I'd never do that nowadays. I think it awful. It's too much like playing around with something you ought to keep your hands off. That silhouette is his business, his alone."

Nationality: Dutch

1946 Born The Hague
1966 Royal Academy of Art, The Hague, Graphic Design and
Communication
(final exam Cum Laude and the Esso Award)
1967 Freelance graphic designer
1969-72 Further graduate study at the Royal College of Art, London,
Department Graphic Design and Communication
1972 Computer aided design course at the Imperial College of Science and
Technology, London
1972 Science research fellowship at the Experimental Cartography Unit,
London
Tutor, Middlesex Polytechnic, London, teaching instructional graphics
Freelance graphic designer
1973 Association with designers Gratama and De Vries, The Hague
1976 Creative director of the Design Department at the State printing and
publishing company
Tutor at the Royal Academy of Art, 's-Hertogenbosch, and Gerrit Rietveld
Academy, Amsterdam
1980 Member of the International Designers group Alliance Graphique
Internationale (AGI)
1982 Total Design, Amsterdam, senior designer
1984-88 Total Design, Amsterdam, creative director
1992-to date Total Design International Holding bv,
Managing Director/Partner
1997-to date Total Design Special Projects bv, Managing Director

Rather curiously, it all began with a clash between Luke Skywalker (aka Rankin) and Darth Vader (sound effects courtesy of Richard Seymour). But what followed was an interesting and wide-ranging exercise in honesty. Rankin talked about his motivations, what he thinks of advertising, which is not a lot, what he thinks of agency middlemen, which is even less, and his perchant for nudity, among other things.

And the relevance of Star Wars? Obvious really. Rankin took as his theme 'How to get your own way in the turbulent world of the media and get your image to the final page.'

"It's simple," he explained, "you just have to be a tosser. But then I thought, no one gives me very much work in advertising, so obviously it isn't working." Rankin, who has shot a host of celebrities, several of which he displayed during the lecture, began taking photographs about 12 years ago so that he could meet girls. However, "the only girl I've ever met taking photographs is my wife, who I got divorced from two years ago."

It seems unbelievable that the man who has done close-ups of intimate parts of Helena Christensen's body originally studied to be an accountant. It was obvious from his performance that he too has trouble reconciling the memory. His eureka moment came when he compared his lot to the "really cute girls and really cool blokes who were studying art. I was doing like eight-hour days and they were doing two hours. I got this real surge of creative energy. And I thought, I can't draw, how can I do what they're doing? They're expressing themselves. I couldn't express myself at all apart from fighting and drinking and all that sort of nonsense," he recalled.

Rankin dropped out of accountancy, bought a camera, returned to his native St Albans and started snapping rugby matches and portraits of cute kids for the local newspaper. He also started a lifetime's love of nude women, at the time with his then girlfriend. After a year's experience he enrolled on a technical course at Barnfield College. His end of year exhibition was devoted to another naked female form, this time his mother's. The show went down a storm with his dad and the interview panel at the London College of Printing, which considered it to be seriously PC, right on, and all those other things art students should be. Rankin found the teaching too esoteric and quickly "took refuge in the student's union." Here he met Jefferson Hack: "who I guess saved me in a lot of ways and started me off on a new course of life," commented Rankin. "He and I basically conned the student union out of as much money as we could for about three years. We stole their equipment every single weekend, and we produced two magazines, one called Untitled, which was fairly bad and was full of left-wing student rhetoric. "The other was called Eat Me and Rankin recalled with relish the issue that blew his year's student budget: Eat Me Naked. It's a theme that's run though his work, right up to his current Raw Nudes exhibition in London.

Not long after their meeting, Rankin and Hack founded Dazed & Confused, which was named after an old Led Zeppelin track that the pair, then about 24 and 19 respectively, felt summed up their mental state. "We put out this fly poster and everyone loved it. And we thought "this is brilliant, we've got some sort of magical gift here, we can put anything out and everyone loves it, what is this?" So we got quite embroiled with drug culture and drug-taking and we realised that if we did Dazed & Confused we could meet all the people we wanted to meet, get into clubs free and everyone would give us free drugs. Then we suddenly thought "shit, there's a bigger agenda," and we started to get morals. I remember it was like creative morality kicking in," revealed Rankin.

So that was it for unconstrained hedonism and the pair began something of a crusade to discover and try out new talent. "Honesty", said Rankin, "is the key to it all. Just be really honest to who you're featuring and to your readers – I think the secret is collaborating with the people you photograph so that they feel like they're part of it; because of that they give me a lot more."

"The other thing is to kind of have a healthy disrespect for the media that utilise photography; advertising and fashion," he continued. "If you have any respect for them, you're an idiot as far as I'm concerned. Basically all it is about is selling something, and if you're selling something, you're selling yourself." His views of agency producers were harsher yet: "I think there's a lot to be said for clients – and I've got a lot of respect for creatives. But I really hate the fucking producers. The middle people are always wrong as far as I'm concerned and they always fuck it up, when there's so many people involved it becomes much of a nothingness," he said passionately.

Creative insecurity spurs him on: "What drives me as a photographer is I don't actually like what I've done in the past, I strive to be better all the time."

Ruth Nicholas, freelance journalist and editor.

1922 Born in Masuren (East Prussia)
1940 High School graduation Johanneum Lübeck
1941-1945 military service in Russia
1945-1950 prisoner of war Russia (quarryman)
1950-1952 apprentice typesetter
1953-1955 State Academy of Fine Arts, Stuttgart
1956-1963 sub-editor *Der Druckspiegel*
1963-1983 Professor State Academy of Fine Arts, Stuttgart.
Freelance Designer, Copywriter, Consultant for free enterprises, CI designer
since 1983 The Koblenz School of Corporate Management
Consultant Daimler Benz
since 1991 Design Academy Karlsruhe
1995 Lucky Strike Design Award '95

Daniel was educated in architecture at the University of Buenos Aires in his native Argentina. He came to Britain as a post-graduate in 1978 to gain an MA in industrial design at the Royal College of Art.

From 1985 to 1991 he was in partnership with Gerard Taylor, producing products, furniture and interiors for such clients as Knoll and Esprit. During this period he developed a flagship store for Alessi in Bari, Southern Italy and his display systems from this were introduced in Alessi shops in Milan and elsewhere.

In 1981 many of his products featured in the original Memphis Exhibition in Milan and in 1987 he worked with Memphis to create new lighting designs. Since then, both Ettore Sottsass and Achille Castiglioni have remained close mentors.

Between 1982 and 1990 his product and furniture designs were manufactured by Parenthesis Limited and by Anthologie Quartett, along with work by Sottsass, Oscar Tusquets, Matteo Thun, Boris Sipek and others. Of these, his Bag Radio has became a design icon and is now held in the permanent collections of the Museum of Modern Art, New York and The Victoria and Albert Museum in London where it is on display in the new 20th Century Gallery.

From 1983-86 he combined his design activities with a position as Unit Master at the radical Architectural Association, alongside Nigel Coates and Zaha Hadid, and in 1991 he began a six-year contract as Professor of Industrial & Vehicle Design at the prestigious Royal College of Art. Here he has been keen to introduce his students to the practicalities of the manufacturing world and is currently running student projects in conjunction with Alessi.

In 1992 he was invited to become a partner of Pentagram, nominated by the Financial Times as one of the top international design consultancies and dubbed by the same paper as "the Rolls Royce of design". From here he continued his educational commitments and formed a team working on interior, product and furniture design with clients including Swatch, Granada Hospitality, Tse Cashmere and Superga.

Daniel is a Fellow of the Chartered Society of Designers and of the Royal College of Art. His designs have featured in major exhibitions in Italy, France, the USA, the UK and Japan and in most of the leading international design and architecture magazines.

In May 1960 I began a three-year typesetting apprenticeship in Stuttgart. By this time typography in Switzerland – as represented by the names of Karl Gerstner, Emil Ruder, Armin Hofmann, Siegfried Odermatt, Carlo Vivarelli, the Basel school, and the design magazine Neue Grafik – had earned worldwide prominence.

In marked contrast to the extremely conventional approach to design and the worn-out practice of typography still prevalent in Germany, the vitality of Swiss Typography had launched a new international movement in the field of design. I was fortunate to have well-informed teachers who encouraged intense discussions and lively debate among their students and apprentices.

This was the first breakthrough for me: the promising alternative of Swiss Typography inspired and enlivened my years as an apprentice.

Around six months before my apprenticeship at Ruwe Printing actually began, I was introduced to the company's consulting designer, Karl-August Hanke, through whom I learned what was happening in the renowned school for art and design in Basel, the Kunstgewerbeschule. In as early as 1942, Emil Ruder began to teach typography to typesetting apprentices and designers, and in 1946, Armin Hofmann joined the staff. One of Hofmann's first students in the early fifties, Hanke worked for a short time in the design office of Dorothea and Armin Hofmann and Karl Gerstner. Adjacent to a residential apartment, they shared the studio space on the top floor of Petersgasse 40 in Basel.

From the day we met, Hanke became my mentor. I was a confused student without the slightest inkling of how design or typography could be rationally defined, but Hanke was able to formulate a concise explanation that allowed me to trust my intuition: "Bearing in mind the purpose and form of communication, design means to organize a certain message within a certain context. By every measure as significant as the words or text to be printed, for typographers, the empty spaces of the page are active shapes that contribute to the expression of the whole. Because it is an integral relationship, we refer to this as 'unity' – in all creative fields, the essential quality of design. We have many techniques at our disposal and great potential for unlimited combinations."

Thirty years later I found a copy of the letter I wrote to my parents in January 1960 telling them about my first meeting with Karl-August Hanke: 'Four days ago I visited the consulting designer of Ruwe Printing. It was a decisive visit. I brought my work in a box, and opened it on the table.

During my presentation, I noticed that Hanke's reaction was one of silence. After a long pause he revealed his disapproval. When I asked the reason for his negative opinion of my work, he opened a drawer filled with examples of his own current design work and past drawings. Karl-August Hanke told me that he had been a student at the Basel School of Design and, with few exceptions, renounced the graphic design practised in Germany as antiquated, having shown no development for decades. His harsh appraisal of the art academies and his scorn for most designers in Stuttgart is justifiable. Hanke's engagement and his collection of amazing work from his teacher, Armin Hofmann, has left no doubt in my mind that the design ideas originating in Switzerland are revolutionary. Tonight I am both inspired, yet disheartened. The night after the meeting with Hanke, I threw most of my work in the trash. Everything that has made me happy over the last years now seems pointless; it's time to take stock of my uncertain future. When Hanke found out that I was about to begin my typesetting apprenticeship, he almost exploded. He has tried to convince me to go to Basel immediately and enrol in their strict programme of study which includes typography, photography, and a foundation of other courses from portrait drawing to poster design.'

I was of a critical age, already 19 and several years older than most German or Swiss apprentices entering the profession. Hanke caused me to doubt whether the investment of another three years to learn typesetting would be worth it. I was unprepared for his adamant attitude and tried to reason with him. Since I had already signed the contract with Ruwe Printing, I could not back out. Furthermore, to learn typesetting skills before attending the Basel School of Design could be a professional advantage. He chided me, "If you go to the Basel School of Design, you'll have your choice of any design position that exists in or around Stuttgart."

Not willing to give up, Hanke wanted to speak with my future master, Wilhelm Ruwe, to release me from my commitment. Vehemently opposed to Hanke's offer, my parents insisted that to relinquish the opportunity of learning a trade would be extremely unwise. I decided to go through with the planned apprenticeship, but resolved to model my work after Swiss Typography and, in my own way, endeavour to apply the ideas behind it. Hanke had opened my eyes, and I understood what typography could be.

Excerpt from My Way to Typography: a Retrospective in 10 Sections published by Lars Müller

My story so far…

I was born in London in 1933, just a few hours after my Russian parents arrived from St Petersburg to make a new life in England.

I emerged more or less intact from a variety of English educational institutions, including Greshams School, in the early fifties.

After studying architecture at the Architectural Association, I took courses in building, welding, dress design and interior design at Hammersmith School of Art.

From there I joined the army where, as a Private in the Royal Army Service Corps, I continued my studies into 'humanity in institutions'.

I entered the world of design in the mid fifties. I gained experience as an Architectural Designer, as a Product Designer and as a Graphic Designer. After ten years it was time to start my own company.

I did. With Wally Olins. Wolff Olins started in the autumn of 1964 in Camden Town London.

During my twenty years leading Wolff Olins we became the leading European company in 'corporate identity' – one of the most effective consultancies in this field in the world.

Among our clients there were Audi, Apple – (the Beatles, not computers), Aral (the brand leader in gas stations in Germany), BOC, Bovis (I was responsible for their humming bird), British Airports Authority, BfG (then the fastest growing bank in Germany), The London Borough of Camden (the first in local government to use professional graphic designers), the city of Paris (I was involved in the re-development of Les Halles – the former site of the Parisian food market in the centre of the city), P&O, Renault, 3i, Pilkington & Volkswagen

We won many international awards for our work with our clients including two Duke of Edinburgh Design Management awards.

In 1971 I was elected President of the Designers & Art Directors Association (D&AD). Throughout the eighties I became increasingly involved in the Chartered Society of Designers (CSD). I went on to become its President.

What I do.

I work with all kinds of organisations – from large international companies to individual people – on their raison- d'etre, which literally means their reason to be. This for me is design in its widest contextual sense.

No reason to be? Then why should anyone notice you or respond to your company in any way at all? Why get up?

People sometimes tell me their point is to make money. Tough talk! But only foundries, mints and printers do that. Everyone else has to earn it. And you can only earn from other people by bringing them value or by cheating them.

So I work on people's visions, their purposes, what they choose as their mission, their strategies and the plans they have to achieve these things. It's really about the inner strength of their ideas, their coherence and relevance. It's about the 'internal life drive' of a company or person.

Then I look at how 'what they are for', exists in the outside world. Their self-expression and identity. The effect that they have on others with who they are and what they do. Their 'external life' if you like. That's what really counts and earns money and makes reputations. Few people in organisations put the outside world on a higher plane than themselves. They forget or have never really understood what it means to serve although they use the word service with ease. Although it's often well intentioned it's a kind of unconscious arrogance.

So I focus my energy and skill on helping people in organisations clarify and evolve what they bring to the world and why it could be valued. For me this design process underpins design in the aesthetic sense.

In the end I think I'm just a designer. Although a designer of context as well as content. For me the word 'design' means three things. First, the grand design, the big idea. Paris, for instance, or IBM. Second, it means bringing the grand design or idea into existence. The whole process from conception, planning and engineering through to styling and the nuances of fashion. Third, it means the design of something. A car, a symbol, an office, set of instructions or a cup and saucer.

All these three are interdependent aspects of design or lenses through which to appreciate it. I have always involved myself with all three.

Hermann Zapf was born November 8, 1918 in Nuremberg, Germany and since 1938 has worked as a freelance designer in Frankfurt. He has lived since 1972 in Darmstadt, a town between Frankfurt and Heidelberg.

1948-50 Instructor for lettering Werkunstschule Offenbach
1980 Professor at Carnegie Institute of Technology, Pittsburgh, Pennsylvania.
1972-81 Instructor for typography Technische Hockschule, Darmstadt.
Since 1977 Professor for typographic computer programs, Rochester Institute of Technology, Rochester, New York.

Work in museums and libraries
Germanisches National Museum, Nuremberg
Gutenberg Museum, Mainz
Klingspor Museum, Offenbach
Bibliothèque Royale de Belgique, Albert I, Brussels
Royal Society of Arts, London
Pierpoint Morgan Library, New York
New York Public Library
Library of Congress, Washington DC
The Melbert B. Cary Jur. Graphic Arts Collection, RIT, Rochester/New York
Richard Harrison Collection, San Francisco Public Library
Cecil H Green Library, Stanford University
The Houghton Library
Harvard University, Cambridge, Massachusetts
Newberry Library (Wing Foundation), Chicago

1947-56 Art Director, D. Stempel AG, Frankfurt
1957-74 Design Consultant Mergenthaler Linotype Company, New York
1966-73 Consultant, Hallmark International, Kansas City, Missouri
1979-81 Consultant to Xerox Corporation, Rochester/New York
1977-85 Vice President DPI, Design Processing International Inc., New York
Since 1986 Partner of URW Master Design GmbH, Hamburg

Honorary member
Double Crown Club, London
Society of Scribes and Illuminators, London
Societé Typographique de France, Paris
Grafiska Institutet, Stockholm
Society of Typographic Arts, Chicago
Type Directors Club, New York
The Typophiles, New York
Society of Printers, Boston
Art Directors Club, Kansas City
Zeta Chapter, Gamma Epsilon Tau, Rochester Institute
The Associates of the Stanford University Libraries, Stanford
Monterey Calligrapher's Guild, Monterey
The Friends of Calligraphy, San Francisco
Society of Graphic Designers of Canada, Toronto

Prizes
1962 Silver Medal, Brussels
1966 First prize for Book Typography, Biennale Brno (Czechoslovakia)
1967 Gold Medal, Type Directors Club, New York
1969 Frederic W. Goudy Award, Rochester Institute of Technology
1970 Honorary Citizen, State of Texas, Austin
1974 Gutenberg Prize, City of Mainz
1975 Gold Medal, Museo Bodoniano, Parma (Italy),
1984 FDI Award, Frankfurt
1986 NCA Award, USA

ACKNOWLEDGEMENTS

To begin with I would like to thank all the participants for generously giving their time and energy in providing the material for this book and entrusting me with this selection of their work.

I thank Mary Mullin (past Secretary General, Icograda) and Brian Davies (past Director, Icograda Foundation) for asking me to come up with an idea to celebrate the 25th anniversary of the Seminars, out of which came this book and CD-Rom.

I acknowledge the late John Aston (past Chairman of the Seminar Steering Committee) for his help in co-ordinating the multi-media presentation which led to this project and Paul Torr (Senior Tutor, Graphic Design, Nene College) for help in compiling the list of speakers for the 25th seminar.

I convey my thanks to Sharon Irving, seminar organiser, who originally coined the title Masters of the 20th Century - The Icograda Hall of Fame for the multi-media presentation.

Thanks go to Ben Bos for his help and advice and for providing the work of Juriaan Schrofer, Otto Treuman and Ootje Oxenaar.

And to Carsten Wolff for the work of Willy Fleckhaus and for translating his biography; to Fred Price for giving us valued material on Germano Facetti's work and biography; to Alan Fletcher for his piece on Fukuda and for providing invaluable information on the participants; to Anne Coco (Margaret Herrick Library) and Jennifer Bass for providing the work of Saul Bass.

Also to Naomi Games for the material on Abram Games; to Mark Hess for providing the work of Richard Hess; to Laurie Haycock Makela for the work of P. Scott Makela; to Lawrence Mirsky, Cathy Gasser and Ann Holcomb (Cooper Union) for Herb Lubalin's material and finally to Tania Prill for the material on Hans Rudolf Lutz.

Thanks to Gareth Tansey and Matthew Strong for help in producing the multi-media presentation and Steve Worland for his assistance in producing the CD-Rom.

Thanks go to Marcia Lotito for her photography and digital imaging work and my gratitude to Bernie Nicholls, who did all the typesetting and put the project to bed.

I am grateful to David Hillman and Pentagram for providing the original material for the multi-media presentation and for their encouragement of the project.

I would like to thank David Kester (Managing Director, D&AD) and Claire Fennelow (Director of Education D&AD) for putting me in touch with Buckinghamshire Chiltern University College, which led to the production of the multi-media presentation.

I am indebted to Michael Spallart and Craig Halgreen of Sappi for their generous support and sponsorship of this project and to Craig for contributing the piece on Sappi.

Acknowledgements to the Board of Icograda for their support of this project. In particular I thank Thierry Van Kerm (Managing Director, Icograda) and Guy Schockaert (past President, Icograda) for providing access to the historical records of the seminars and David Grossman (President, Icograda) for contributing the text on Icograda.

I am grateful to Marion Wesel-Henrion for providing the history of the seminars, list of speakers and Henrion's work.

Thank you Jeremy Myerson for writing the text for the back cover and for editing my foreword and Marion's history.

And thank you Steven Heller for contributing your inspiring overview to the book.

My gratitude to Søren Michaelsen for his invaluable assistance during the entire process of design and production.

I thank Marianne Møller for her help with production at a critical time and Jane Eady for proof reading.

I am most grateful to B. Martin Pedersen of Graphis for publishing this book and to his team - Andrea Birnbaum, Michael Gerbino, Lauren Slutsky and Doug Wolske for their helpfulness and efficiency.

Thank you to Tim Jenns and Creative Input for making available their resources in the compiling and completion of the project.

To Philip Giggle who has partnered this project from the very beginning - my special appreciation and thanks. He designed and produced the multi-media presentation, collated all the text, scanned and prepared all the images for reproduction and provided invaluable general and technical advice throughout.

...finally, a special thanks to my family. To my wife Karen for her advice, support and help throughout the project; to daughters, Karen and Dana for co-ordinating all the material; to daughters Anna and Philippa and sons-in-law Matthew, Søren and San for their support. Thanks to them all for their patience and encouragement.

Mervyn Kurlansky

Design and Art Direction	Mervyn Kurlansky
Design Assistant	Søren Michaelsen
Editors	Mervyn Kurlansky
	Philip Giggle
Co-ordination	Karen Kurlansky
	Dana Kurlansky
Writers	Mervyn Kurlansky
	Craig Halgreen
	David Grossman
	Marion Wesel-Henrion
	Steven Heller
	Jeremy Myerson
Digital Image Production	Philip Giggle
	Marcia Lotito
Typesetting	Bernie Nicholls
Digital Artwork	Søren Michaelsen
	Marianne Møller
	Bernie Nicholls
Sponsors	Mervyn Kurlansky Design
	Sappi Fine Paper Europe
	Creative Input

Throughout this book we have have endeavoured to retain the editorial style and feel of the biographies supplied.

This book was produced using QuarkXPress, Adobe Photoshop, Adobe Illustrator, Macromedia Freehand, Microsoft Word and Caere Omnipage